35

The Rudiments of Paradise

THE
RUDIMENTS
OF
PARADISE

various essays on various arts
by
Michael Ayrton

Weybright and Talley
New York

to Elisabeth

Contents

ACKNOWLEDGMENTS

The author's thanks are due to the Folio Society for permission to reprint *Prometheus Bound*, the first of the three essays on Michelangelo, and to the editor of *Horizon*, New York, for permission to reprint *The 'Unwearying Bronze'* and *The Making of a Maze*.

The Rudiments of
Paradise

SOME POETICAL PERSON told me when I was a small child that
the night was a cloak and the stars were holes in it through
which might be glimpsed the gold vault of heaven, beneath which
the blessed sat, presumably on the upper side of the cloak as on
a vast inverted hammock. I was much struck with this conceit,
derived from fairly obvious literary sources and amiably intended
to prevent me from being frightened of the dark, which I was not.
I remembered it from time to time, particularly when I learned
the symbolic intention of the gold ground in medieval painting
and much more recently when I made a golden honeycomb for
a man in New Zealand. Meanwhile, when I had assembled the
material for an earlier volume which I had called *Golden Sections*,
it had occurred to me that that title implied not only the use of
the harmonic division sometimes called 'the golden mean' or
'golden section' but also the parts of my life which I had found
golden. For this enlarged collection, therefore, I needed some
sequential title.

I am not good at titles, but such essays as I have written, apart
from those best forgotten, have all been concerned with glimpses
of the gold ground seen through holes in the dark and I have had
astonishing luck in the number of them I seem to have enjoyed.
Indeed, I have had as much joy in the recollection of such flecks
of paradise as I have received through the seven holes I wear
which are the standard issue for the human head. One recent
flash of light for me has been a volume called *Labyrinths* by Jorge
Luis Borges which I discovered in the British Embassy in Wash-
ington. In it I found a quotation which runs: 'Robert South
conspicuously wrote: "Aristotle is but a fragment of Adam and
Athens the rudiments of paradise."' Conspicuously as he may

have written, Robert South had not before then been conspicuous
to me, but such a new-minted golden phrase made him so, and
it was not diminished by my discovery that the Reverend Robert
South was a prototype of the Vicar of Bray. I confess I have not
pinned down the line, for I have been daunted by the six volumes
of his sermons (1692) and put off by the titles of his subsequent
works. Among the most celebrated of these is *Animadversions on
Dr Sherlock's Book, entitled a Vindication of the Holy and Ever Blessed
Trinity,* published in 1692, soon to be followed by a rebuttal of
Dr Sherlock's retort entitled *Tritheism charged upon Dr Sherlock's
New Notion of The Trinity and the Charge Proved* (1694). The depth
and potency of these arguments notwithstanding, what remains
to me is that if the holes in the sky have been glimpses of Eternity
then the ruins of ancient Athens must be among such rudiments
of Paradise as I may hope to have seen on earth. They move me
to reverence and to a sense of the numinous much as do certain
other works of art I have seen and read and heard, and which
live in my mind as they do in many people's.

I have spent much of my life in responding to rudiments of
such a kind and in paying some sort of rudimentary homage to
their creators. I seem to find some special satisfaction in trying
to discharge such debts, perhaps with something of the absurdity
of Dryden's lines when in one of his plays he had a character pro-
pose: 'Thy father's, mother's, brother's deaths I pardon. That's
somewhat sure a mighty sum of murder, Of innocent and kindred
blood struck off. My prayers and penance shall discount for these,
And beg of Heaven, charge the bill on me.'

Therefore I would have Heaven charge on me the bill for rudi-
ments and fragments, for I am as much in debt to those who made
the things I cannot hope to emulate as to any fragments of Adam
or Aristotle, living or dead.

A rudiment, however, is not a fragment nor a glimpse, although
a rudiment may survive as a fragment and a fragment may suggest
the presence of a rudiment. A rudiment is an element or first
principle. It may also be an imperfect beginning of something
that will develop, or might under other conditions develop, in
which case I have myself spent my time striving to attain the
condition of a fragment of Adam and produce a rudiment, at
least in terms of something that might yet develop. If not, and

I am by no means sure, then I have produced a parcel of objects also, but otherwise, defined as a rudiment, which is a part or organ imperfectly developed as having no function (e.g. the breast in males) and I am frequently disturbed by the thought.

My reasons for quoting the dictionary definitions of the word so conscientiously are that the word does more than justify the title of this book, which is filled with the imperfect beginnings of attempts to explain to myself and anyone else who has time to listen, what elements have contributed to my sense of the rudiments of Paradise on earth. They also comfort me with the hope that my own work in other media might have, or even might yet develop, under some condition or other, into more than the assorted litter of visual images in bronze or paint, having no function, which I see them to be.

I am unlike the Reverend Robert South in various ways. I have not, for instance, been a zealous advocate of passive obedience to a *Zeitgeist,* as he was to the frequently changing proprieties of religious observance in his day. I do not therefore expect to find myself buried in Westminster Abbey with him, nor shall I be found entombed in the contemporary equivalent which, in my trade, is an inevitable if simple entry in the recently widely expanded sepulchre called art-history. My animadversions have led me into notions and I see the contents of this book as no more than rudimentary, for they are to be justified only if a stern piety towards those substantial fragments of Adam, to whom I owe my glimpses of the vault, and a sense of obligation to them, are positive virtues. All my most laborious activity has been to celebrate my superiors in one way or another, which joins me, at least in this, with the Reverend Robert South and I have had the advantage of having no place directly to seek or to obtain from Daedalus, Giovanni Pisano, Michelangelo or Hector Berlioz, whereas he had to extol the qualities of Lord Clarendon and the Earl of Rochester in order to advance.

I have not, however, conspicuously written a line as good as: 'Aristotle is but a fragment of Adam and Athens but the rudiments of paradise' nor three pages as impressive as Borges' 'The Fearful Sphere of Pascal' wherein I found those lines. In this essay Borges points out that the divine sphere, as described by Plato in the *Timaeus,* gradually rotated and came to create a labyrinth

and an abyss for Pascal, who felt the incessant weight of the physical world and experienced vertigo, fright and solitude, expressing his feelings in the words 'Nature is an infinite sphere, whose centre is everywhere and whose circumference is nowhere'. What is even worse is his earlier version of this awesome proposition which he began to write and crossed out. In this he wrote 'Nature is a *fearful* sphere'. 'It may be', as Borges concludes, 'that universal history is the history of the different intonation given a handful of metaphors.' Certainly the history of my life and of the works of art which have especially enriched it is precisely that: the depiction or incantation of a handful of metaphors whose splendour rests upon their intonation. About the fearful sphere which we inhabit, whose centre may be calculated and whose circumference is physically established, there spin metaphors whose centre is everywhere and whose circumference shows itself only through holes in the dark.

If I can no longer see the stars as literal holes in that dark, but must accept them as conquerable territories where future generations may come to leave such tributes of urine, old boots and puerile messages from politicians as the moon now endures, the gold ground which is but metal laid on wooden panels does not lose its mysterious intimation of eternity. The sphere frightened Pascal and it frightens me but there are metaphors at its imagined corners but for which it would be unendurable. They are not fragile. It is we who are that.

The
Terrible Survivor

Uno maestro, il quale fu chiamato Barna: costui
fu eccellentissimo fra gli altri. . . .

LORENZO GHIBERTI

UPON THE RIGHT-HAND WALL of the nave of the Collegiate Church *plates*
2–4 at San Gimignano in Tuscany, is a great fresco which within its twenty-seven divisions sets forth the Life and Passion of Christ. It is the surviving masterpiece of a painter whose name may have been Barna and who may have been a Sienese, a man about whom nothing certain is known, not even his name, but a man who took the subject of the Passion of Christ and turned it subtly and terribly into the Passion of his age, for in his time he saw and survived the cataclysm which has been called the Black Death, a pestilence more dreadful than any the western world has ever known. In two hot summer months it wiped out one-third of the people of Italy; within a year it devastated all Europe and it swept across the minds of men as the wrath of God. The fresco at San Gimignano, which so simply and movingly presents the story of the New Testament with its heroic and tragic climax, implies at another level the tragic climax of the medieval world.

For ten years this strange sequence of pictures and the enigma of the man whose hand, mind and eye controlled and designed its creation have drawn me uneasily to the study of this fresco and to the personality who is called Barna. In seeking the sources of his style and the climate of ideas in which he worked I have not discovered why, of all the painters of that time, only Barna could contain, within the formal convention of the Sienese tradition, such an essence of the pessimism of man in an age of disaster.

I am not a scholar but rather a celebrant, and such bare bones of history as I can assemble, I must, by my temperament, build into a human reality in a manner which true historians would probably regard as unsound. Yet Barna, whose spectre has continual access to my heart, looks out from the narrow eyes of

his painted people and into mine and the communication thus established is not one that I can discount or deny.

The name of Barna is first mentioned in the *Commentari* of Lorenzo Ghiberti, the sculptor who made the 'Doors of Paradise' for the Florentine Baptistry. He wrote not less than sixty and more probably nearer one hundred years after the painter of the San Gimignano frescoes may be presumed to have died, and hailed him as a master. To be a master was to take what one had learned and bring it to excellence in care and precision, in exactness of observation; to continue to see clearly within an established convention: and this need be no more than to rank level with one's predecessor. Barna's vision was born in Simone Martini and so he found his style. He borrowed from Duccio and took what he had seen in Giotto and he found qualities valuable to him in the work of the brothers Pietro and Ambrogio Lorenzetti. Some time during his life, Barna strung this instrument of styles, which he had assembled, to a different pitch and played upon it the same music but with overtones and dissonances which sound savage and sad upon that gentle ground. The *Dies Irae* sounds beneath the *Gloria* but it is not the clacking bones nor the rumbling funeral, lurching with bells, nor the sour note of death's triumph which Barna strikes. It is the slender music of survival, the indomitable, solitary, clear, unconquerable voice of the living unvanquished.

The formality of Barna's style does not disguise him. That he alone should have brought to painting in his time such a bitter capacity to express suffering and so sure a power to triumph over it must surely come from something in his own life. There are no morbid fancies embodied on his work, nothing of the voluptuous masochism of Nardo da Cione's *Hell* in Santa Maria Novella: or the nauseous gaiety of Traini's *Triumph of Death* at Pisa. Nothing survives from Barna's hand of glutinous martyrdom nor delectable torment and he does not beat his breast. He lived his unrecorded life and during it, he survived the Black Death. I accept that this is mere speculation but his response to his own survival seems to me to be the key to his strange and high-strung inspiration.

I do not think that I am reading into Barna's pictures the psychological effects of the Black Death. I think they are there.

Almost every authority from Vasari onwards has been struck by Barna's tragic power. Vasari, referring to a fresco, once in Sant' Agostino at Siena, speaks of the image of a monk led to execution, as a work as perfect as it was possible to conceive: 'The pallor and dread of death were depicted upon his face with such truth and reality . . . that we clearly perceive the artist to have formed a most vivid conception of the fearful circumstance he describes . . . full of the bitterest agony, the most cruel terror. . . .' To these qualities might be added an ability to depict raging hatred as it had seldom, if ever, been shown before.

To read Vasari's 'Lives' is invariably to read of works of art no longer in existence, and in the case of Barna the list of his achievements destroyed since the sixteenth century is a long one. The conspiracy of the fates has not only removed all written records of his life but the major proportion of his works. Vasari speaks of extensive frescoes in Siena, Cortona, Arezzo and Florence, aside from his work in San Gimignano and 'numerous pictures on panel, both large and small' of which all but a bare half-dozen, at the most, have perished. Of those presumed to have survived, only the little *Crucifixion* in the Vatican, the *Christ carrying the Cross* in the Frick Collection in New York and the early *Madonna of San Francesco* at Asciano seem to me utterly convincing. There are pictures at Oxford, Boston, Yale University, Berlin and Douai which were painted at least under Barna's influence, but they are to be associated with Barna's principal pupil, Giovanni d'Asciano, or with other hands.

There are two frescoes aside from those in the Collegiata at San Gimignano, which Vasari ascribes to Barna and which still survive, at least to the extent that there are pictures of the subjects Vasari mentions in the places he mentions. Of these, the *Madonna and Saints* in San Pietro at San Gimignano is so much re-worked that it might be by anyone. It possesses the one unusual feature that the Christ Child walks beside the Madonna and is not carried in her arms. This inclined Berenson to ascribe a little picture with similar characteristics in his own collection at Settignano to Barna da Siena.

The other surviving fresco is that supposedly executed for Guccio di Vanni Tarlati in the cathedral at Arezzo. A *Crucifixion with Saints,* somewhat lacking in dramatic power, graceless,

and without Barna's idiosyncratically agitated mood, it bears today precious little resemblance to the work of the Barna da Siena with whose mysterious personality I am concerned. The most interesting thing about it is the fact that the small kneeling figure of Guccio (or Ciuccio) at the foot of the cross was, according to Montani, violently and severally stabbed by his enemies and those of his family. The plaster has been much scarred.

It is, however, by the single great wall of the Collegiata at San Gimignano that Barna must be judged. That wall is his surviving masterwork, yet even that has suffered extensively. It was severely damaged in two places by military action in World War Two, the panel of the Marriage at Cana and a portion of the great Crucifixion, that area occupied by the soldiers gambling over the raiment, having been destroyed. This was only the most recent vicissitude. The whole fresco was repainted by one Bartolommeo Lupinari in 1745, although this overpaint was partly removed in 1891 and further reduced in 1949. And how much of the whole is in fact by Barna? No one agrees, but six, and possibly ten, of the twenty-seven panels comprising the fresco, although clearly designed by Barna, are in execution pupil work, some of it fumbling and much of it partly erased, particularly in the lunettes. There remains, however, evidence enough of an extraordinary talent, a genius sufficient to elevate Barna far above his contemporaries. Only Orcagna can approach him among the Florentines; and he is incomparably greater than the Sienese, Bartolo di Fredi, Luca di Tomme and Andrea Vanni. Presumably, however, he was older than these artists, certainly his work is much closer to the tradition of the first half of the century and, despite its innately Sienese quality, curiously closer to Giotto than that of such Florentines as Maso di Banco, Nardo da Cione and Andrea da Firenze.

The circumstances in which Barna must have worked almost six hundred years ago were as uneasy as our own. Not only pictorial styles but religious, political and moral tenets swung sharply unstable. Yet in fact these abrupt movements of the human pendulum were the palpitations of the heart when the breath is held, for Barna's moment in history was just such an indrawn breath, a momentous pause when all seemed to change continually but all stood still: such a moment, perhaps, as our own.

In painting the pause is evident. It lies between Giotto's revelation of plasticity and Masaccio's vast development of Giotto's vision to embrace three-dimensional forms fully realized in space. In that pause Barna's tradition was dying and after him the art of Siena dwindled into exquisite triviality. The future lay in Florence. But in the last flickering medieval glow of Sienese art which died into the stinking smoke of useless specifics against the plague, Barna took that amalgam of elegant styles, took Sienese art itself with its linear delicacy and spiritual refinement and charged it with emotions of a terrible power, making it the vehicle of an expression for which it was entirely unsuited and in doing so he gave to the end of his tradition that piercing poignancy which can only be achieved at the uttermost limits of an art. Nor did he overstep these limits. Barna was aware of Giotto and surely possessed some inkling of the implications of Giotto's innovations, but Barna himself was not an innovator or at least he was not concerned with innovation in the realm of plasticity. He needed only to make the subtlest adjustments and manipulate the most inconspicuous details of the image, to achieve his ends, to enable the delicate vessel of the Sienese tradition to contain the raw spirit of his vision. It was not in him to extend man's direct experience of the visible world. This was to be the central aim of the Renaissance and Barna was not concerned with that impulse even if he saw it born. He was the survivor of a medieval world and his concern to extend experience lay not in the physical world but in the spiritual.

Outwardly his times must have seemed to change at bewildering speed. Crisis followed crisis and the times jibbed and kicked, sidling and shying at omens, rearing unbridled as calamity followed calamity and bolting into confusion at the mid-century. The first decades of that century had gone well in Tuscany. Florence and Siena had enjoyed prosperity and political stability. Both cities had risen to become manufacturing and financial centres of European importance and both were republics organized on the guild system which, despite its hypothetically liberal conception, had produced an oligarchy in whose hands all government rested. During these forty years the bourgeoisie grew to be the dominant factor in society. The effect upon the visual arts had been cheerful and humane. The Child and his

Mother emerged from hieratic aloofness into the broad daylight of family life; and man's relationship with man gradually took on an importance in painting not less significant if less profound than his relationship with God.

But the thirties and early forties did not go so well. Crop failures were general and in 1343 the failure of the Florentine banks, first the Peruzzi and subsequently the Bardi and Acciaioli, caused a desperate slump. The mounting crisis was inadequately met in Florence by the establishment of a dictatorship, and in Siena it provoked a series of minor revolutions which led to a strengthening of the existing oligarch. In 1347 severe hailstorms throughout Tuscany ruined the harvest and in the following year the only harvest to be gathered was one of human corpses.

The Black Death, it has been estimated, destroyed one-third of the population of the known world. It spread swiftly and killed horribly, so that between July and September 1348 Florence lost 35,000 souls and Siena was reduced from 42,000 to 15,000 inhabitants. Inevitably and profoundly, it changed the ways of life of all those who survived, not only in the social and political upheaval which inevitably followed but in the psychological effects which can only be guessed at and to which Barna's genius was curiously and especially attuned. Men and women ran mad, dancing in great bands before the altars of their churches and flogging themselves with whips; religion became a frenzy; heroism became a farce. The Black Death struck a punctuation mark upon the pages of history not altogether incomparable to the social changes wrought by the 1914–18 war. Nothing was ever the same after it. The serfs were dead and with the serfs died the divine rights of feudal landlords. The deep and general faith had been tried and the priest was no longer trusted. The survivors were different men and among them was a new sense of their own value as individuals and a new insecurity. Through all this, Barna surely must have lived. In the whole art of the fourteenth century, no other master so mirrored the condition of brooding anxiety and ferocious distress, which must have been general, and no other painting has survived from those times which evokes so deeply tragic a mood, nor is possessed of such majestic *terribilità*.

The bubonic plague, endemic in the East, is communicated by fleas, carried for the most part by rats. The even more deadly pneumonic form was fiercely and directly contagious. In medieval Europe neither had been known, and when they came, they were proportionately violent and fatal. As far as the progress of the plague can be traced it was brought first to the Black Sea port of Caffa and thence in the galleys of Venetian and Genoese merchants to Italy. Once the infection had taken, the pestilence was completely beyond any control, and the descriptions of Boccaccio, of Matteo Villani, of Michele di Piazza and Angelo da Tura, to name only Italian sources, all concur in content. In fear of contagion, fathers fled from their sons, doctors fled from their patients, priests deserted their flocks. Friends and lovers abandoned one another and lay dying in the streets and no man could be found to bury them. As might be expected, it was the poor who suffered most. The Pope shut himself away, the bishops retired to the country and it is a curious fact that no medieval chronicler testifies to any act of special devotion on the part of any prelate. There is absolute silence on this score. With the prelacy went the nobility and, as the Rimini Chronicler sums the matter up, 'First died the poor folk and then other greater folk; except that no despot or great lord died.'

Although, in fact, a fair number of great lords died elsewhere and some thirty-three per cent even of bishops succumbed, the proportion of the deaths among the labouring and artisan classes, including the painters, was far greater. Bernardo Daddi, the most influential Florentine artist, was among the victims, as almost certainly were the Sienese brothers Ambrogio and Pietro Lorenzetti, for no more is heard of them. Barna survived.

The immediate consequence of the plague was an unparalleled abundance of food and goods and, very naturally, a hysterical gratification of all appetites among the survivors. Accepted patterns of social and moral behaviour were largely abandoned and persons exaggerated their behaviour according to their desires, whether in extremes of self-indulgence or in intense piety.

In a short time this phase was complicated by the inevitable economic reversals inherent in it. Prices rose wildly, including the price of labour. Minor wars broke out on either side, waged by the mercenary companies of John Hawkwood, Conte Lando,

Fra Moriale and others whose profession it was to set communities against one another on a lucrative basis.

On the wall facing Barna's frescoes in the Collegiata at San Gimignano, Bartolo di Fredi depicted the sufferings of Job, a subject rarely treated hitherto in Tuscan painting, and one which must have had an intense relevance to those who first saw it. And on all sides, from the country, from the abandoned villages and the more than decimated towns, people flocked to the cities, wherein a class of *nouveaux riches,* of entrepreneurs and speculators arose, who called themselves the *gente nuova,* causing a bitter resentment which was also extended to foreigners and Jews. None of this is directly reflected in Barna's work and nothing has survived from his hand which reports, with such directness as Traini's *Triumph of Death* or Orcagna's fragmentary version of the same subject, the spectacle of the plague itself. There are, however, implications far more profound and disturbing in Barna's indirect response to the Black Death and its aftermath than may be discovered in the art of his contemporaries.

To us, the quality of *Angst* is so familiar as to have become almost a joke and *Angst* is essentially the privilege and the complaint of the survivor. We, who live with the survivors of great wars in which the combined casualties, even including the victims of genocide, are yet proportionately less than the casualties of that one summer of 1348, have reason to be drawn to the expression of anxiety in works of art, however much we may resent and attempt to reject the attraction. The pessimism of Barna's art has at its root that dread anxieity which six centuries later has been our own heritage.

In six of the sections of the Collegiata frescoes there is the recurrent image of an old man of a type differing more than superficially from any to be found in the work of Simone Martini or the Lorenzetti. The main role this figure plays is that of the High Priest Caiaphas and as such he is prominent in three of the pictures. But he also seems to appear as one of the doctors to whom the young Jesus speaks in the Temple and, curiously, he plays the part of Herod in the *Massacre of the Innocents.* He is, in every case, a man in torment, his heavy face lined and twisted, his great beard writhing, his shoulders hunched, with his head sunk between them. One of Barna's characteristic mannerisms, the

heightening of the whites of the eyes, is particularly in evidence in the case of this old man and he wears, as might be expected, a look of hatred. But much more than of hatred, his expression is of doubt and conflict. He is not a simple image of evil, the usual fate of those on the wrong side in medieval art, but an expression of inner confusion. He has patriarchal equipment of a familiar kind, the long bifurcated beard and the voluminous robes, but his head has more in common with the anguished prophets of Giovanni Pisano than with the slightly effeminate malignants usually clustered about the mourners at the foot of the Cross in Sienese painting. Caiaphas and three of his fellow doctors, to- gether with those Judaic functionaries who participate with him in *The Pact with Judas* and in *The Conclave with Pilate,* are all 3 merciless old men, but unlike Caiaphas these subsidiary function- aries are fearless. And the Pharisee who is present upon the *Way to Calvary* is entirely untroubled in his stubborn brutality.

 The Way to Calvary, despite its reliance on Simone Martini, 2 differs subtly and significantly from that prototype. Barna has taken as his model the little panel of the same subject, a late work now in the Louvre, and has reversed the composition. Broadly speaking, he follows this design with close attention, but where Simone offsets his main diagonal, the Cross, against a series of verticals created by the spears of the soldiers and by the walls of Jerusalem, achieving a harmonious balance of forms, Barna rejects harmony and repeats the diagonals with violent emphasis, using not only spears but a ladder to add to the burden of the Cross. Against this he sets the figure of an executioner, thrusting both the Cross and its bearer forward, his body in line with the cross-piece and at right angles to the main weight of the design. The effect is one of compression, a sort of confusedly lurching mass which is emphasized by the bobbing and milling heads of the soldiers, and the whole image is, as a result, more cruelly expressive than Simone's orderly procession. On the other hand, the women in Simone's panel gesticulate in their anguish, particularly the Magdalene whose arms are raised in exhortation, whereas Barna crowds the entire group of women into a gateway, compelling them there by the action of a soldier with drawn sword who menaces Mary deliberately. The women are so tightly packed that they are virtually immobile and only Christ's mother, who

raises one hand towards her face in a gesture far less rhetorical than Simone's Madonna attempts, is capable even of this movement. In the centre of the composition, a soldier carries a great claw-hammer and a bunch of huge nails. This extraordinary symbolic innovation in Sienese art is placed so curiously that at first glance it might appear that Christ not only carries His Cross but the instruments of His Passion as well. Isolated by His persecutors, He walks in absolute loneliness, clearly beyond the reach of His mother or His followers.

This comparison between Simone's iconography and Barna's, apparently so slightly distinguished from one another in pictorial organization, surely emphasizes the profound psychological difference between the master of the first part of the century and his follower. Simone's panel is a superb generalization upon a tragic theme. Barna's fresco is particular in its concern with the personal, emotional implications of the participants in a tragedy. So powerful is Barna's urge to create an emotional impact that in no less than four divisions of the fresco he dispenses entirely with an architectural setting for his figures. Whereas, in earlier Sienese art, the framework of architecture or landscape is often subordinate but always important to the arrangement of the figures contained in it, Barna so manipulates his design that the figures achieve an added poignancy in the neutral, spatial limbo in which they play their parts and when, as in *The Pact with Judas,* he employs architecture, it is with the deliberate intention of constricting the action into that uncomfortably compressed space which will give the maximum tension to the gestures of the protagonists. The panel from Duccio's *Maestà,* upon which Barna has based the composition of *The Pact with Judas,* shows the conspiratorial priests grouped easily, comfortably, before a gracefully arched loggia. Barna places them in a Gothic box, the cruel angularity of which so weighs upon the group that none of them stands upright. All are bent inwards, emphasizing not only the secrecy of the event but also the guilt of those taking part. Nowhere is Barna's ferocious dramatic power more in evidence, nor the calculated means by which he achieved his effect.

There is something unsimple in Barna's Christianity. He has little mercy and one is almost tempted to see in him the asceticism of the reformed rake. It may be that in those months that im-

mediately followed the epidemic, Barna, like many of his contemporaries, gave himself up to his physical appetites. Perhaps, too, one may detect in his painting a trace of the wave of anticlericalism which followed hard on the plague. Certainly the intensity which Barna brings to all the aspects of *The Betrayal* suggests it. At all events, his art, except in its superficial and technical aspects, is at the opposite pole from the gentle and courtly vision of Simone Martini, who may at least be supposed to have been his master.

There is little probability of any concrete evidence as to Barna's early life and apprenticeship coming to light. No sure reference of any kind seems to have survived and maybe little enough information was even recorded. It is possible that the records of Barna's acceptance into a guild, and his early commissions, were lost during the plague or after it, at a time when the record offices were totally disorganized and the few surviving clerks vastly overworked in attempting to cope with the numerous testaments and bequests of the dead and the litigation which, in Mediterranean countries, invariably accompanies these things. Only one mention of the name Barna occurs at that time in the Sienese records, and this, quoted by Milanesi, is a reference to *Barna di Bertino, pittore del Popolo di San Pellegrino che nel 1340 si trova nominato fra i giurati al Tribunale della Mercanzia.* It may be that the Barna with whom we are concerned was Barna di Bertino, it may be not, at any rate his name is not included in the 1355 list of Sienese painters. By then, he may have left Siena to work at San Gimignano, which had come under Florentine domination in 1353, or he may even have been dead.

Such unsatisfactory delving among archives and books of reference as I have made reveals nothing, and with no evidence to go on, one can only read in the Collegiata frescoes themselves, and that of course, imperfectly, the nature of the man. That he dwelt in fear and turned it to account, that he had witnessed treachery, callousness, brutality, despair and loneliness, one can only surmise, but how could he have understood and portrayed them so much more profoundly than his contemporaries, had he not known them in the heart of his being?

The effect of the terrible years upon living artists varied. In Orcagna it gave rise to a mystical rapture tinged with masochism.

Traini, at Pisa, paints with almost clinical directness the spectacle which must have been so familiar. Bartolo di Fredi depicted disaster with a vulgar gusto and Andrea da Firenze with a raptly contemplative detachment. But the major trend in Tuscan art then was towards penitence and the appeasement of an implacably condemnatory God who pours his wrath from the judgement seat upon a guilty world. For it is not to be wondered at that mankind felt the Black Death to be a divine retribution.

Barna undoubtedly expresses as deep a grief as any and as deep a sense of human frailty, but his share in the prevailing pessimism of his age takes the form primarily of an intense consciousness of individual loneliness and betrayal. His impassive Christ is a man utterly separate from his disciples and, even as a child, Jesus, among the doctors, does not acknowledge his family in the Temple, as he does with such joy in Duccio's portrayal of the subject.

Yet Barna does not lack tenderness. The *Madonna of Asciano* nurses her son with a sweet warmth and in a lunette of the San Gimignano fresco his birth is announced with gentle gravity, although the tranquillity of the event is disturbed. The Angel and the Madonna, taken from Simone Martini's Annunciation panel (now in the Uffizi), act out their parts quietly but Barna has borrowed from Giotto's *Annunciation to St Anne,* in the Scrovegni Chapel at Padua, the subsidiary figure of a maidservant who sits eavesdropping, whilst she cards wool, outside the door. Barna places her at the opposite side of the composition and she listens through the wall with a fearful curiosity as one would listen in the expectation of calamity. Giotto's maid listens covertly, not pausing in her work. Barna's maid leans sideways, her distaff forgotten, nervous that the sounds may be ominous. To her, whispered voices are dangerous.

The mood of the great protagonist in the entire fresco cycle is not one of rapture nor yet of detachment, but of fortitude. In the face of a vast weight of hatred and injustice, Christ is at once stoical and grief-filled. Curiously, He also gives the impression of one who never speaks. Around Him a cruel turbulence ebbs and flows and He remains the inviolate but tormented victim. Lazarus raised has about him the same remote and tragic singularity in an otherwise unsatisfactory picture mainly executed by Barna's followers.

Where, in most Tuscan painting of the period, it is a corporate penitence which is expressed and humanity in general which is shown as culpable or suffering, in Barna the individual victim is paramount and this applies not only to the central figure of the Passion but also to Caiaphas who is both tyrant and victim, to Lazarus, who clearly has no wish to be raised, and not less to Mary, who at the Crucifixion is far beyond the ministrations of her fellow mourners, in a solitary trance of grief. The isolated individual is the centre of Barna's world, perhaps because, like twentieth-century man, he knew himself to be so isolated; it is a state of mind which touches us nearly. It is contained and magnified in the gaze of Piero della Francesca's *Risen Christ* at Borgo San Sepolcro.

The *Crucifixion* in Barna's Collegiata fresco sequence is very large, four times the size of the majority of the other scenes and twice the size of the *Entry into Jerusalem*. This great design belongs to a short but highly sophisticated tradition in which the Crucifixion is treated spectacularly and Golgotha is crowded with figures. Such a treatment is to be found in the much mutilated fresco by Pietro Lorenzetti, in San Francesco at Assisi, painted during the thirteen-thirties, at the outset of the troubled years. It culminates in the grandiose and wildly complex decoration of the Spanish Chapel of Santa Maria Novella in Florence, frescoed between 1366 and 1368 by Andrea da Firenze. The Spanish Chapel is, itself, a monument to the Black Death, for it was undertaken with money provided by Buonamico di Lapo Guidalotti, whose wife had died of the pestilence and in whose memory he gave to the Dominicans of Santa Maria Novella a large portion of his fortune to forward this expensive venture. Andrea's *Crucifixion* occupies a huge semi-circular area above the altar with, below it at left and right, *The Way to Calvary* and *The Descent into Limbo*. The *Crucifixion* alone is composed of more than one hundred and thirty figures, many of them on horseback. Such dignity as it has, derives mainly from its size. Barna's *Crucifixion* contains less than half that number of figures, but they are assembled with infinitely greater cunning and, unlike Pietro Lorenzetti's or Andrea da Firenze's crowds of participants, the actors in Barna's drama are related to the space surrounding them and are not simply stacked like cordwood.

It is interesting that the Crowded Crucifixion (as it might be called) should have become so popular a convention in the mid-fourteenth century. The trend extends to Padua, where the same scene, frescoed by Altichiero and Avanzo, in the Oratory of San Giorgio, contains fifty-seven participants; and to Urbino, where Lorenzo and Giacomo Salimbeni's composition contains a mob of not less than eighty. It is a realistic convention which once more must be connected with the Black Death and contingent disasters, for it is utterly remote from the schematic treatment of earlier masters.

From the famine years of the thirties and forties onwards, the whole latter part of the fourteenth century was a period of calamity in Europe. As if the Black Death itself were not enough, mankind was scourged again and again not only by the bubonic and pneumonic plagues which recurred in 1363, but by the Hundred Years War which continued with hardly abated violence throughout the entire period. The initial outbreak of the Black Death itself in 1348 found England at war with France, the King of Hungary at war with Apulia, Bohemia and Bavaria at each other's throats, Rome in revolt and the Turks pressing hard against Byzantium. The year 1374 saw floods and rotting crops followed by a widespread epidemic of St Anthony's Fire throughout Northern Europe. This disease, caused by eating cereals infected with ergot, causes its sufferers to relieve intense cramps by indulging in violent, involuntary motions which make them appear to dance, with the result that these may have created the hysteria which caused enormous bands of 'dancers' to wander about the country from church to church, and who were thought to be inhabited by evil spirits. In the same year the Black Death struck again, although less severely, and this outbreak was, as before, accompanied by innumerable penitential processions. Seldom, if ever, can Western Europe have seen so continual a display of public exorcisms, mass penances, troupes of choreomaniacs, flagellants, and other manifestations of mass hysteria, set like a cruel parody against endless scarcely more intelligible and no less ruinous troop movements.

It is possible that these bizarre activities may to some extent have given rise to the peculiarity of the Crowded Crucifixion. The Church was wholehearted in advocating public rituals of

intercession and the carrying of relics through the streets. The spectacle of crowds of penitents must have been an almost continual one and it would seem to follow that the turbulent movement of spectators at the foot of the Cross, in the Crucifixions of the period, is a reflection of these familiar processions. It is significant that as the plague became endemic and began to lose its severity the Crucifixion became less and less a public spectacle in painting. The most important exception to this, Masolino's fresco in San Clemente in Rome, is of the early *quattrocento*. Thereafter the trend is towards compositions of relatively few figures.

Where Barna's vision differs from that of Andrea da Firenze or the Salimbeni or from the Pisan tradition, is in his separation of the crowd into isolated groups. Andrea's huge, dull concourse of figures is homogeneous. It has the anonymity of a mob and, as in Pietro Lorenzetti's fresco, specific incidents must be searched out from their confused context. Barna isolates these incidents – the comforting of Mary; the gambling for the raiment; Joseph of Arimathea's request for the body, and the mounted soldiers executing their office – without sacrificing the unity of the design. He avoids this sacrifice by giving the groups of figures room to move and clearly established ground to stand upon. As a linking device he uses clusters of inquisitive children, in the manner of Simone. To them the spectacle is a holiday and they have no complicity in the crime. They are merely surprised and curious as children might be to see an execution on their way home from school. Except for the children, every individual is an island, spiritually cut off from his neighbour even when forced to be in contact with him. Mary is remote with pain, John grief-stricken but helplessly solitary. Joseph of Arimathea clips his speech, the high priest answers in monosyllables, the gamblers hate one another and the soldiers commit their surly crimes in bitter silence. No human being looks at the figure on the central cross except the man who drives his spear into Christ's side with casual expertise. Again, the isolation of the individual is at the centre of Barna's truth.

When I first came to San Gimignano, the holes in the walls of the Collegiata were unmended. They had been made by artillery and crumbled rubble lay beneath the fresco. *The Marriage at*

Cana had become a window to the clear sky, the game for Christ's raiment had been played out and the gamblers were dust on the floor below the Cross. When I looked at the wall from outside the church, I saw the shapes of two blocked windows, blocked presumably in order that Barna should paint the whole uninterrupted wall area. The new holes, two new jagged arbitrary windows, had appeared six centuries later, memorials to a new man-made Black Death, carried not by fleas, but by lies and cordite. But on the great painted wall, the figures still acted out their roles, their feverish eyes, with their unnatural whites gleaming in their sooty sockets, turned in upon the Passion.

The man who saw such sights within his mind and cried aloud in paint upon a mended wall, is secret still: a name without a history. Yet I could see him, dark and with such eyes as he had painted, for all painting is in some sort a self-portrait. What that man made with his hands out of the torment in his heart came out of six hundred years of silence and took me by the throat and I saw not only the ever-present Passion but the grinding despair of which Barna had not rid himself. What I saw was a survivor more lonely than the dead, who took the wine of a gentle and formal art and turned it through the years of plague into the bitter alcohol of suffering, without spilling a drop.

1956

'La Madonna del Parto'

I IMAGINE that most people experience, from time to time, absurd *plate 1*
bouts of totally inexplicable, totally unreasonable joy – a sort of
pointless but wonderful sense of well-being, a vigorous excite-
ment without any specific cause. In me, this excitement is a specific
sensation unlike any more rational feeling of pleasure. It is a sort
of glorious delirium, in which I feel myself encompassed by a
great bowl of silence, and yet this silence contains a strange,
audible quality; a sort of thunderous quiet. The outer world
seems to advance and recede, but within my protective cone I
exist in an immense but utterly detached state of elation. I await
an event. I await something unspecified.

The curious thing is that when I arrive at this remarkable state
I am, more often than not, travelling on a bus, and I have felt
this wild splendour as intensely between Westminster Bridge
and Camberwell Green as I have on the bus journey between
Arezzo and Borgo San Sepolcro in Umbria, with which I am
here concerned. Usually it has nothing to do with either previous
or subsequent events – but on this occasion it had. I was on a ram-
shackle bus in Umbria. In a moment of foolhardy enthusiasm,
arising from the state of mind I have attempted to describe, I
descended from this inevitable bus at a dissolute-looking village,
the name of which I never discovered, and, directed by a sign-
post, I began to walk towards the hill town of Monterchi. The
bus trundled away towards Borgo. It was noon and it was hot.

I walked up the road, filled with remembrances of Piero, of the
Arezzo frescoes, and of the San Sepolcro *Resurrection;* and the
earth, a personal gift from the *quattrocento,* was at my own dis-
posal. The road, of which I was only visually aware, since none
of the tediums of walking in a blazing midday upon a shadeless

27

path were apparent, continued circuitously in the direction of Monterchi. I permitted it to carry me there.

I should like to be able to pretend that I came upon the picture in the cemetery all unknowing. That would indeed be a romantic culmination to this story. But I knew it was at Monterchi or somewhere near, in a cemetery chapel. No one knows quite why it should be. No one knows why Piero, sometime in the fourteensixties, at the height of his powers and with his work in great demand, should have chosen the little town of Monterchi to honour with one of the greatest of his masterpieces. We know that his mother came from there and perhaps she was buried there, but no one knows why Piero should have chosen to paint, as her memorial, if this it was, a subject unique in Renaissance Italian painting, an image of the Madonna pregnant. Despite my deep admiration of Piero della Francesca, I was not prepared, at least not fully prepared, for this picture. The more celebrated panels and frescoes of the master, those at Borgo San Sepolcro, at Arezzo, at Urbino, and in London, I had seen and admired with all the reverence and passion of which I was capable, in the cool normality of everyday life. The little-known fresco of Monterchi was another matter. I was approaching it white-hot, in a state of spiritual intoxication engendered on a bus.

Monterchi, like so many towns in central Italy, is like a crumbling honeycomb. It grows upon its little hill, tightly embraced by its bastioned wall, hot, comfortably small, and modestly casual about its long and probably turbulent history. When I walked up to it at two or so in the afternoon it was absolutely silent. A few motionless old men were carefully composed into their setting; a few angular children, black and spiky in silhouette against the dust-pale houses, moved sharply about the streets. A girl, burned to almost violet bronze, wore dusty pink at exactly the right moment and was posed in exactly the right place. The church was shut with an uncompromising midday closeness. I walked on and out of the town, and down the hill. On the other side of the dip, a few hundred yards up the opposite rise, stood, or rather sagged, a drunken little cemetery of a size approaching a suburban back garden, and containing within its stucco walls a concourse of bizarre marble monuments, at once solemn, eccentric, and hideously gay.

28

The road leading to the cemetery was incandescent, of a dry bright whiteness and a silence curiously wrought. The noise of the absolute silence was like the sea. No bird sang, presumably because the inhabitants of Monterchi had lunched and dined off the available larks and thrushes for many years past. The sun, beating off the road, made it ripple, and I felt myself suspended above the path, moving forward with my feet just touching the dust, which in some obscure way was edible. On the terraces of the surrounding hills, the gesticulating olives struggled anxiously to rid themselves of their silver mist, despite their complete immobility. Their shadows were darker than their foliage, a metallic explosion underlined. The gates of the cemetery, sensibly forged and sensibly black, were ajar, and I entered a carnival of idiotic marble.

The unintentional comedy of the ways and means employed to commemorate the deceased Italian has been going on since the Baroque lost its dignity – a matter of 200 years or so. You will find this rigid farce matched in France only by certain *tours de force* in the cemetery of Père Lachaise; and, with diligence, you may discover a very few provincial examples at Golders Green. But for an unrestrained and lyrical expression of the necropolis, as, for example, a middle-aged marble gentleman who, bowing, removes a marble bowler hat and adjusts opaque marble pince-nez, you cannot better Liguria. It was the influence of this stately mode of expression – albeit much modified – upon Umbria, which ennobled the conglomeration of gregarious statuary through which I made my way, in search of Piero della Francesca. The sense of paradox was hugely and yet remotely apparent to me, but even the robust idiocy of the tombs themselves failed to remove the sense of mortality. Despite the farce, this was a resting place for the dead, a place which brandished about it the twisting blades of the cypresses like deadly weapons. The comedy had an underlying terror.

At one end of the little patch of monuments stood an un-inspired little building, designed to house the custodian and his family, and, next to it, a little chapel. I advanced towards this chapel and was presently met by a very small, very sunburnt little girl, who was entirely out of breath. I began to inquire as to the whereabouts of the fresco, but before I had voiced a single in-

accurate phrase in Italian, the little girl dashed madly at the doors of the building and, gasping for breath, began to unbolt, unbar, unlock, and unbarricade them with tremendous and needless energy. The sun, by this time at its most powerful, both sharpened and obscured her action, since I could only see her through the glare, with my eyes almost closed.

Presently she contrived to wrench open the doors, and, pushing them back, revealed what appeared to be the interior of a sturdily constructed bicycle shed. I could see very little of this dark interior in the sudden transition from the ferocity of the sun. But as I stood outside, several yards from the doorway and from the gasping child, I could make out an elderly bicycle and a table covered with a cloth upon which stood the skeletal remains of flowers in a remarkably distasteful vase. By wild prodding and stabbing with a bamboo pole, three times her own height, the little girl dislodged a grubby canvas curtain which hung behind the table and the bicycle. Then, unexpectedly, a silver face appeared, high on the wall, against a background the colour of weathered clay.

Suddenly the combination of improbability and my own delirium resolved into a moment of incredible and inexpressible magnificence. From the bicycle shed, above the decaying flowers, there emerged an image of a woman of such dignity, such gentleness, and such uncompromising divinity, that all sense of time, of place, and that critical currency with which one views and judges a work of art, ceased to signify. The sun, cutting across the doorway, hung like a blazing veil and obscured all but her face; the rest, the walls, floor and all the details of the place, were dust grey, dust pale, and soft as sleep. The silver head, immobile, ageless, proud, and tender, set with an absolute strength upon the silver neck, looked down. The heavy-lidded eyes were lowered and the grave tranquillity of those eyes, the quiet of the brows beneath the severe headdress, caused the halo to seem redundant. Indeed, time itself had so judged it, and had all but erased the metallic symbol. As I went towards the picture, I detected only a shadow of what once must have been a gilded circlet.

She stands, *La Madonna del Parto,* within a little tent, in a stillness greater than mere lack of motion, between the soft, deep-red folds of the tent's opening. Time has faded and dulled the material,

so that the burden of the two angels who hold these tented folds apart is as intangible as a cloud. She stands, her child within her, heavy beneath her heart, with her hand parting the worn blue dress above the great curve of her pregnancy.

I existed in the chapel, within the great orb and bubble of still-ness which enlarged my little complacent cone of well-being, beyond places and circumstances. I heard only the sharp, panting breath of the little girl behind me, and gradually this painful breathing was somehow transferred to the Madonna. The lady seemed to breathe, and to breathe more quickly than one should be allowed to see; I had no right to be present. I saw a pulse in her throat as I looked at her, standing in a womb of dust, against dust, waiting to give birth . . . in a cemetery.

I walked back through the door and out into the sun, and I saw three small dishevelled boys grouped among the gravestones. They were staring beyond me, through an open door. For a moment I feared to look, but when I turned and looked back, I saw only the little girl arranging the battered flowers and placing on the altar a large and ornate cross she seemed to have found. The silver face still gazed gently down. 'E bella – la donna', said one little boy, very quietly. 'Eccola', said the second. I walked in the glittering heat towards the black iron gate and towards the town. As I left: 'Bella', repeated the third little boy, in a whisper.

1947

Postscript

Since this essay was written in 1947, the Commune of Monterchi have removed La Madonna del Parto to a specially built chapel a few yards from the little structure where she was painted and where I first saw her. The family of the custodian is the same but nowadays they have a book of tickets and you must pay a small sum to see the picture. However, the circumstances are not pro-foundly changed, the bicycle is still in evidence and when, this year, I bought my ticket and walked through the open doors of the new building, I found that I had been followed by a small black and white pig. The sensitive animal made no disturbance and presently wandered out again into the sunlight.

1956

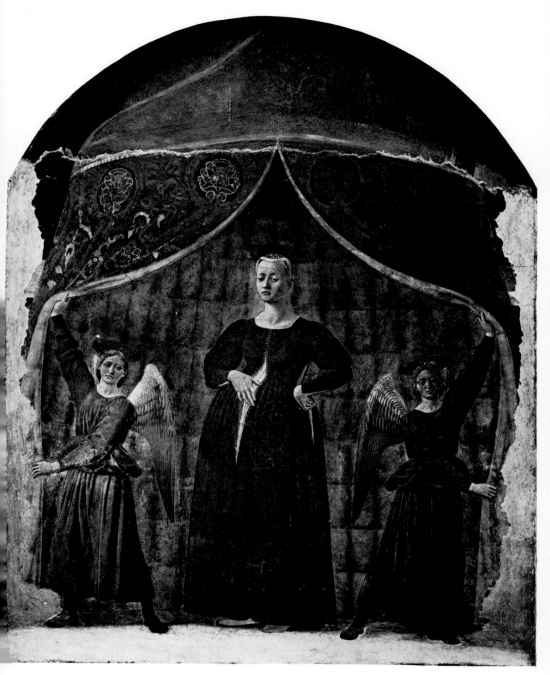

1 PIERO DELLA FRANCESCA (1410/20-92) *La Madonna del Parto*, after 1460

page 27

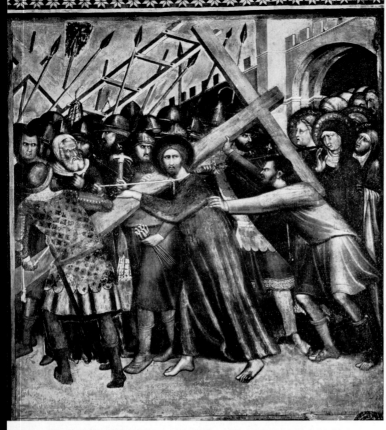

2 BARNA DA SIENA
(active c. 1350–56)
The Way to Calvary,
c. 1350–56

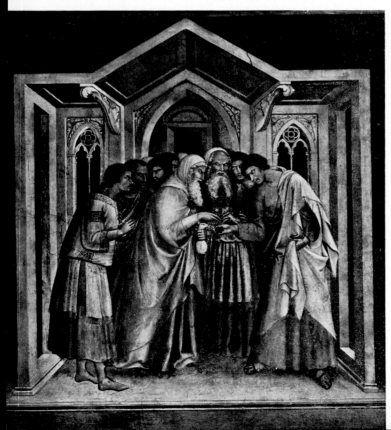

3 BARNA DA SIENA
The Pact with Judas,
c. 1350–56

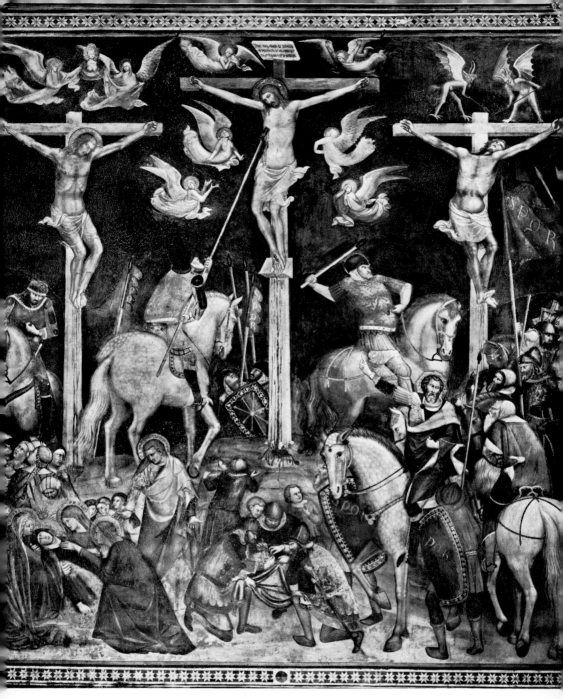

4 BARNA DA SIENNA *The Crucifixion, c. 1350-56 (Photographed before the destruction, in World War II, of the area showing the soldiers gambling for Christ's raiment)*

The Terrible Survivor

page 11

MASACCIO

The
Madonna and
Child
with Angels

page 50

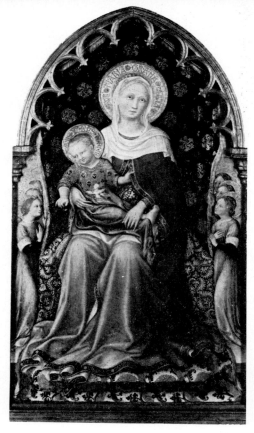

5 GENTILE DA FABRIANO (*c.* 1370–1427)
Madonna and Child: central panel of the
Quaratesi Altarpiece, 1425

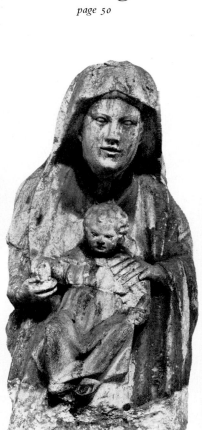

6 GIOVANNI PISANO
(*c.* 1245/50–after 1314)
Madonna and Child:
part of the external decoration
of the Pisa Baptistry,
c. 1275 or later

7 MASACCIO (1401–28?)
Adoration of the Magi:
predella of the Pisa Altarpiece
(detail of Madonna and Child),
documented 1426

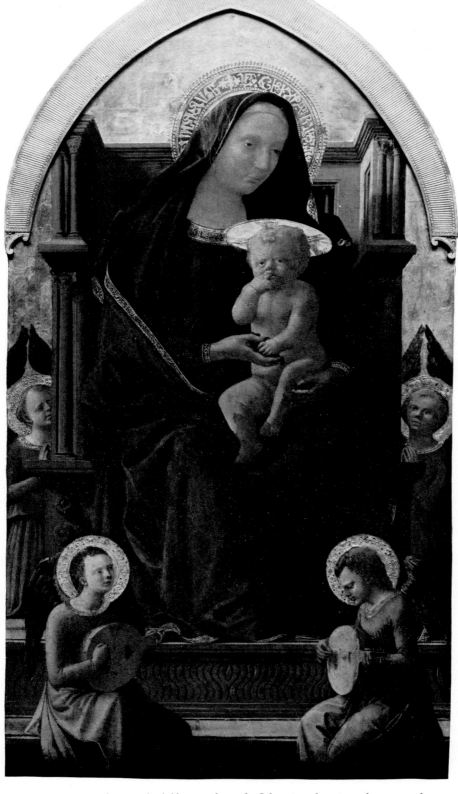

8 MASACCIO *Madonna and Child:* central panel of the Pisa Altarpiece, documented 1426

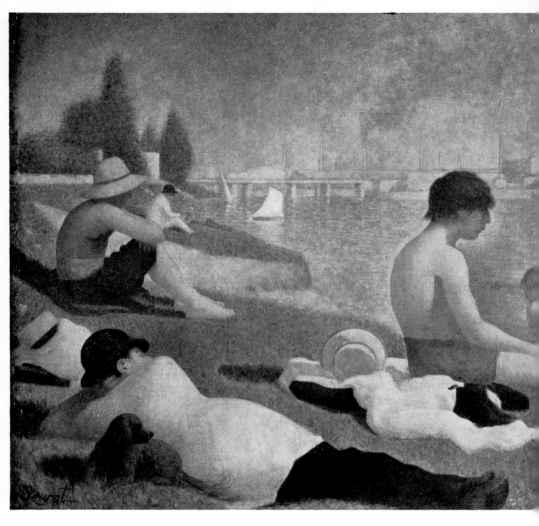

10 (below) GEORGES SEURAT *Clothes on the Grass: croqueton* for *Une Baignade, Asnières*, 1883

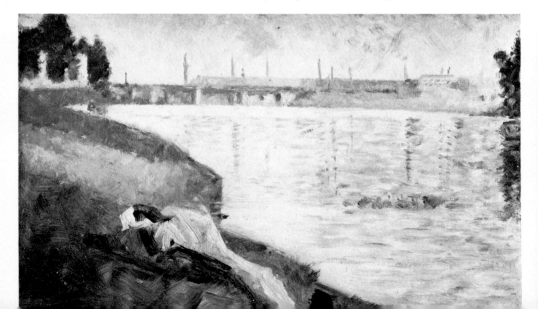

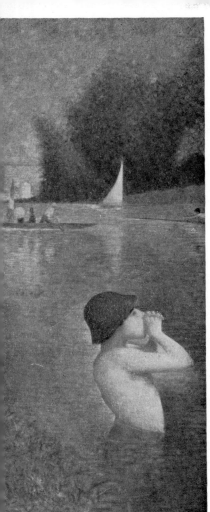

GEORGES SEURAT
'Une Baignade, Asnières'
page 71

9 (left) GEORGES SEURAT (1859-91)
Une Baignade, Asnières, 1883-4 (retouched towards 1887)

11 GEORGES SEURAT
L'Echo: study for *Une Baignade, Asnières, c.* 1883-4

12 (below) PAOLO UCCELLO (1396/7-1475) *Deluge, c.* 1445

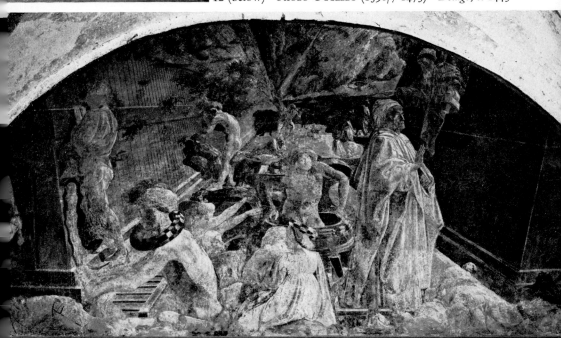

The Baptism of Christ

page 62

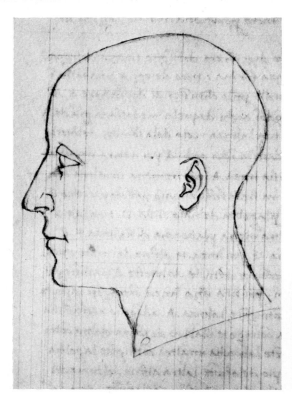

15 PIERO DELLA FRANCESCA (141⊃/20-92)
The Proof of the Cross (detail of Constantine's mother), begun 1452

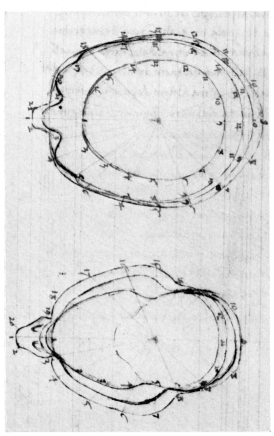

13-14 After PIERO DELLA FRANCESCA
Measured heads from an early manuscript of
De Prospectiva Pingendi

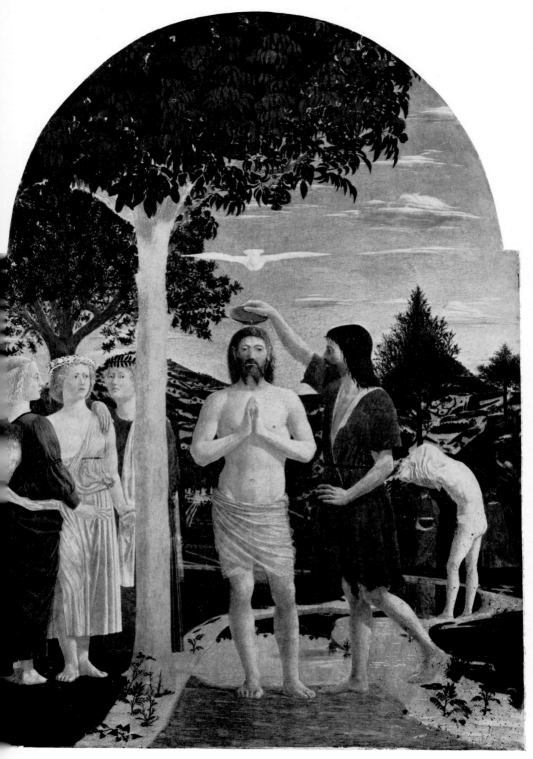

16 PIERO DELLA FRANCESCA *The Baptism*, soon after 1445

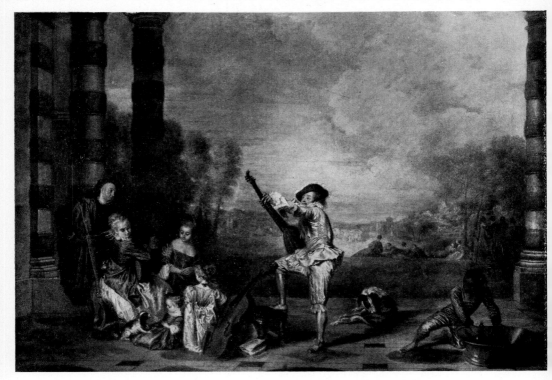

17 ANTOINE WATTEAU (1684-1721) *The Music Party (Les Charmes de la Vie), c. 1718-19*

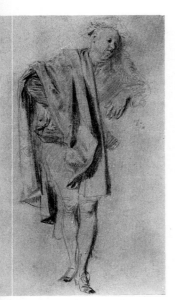

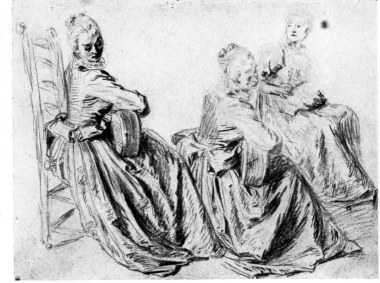

18 ANTOINE WATTEAU
*Nicholas Wleughels in the
Costume of Gilles,
c. 1718-19*

19 ANTOINE WATTEAU
Studies of *Three Seated Women,
Two of Them Playing the Guitar,
c. 1718-19*

ANTOINE WATTEAU

The Music Party

The Woman taken in Adultery

page 81

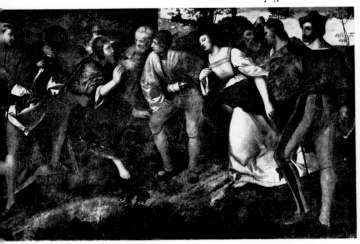

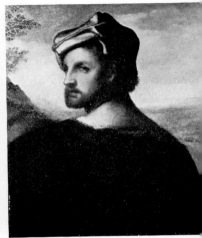

20 CARIANI (active 1514-41)
Copy of Giorgione's *The Woman Taken
in Adultery*

21 GIORGIONE (*c.* 1476/8-1510)
Bust of a Man: fragment of *The
Woman Taken in Adultery,*
before 1510

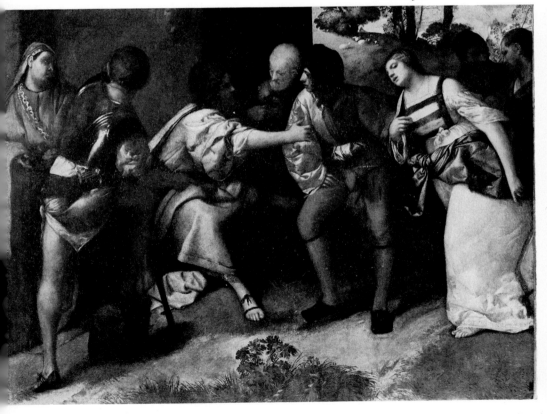

22 GIORGIONE *The Woman Taken in Adultery,* before 1510

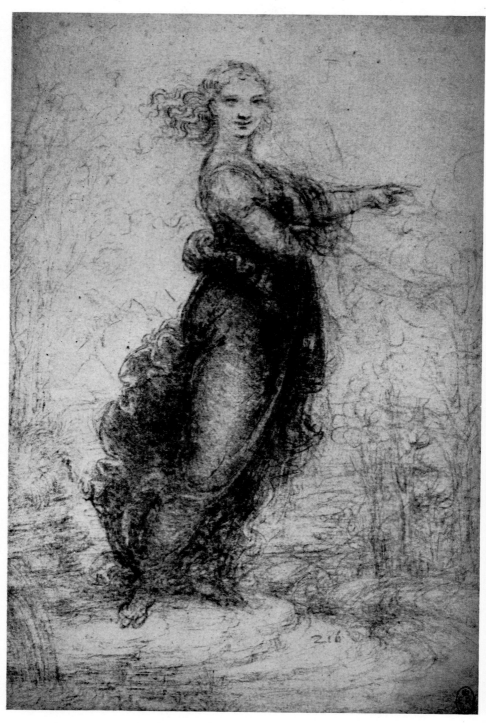

23 LEONARDO DA VINCI (1452-1519) *Young Woman Pointing, c.* 1516 Black chalk

Six Pictures

Six Pictures

NOTHING, as Dr Johnson sagely observed, so wonderfully con- plate 23
centrates the mind as the imminent prospect of hanging. This
remark was, I believe, prompted by conversations in Newgate
prison with a divine who, being tutor to the son of Lord Chester-
field, had unwisely forged a large bill on his patron, with the
predictable result that the culprit was strung up at Tyburn.
Concentrated of mind he was prior to this event, and remarked
that he was unrepentant, since Lord Chesterfield's money had
enabled him to live 'most voluptuously'. I cannot pretend that
the imminent prospect of delivering a broadcast on a single
masterpiece comparably affects my mind, nor does it contribute
much to voluptuous living, unless the contemplation of the
masterpiece itself may be considered voluptuous, but it does, I
hope, concentrate my faculties enough to curtail the rash generaliz-
ations an artist as great as Masaccio or Giorgione might prompt
me to repeat.

In these instances, the artist was of my choice, but the brief
imposed the limitation that I must treat of one picture by each
artist and that picture had to be in a British public gallery. Had
it been otherwise I might have risked Masaccio's Brancacci
frescoes or Giorgione's *Tempestà* and thus in the latter instance
would have run foolishly into an area of recondite poetic allegory
which needed Professor Edgar Wind to clarify it, as he has
subsequently done.

The discipline of broadcasting has its drawbacks since no one
really knows who the audience is and it must be assumed that the
putative listener knows so much and no more, although how
much, more or less, is the subject of a deal of empty debate. I
am even now taken aback when I reflect that on one occasion, an
awe-inspiring debate between Bertrand Russell, Dr J. Bronowski

47

and, in small measure, myself on The Nature of Truth had been transmitted only to limited areas of South-East Asia where pressure of events may well have interfered with the attention of the numberless audience in possession of the English language and of radio sets. Be that as it may, talking about an individual picture wonderfully concentrates one's mind if one has also to go into the circumstances in which it was painted, the character of the painter, the history of the picture and what studies for it survive. One is forced to rediscover the picture itself and although this is not perhaps the revelation which making a film of it would and does involve, it serves a purpose if it brings spectators to the gallery. Nothing, to me, is comparable to filming great works of painting and sculpture, simply because it takes so long and one is forced to look so hard at what most visitors to galleries might pass over with a glance. Indeed, if I were the Chairman of the Art Department at a university, I would propose to many of my graduate students that they make their Ph.D. theses as films or be hanged.

The six essays that follow are all adapted from sound broadcasts and may in the course of time become the material for film scripts. One never knows. In any case, several of them are pretty radically adapted because, when I made the broadcasts, I was even more ignorant than I am now. The first three essays treat of pictures which are above all concerned with the ordering of forms by a deliberate adherence to systematic disciplines.

This austere deliberation, it becomes clear to me, is a quality of mind for which I have a deep reverence and taken as a group the pieces on Masaccio, Piero della Francesca, Seurat and, *pari passu,* Uccello, are all related essays about this quality. They are essays about Plato's dictum that 'the god is always doing geometry', which man must seek to understand, if he is to imitate the handi-work of the god. Leonardo da Vinci expressed this view when he said, 'He who blames the supreme certainty of mathematics feeds on confusion and will never impose silence upon the contradic-tions of the sophistical sciences which occasion a perpetual clamour.' This was a concept which recurred in Leonardo's thought. He, the most insatiable explorer of the connections between com-plexities which might reconcile those complexities, yearned for a single, all-embracing truth which would silence the clamour of

48

'the lying sciences' and create a quiet beyond dispute. The most eloquent of artists, his ambition was to arrive beyond eloquence.

It is in this sense that, to me, the bridge exists between those 'ineloquent' artists whose disciplines I so much admire and have sought to understand and the total mystery which Giorgione and, on a much more modest scale, Watteau impose upon me. My personal response to both these latter artists derives from another quality of silence which is as remote from my comprehension as Elysium and a no less desirable goal.

Certain late Leonardo drawings, perhaps made as costumes for masques, have, like certain very late Michelangelo drawings, a formal ambiguity about them which is beyond analysis, and it is achieved by means the results of which Cézanne described as *dessiné dans la forme;* that is to say, a mysterious inner modelling which adumbrates structures as dense as flesh yet bounded by contours as remote from clamour as gentle breathing. Leonardo, the greatest intellect in the history of art, is the figure who, in his practice, bestrides the chasm which long existed between the adherents of Plato and those of Aristotle and it seems to me that he also spans the clamorous area between Piero and Giorgione, not in terms of invidious comparisons in stature as a painter but in the distance between their mysteries.

That Sickert should find himself in such company here is again no matter of comparisons, which would be absurd rather than invidious. He was a minor artist, but in the portrait that I discuss there is a noble quality of silence. Very remote he may have been from any divine geometry but his intellect was not negligible.

1970

MASACCIO

The Madonna and Child with Angels

plates
5–8 WHEN, in 1962, I wrote on this subject as a broadcast, I was still partially enveloped in a dream of the golden age of the Florentine *quattrocento*. It was a splendid dream, intoxicating me as the Florentines themselves had been intoxicated by the concept of a golden age which they believed had existed in antiquity, but my experience of it was as oversimple as the eighteenth- and nineteenth-century dreams, which had elevated not only the Renaissance but the medieval Gothic world into wholly separate but co-existent fantasies. Nostalgia is a great provoker of simplicities. The Renaissance had come so suddenly, leaping out of the city of Florence, that it had seemed as if almost overnight an inexplicable wonder had come about. And so it had. In the surge of that great joyous leap of the human spirit, I splashed about like an overgrown *putto*. All the clichés came trippingly to my mind and off my tongue, with only one or two hesitations. Antiquity rediscovered, of course: the Gothic relegated to the 'medieval' past, philosophy unchained, the natural world revealed, the sciences released to evolve, mathematics enlarged to embrace new and daring speculation and above all Man the Measure. I flung these conventional notions on to the air and now, chagrined, I must re-write the whole thing.

Fortunately, the one point which was and remains central to my discourse, the reliance of the Florentine *avant garde,* during the crucial years between 1401 and 1450, upon sculpture as the pace-making art, was, and I believe is, valid, if not strikingly original. The rest was a garland of notions: not absolutely remote from Renaissance thinking on the one hand and very familiar in type to the kind of thinking nowadays which celebrates the art of the second half of the twentieth century as a

50

'breakthrough'. I do not dispute the event in either case. The Florentine Renaissance was a breakthrough, and if the twentieth-century version seems to me to resemble a tea break rather than a breakthrough, that is because I am a square who comforts himself only with the Pythagorean theorem as to the one on the hypotenuse. Breakthroughs are, as often as not, equivalent to the fracture of very thin membranes, else defloration would be even more of a labour than it is, but once a virginity is taken, a first love can result which in favourable circumstances can create a brief golden age in the lives of individuals no less than in the history of the human race.

It has long been acknowledged that Giotto was the father of the Florentine Renaissance and so far as the 'rebirth' of painting is concerned he was undoubtedly the major progenitor. The child however was delicate and grew through a century to its springtime, with graver ills than many, for it endured and survived the Black Death of 1348 and in addition more successive plagues and famines than were endured in any comparable period in Italian history. Surviving these, it appears to leap from the jaws of an apocalypse the more miraculously, but its immediate progenitors had been overlong dead, and their procreation being so long past, the miraculous child in general paid more respect to its remote ancestors. It grew up a romantic child. The Renaissance was a highly romantic episode and it created an essentially illogical climate. This climate produced a stormy reaction against the Gothic in the arts and, in the realm of ideas, a reaction to medieval logic of which it has been said that whilst the medieval schoolmen created the finest system of logic the world had ever known, they eventually achieved more logic than the world could be expected to stand.

In many ways that satisfying if pedantic system of logic had encompassed the ancient world as easily as it encompassed everything else, but one of the notions which Renaissance savants propagated was that the rediscovery of the ancient world was their new and personal achievement. It was not. The neoplatonism of Florentine humanism contributed gratifying arguments but could scarcely be said to have overthrown philosophies which had been endlessly debated from the twelfth century onward, although a *quattrocento* Florentine *élite* glossed Plato and Aristotle

with a different emphasis and tended to insist that what had gone before in the visual arts was barbarism. It was not. The recognition of the natural world as a part of God's achievement to be revered rather than as the mirror of another and better one seen through a glass darkly, was given its mandate by Aquinas, whilst the geometry of Euclid had been as pertinent to the medieval scholar as had his passion for symbolic numbers. The Renaissance Florentines did however turn all this machinery counter-clockwise, turning it much further back than their recent and unpalatable past. By giving it the most vigorous twist the phenomenon called *humanism* took the light from that turn much as sculpture in the round may seem totally transformed by an abrupt variation of the fall of light upon it.

Renaissance man felt lucky to be alive and he reacted joyously to that sense of unexpected survival. Perhaps he set out to merit it. He was however tired of that logic which had been an attempt to understand the inimitable nature of the divine order and he substituted for it the idea that if man looks hard enough at the results of creation, he can discover and reproduce an order in imitation of God which will serve, especially when the whereabouts of God is no longer altogether certain. We ourselves are the inheritors of this concept and the vanity of our scientists is very largely the end product of it, just as we are the inheritors of the capitalist system which rapidly developed at that time.

In the visual arts, the 'classical' element in proto-Renaissance sculpture implied the ordered formality which showed how this goal might be attained, and architecture, which throughout history has been twin to the art of sculpture, would make its most dramatic and consequential contribution by re-establishing the human being as the ideal measure of proportion, whatever the size of the structure. In this particular, humanism did indeed supplant the Gothic.

In the year 1401, Tomaso di Ser Giovanni di Simone Guidi was born and grew up to be called *Masaccio,* which means 'hulking Tom' or 'awkward' or 'helpless' or 'stupid' Tom, to distinguish him from *Masolino* his colleague, whose name meant 'little Tom'. Vasari tells us that he received this nickname not because he was disliked but because of his excessive negligence of all matters aside from his art. Let us be deeply grateful for that. In

1401, Great Tom was cast and in that year the competition was set by the Guild of the *Calimala* for the casting of a pair of bronze doors for the Florentine Baptistry. It was the second pair, the first having been cast by Andrea Pisano soon after 1330, and the date 1401 is useful in that it may, for practical purposes at least, stand for the date of birth of the Florentine Renaissance itself. The competition was won by Lorenzo Ghiberti, who defeated six other sculptors. The runner-up was Brunelleschi, who thereafter turned his attention principally to architecture and presently codified his famous systems of linear perspective, which he demonstrated by means of paintings which have been lost. The competition reliefs by both Ghiberti and Brunelleschi, however, survive and demonstrate an evolution from the Gothic style which was abrupt and paradoxical. Brunelleschi, the great pioneer of Renaissance architecture, with its debt to classical antiquity, produced a comparatively 'Gothic' relief, whilst Ghiberti, who, despite his passionate concern with antique art, remained a sculptor in the Gothic mould, produced a 'Renaissance' one which embodies what appears to be a 'quotation' from a Hellenistic torso. Upon these two small bronze reliefs the compass needle of the Renaissance might be said in that moment to have balanced.

Among Ghiberti's assistants was the young Donatello and thus the three key figures in the formation of the Florentine Renaissance are brought together in the year of the birth of the fourth. All but the fourth were sculptors and, more than any other single factor, the *avant garde* of Renaissance painting was born out of sculpture. The seemingly sudden passion for the virtues of the ancient world was fathered by Petrarch. A century later it was the unearthing of Roman and, at a considerable remove, Greek sculpture, together with those fragments of Roman buildings which remained visible, which transformed architecture. Since, inevitably, it was the ruins of sculpture in the ruins of buildings and not the painting of the ancient world which had survived to be rediscovered, these, in turn, transformed painting. Ghiberti collected antiquities and Donatello studied them closely, whilst Brunelleschi as an architect had the further advantage of knowing the *Ten Books of Architecture* by Vitruvius, the one treatise on architecture to have survived from ancient times.

It is part of the folklore that grew round the Renaissance

during the nineteenth century that these great artists rediscovered antiquity. The truth is that it had not been lost. In manuscript, Vitruvius had been constantly recopied throughout the Middle Ages and the work was thoroughly revised by Poggio Bracciolini in about 1415. Roman marbles had been the inspiration of the 'Imperial' sculptors of the Emperor Frederick of Hohenstaufen no less than those of the Cathedral of Rheims in the thirteenth century, and the direct source both of Nicola Pisano's pulpit reliefs in the Pisa Baptistry, completed in 1260, and of a substantial proportion of the carvings of Giovanni, his even greater son. There is no need to go further than the Pisan Campo Santo to find surviving Roman marbles which both Nicola and Giovanni used as specific models and there were ample remains, scattered elsewhere in France and Italy, to make the art of antiquity a natural part of the medieval sculptor's heritage. It is true that Greek texts were less copiously available to medieval scholars than they were to become after the fall of Constantinople, but such intrepid travellers as Adelard of Bath had brought back enough of Aristotle, Plato and Euclid, in the centuries before the Renaissance, to make them almost as readily available as Pliny and Virgil and scarcely less famous. In truth, the major distinction which, apart from the quality of their individual genius, the early Renaissance sculptors and scholars brought to the study of antiquity was the taking of a different stance towards it from their predecessors. This stance dislodged a fragment of the past and elevated it, which is how the concept of a golden age is born, but it also dislodged the medieval web of *interpretatio Christiana* which had bound the past into a unity. In electing to view this fragment man to man, they had ample precept in poetry, sculpture and architecture, *but not in painting,* for in that they had nothing much to go on except reportage from Pliny. And it was in painting that, with hulking weight and density, Masaccio strode upon the scene exactly twenty years after Ghiberti was judged the winner of that epoch-making competition. On 7th January 1422, Masaccio was recorded as entered in the Guild of Doctors and Apothecaries, which naturally enough incorporated the painters since St Luke was the patron saint of both.

The total disappearance of Greek painting, on any larger scale or in any other form than painted vases, and the fact that what

Roman wall painting survived was still unexcavated, meant that the art of painting had no pre-Byzantine precedent to show. Giotto's re-establishment of the illusion of plasticity was indeed a major 'rediscovery' but he, no less than his *quattrocento* successors, had the example not only of antique sculpture, but of the sculpture of the Pisani to follow. What he did not have was any great exemplar of the illusion of depth, beyond the shallow depth of relief sculpture, in which to set his figures. Nor did he, however powerful his images remain, attempt to show this. In providing such depth by means of his system of linear perspective, which was a re-invention rather than a re-discovery, Brunelleschi supplied an architectural 'acting area' in which the painted figure might seem to move in deep space. This long view through the proscenium arch established by the boundaries of the picture, was also geometrically unified, being measurable and not therefore arbitrary. This, then, was the setting, in both senses of the word, which Masaccio was the first since antiquity to fill with pictorial figures conceived and comprehended fully in the round, thus creating an illusion of weight and density in the images of the beings he represented, which has never been surpassed. The nickname 'hulking Tom' was no misnomer. He alone among the painters of his time could invest the image of man with the weight and thickness of flesh and bone. Seated or standing, his protagonists occupied the space they had been given. Room was made for them and they fully occupied that room. In doing so they were able at once to breathe and to adopt relationships not only formal but human in the sense that the eye transmits the quality of solidity to the brain and gives it information as to solids which Gothic pictorial schemata did not require.

The drama of this occupation of space occurred with astonishing speed. It took no more than the five years, between 1422 and Masaccio's death, or disappearance from history, in *c.* 1427–28. What survives of the Pisa polyptich shows the human figure taking on bulk *within a Gothic convention which had not been conceived to contain* that bulk. As such, it is a landmark of the most astonishing kind and the very unease of it contributes to the miracle.

The belief that once the bulk had thrust its way back into pictorial space, the job was done for all instantly and thereafter to admire, is yet another notion less relevant to the facts than to

55

that of the nineteenth-century thinking to which many simple persons in the world of art still adhere. That the price paid for Gentile da Fabriano's *Palla Strozzi* was far greater than the sum for Masaccio's Pisa altarpiece is significant, for Masaccio's older contemporaries, Gentile, and Lorenzo Monaco among others, were far more readily acceptable to the patronage of their time. Theirs was the epitome of the long final flowering of Gothic painting in Italy and their painting, together with that of their *trecento* predecessors, had a more marked and continuing influence on fifteenth-century painting beyond Italy than those 'in at the birth' of the *quattrocento élite* in Florence. It took Michelangelo and Leonardo to restore Masaccio and Alberti's circle of intellectual artists to fame. That Masaccio's monumental contribution was not generally adopted of course accords with the popular romance of the conventional response to an *avant garde* and the retrospectively enjoyable misunderstanding of genius which gathered around the great masters of the French nineteenth century. It does not conform with the popular notion of that springtime of the new-born golden age, when the arts are believed to have been instantly understood by princes and prelates no less than by poets and scholars. Certainly Masaccio's art was influential and it affected both Beato Angelico and Andrea Castagno, who were profoundly different kinds of artist. A generation later it produced his greatest follower in the Umbrian Piero della Francesca, but in Florence itself the stamp of the late Gothic style remained firmly impressed upon painting throughout the fifteenth century, even gaining ground in the second half of that century. Certainly a small *élite* recognized the stride Masaccio had taken, soon after he had taken it, and of these the most intellectually influential was Leone Battista Alberti, whose father, with all his family, had been banished from Florence in that germinal year of 1401. Leone Battista may have returned there, briefly, in the year of Masaccio's departure, but he first established himself in the city in 1434. There he became the centre of a circle of the most profound consequence to the whole history of the visual arts. There he wrote the first treatise on the art of painting since antiquity, and in the prologue to it he named Masaccio among the few with 'a genius for every praiseworthy thing' in the art of painting.

When Masaccio was twenty-four, with three years left to live, he was commissioned, through the good offices of Fra Barto-lommeo da Firenze, Vice-Prior of the Carmelites of Pisa, to paint for the Church of the Carmine there. The commission was conferred by Giuliano di Colino degli Scarsi, notary of San Giusto, and whilst the Carmelites were Masaccio's most enlight-ened patrons it was natural enough that they should specify a traditional Gothic altarpiece consisting of a large group of panels framed together. The painting was begun on 19th February 1426 upon panels prepared, framed and possibly gilded by a Sienese craftsman called Antonio da Biogia at a cost of eighteen florins, and on the 25th of February Masaccio received his first payment of ten florins. The remaining sum of seventy florins was paid in parts. Two of these payments were made in the presence of the sculptor Donatello and the final settlement was made on the 26th of December.

The number of panels which were painted and assembled into the polyptych is not certain. What survive are the central *Madonna* 8
and Child, the *Crucifixion with the Virgin,* the *Magdalen and St John,* now in Naples, which surmounted the structure, the pre-della panels now in Berlin, together with four small panels of 7
saints which may have been set in the pilasters and two larger panels representing St Andrew and St Paul. All that remains of Masaccio's work in Pisa today is the single panel of St Paul. What does remain in Pisa is a great corpus of the sculpture of Nicola and Giovanni Pisano, which both Donatello and Masaccio must have seen day in and day out during their sojourn there.* 6

The sculpture of both Nicola and Giovanni, but especially that of Giovanni, seems to me to have been a key to the door which Donatello and Masaccio opened; Giovanni took relief carving to greater depths than any forerunner and released his monumental sculpture further from the confining Gothic niche than any forerunner of the Renaissance. By Giovanni's example, especially that of his sculptures on the façade of Siena Cathedral, Donatello understood how the sculptured figure must emerge

* No more striking example of Masaccio's direct debt to Giovanni is to be found than the fresco of *The Expulsion* in the Brancacci Chapel of Sta Maria del Carmine. The figure of Eve is derived from part of a support for Giovanni's Pisa Cathedral pulpit. This marble may in turn derive from an antique *Venus Pudica*.

from its confinement, and move freestanding into spatial freedom, and by Giovanni's example Masaccio drove back a golden wall, bringing the art of painting to rival that of sculpture by exactly the opposed procedure. The door swung both ways. Masaccio's was the greater and the more remarkable intellectual and formal achievement, for he had no precedent in his own art to follow, but Donatello was the greatest sculptor of his age for all that.

In this panel of the Pisa polyptych we see the door opening inwards into the frame and the implacable gold begin to give ground.

The late George Antal drew attention to the comparison which can be made between the Pisa *Madonna and Child* in the London National Gallery and a painting of the same subject by Gentile da Fabriano in the same gallery. One year separates these two pictures in date. The Gentile is 1425, the Masaccio, 1426. The difference is dramatic. Gentile's Madonna is elegant, decorative and insubstantial. The linear rhythms of the composition are long and sinuous; the space is as shallow as a low relief and the garments do not contain or suggest the presence of physical bodies. These garments are, however, sumptuous and the furnishings are rich. The picture is a charming piece of jewellery, a subtle trinket for reverent gentlefolk. The Masaccio, on the other hand, although it is Gothic in its form, is austere and substantial. Even on the flat gold ground, that expensive metal symbol of eternity, the illusion of solidity set in space is pre-eminent. Not only this, but the Madonna is palpably human. Yet it is the figure of the Child which presents the greatest contrast of all. Gentile's baby is a weightless doll. Masaccio's is a fat, worried infant whose major problem is quite clearly the immediate and distressing necessity of ridding his mouth of a grape-pip. This grape-pip seems to me to have escaped the attention of iconographers, but no more natural and immediate piece of observation exists in Renaissance painting. In innumerable pictures the Christ child plays with flowers and fruit and symbolic goldfinches without running into trouble, but give a real infant a bunch of grapes and the chances are that he will get a pip between his milk teeth. Masaccio's infant is as human as that.

In this *Madonna and Child,* we can see the tremendous moment of transition for which Masaccio was responsible, precisely caught.

58

The Madonna's halo is flat and pounced with arabic letters in the gold ground. It is a Gothic halo, yet the throne in which she sits, although set behind a Gothic gold-ground arch, is not a Gothic throne.* Furthermore it recedes in logical perspective towards a single vanishing point and the halo of the Child is foreshortened to accord with the recession of the throne. This compromise, this inconsistency was inevitable, since Masaccio's commission imposed upon him a convention from which clearly he wished impatiently to depart – the gold-ground polyptych. The composition itself, severe in its verticals and horizontals, succeeds in emphasizing the sculptural element to an extent which almost defeats that convention. Aware of this inconsistency, Masaccio has sought to overcome the problem of imposing depth upon the Gothic format designed to exploit two dimensions only, by a number of subtle devices. He presents the scene from a low viewpoint, which emphasizes the perspective. The angels' lutes, sharply foreshortened, add to the illusion and so does the slightly turned figure of the Virgin, the direction of whose body is opposed to that of the Child.

It is possible that Donatello conceived the device of the fore-shortened lute: at least someone in his workshop used the identical motif in a stucco relief, now in Berlin. It seems to me more likely that in its pictorial utility it was the brainchild of Masaccio. It may be that the deliberate *contraposto* of the Madonna to the Child came from Giovanni Pisano or from Donatello, for it is a sculptural expedient to create a plastic relationship which plays little part in Gothic painting. It may have been an Etruscan bronze, as has been suggested in another connection, which gave the Child his stalwart form, for however difficult it is to pin down the specific antique models which influenced both Donatello and Masaccio in those years, there is no doubt of their general debt to antiquity. Whatever the admixture of source material they found available, there is also no doubt that in the 1420's painting and sculpture moved briefly towards a unity, a fusion of the arts at once perilous and marvellous. Whilst Masaccio was at

* The throne is as Panofsky has described it in *Renaissance and Renascences in Western Art* (Paladin, London, 1970): 'an object lesson in ancient architecture displaying diminutive examples of three classical orders in the form of miniature columns with Corinthian, Ionic and Composite Capitals'.

Pisa, in company with Donatello and bringing the art of painting ever closer to that of sculpture, Ghiberti in Florence had begun work on his second bronze doors for the Baptistry and these were to bring relief sculpture as near to painting as it would ever come. These doors, which Michelangelo was to call 'The Doors of Paradise', owed no less to Brunelleschi's perspective system in this direction than Masaccio owed to the great architect in his progress towards the opposite pole. Both achieve a miraculous marriage of painting with sculpture, as if the two arts momentarily moved into a single entity, a consistent visual expression, and to this, in his reliefs, Donatello made a comparable contribution. Yet Masaccio, a painter working in a medium which creates the illusion of depth upon a flat surface, was drawn not to low-relief sculpture which is the sculpture nearest to painting but to sculpture in the round, physically closest to corporeal reality. The antithesis of all that is sinuous and elegant, his figures move ponderously in quiet splendour and gravity. They are blunt and fleshed like earth gods; they are bulky parcels disposed unshakably in space and like Tuscan hills they seem to ride the slow movements of the seasons. They appear to me as massives of deep coloured earths packed thickly round cores of rock. I feel them as fertile. I feel them as dense in texture like the taste of new bread in the morning when one is enormously hungry. They are the painted essence of sculpture but moulded from the land, rather than carved. They are not the twisting forms Michelangelo released by carving from the marble block but rather they move with the calm ease of hills into the plain. No tempest can disturb the heavy garments these figures wear and there is no possibility of death in them. They move largely, in unhurried dignity and they could move mountains, not by muscular effort, as could Michelangelo's titanic demi-gods, but by irresistible growth.

Perhaps these qualities will not be apparent to the visitor who, in the National Gallery, is restricted to the sight of a single panel, a single fragment of an altarpiece, and yet the Christ child scrabbling for that tiresome grape-pip is a young Hercules and his mother has all the weight and solidity of archaic Greek sculpture imposed upon and in despite of the metallic resistance of her gold ground. When I say that this picture shows us the door opening I must add that anyone who wishes to pass through that door must

see Masaccio's frescoes in the Brancacci Chapel in Florence. In the Brancacci Chapel two young sculptors went to learn their trade from those frescoes at a time when the Renaissance was in full flower. A dispute arose and Torrigiano, who was to cast the bronze tomb of Henry VII and his queen in Westminster Abbey, broke the nose of the young Michelangelo. In a less violent atmosphere, the Brancacci Chapel has seen sculptors from that day to this, from Michelangelo to Henry Moore, devoutly copying Masaccio's frescoes and paradoxically learning the trade of sculpture from a painter who himself had learned his trade from sculpture and who died at twenty-seven.

1962–70

PIERO DELLA FRANCESCA

The Baptism of Christ

plates
13–16 As AN ACT, baptism is simple; as a sacrament, it is not, for it is at once a symbolic purification and a rite of initiation into a mystery which requires submission to the Church and to its laws. The Baptism of Christ is the fountainhead of all baptism, and the solemn moment of the act was the fountainhead of Christendom. That solemnity has never been more gravely represented in painting than by Piero della Francesca. No other representation of the event so compels the spectator to bear witness. He must contemplate it as if he were under oath, seeing enshrined in a hidden geometry the figure of the Son of God, standing motionless beneath the spread wings of the white and motionless dove which, at the apex of an isosceles triangle, hangs poised in a silence which suspends time. He, the spectator, bears witness to a humility wherein man, the Son of God, submits to the Law of God.

It is this sense of divine justice which penetrates and embraces the art of Piero della Francesca, for in law it is axiomatic, not only that justice should be done, *but that it should be seen to be done*. It is this axiom which Piero demonstrates in every form, in every measured aspect of his design, in every one of his works. He achieved the sublime gravity of his monumental art because such was his cast of mind that to him truth was a thing to be discovered by an impartial and deliberate pursuit of it. He disdained emotional attitudes, rendering justice, with calm logic, to the forms he depicted and thus to the image as a whole, and thus in due order to the visible world. It is not that such an approach is passionless. It is that his passion was for a kind of certainty, a kind of truth as near to God's as human fallibility would allow. He is the great impartial jurist of painting who sought to obey and to administer a code of visual law and to clarify it that visual justice might be seen to be done.

The way in which law seeks to be consistent is in the establishment of precedent, but it should not be confused, either in human or pictorial matters, with a blind attachment to established usage. When laws cease to be relevant, they must be repealed lest they cease to be the instruments of justice, and Piero's high court stood in lonely isolation above the lower courts of stipendiary magistrates obedient to outdated procedures.

The processes of pictorial law which were so powerfully relevant to the art of Piero della Francesca, were based upon the logical procedures proposed in Euclidean geometry. These processes seemed to him the most truthful way to do justice to, and impose order upon, natural appearances, when presented as painted images. Not the least of their virtues lay in a mathematically constant inter-relation of forms and the calculated intervals between them which made every part of the picture relate perfectly to every other part.

This system itself did not make Piero a great artist. There would be good judges and bad judges acting within the framework of any legal system, however exemplary, and the pictorial laws in which Piero believed, and which have remained the framework of classical painting, are by no means perfect. Scientifically, they no longer represent 'truths', since Euclidean geometry is no longer accepted in those ultimate terms by mathematicians, but Piero believed in the divine nature of calculated harmonic relationships of form, just as the Greeks had believed, two thousand years earlier. He believed it to some extent *because* the Greeks, and Plato in particular, had believed it, for he lived at a moment when Plato stood so close to Christ in the minds of Florentine savants that the humanist Marsilio Ficcino could propose Christ as the example of Plato's ideal man. He lived at a time when the climate of ideas embraced the concept that man on earth and man's works were perfectable, in considerable contrast both to early medieval theory and to our own ideas which are shot through with Manichean pessimism.

Plato had considerable reservations about the propriety and validity of the arts themselves. He believed that the sharp line which to him distinguished truth from falsehood was inevitably blurred both by the poet and the artist. He did not see art as a truth in itself, in its own terms, but as a distortion of the reality

art set out to imitate. In consequence, the intellectuals upon whom Leone Battista Alberti's thesis on painting exercised so profound an influence, and who were as much in love with art as with Plato, sought a compromise in which works of visual art should be composed as far as possible of forms which were of their own nature 'perfect' and therefore 'true' because they were 'certain'. And by the 'certain' was meant the 'precisely measurable'. These certainties were required to be related to each other as perfectly as possible by measured forms and intervals in balanced harmony, the whole image being related mathematically to its initial dimensions, that is to say, the shape of the picture surface itself.

To some extent these certainties, *certezze* as the Florentines called them, embodied a degree of mysticism. Pythagoras was a mystic as well as a geometer. The 'five regular bodies', the regular or 'closed' polyhedra, are forms in solid geometry which were of obsessional importance to Paolo Uccello and scarcely less so to Piero, who wrote a book about them. They were significant because they were perfect forms. A cube is the simplest of these solids, all of which are bounded by regular polygons, the others being the tetrahedron, the octahedron, the dodecahedron and the icosahedron. In addition, there are thirteen semi-regular, or archimedean, polyhedra which approach 'perfection' and there are other 'perfect' forms of which the sphere is one. All of these may be juxtaposed, combined and related to one another in a multitude of ways.

Now Euclidean geometry, wherein proofs can be demonstrated, seemed nearer to Plato's 'truth' than the capricious, curious and apparently illogical appearance of the natural world. But theologically the natural world is only *apparently* disordered, else God himself must be disorderly, which he is not. Therefore the natural world is properly ordered and this can be properly paraphrased in art by employing supposedly perfect forms, if the manipulation of those forms is various and subtle enough. Finally, the design of images may become accepted as equivalents for the behaviour of forms in nature, creating an order in a way comparable to divine order. Thus they may be related to that justice which society seeks to discover and apply to the governance of the unruly and apparently inexplicable motives which determine human behaviour. This, in its turn, reflects the axiom that God

is just. In nature, such a formal order was seen to exist and crystalline forms are the most readily demonstrable examples of it. To control the world of appearances, to create an architecture to house it and order its apparently protean disorder, was to a small but highly consequential group of Florentines to do justice by imitation to God's handiwork, just as a Tuscan farmer trains his vines and cleans out the wilderness to achieve an orderly husbandry. This, too, is commanded in Scripture. And for much the same reasons, the Renaissance in one significant aspect was concerned with such husbandry in painting. Thus Masaccio ordered solids in the space ordered by Brunelleschi's perspective system. Sculpture, which approached 'truth' in that it was corporeal and less illusory than painting, inspired Masaccio's solution to the primary problem of portraying solids in illusory space. The evolution, in the first quarter of the Florentine *quattro-cento*, of the visual arts as they were viewed and understood by the architect and theorist Leone Battista Alberti, were established in his treatise on painting in 1435, during Piero's most formative years in Florence.

Alberti investigated three main ideas in his thesis: visible reality, its control by mathematics and the ordered revelation of the verities by means of monumental and dramatic imagery, which was the central aim of humanist painting. This he called *istoria*.

Taking his cue from the work of Masaccio, Alberti also makes a maxim of proposing to painters the practice of drawing from sculpture. He advises the painter to copy even a mediocre sculpture rather than an excellent painting. 'If I am not mistaken,' he says, 'sculpture is more certain than painting. He who does not understand the relief of the things he paints will not paint well.' The word *certain* is the key word. By 'the relief of things' Alberti meant the way in which the fall of light defines and thus explains the shape of forms, and he goes on to deal with the effect of light on colour which is varied by light because, as he says, 'all colours put in the shade appear different in the light'. Upon this perfectly correct assumption and with the aid of an empirical but rational system of colour chords, Alberti then proceeds to make the first important investigation of the problems of light and space related to colour, in European history. For Piero he did so at the key moment of the painter's development and although Piero later

discarded certain of Alberti's implied limitations, as he came to
have a deeper knowledge of the location and disposition of solids
in illusory space than his master possessed, he never departed from
Alberti's basic tenets, from the concept of *certezze*.

The moment when Alberti's thesis came into Piero's hands
and he joined, as it seems probable he did, the intellectual *élite*
gathered around Alberti in Florence, lies somewhere between
1435 and the painting of *The Baptism,* which is one of his earliest
works. *The Baptism* demonstrates Alberti's thesis with the absolute
clarity of a Euclidean proof and that thesis which in its Italian
version of 1436 is dedicated to the sculptors Donatello, Ghiberti
and Luca della Robbia, to the architect Brunelleschi, to Masaccio
who was dead before it was written, numbered among its
adherents of the younger generation the painters Uccello,
Castagno, Domenico Veneziano and Beato Angelico. Piero
was of a generation even younger but he, more than any master
of his time, may be seen to be the perfect exemplar in painting
of the ideals Alberti proposed. It is wholly appropriate that the
shadowy remnant which is all that remains of Piero's great portrait
of Sigismondo Malatesta should have been painted for Alberti's
Tempio Malatestiana at Rimini, in which incomplete building the
relation of pagan to Christian elements was most strangely
elaborated and superimposed upon an existing Gothic structure, to
satisfy the whim of one of the cruellest despots of his time.

Piero's age when he became aware of Alberti remains un-
certain. The date of his birth is unknown, but he was an Umbrian
from Borgo San Sepolcro who is recorded as having 'been with'
Domenico Veneziano in 1439, when that master worked on
frescoes in the choir of S. Egidio. Piero was not then a master in
his own right and may not have become one before he left
Florence to return to his native town. In 1445 he painted his first
recorded work, the *Madonna della Misericordia* polyptych and
there, probably soon after, it is likely that he painted *The Baptism.*
His stay in Florence, however brief, had been of cardinal import-
ance, for it was then that he must have taken Alberti as his mentor
and seen the paintings of Masaccio for the first time. The effect
of Masaccio upon Piero was not only profound, it was unfashion-
able. This very fact had a saving grace about it, because such was
the local reaction against the greatest Florentine masters of the

16

first quarter of the century in the third quarter, that Piero was saved from that unhappy fate which has bedevilled the classical tradition, the overpowering weight of the tendency to stereotype. The very fact that Piero was not a Florentine, but could quietly practise his classical geometry in Urbino, in Ferrara, in Arezzo, and in his own town of Borgo, may well have been a fortunate chance, if in fact anything on earth could have dislodged him from his chosen and measured path. Not until Leonardo and Raphael revived Alberti's theories did the classical tradition receive a further impetus and it is part of the irony of history that Piero, of all classical masters, should virtually have remained forgotten until the twentieth century.

What Piero found in Florence, as Roberto Longhi put it, was 'man fashioned in the rough by the thumb of Masaccio', and Masaccio's vital clay Piero changed to silver, polishing it with the silver light of Umbria, and setting it in a geometrical architecture, intrepidly seeking an ordering of natural landscape and of organic forms which could be shaped to conform to that abstraction. The geometrical construction of *The Baptism* is relatively simple. In later life Piero's harmonic inventions became incredibly involved and his measured relationships of form embraced even the proper dimensions of the nostril of a single figure as it related to the face *13, 14* and body of that single figure, and, in turn, that figure's precise relationship to all other figures in the composition: their precise relationship, in turn, to the architecture and, as far as possible, to the landscape and the sky which occupied space between these elements; all these he considered mathematically in terms of perspective in depth, quite apart from their planar length and breadth on the area to be covered on wall or panel. This was, of course, also a point of departure for these calculations, but the eye-level of the spectator had to be taken into account, so that a wall high in the nave of a church, which would be seen by worshippers from far below, presented different spatial and therefore different mathematical problems from a panel to be viewed at normal eye-level. Some idea of these niceties may be seen in the detail from *The Proof of the Cross,* where the head-dress of the mother of Constantine in one of the great Arezzo frescoes has faded to reveal its underlying structure as a hemisphere within an *15* equilateral triangle.

The theory of linear perspective propounded by Brunelleschi and its development by Alberti is imperfect. It is fairly satisfactory when limited to architecture, but it is based upon monocular vision, a single fixed eye, looking as it were through a peephole, and since we ourselves have two eyes and our heads are made to turn on flexible necks, the system is ultimately inadequate except as applied to architecture. The limitations of monocular perspective were recognized but the system was no less logical than the tenets of Euclidean optics which depend from an assumption called *spherical perspective,* which also contains truths. Both were less empirical than those adopted by Uccello in his use of multiple vanishing points in the fresco of *The Deluge* in Sta Maria Novella. These optical discrepancies, upon which Piero touches in his book *De Prospectiva Pingendi,* resulted in what is now called *synthetic perspective* and this study was continued by Leonardo da Vinci, who wrote a treatise on it which is now lost. That no system achieves perfection in terms of divinity does not diminish the awe in which Piero must be held, for it was in the search for an unknowable perfection that he attained his unparalleled *gravitas.*

The Baptism shows Piero's majestic passion for mathematics at the very beginning of its development. Nevertheless, the dignity and gravity which emanate from the picture are the product of a mind occupied with subduing unruly natural forms to the harness of eternal abstractions. The mathematician is already mature in *The Baptism.* The ineloquence which makes it needless for the picture to 'speak' because it is sufficient to the spectator that it should simply *exist,* is the creation of a man dedicated to the grave satisfactions of the silent and meticulous world of numbers.

The structure of the picture is a far less complicated equation than may be found in Piero's later works. Even so, the geometrical framework, which again gives dignity to the work, is apparent. Horizontally the picture is divided into thirds, vertically into quarters. A central square is formed by the dove's wings, the edge of the angels' rose-coloured drapery, John the Baptist's back and the line of Christ's loincloth. To this square, emphasis is added by the sequence of hands from that of the left-hand angel to that of the Baptist. Within this square, another system of division exists, also based on the proportion of thirds to quarters, and a triangle, with the dove as its apex, is raised upon

12

68

the horizontal base line of the picture itself. A central vertical runs from the dove between the hands of Christ which, by chance, is emphasized today by the ill-repaired split in the panel and this precisely bisects the triangle. This is a crude description of the picture's basic design and although, compared to the formidable mathematics of Piero's later works, *The Baptism* is a simple construction, there are further subtle measurements of interval in the picture, of which space here prevents a fuller description.

As in all Piero's pictures, the structure of the design is so large and harmonious that it approaches great architecture, and his instinct for architectural stability is present even in a work like *The Baptism,* which shows no buildings. The white tree, placed on the 'golden section' of the elevation, is, in its deliberate use of a 'perfect' cylinder subtly modified to convey its organic nature, made to resemble the column of a temple and seems, in truth, to bear the weight not only of the hemispherical summit of the picture but of the whole sky, so that the slashed and speckled paraphrase of the Umbrian landscape, which forms the background, appears almost casual compared to this firm tree.

Colour Piero uses with a similar logic, and again he takes Alberti's theories as his point of departure. The results are unlike any other in Italian art. They bear no resemblance to the warm, rather brash use of colour popular in contemporary Florentine painting. They do occasionally bear a resemblance to the varied and contrasting marbles with which Alberti so subtly decorated his architecture. 'Grace will be found, when one colour is greatly different from the others set near it,' as Alberti says in Book II of the *Della Pittura*. 'When you paint Diana leading her troop, the robes of one nymph should be green, of another white, of another rose, of another yellow and thus different colours to each one, *so that clear colours are always near other different darker colours.* There is a certain friendship of colour so that one joined with another gives dignity and grace. Rose near green and sky-blue gives both honour and life. White not only near ash and crocus-yellow but placed near almost any other gives gladness. Dark colours stand among light with dignity and *the light colours turn about among the darks.*' He then goes on to condemn the gold ground. Piero's use of colour is designed to show light colours turn among the dark in an orderly sequence of warm and cool

fixed within a matrix of that silvery light which is coloured only in the sense that clear water or air is coloured.

This silvery light essentially reflects Piero's temperament. He marries it to a logical and ordered manipulation of forms and he brings this order even to forms as evasive of mathematical precision as the human body. Laws, rules which he himself devises and which will in time become stale and arid tricks in the hands of lesser men, are imposed by Piero in reverence for a divine order. His coolness, like his precision, is judicial and he paints with the gravity of a great jurist. He avoids no issues; he can manipulate strong hot colours, such as the robe of the angel or the vivid reds of the robes and hat of the persons in the middle distance of *The Baptism,* but he binds them into a unity by means of the clear, cold light which envelops them and the light in itself seems washed in the water of the sacrament. He draws all forms justly, even the chin of the Baptist, once covered with a beard, but which time has now revealed again beneath it. All the parts of the picture are relevant, all relate to one another in just proportion governed by the laws of geometry.

The nobility of *The Baptism* lies for me in its justice. In its ineloquence it discards the pleading of counsel: that is already past. Justice is done and may be seen to be done to the appearance of man in God's image set upon the ground and enveloped in the light and space that a humane man in an age of humanism believed was justly due to him. And the Son of God, who became a man, stands at the centre.

1962

GEORGES SEURAT

Une Baignade, Asnières

GEORGES SEURAT was one of the greatest, and is one of the most *plates* *9–12* famous, of the Post-Impressionists, although certainly not one of the most popular, and he is the only master of the school he founded, which came to be called Neo-Impressionist. He is, in my view, despite his great celebrity, an artist much misunderstood. There are two reasons for this; firstly, a cool austerity about his genius which people find forbidding, and secondly his novel painting technique, his way of putting the paint on canvas in small dots. This has overshadowed other and more important aspects of his work.

Curiously enough, he is misunderstood in rather the same way as an earlier and even greater artist, Paolo Uccello, but whereas Seurat's disdain for charm has motivated against him, the survival of a body of Uccello's most charming, elegant and decorative paintings has contributed to a failure to understand his more profound achievements. There are two different artists in Uccello, the great master of the *Deluge,* to be found among the shadowy *12* splendours of the Chiostro Verde frescoes, painted for Santa Maria Novella, and the superb decorator who painted the battle pieces. Equally, there are two Seurats, the exquisite impressionist observer of nature in the *plein air* sketches and the aloof, intellectual master of the large studio pictures into which he poured his whole mind and heart.

The word 'perspective' has bedevilled poor Uccello's reputation ever since Vasari related the famous anecdote about his wife trying to get him to go to bed and his unwillingness to leave the sweet science for the alternative of sleep. Yet the most familiar Uccellos, such as the so-called *Rout of San Romano* in the London National Gallery, are *not* remarkable for their researches into

space in depth. Like its companion pieces in the Louvre and the Uffizi, *The Rout* was painted to simulate tapestry and intentionally designed in shallow depth, deliberately flattened, for this reason. Perspective, in the usual sense of the word, is far more profoundly exploited in the *Deluge* but its high-water mark in the *quattrocento* is reached in the work of Piero della Francesca and this has led to rather patronizing criticism of Uccello's perspective as primitive. Nevertheless, the words 'perspective' and 'Uccello' have become synonymous. No less so are *'pointillisme'* and 'Seurat'. But *pointillisme,* as such, is not the secret of Seurat's greatness, nor, in my view, is 'perspective' precisely the key to Uccello.

The reason for this comparison and for this rather extended preamble is that the key to Uccello is also the key to Seurat, although there are four hundred years between them and their work appears very different. Both these great artists were as preoccupied with the poetry of mathematics as Piero della Francesca.

Now it is not easy for the casual spectator to come to terms with the profound and subtle intellectual study of pictorial geometry, and it is especially difficult in the present day when many people have been conditioned to believe that painting must be viewed as a product of feeling, emotion and intuition rather than cognition. Romantic notions about inspiration and spontaneity are commonly thought to be the atmosphere in which all painters work. It is, however, as important to recognize the mathematics in the art of Seurat, in order that he should be understood, as it is to recognize the mathematics in the music of Bach, if he is to be fully enjoyed.

Both the preceding essays, on Masaccio and Piero della Francesca, have concentrated upon an early *quattrocento* concern with measured forms within a unified concept of space. Confusingly enough, since it was by no means the only product of the Renaissance to respond to 'classical' antiquity, one of the uses of the term *classical* has come to mean an overriding concern in art with a particular logical solution to formal pictorial problems. This classicism reached its acknowledged apogee with the work of Raphael, whose fame has never dimmed, and because the art of Raphael was, and has remained, revered as an ideal, the stream of European classical painting descended unbroken through Poussin to Cézanne, and no less to Seurat. It has often been a very dry,

narrow and academic stream, for any system which clings tenaciously to strict rules is perpetually endangered by the fact that such rules can be learned by very dull men. Nevertheless, it has survived as a special way in which to create images.

As so defined, this 'classicism' rules me with a rod of envy, since it describes the kind of artist I should like to be and, in certain fundamental ways, I am not. The alternative modes of seeing obviously preceded the Renaissance, but they also co-existed with it, and have continued to co-exist with classicism ever since. Gothic art was formulated not in terms of the total unity of the image, but as a method of juxtaposing persons and objects in sequence to establish the importance and the drama of events. It was not concerned either with unified space or with closed geometrical forms. Equally Mannerism, which developed as much from a sceptical distaste for anything so unequivocal as *certezze* as from other sources, discarded any attempt at unified space or indeed any indivisible unity, and supplanted homogeneity with drama and often with melodrama.

I have in these essays been so concerned to celebrate the classical that perhaps I should now emphasize the alternatives. Breughel, Caravaggio, Goya and Courbet, to pick the names of major artists almost at random, were none of them concerned with classical formalities, although naturally all were aware of them in that they had become the scaffolding upon which much good and bad art had been supported. Equally, the rigours of naturalism, which depended from an intense and direct concentration on the appearance of the visible world, and that most significant of other dominants, the effect of light, could be and were revealed empirically to those who endured them. Such is the extraordinary co-ordination of the human eye and brain that such a master as Turner could and did evolve his vision beyond established schemata in the course of a lifetime.

There is, however, a polarity which has magnetized painters since the Renaissance, dragging them towards the pole of classicism in one period and away from it in another. What is truly remarkable about Seurat is that he should deliberately, and at a very early age, have adopted an approach to painting entirely at odds with the *avant garde* of his time, in order to adjust the discoveries of that *avant garde* to what he believed to be a

73

larger issue. He back-tracked to the archaic disciplines of the early *quattrocento* in the face both of Impressionism on the one hand and the tattered remnants of a worn-out academic tradition, whose worship extended no further back than Raphael, on the other.

The greatest leaps forward, which appear at intervals to lend credence to the notion of progress in the arts, all tend to arise from withdrawing further into the past than is the current practice at the time. The principle of *recueiller pour mieux sauter* is the instinct of genius and just as the *quattrocento* Florentine masters looked back beyond their predecessors to a golden vision of the ancient world, so Seurat's originality lies in dispensing with much of the evolution of painting in the four and a half centuries which preceded his birth, and giving his full attention to that second golden age, which had given birth to Piero. This intuitive recognition that the discipline for which late nineteenth-century painting cried out was the logical ordering of space and a new recognition of the sober splendours of geometrical forms, both Seurat and Cézanne shared. It is the seed of Cézanne's famous dictum about the essential reducibility of natural forms to the cube, the cone and the cylinder, a proposition which Piero no less than Uccello would have accepted.

The 'divinity' of proportion, the geometrically perfect ratios between every shape and form in the rectangle of a picture accounts for Uccello's preoccupation with the plates, cylinders and metal ornament of armour, the pattern of lances and so on. In Seurat's harbour scenes, exactly the same preoccupation with the frozen music of geometry is paramount. Every windlass, every bollard, fence post, jetty and mast are placed precisely to accord with those *certezze* of geometry of which perhaps the most celebrated is the 'golden section', that 'perfect' division of a line. But because these sacred, mysterious and complicated mechanics are very subtly disguised, the things that strike the spectator are the curiously unrealistic rocking horses of Uccello and those damned dots in Seurat's later work. Both these are by-products of genius, but they have obscured the real nature of the greatness of these two artists.

Nevertheless, *pointillisme* or rather *divisionisme* as he described the theory he evolved, was of such consequence to Seurat that even in so short an essay as this, it must be documented.

Among the literary sources of his theoretical studies, of composition and optics, were *De la Loi du Contraste Simultané* by Chevreul, *Le Cercle Chromatique* by Charles Henry, *Les Phénomènes de la Vue* by D. M. Sutter and *Le Grammaire des Arts et du Dessin* by Charles Blanc. These books were found among Seurat's belongings after his death.

Chevreul's book proposed a circle of four fundamental colours and Seurat deliberately limited his colour to this circle of four together with their intermediate tones. His palette was laid out thus: BLUE, blue-violet, violet, violet-red; RED, red-orange, orange, orange-yellow; YELLOW, yellow-green; GREEN, green-blue and back to blue again. With the colours in that order he did not mix them although he added white to the tint where necessary but applied each pure in complementary juxtaposition. This meticulous dotting had, to Seurat, the advantage of replacing the 'disorderly' brush strokes of the Impressionists with a more disciplined touch.

The influence of this system was considerable, not only upon Seurat's doctrinaire followers, of whom Signac is the most celebrated, but upon Camille Pissarro, who adopted the method for some time, and later upon the major Cubists, all of whom employed it, or a pastiche of it, in passages in their paintings between 1912 and 1920. Juan Gris, in that he alone also understood the geometry, must therefore rank as Seurat's greatest twentieth-century follower.

The principle of *divisionisme* depends from the assumption that pure colour, based on the divisions of the spectrum, will mix in the eyes of the spectator at a certain distance from the canvas and blend into tones in a harmony governed by the duration of light impressions falling on the human retina. As such, this harmony is 'truer' or more 'perfect' than the 'disorderly' mixing of tones upon the artist's palette to be applied to the canvas in arbitrary patches at the artist's will. As a way of thought this mystique sorts well with Renaissance perspective and geometrical theory, which also attempted perfection by *certezze* as a visual demonstration of Platonic Truth, but just as the *monocular* perspective system of Brunelleschi could only be used 'truthfully' in terms of architecture, since human beings are *binocular,* so too the theory of *divisionisme* has comparable limitations, since it

inevitably fails to take into account the incredibly complex mechanism of the relationship of the eye to the brain, which makes visual 'corrections' far beyond the comparative crudity of Chevreul's theory, no matter how soundly based his theory was.

Une Baignade, Asnières precedes Seurat's most doctrinaire and self-defeating adherence to Chevreul's theory, for it is executed in a technique called *balayé* wherein the colours are mixed as traditionally they had always been, on the palette, but they are applied to the canvas in dry, short and very orderly strokes diminishing in size towards the horizon. *Pointillisme* is only used in areas of retouching such as the hat of the boy in right foreground.

The design of the picture is majestic, and here Seurat's addiction to theory of a different sort is utterly justified, for here he turned to the grammar and syntax of his art. No artist since Raphael has had a surer command of the resources of geometry, and the line goes back from Seurat through Ingres and Poussin to Raphael's *School at Athens,* hence to Piero della Francesca, and ultimately to the Uccello of *The Deluge.* The desire for order is essentially a classical preoccupation, and by classical I mean the desire to arrive at an *impersonal,* universal image. This means, to the artist, the clarification and extension of a *particular* experience into a general one. It is to be able to say, as it were, in paint: 'I shall take this specific apple at which I am looking and make an image of it which, in the completeness of its realization, will stand as *the* apple of apples.' Not, as a romantic might say, 'This is my personal apple and this picture expresses my feelings about this apple.' The classical apple expresses nothing about the artist, except incidentally, but everything about apples. The image simply *exists* in its own right. This attitude of mind produces a noble art of the kind which Berenson called 'ineloquent', meaning that it achieves a timeless, monumental grandeur which, in its absence of rhetoric, is the true and splendid expression of emotion recollected in tranquillity. You will find it supremely in Piero della Francesca, you will often find it in Ingres portraits, you will sometimes find it in Degas and always in Cézanne, but not in Van Gogh, and not in Turner. The only English artist who possessed it was George Stubbs.

The *Baignade* is just such a monumental and ineloquent picture.

It is poetic and deeply felt, but the image is governed, throughout, by an extraordinary intellectual clarity and the calm exercise of a prodigious will. The poetic element is pastoral. The relaxed figures brooding in the sunshine are all of them isolated. As individuals they make no human contact with one another. They manifest no visible emotion, but seem to be content simply to exist – to be – making no particular gesture, except that the boy on the right, waist-deep in water, calls to a companion. Whatever he shouts would seem to evoke no response. No one takes any notice. But the figures are precisely and delicately related to one another as elements of the design. The balance and distribution of the solid heavy bodies, bathed in light, gives to the picture its solemn tranquillity.

Seurat's ambition in the *Baignade* was a large one. He wished to bring a classical order to impressionism without losing the crispness of handling and the luminosity of colour which that movement had achieved, and at the same time he sought to transpose a technique which had evolved from the sketch, the 'impression', up to the scale of a picture six foot by twelve foot (or to be exact, $71\frac{3}{4}$ inches by $144\frac{1}{4}$ inches). The picture is therefore the height of a tall man and twice the length. This problem of scale required the translation of a method suitable for the oil sketch a few inches long, into a means of achieving a work conceived on the grand scale of a Renaissance fresco. Furthermore, Seurat wanted to give to the appearance of everyday people, and very ordinary ones, the air of noble permanence which the Florentines had achieved, but without any of the overt splendours of exotic costume and setting, familiar to the fifteenth century, without, as it were, Uccello's knights in armour. For this reason the anatomy of the figures is simplified and all detail is subordinated to the clarity of the over-all design.

In terms of actual size, Seurat's *Baignade* is not a big picture, but it was a very large undertaking for the artist himself. Since the Middle Ages the size of a picture has usually been predetermined, and in the case of big pictures their architectural setting has been the determining factor. But by the end of the nineteenth century public patronage was philistine. The greatest talents alive in France were not, and did not expect to be, employed upon projects in public buildings which would have given them scope for

work on a large scale. Delacroix was the last truly great master to have achieved this good fortune.

The painting of Degas, Renoir, Cézanne and the other masters of this period tended to be of modest size for economic reasons, apart from any others, since their setting lay, if anywhere, in the bourgeois dining-rooms of enlightened, but not particularly wealthy, collectors. Nevertheless, the urge to work large persists among European artists, even when the onus of the challenge, set by earlier masters, must rest on the ambition of the artist alone. Seurat met that challenge regardless of any lack of commission. The architectural setting for the *Baignade,* which, in another age, would have imposed its dimensions, existed only in his mind, yet the picture is as architectural as one of Piero della Francesca's Arezzo frescoes. The *Baignade,* although it is the largest of Seurat's works, is little more than half the size of one single scene from Piero's great corpus of work on the walls of the nave of the church of San Francesco. Even so, the *Baignade* has the grandeur which makes one remember it as much larger than it is. Monumentality is the result of scale and style rather than size itself.

Kenneth Clark has pointed out that although Seurat had not been to Italy and indeed had never seen a Piero della Francesca, for there are none in France, he knew the copies, which hung in the Ecole des Beaux-Arts, of two of Piero's Arezzo frescoes, by the painter Loyaux. Furthermore, he must also have known Uccello's battle piece in the Louvre, if not the companion pictures in London and Florence, so that there is perhaps a direct link between these two artists.

Nevertheless, that Seurat should have found Uccello and, at a remove, Piero, is something to be wondered at in a young artist of his time. In the light of these sparse examples, in a period before the early fifteenth-century masters were greatly admired, Seurat set about the titanic task of re-creating a comparable monumental art.

It is unusual in modern times to find an artist of genius developing a strikingly original art by direct obedience to precept and rigidly abstaining from any rebellion, only to find the result as mindlessly misunderstood and condemned as if he had mounted the barricades. Yet this was exactly the fate of Seurat. Entering the *Ecole des Beaux-Arts* at nineteen, as the pupil of Justin Lequien,

himself a pupil of Ingres, he submitted with joy to the classic disciplines of his master who was *Ingriste* enough to have founded a prize 'to encourage the defence of the academic tradition'. Furthermore, Seurat was encouraged, after his return from military service in 1881, by Puvis de Chavannes who may have influenced him towards undertaking the grand compositions upon which his life was concentrated and of which, before his death in 1890 at the age of thirty-one, Seurat accomplished seven.

At the age of twenty-four, with the utmost deliberation and the most painstaking calculation, he began to realize the first of them. He chose a site on the river at Asnières, an industrial suburb north of Paris, and settled down to assemble the visual data he required. He worked for months on the spot, painting on little wooden panels fitted into the lid of a small paintbox. At his death, thirteen such *croquetons,* made as preparation for the *Baignade,* were found in his studio, and he may have made many more. They are masterly fragments of summary impressionism. In his studio he made numerous careful and very beautiful drawings from models, and studies of the pile of clothes which occupies the centre of the foreground of the picture. Finally, he evolved from these fragments, with the aid of his studies in geometry, the great painting itself.

Impressionism as a movement, expressly concerned with the transitory play of light on form, although still subject to critical desecration, had largely established itself by 1884. The years that followed saw the Impressionists, and Monet in particular, accepted at least by a section of the public. The great struggle was over. But further developments had already taken place. The immediacy of Impressionism, with its total concentration on spontaneity, its sketchiness, seemed to Seurat and no less to Cézanne to have about it a distressing impermanence. Both artists, in their different ways, felt that the quality of architectural stability was necessary as a part of great painting, and this Impressionism, of its nature, lacked.

Discontented with forms which seemed to shift about in a frothing bath of light, the great masters of the eighties began to seek to rebuild the solid structure of painting which they felt had become vitiated. And to this restoration of formal order Seurat, in his twenty-fifth year, made the most profound contribution.

79

He submitted the *Baignade* to the Salon, from which it was summarily rejected, and in the same year he sent it to the *Indépendants,* where it was hung in the buffet and received little attention and much of that contemptuous. The picture remained unsold at the artist's death.

Seurat himself was a withdrawn and reticent man. He saw his own art as dispassionate. When friends praised his work, he irritably dismissed their praises. 'They see', he said, 'poetry in what I have done. No: I apply my method and that is all there is to it.' It may seem, perhaps, that he was right, that a mathematical method is at the opposite pole from poetry and that when I insist that there *is* poetry in the *Baignade,* I seem to contradict myself. I do not, and I do not think a mathematician would think it absurd to call mathematics a poetic form. In fact, all the arts have more to do with mathematics than many people think. There *is* poetry to be seen in Seurat's work: a serene poetry of almost puritanical gravity. However firmly he tried to organize and order his vision, there is, in the almost sacerdotal tranquillity of his best works, great visual poetry. He applied his method, but that is *not* all there is to it.

1960

GIORGIONE

The Woman Taken in Adultery

THE PAINTER usually known as Giorgione or Giorgio da Castel-franco, but known to his contemporaries, in Venetian dialect, as 'Zorzo' or 'Zorzi', was probably called Giorgio Barbarelli. He was born between 1476 and 1478 at Castelfranco in the March of Treviso and probably trained under Giovanni and Gentile Bellini. His working life, of some fifteen years' duration, was conducted almost entirely in Venice and he is not known to have travelled farther than Treviso, Padua, Asolo and Frioli, all places a few miles from Venice, unless he visited Ferrara, which is uncertain. Almost everything about Giorgione's career is uncertain. He is thought to have lived in Venice in the Campo S. Silvestro or in the Riva dell' Olio. He is reported to have been most accept-able socially, attractive to women and a fine musician. He died of the plague in 1510 and it is presumed he was buried on Poreglia, the island to which the bodies of plague victims were taken.

plates 20–22

There are two official documents which relate to Giorgione's work. The first, dated 14 August 1507, is a commission to paint a picture, now lost, subject unknown, for the Audience Chamber of the Ducal Palace. The second, a commission dated 23 May 1508, is for the decoration in fresco of the façade of the Fondaco Tedesco or German Exchange Building. These frescoes were worn away by the weather and even in the eighteenth century they had all but vanished. An amorphous, faded pink area of paint, on a section of wall, is preserved in the Accademia in Venice and this is all that remains of the work.

Three of his surviving works are datable, of which the Fondaco Tedesco shadow is one. The others are the *Laura* in Vienna of 1506 and the so-called 'Terris Portrait' of 1508.

All other evidence concerning Giorgione is at second hand. It

is contained in Vasari's 'Lives', which is unusually unreliable in this instance concerning the pictures listed, interesting for its anecdotes as usual, and records Giorgione's association with Titian and Sebastiano del Piombo. Vasari lays much stress upon Leonardo's influence on Giorgione's manner but this poses the problem as to whether Giorgione could, in Venice, have seen any original painting by Leonardo.

Traditionally, Titian and Sebastiano are referred to as Giorgione's 'pupils', although if they were, they were no younger than their master, and his 'assistants' were Morto da Feltre and Giovanni da Udine. Giorgione is supposed to have shared a studio with Catena in 1506.

His death is recorded in a letter from Taddeo Albano to Isabella d'Este, in which Giorgione is referred to as having died 'a few days ago of the plague'.

Apart from the two contracts, far and away the most reliable of the documents upon which all Giorgione studies are founded is a diary kept by Marcantonio Michiel, who may actually have known the artist. Even so, his notes, which extend from 1512 to 1543, are all written after Giorgione's death and are scanty. Michiel mentions fourteen authentic pictures, three copies and one doubtful work and he writes specifically of the *Tempestà*, the Vienna *Three Philosophers* and the Dresden *Venus*.

Contemporary, or near contemporary, literary sources establish that Giorgione's work was in great demand and very highly valued. His greatness is continually commented upon and the letter from Taddeo Albano which records Giorgione's death makes it clear that Isabella d'Este was unlikely to obtain a picture from his hand. Nothing was available for sale.

As with most of Giorgione's work, the history of the picture now in Glasgow and called *The Woman Taken in Adultery* is extremely vague. It may be the picture called an *Adultera*, referred to in a letter of 1612 from Camillo Sordi to Francesco Gonzaga. It may be the *Adultera* in the collection of Michele Spietra in Venice in 1656. It may or may not be the *Adultera* referred to in the inventory of the possessions of Vincenzo Imperiale, taken at Genoa in 1661. It may, as Tietze-Conrat maintains, represent not *The Woman Taken in Adultery* but *Daniel and Susannah* on the grounds that there is evidence of a

82

sort that Giorgione contracted to paint such a picture. This, I doubt. The evidence is based on a document which has disappeared since 1878, when it was published by Molmenti. It purports to record a promise made by Giorgione, on 15 February 1508, to paint four canvases portraying *The Deeds of Daniel* for Alvise de Sesti. This is the connection, and the only one, between Giorgione and Tietze-Conrat's title. For various complicated reasons it is possible that the missing document was a forgery. If the picture is an *Adultera* it is likely to be the painting in the collection of Queen Christina of Sweden in 1689. It had not, it seems, been cut down at that date. By 1721 it was no longer attributed to Giorgione but to Pordenone and thereafter critics have contended at length on its attribution. After a long series of heats, the finalists are Titian and Giorgione, and in my opinion Giorgione is the artist who painted the picture. In the early nineteenth century it was acquired, from an as yet unknown source, by Archibald McLellan, a coachbuilder of Glasgow, who left it upon his death to the City of Glasgow. However, his affairs were not in order and his effects were sold. After bitter wrangling in committee, the Town Council, some of whose members referred to the McLellan Collection as 'a heap of rubbish' paid £15,000 for all his works of art. These consisted of four hundred and thirty-seven items, many of which would now be worth two or three times the purchase price of the entire collection. The Giorgione alone would surely fetch a million today.

At some time in the course of its career, *The Woman Taken in Adultery* was mutilated. A copy attributed to Cariani, now at Bergamo, shows that originally a full-length figure of a man in parti-coloured hose occupied the right-hand foreground, effectively establishing the balance of the composition. Spatially, this figure and the area of sky behind his head were of the greatest importance. The relationship between the right leg of this figure and the left leg of the armoured man, who also turns his back on the spectator, on the opposite side of the picture, are vital elements in the structure of the design. The area of sky now missing must have played an important part in relation to the pale blue robe of the central figure. Since the picture was cleaned in 1952, the knee of the missing figure is visible and despite its inconsistent presence in the now cut-down picture, it is valuable in giving a forward

20

movement to the figure of the woman by the angle at which it crosses her skirt.

21 A fragment of the missing section, the bust of the man looking back over his shoulder, was discovered in London some years ago by Mr Colin Agnew, went to New York and has now returned to London, where it hangs in the National Gallery. The rest of the body and the legs have presumably been destroyed.

Before cleaning, the picture was not only coated with dark varnish but whole sections of it were overpainted, notably the robe of the central figure, whose leg was consequently out of drawing. Some disfiguring damage was also revealed elsewhere, especially in the central area, including the head of the old man between the two principal central figures and the left forearm and hand of the adulteress. This latter damage may perhaps explain the mutilation of the whole, since if the body of the missing man was in exceptionally poor condition, the cutting down of the picture becomes comprehensible, if unforgivable. The picture unquestionably needed to be radically cleaned and repaired and it has been, leaving it somewhat ill-adjusted in tone, causing the head of the old man in the centre and the cleaned blue robe to 'jump out' at the spectator, which is regrettable. Furthermore, the drawing of the right leg of the figure in the brilliant red-gold tunic can surely not have looked as it does when it left the artist's hand. As a leg, it does not bear its proportion of the weight of the body.

The prosaic pages which formally preface this essay are, I confess, a deliberate attempt on my part to get down to brass tacks. They record the facts, they explain nothing, but the facts perhaps sober me. Re-reading them, I find they cool the blood and perhaps they may prove useful, but as to the essay itself I find it displays in me the dilemma of a man at once enriched and undermined in a most disturbing fashion. That is the effect that the art of Giorgione has on me, as does that of no other painter. I write about him simply because I don't understand what he distils unless he had the secret of that liquor which Oberon poured into Titania's eyes.

I do not wish to convey that I believe myself fully to understand the other great masters discussed in this book as they might be

understood by their equals, but at least I can grope to do so. On the frontier of Giorgione's promised land I find myself a minute Moses. Nor am I alone, for I do not believe anyone has entered it, not even Titian who inherited it and gives me the impression that he strode masterfully about on the perimeter without truly gaining a welcome. Yet in itself this statement is absurd, for more masterful brushwork and more muddy boots have passed and tramped over that territory than most. Titian was there and Sebastiano del Piombo, both of whom painted or completed parts of Giorgione's pictures, and a host of daubers, hardly worthy to be named, have laid hands on his country and despoiled it. Yet if one stands before *The Woman Taken in Adultery*, it is at once a mutilated oil painting, in a hideous frame, wherein the tones no longer keep their intended distance, where the balance of the composition is destroyed, where Christ's hands are of different sizes, where the inswinging adulteress is off balance, lacking her foil, the missing full-length figure, who would have redressed this. The accuser, in his red hose, does not take his place securely before her. He, too, is off balance. His right foot is not planted on the ground, due to some insecure drawing of the achilles tendon of that leg and a misplaced shadow under the foot. The antique sculptural virtues of Masaccio and Piero, who placed their figures with such an absolute stance upon the ground, are not to be found here. And yet all these strictures come to nothing. Disbelief is as suspended as judgement. The early evening is perpetual, the spell is total. And that this should be, I find inexplicable. Ill-treatment and mutilation, falsification by time and maladroit treatment; these are ills which Giorgione's painting overcomes effortlessly in the illusory world of his invention.

His art exercises a compelling, hallucinatory power so strong that, confronted with it, the real world seems to dissolve around one. It is the material world which becomes unreal. Not only does the real world seem to recede, quivering, from the mind, but Giorgione himself moves in it as elusively as Oberon. There have been times when many pundits came to believe that he did not exist. In about 1900 it was predicted that he would become a myth and there were those who attributed all his works to other hands. Since that ebb, the tide has turned and the number of his

extant works conceded by contributors to the learned journals now varies from a dozen or so to about eighty. Even so, the experts still blunder about in Giorgione's enchanted wood like Bottom the Weaver and his rude mechanicals. Seeking attributions, they have awarded the Glasgow picture at various times to Pordenone, to Cariani, to Campagnola, to Romanino, to Sebastiano del Piombo, to Titian or even to a collaboration between one or more of these. Here a connoisseur detects the work of Titian in the landscape, but of Sebastiano in the figures. In this case Giorgione himself may perhaps be credited with the over-all conception and the execution of the figure on the extreme left. But these critical battles usually end with Titian versus Giorgione alone in the field. What is left is Giorgione's everlasting, pastoral world vanishing gently into a golden dream and Titian robustly moving away from it towards the later triumphs of his own quite different temperament.

When Giorgione died of the plague in 1510, he had so mastered the depiction of hermetic allegory or alternatively had buried it so deep that the exact interpretation to be placed upon one of his pictures is frequently wholly lost to us, and even his contemporaries, it seems, were often puzzled by the meaning of his images. The allegorical content of the *Tempestà* and Giorgione's poetic use of it has been ingeniously argued by Professor Edgar Wind,* but such is the painter's power that one seeks for yet further mysteries to explore, so that the picture in the London National Gallery which used to be called *Aeneas and Anchises* and is now called *Il Tramonto* or, alternatively, *A Sunset Landscape with St George and St Anthony* seems strangely to accept and enlarge the implications of any title set on it.

Except to iconographers, it may seem of no great interest whether the Glasgow picture represents the story of *The Woman Taken in Adultery* from the New Testament or that of *Daniel and Susannah* from the Old. The group of figures, the chord of colour, the spatial and formal relations of the participants in the drama are, to the twentieth century, more important than their personal or historical or theological relationships. This would not however have been true in most periods of history, when

* Professor Wind is also enlightening as to the allegorical content of other pictures by Giorgione in his *Giorgione's 'Tempestà'* (Clarendon Press, Oxford, 1969).

the artist was called upon to portray a scene from scripture or history or celebrate the known actions of gods and men in some clearly recognizable way. In certain circumstances patrons were found who wanted things made more difficult. The later Renaissance, particularly at Ferrara, produced a school of painters whose work is so packed with refined allegory that only persons highly advanced in scholarship could ever have known what their pictures meant, but they did mean something specific, just as the thronging fantasies of Hieronymus Bosch must have conveyed something specific, in every detail, to the people who commissioned them.

The pure landscape, the still life, the 'slice of life', the painting for painting's sake, is a late development. What is relevant in the case of Giorgione is that he painted so compelling and so private a world that it would seem ill-mannered and intrusive to inquire of his people what they are doing in it and why. To us, it may also seem less important than it is in other Renaissance painting, but it was apparently less important even to his contemporaries than it would have been to his predecessors. He was, although perhaps in this he was to some extent foreshadowed by Giovanni Bellini at the very end of his long life, one of the first masters to create a pre-eminently emotional and sensual climate, *a mood* so elegiac, so pregnant with sensual implications, so heavy with physical sensation that the spectator is spellbound. What is being said, in Giorgione's pictures, by one person to another, one hears, in one's mind, like the drowsy hum of bees. What is being done is something one wonders idly about, like the activities of people on the other side of the lawn on a midsummer afternoon. Metaphorically they move and speak, but because one is on such curiously intimate terms with them, one does not ask them to speak up or repeat what they have said or make their intentions clear, if one does not understand them. There seems to be no hurry.

If I try to analyse the special causes why this should be, waking myself out of my drowse, it becomes obvious that the exposition of form and a highly personal use of colour must explain the physical nature of this dream. Giorgione contemplates forms as dense masses, sculpturally shaped and explained by the fall of light. This is a way of seeing which derives from Masaccio and eventually, via Piero and then Bellini, from Florence. But Gior-

gione's vision of the three-dimensional nature of form is subtly more ambiguous than that of his predecessors, and he imparts to it the illusion of a very slight vibration which makes flesh seem to breathe. Now this does not seem solely a matter of technique, although it must be. If it is, I do not know how it is done. His colour is sumptuous. This richness is produced by intelligent juxtaposition of hot and cold colours and light and dark tones and unified by the binding agent of a warm light. But if I look at the orange tunic of the man who drags the adulteress forward, I find a blazing area of gold shot with red which is, for me, more potent than anything in Titian's whole work. Technically, this intensity is achieved by contrasting the colours of light and dark areas, an effect deliberately caused by the depiction of certain fabrics, 'shot' silk for instance, and by building the colour chord up from the full red of the man's hose and abutting it to the green of the landscape and the different green of the woman's overskirt. Juxtaposed to the blue robe of the central figure this colour chord 'sings'. But then 'shot' materials had been used in painting for many decades for just this purpose of heightened colour intensity and contrasts of red, blue and green are entirely familiar. How is Giorgione able to produce his unique intensity? It is not the precious intensity, the rich bejewelling of surfaces, which the Sienese produced a century and a half earlier. Is it perhaps an illusion of light burning within the forms and not light shining upon them?

The impact upon Venetian society created by Giorgione's painting during the brief period of his working life was astounding. His success was so overwhelming that for some time Giorgionesque paintings were the only kind that private individuals wanted, and here again a precedent was created, for the turn of that century was a time when private collecting came to be widely practised. It was not precisely new. The rich and highly educated had been assembling private collections, especially of antiquities, for a century or so, and I distinguish here between the assembling of sacred works ostensibly for reasons of piety, and the collection of works of art for aesthetic reasons; but it was the sixteenth and seventeenth centuries which were to see the full re-establishment of a fashion for the private collector of modern art. He had existed in Hellenistic and Roman times. He had been

88

most uncommon thereafter. The portrait, of course, fulfils a rather different and special function, but even portraiture is relatively uncommon before the Renaissance. That is to say, private portraiture for the private individual as opposed to the pious images of donors.

Privacy is the key, I think, to Giorgione. In a special way, in painting, it is his invention, or perhaps to put it the other way, he arrived at a moment when there seemed some special need for it. His muse speaks vibrantly but to me inaudibly. She keeps her profile dark against the light, her head turned into shadow and I do not know what she says. I only know that if I could hear her she would seduce me utterly.

In the moment when Giorgione arrived upon the stage of history, immediately before the Reformation, Europe was pregnant with social change and the relatively safely isolated Republic of Venice was ideally suited to house the high bourgeois, that rich but circumspect man whose pretensions were subtle rather than grandiose. He, this new man, product of humanism but spared the penitential reaction from it, responded to Giorgione's sumptuous lack of pomp as one might open a bottle of expensive wine among close friends, rather than spend the money on great hogsheads for one's retainers. This was only a brief, highly sophisticated interlude, but it was prophetic for it altered the relationship of the spectator to the work of art, and gave the artist a new and perhaps perilous liberty. He became the seller who dictated terms to the buyer. What he painted the patron could buy if he had the taste, but in that presumption the slow withering of mutual responsibility was begun which has gradually drained an ancient purpose out of the visual arts, leaving *homo ludens* in place of *homo sapiens*. Nevertheless, the practice of working at the behest of a patron upon a theme often minutely specified in every detail, remained general long after Giorgione's time. It was not common practice for the painter to work on speculation, producing pictures which were offered for sale upon completion, indeed it was very unusual until the seventeenth century, but it seems to have been Giorgione's practice, although not exclusively, for he was commissioned on two specifically datable occasions and several of his other works are clearly specific commissions. Yet at his death Isabella d'Este was trying and failing

to buy a picture – any picture – from him and early records of his work are concerned more often with pictures already in private hands than with pictures in public places.

The point about all this is that it placed Giorgione in very special circumstances. He was an outstanding success not because he satisfactorily fulfilled important functions entrusted to him by exigent popes or capricious aristrocrats, or even prosperous citizens on committees, but because he produced a kind of art which was at once irresistible to individuals and has continued to be ever since. His art is private in a special sense. His are not the honest bourgeois talents with which the Dutch came to gratify honest bourgeois desires for cabinet pictures in private houses. Nor were his talents suited, like those of Titian, or Tintoretto, or Veronese, to the creation of pomps and splendid public arts, as well as private ones. He created a dream in which private people wish privately to participate and of his successors perhaps only Watteau enjoyed the secret of the dreaming of this dream and he dreamed only a corner of it, however elegant.

There is, deep in Giorgione's art, an intense sexuality so potent that it disdains the voluptuous. It can contain an innocence which is never virginal, yet is incorruptible. It is rarely touched with any sense of sin, even when a distant thunder seems to roll like a warning across the sky, shaking the golden age. Who is there who would cast a stone at any woman taken in Elysium? Yet even in Giorgione's most golden time the thunder does roll to presage a stormy end of summer.

The special paganism of Venice, at the turn of the sixteenth century, is quite unlike that of Florence which preceded it It is hotter and richer. Plato and Virgil are not the inspiration, but rather Ovid and Philostratus. Piero's silver justice and Masaccio's bulky truths had grown out of the winter into a spring in which man's image of man was reborn, but the *Primavera* of Botticelli is unthinkable in Venetian terms. Spring moves on to summer and moves from Florence to Venice. The times produced Giorgione, who holds the golden August in his hand, knowing, it seems to me, that autumn comes and winter is inescapable. He knows that winter comes and yet he holds high summer in so splendid a chancery that the warning seems unimportantly remote.

I have said that I do not understand Giorgione, and that is true.

In the presence of great masters one may, if one is a painter, admire them, even identify oneself with them, greet them with that humility enjoined upon one towards one's parents and sit at their feet. But with magicians, no matter how you strive, you are not a whit the wiser. When I stand in front of a Giorgione I realize that my feet are clay and that I shall never drag them, making muddy footprints, into that landscape, the place wherein his figures stand and talk so that I cannot hear them.

1962

WATTEAU

The Music Party

or Les charmes de la Vie

plates
17–19
The Music Party hangs in a room at the Wallace Collection which contains seven paintings by Watteau, and it must be about the only room in England which does. Two other large ones hang in a room nearby.

As a picture it is by no means Watteau's greatest achievement. It is not so beautiful, to me, at least, as two other little panels in the same gallery, the *Harlequin and Columbine* and the small version of the *Champs Elysées;* nor is it so perfect as the painting at Dulwich; nor does it compare with the *Gilles* in the Louvre; nor does it approach for one moment the incomparable *L'Enseigne de Gersaint,* that shop sign for a picture dealer, which is now in Berlin. Yet *The Music Party* has Watteau's special magic, and it is because this magic is present in all his works in all circumstances, because he could not touch a crayon to paper, nor a brush, even a dirty brush, to canvas, without conveying a unique and mysterious quality, that I have chosen to discuss it here. It displays his faults, and his debts to Rubens and the Venetians. It even contains an unusual, an amazing, piece of clumsiness, totally unlike him in its imperfection.

Yet seen where it hangs with the work of his immediate followers, with paintings extraordinarily similar in subject and treatment by Pater and Lancret; with paintings by subsequent generations who also owed their vision to him, then even the admirable and accomplished pictures of Boucher fade into insignificance in Watteau's company; even the masterpieces of Fragonard.

17 *The Music Party* is typical of Watteau in its choice of subject, the disposition of the figures, the limpid delicacy of its landscape. His world was a stage peopled by aristocrats who have no pressing

problems: by ladies to whom the whispered compliment is all and gentlemen who turn a phrase and execute a gesture with studied elegance. Yet they are melancholy. When they sing one can almost hear with what subtle phrasing the gentlemen blend their light tenor voices with the soft mezzo-soprani of the ladies. The songs are by Lully: the voices would not be adequate for opera. They have no cares, these people, yet they are melancholy. They are always in the garden, but the day is never hot. Their love is formal, their lust a matter of prestige.

Why, then, are these puppets so moving? They are butterflies. One can well understand why, less than a century later, the stern puritans who followed Jacques Louis David should have brushed them aside, and why David's pupils should have flicked bread pellets, bread pellets black with charcoal from rubbing at their nobly wooden drawings, at the Watteau which hung in their life class. And that painting was *L'Embarquement pour L'Ile de Cythère,* depicting a party of young people taking ship for the island of love. This was his diploma picture, and the first to be called a *fête galante.*

But to see the participants in Watteau's pictures as ghosts is to be too hasty. Slight and inconsequential though their activities may be, feckless as they may seem, they have bones and flesh and blood. The strength of their forms, beneath the rustling silks, is by no means insubstantial. Watteau was after all a Fleming, for all his Parisian delicacy, and a trace of that robust race is always apparent in the drawing of his figures. Furthermore, Watteau's debt to Rubens is so strong that the same blood seems to run in their veins, even though in Watteau it was thinned by the ravages of consumption.

The Goncourts say that Rubens 'wanders a stranger through Watteau's *fêtes champêtres* where the tumult of the senses has been stilled', and certainly the earthy richness of Rubens, although he 'lives on in [Watteau's] palette of carmine and golden flesh tints' is not at first apparent in Watteau's painting. His colour, often silvered by his love for Veronese's cooler range, is lunar where Rubens' echoes the full blaze of sun. The fat rollick of Rubens' dancing peasants, the vigorous activities of his robust divinities, is transmuted to the graceful posturing of slender members of the smart set. But without the warm example and noble repose of

Rubens' *Garden of Love* the amorous conduct of Watteau's *fêtes champêtres* might have been differently conceived.

Watteau was one of those artists naturally given to nostalgia. To him, one suspects, a golden age, an age of Rubens, of Titian's *Bacchanals,* of the fiery loves of gods with mortals, lived on as in a dream, silver, not golden.

> *Dans le vieux parc solitaire et glacé,*
> *Deux spectres ont évoqué le passé,*

as Paul Verlaine, re-evoking Watteau in his turn, saw and celebrated the silver age, then past.

Yet they are not spectres. The fingers, taut and bony, with which Mezzetin tunes his lute in the centre of *The Music Party* are vital and full of strength, but a sinewy, not a weighty strength. The hands in Watteau's drawings and paintings are as astonishing in their muscularity as in their delicacy. They clamp the lute strings, where Rubens would have wrapped them round a sword hilt; but could Watteau's gentlemen not have held a rapier, if necessary?

Watteau chose to have his tender and fragile comedians act out their masque in a landscape at once convincingly pastoral and cunningly contrived. It has a long tradition. This glade, this gently disordered garden you can see peopled by graceful personages through the colonnade in *The Music Party,* was once the home of pagan gods. Bellini, looking back to a dream of Parnassus, had the gods' picnic there, and Titian got them drunk. Rubens got them drunker; Poussin calmed them in the evening. In such a place Giorgione was at home. On such Greek islands, now bare and washed as the sea-shore, as Andros and Naxos the gods had trifled with privileged mortals, and their stories, conjured by Philostratus, had sent the painters of Venice into a dream of wine and golden glory two thousand years later.

But this landscape of a Mediterranean dream has become muted on the journey north. Watteau took Andros from the Aegean into the Luxembourg Gardens and made an Elysium of the Champs Elysées, peopling it, not with gods, but with gallants. And who are these idle persons? They are not the courtiers of Versailles, all pomp and protocol. They are not the vagabonds of the theatre, whose costumes they often wear, and in whom

94

Watteau's master, Claude Gillot, took such saturnine pleasure. They are a poet's figments, a concourse *en travesti,* dressed sometimes in the costumes of the ball, sometimes as Pierrot, Harlequin, Scapin, Tartaglia, Gilles, and Mezzetin. And even these stereotypes trace their ancestry, in the Commedia dell' Arte, to the Atellane fables of ancient Rome. Puppets with a lineage, they refine their bawdy jokes for ladies' ears, but the gossip is still a scandal.

What is important, in that it saves Watteau from *fin de siècle langueurs,* is that vitality and precision which, however broken in health he himself was (and he was slowly dying of tuberculosis in all the latter part of his life), he imparted to his figures in painting and above all in drawing. He avoided sentimentality by the sheer penetration of his glance. He was a matchless observer of living people and a great natural draughtsman.

There is a study in chalks by Watteau of three seated women. *19* One of them, in two versions reaches across her guitar, her shoulder as tense as steel under the satin. Her hand is not in sight yet her fingers pluck the strings with sharp accuracy, and this can be felt from the action of her arm. The turned head is vigorously concentrated, crisply modelled, as sharply cut as a cameo. In *The Music Party* to which she has been transferred, she is softer, and this brings us to the sad fact that, great though he was, Watteau's temperament all too frequently betrayed him in the execution of a painting. The drawings are incomparable, the painting is seldom quite so fresh, quite so crisp.

He was impatient, so impatient that his friend and biographer Le Comte de Caylus criticized him most sternly for it. In his love for rapidity of effect, and he worked at frenetic speed, he made no proper preparation for a picture. He would select from his sketchbooks a group of drawings and transpose them to canvas. Thus all the main figures in *The Music Party* exist as separate drawings made at different times, except, by chance, that of the central figure with a lute, which has been lost although an engraving of it does exist. Having selected a group he would paint *du premier coup,* using thick paint, and if he wished to correct a passage he would rub it away with an oily rag and paint again at once. He rarely cleaned his palette and, according to Caylus, the pot of thick oil he used was 'full of dirt and dust, and mixed with all sorts of colours which adhered to his brushes.' The result was the

eventual ruin sometimes of whole pictures, sometimes of parts of them. In *The Music Party* the lady with her hands folded in the left-hand group is badly discoloured, and the Negro page on the right is clotted and messy, especially his head and left hand. A further maladroitness, and an astonishing one, is the hand of the figure of Gilles on the extreme left of the group. In the drawing for it the hand lies loosely on the chair-back, faultlessly drawn. In the painting it is hastily and horribly botched, ill-articulated, deformed even, so badly indeed that one might charitably hope it is the work of a restorer. But I fear it is not. In many of Watteau's finest pictures one may find this kind of deterioration, this small hint of carelessness.

Watteau's exclusive use of existing drawings was unusual. Traditionally artists had made specific preparatory drawings for their different pictures. Rubens, for instance, has left hundreds of composition studies and detailed drawings from models, clearly made with specific pictures in mind. True, he would sometimes insert a figure from an earlier picture of his own, or even sometimes a figure from another artist's work, but in general he would plan a new composition with the care of a general launching an attack. When his plan of campaign was fully envisaged his army of assistants would put the prepared plan into action, transferring the drawings to canvas. Rubens might then make drastic alterations in completing the picture, but his forces had been carefully disposed. This careful practice was usual but not invariable. Poussin, although so deliberate and classical a master, seems to have found such preliminary notation largely unnecessary; so did Rembrandt. Their drawings are mostly shorthand notes, however marvellous.

Watteau's drawings were not in shorthand: his paintings sometimes were. The result could be disastrous. Until the nineteenth century, oil paintings were built up in layers and paint was applied thinly, especially in the dark areas of the canvas. Even Rembrandt limited his heavy *impasto* to his lights, and if he over-painted these it was with the thinnest of transparent glazes. This is because it is vital that a passage of oil paint be dry before it is over-painted. By scrubbing out with oil and painting again immediately on the resulting wet surface, Watteau endangered the permanence of his pictures because paint contracts as it dries and different stages

of drying contract at different speeds. Wet paint on partially dry paint leads to clotting, wrinkling, and finally cracking, and much twentieth-century painting will die of it. Manipulating this sticky mass is what Sickert used to call 'mauling the paint', and although it is extraordinary to imagine an artist of Watteau's extreme delicacy of touch mauling his paint, that is what from time to time he did. Working against disease and therefore against time, he was, according to Caylus, at once listless and lazy, yet given to a vivacity which inspired in him 'an eager need to transfer at once to canvas some effect conceived in the imagination'. He was, we are told, morose and caustic, timid, ill-favoured, restless, capricious, unstable and of a temperament *sombre et mélancolique*. We are also told that he could produce such drawings as are contained in the magnificent collection of his studies in the British Museum at a rate of one an hour, working in his favourite drawing medium of three chalks, black, white and sanguine red, on tinted paper. Small wonder, perhaps, that such virtuosity tempted him to careless rapidity in painting. We are the losers.

Ill-favoured and graceless, Antoine Watteau restored grace to favour French art after a pompous century of grandiose solemnity. The period through which he lived coincided with the long setting of the Sun King's reign. In one sense, Watteau is the epitome of the *fin de siècle* artist and the romantic mood of his pictures is properly elegiac. At the same time, he represents the first vigorous stirring of a new spirit which, in the name of Rubens, would reach its final climax in Delacroix. Watteau came to fame under the patronage of a new *élite* who had centred upon Paris. This new aristocracy of wealth as well as lineage, which included such connoisseurs as the banker Crozat, felt itself to be exceptionally civilized and its influence made itself fully felt under the Regency. Although Watteau himself lived for only six years after the death, in 1715, of Louis XIV, he represents the Regency rather than the austere grandeurs of the court at Versailles.

In 1684, the year of Watteau's birth, the King's reign was at its zenith. Its decline marked no less the decline of the classical, official art which Louis XIV had fostered. This classicism, based upon the aesthetic of Poussin (sadly misapplied) is represented in painting by the vast canvases of Lebrun. In these the concept of absolute monarchy is continuously celebrated. Rhetoric, noble

97

in the verse of Racine but banal in the pictures of Lemoyne, continued to play its part in French art, but the first decades of the eighteenth century are typified by a retreat from the grandiose in favour of the intimate. Watteau's whisper was clearly heard perhaps because the distant fanfares were celebrating Marlborough's victories and sounding the knell of *le grand siècle*. The reign of Louis XIV had lasted sixty-seven years. Within another such span of years, the French monarchy and its aristocracy would stand on the brink of complete and final dissolution. But during those intervening years the art of painting in France was pervaded by the spirit of Antoine Watteau. The one outstanding exception, the one influential alternative vision, was that of Chardin, and despite the gifts of Fragonard most of Watteau's imitators were as frivolous and trivial as Poussin's followers were pompous and rhetorical. In the seventeen-nineties Poussin came back into his own and Watteau was eclipsed by the neo-classicists, of whom David and Ingres were the greatest, yet, strangely enough, in the nineteenth century, Watteau was restored to favour, in no small measure owing to Ingres. It is in this way that tendencies in painting move counter to one another; and it is by these magnetic polarities that the art sustains its vitality.

In *The Music Party,* the landscape looks back in sentiment to the god-haunted glades of the golden age but it is unified by a treatment of light in which Impressionism is foreshadowed, although that light is coolly unemphatic. The colonnade owes much to Rubens' *Coronation of Maria de' Medici* which the young Watteau had often seen in the Luxembourg Palace. The colour owes much to Veronese. The figures, perfect or botched, and especially the disproportionate dog, are a little imperfectly disposed in space compared with such achievements as *The Ball in the Colonnade* in the Dulwich Gallery or, greatest of all, *L'Enseigne de Gersaint* in Berlin.

Why, then, did I choose this picture which I have been so ready to criticize in detail? I did not do it capriciously, or perhaps I did. If I did, it was a Watteauesque caprice on my part. It is because, for no reason that I can adequately explain, I am haunted by it. It is in this that Watteau's magic defies analysis. There is a slim thread of this special magic running right through the history of painting, and it is curiously consistent. Giorgione had it and,

having cast his spell over the art of the Venetians, he died young. Watteau, in a mere twelve years of maturity, threw a net of imagery over the whole eighteenth century, far beyond Paris, and he set his scene in just that Cythera, those Elysian Fields, inhabited in warmer weather by Giorgione's lute-player and his friends in the *Concert Champêtre,* now in the Louvre. The young Gainsborough and the young Goya both visited the place and went their different ways. It is an enchanted place.

When I was asked to choose a picture I said at once *Les Charmes de la Vie,* the original title of *The Music Party.* When I went again to look at it I could not think why I should have chosen it rather than the Dulwich picture or even two others in the same room at the Wallace Collection. It is a mystery to me. Some pictures haunt the mind in a special way. Giorgione, the greatest of all such alchemists, defies explanation at any level, Watteau at one. His magic haunts the mind when one is *not* looking at his pictures.

1960

A Postscript

The Music Party led me to a strange tea-party in a remote part of South London. As a result of my broadcast on Watteau I was invited to visit a collector who claimed to own the drawing of Mezzetin tuning his lute, which I had described as lost. Admitted to a neat, grey, little house in a back street and thence into a neat, grey, little room, I was offered tea with strawberries and cream by a Mr Fussel (as I shall call him) who claimed to be Swiss, eighty-nine years of age and a watch repairer. He had, he told me, collected drawings since the turn of the century and never paid more than one pound sterling for any one of them. He did not know how many he had, but among the French ones was the missing Watteau, and after tea, presided over by Mrs Fussel, a grey and purse-lipped person, he produced a parcel of chalk drawings. On top of the pile lay a feeble copy after a detail from the painting. Certainly it represented Mezzetin tuning his lute, but as I delved depressingly into the batch every drawing I found was either a poor copy or so rubbed as to be beyond recognition. Until the tenth drawing and that was, without any question, a Watteau of Mezzetin *en trois crayons,* in perfect condition, but not tuning a lute.

At this point Mrs Fussel embarked, in a low voice, upon a ceaseless monologue. She regarded, and always had regarded, her husband's hobby as extravagant, aimless and aberrant. She regarded her whole life with him as wasted. She proposed to throw all the nasty parcels out as soon as he was gone and good riddance. I pointed out that she might be throwing away a fortune but she disdained this possibility and whispered on in a savage threnody which was not interrupted when Mr Fussel reasonably pointed out that she might go first. To mark the point he produced his pocket watch which he told me he had made himself.

The situation was hallucinatory. There was an aged watch repairer sitting on a hardback chair, across from a fumed oak table, on which, among the teacups and the buns, lay a parcel of drawings all but one of which was valueless. That one was a Watteau. And under the bed, in the room above, it seemed there were numberless such parcels containing numberless drawings most of them bought 'before Sothebys went up Bond Street' as Mr Fussel put it. All of these drawings were of equal quality in his view and they were all in the world he cared about.

I asked him if he would sell any. What did he want with money at eighty-nine, he reasonably inquired.

'Rubbish, out to the rag and bone,' whispered Mrs Fussel.

'I wouldn't part with one scrap,' said Mr Fussel. I asked if I might publish some of his drawings.

'No,' retorted Mr Fussel. 'I only showed you them because you're ignorant.' He took out his watch again and opened the back. 'Look at the workmanship,' he said. I looked.

'Getting late,' said Mr Fussel, turning the watch over.

'May I come back and go through some more of your drawings?'

'We'll see,' said Mr Fussel, closing the watch with a snap.

'You won't be here long,' whispered Mrs Fussel, 'not another winter, not you.'

And I suppose he wasn't. I wrote and he replied, but he wouldn't invite me again on the grounds that it upset Mrs Fussel whom he described as 'advanced in years'. I wrote again several times and got no reply. Then the following spring I went to the house. It was empty and up for sale.

1968

W. R. SICKERT

A Portrait
of Israel Zangwill

IN MY OPINION, Walter Richard Sickert came, in his time, as *plates* near to being a painter of the first rank as anyone in England. *24–26* In terms of European painting that is not a great claim to make, but it places him on a par with Vuillard, which is exactly where in reputation he would stand today if he had signed the contract Bernheim-Jeune offered him in 1904. Given that he had thereafter been as efficiently handled as he would have been by a French dealer of such stature, he would have come to be of the School of Paris and in due course his work would have arrived *au bourse* which means a sound commercial investment anywhere in the western world. He might not have been so idiosyncratic had he drawn his material from Montmartre rather than Mornington Crescent and he might have developed differently, but as it turned out he went on painting good Sickerts for fifty years, whereas Vuillard ceased to paint really good Vuillards soon after 1908.

Sickert was born in 1860 and started his career as an actor. He failed in that profession in 1881 without much departing from theatricality in his private behaviour nor from the theatre and the music hall as subjects for his brush. He entered the Slade School in 1882, met Whistler in the same year and became his studio assistant, with the result that in 1883 he was entrusted with taking Whistler's *Portrait of My Mother* to be exhibited in Paris. In Paris, Sickert met Degas and he owed that meeting to Whistler; indeed, he took a great deal from Whistler, even going so far as to paint a picture called *The Blue Girl* with the mixtures of colour set out on Whistler's palette. From Whistler he gained his skill as an etcher and his preference for a low tonality in paint, but from Degas he learned to draw, which was not a skill Whistler ever totally mastered.

Given the luck of knowing his twin stars, Whistler and Degas, as man to man before he had turned twenty-three, he forged his style by combining their virtues to the full extent of which he was capable and his *intimisme* was founded upon a choice of subject and a treatment of it which he inherited from both of them. What he did not share with either was their aristocratic stance, for there is often a scent of the British Sunday Dinner emanating from his pictures and that is a better midday meal than many people think, even if it sometimes smells better than it tastes. With Sickert the taste is excellent for he never over-cooked the meat nor overboiled the cabbage.

'There is hardly any paint. No scaffolding. No groans. No cutting of himself with a knife. But on to the canvas the artist has applied a living being, with nothing, with a breath.' That is Sickert writing about Manet, but one could say the same of Sickert at his best and the portrait of Israel Zangwill is Sickert at his best. The paint is put on in the right place – once – and not 'mauled', as he used to call the unhappy process of muddling about with the stuff whilst it is still wet, a procedure which painters find tempting when they are not sure of their drawing nor of what will happen to a tone when it is set next to another tone on the canvas. If it seats itself and performs its correct function either of advancing towards or retreating from the eye, there will be no need to touch it twice, and this is where Sickert as the pupil of Whistler and Degas scored heavily, for he was among the last of the great tonal painters. He had a marvellous gift for judging the exact tonal depth of the pigment he had mixed up on the palette in relation to what was already on the canvas, and when he scrubbed or touched it on to the picture he declined to modify. The paint took its proper place and performed its function, which was to create the illusion of space in depth. If he got it wrong, he would wait for days until the picture was dry and then whack, or dab, or stab a new tone in as abruptly and as confidently as he had the first. This is what makes even the darkest Sickert pristine. He is, to me, at his most satisfactory when he worked in a low key, but even in a high one he had a superb sense of what used to be called 'values' and he maintained that if the drawing were right and the canvas were touched as seldom as possible, the picture would be crisp and clean and would ring like a bell, even if it were painted

with mud. Delacroix, before him, had made a similar point.

Sickert commented on this, to him, vital matter of attack in a note on an unfinished portrait by Ingres. He speaks of the long-standing convention, less relevant nowadays, 'that every inch of a canvas should be covered by thick opaque paint' and accuses the patrons of his day of a tendency to influence the painter 'to destroy the flowerlike perfection of the *mot juste* by tautology . . . lumbering and murderous'.

'The flowerlike perfection of the *mot juste*' was Sickert's aim and the thing about the *mot juste* is that it is a concise expression – a pared-down statement summing up the subject. It is the sort of expression Manet could achieve with a flower or a couple of fish on a plate, and Whistler, now and then, could manage with a stretch of the Thames at twilight. To do it with a portrait requires a higher talent, the greatness of a Degas, and Sickert's portrait of Israel Zangwill is an example of a fine, but not a great, portraitist rising to a moment of greatness. It is also, as luck would have it, especially instructive to me personally, because the sitter was my uncle by marriage. I knew him when I was a small boy, spending much of my childhood in his house, and I remember him very clearly from the specialized situation in which a noisy nephew finds himself when tolerated as a member of the family by a distinguished and irritable man. I also knew the painter slightly, having been to tea with him on various occasions towards the end of his life. Both sitter and painter, as personages, filled me with alarm.

Israel Zangwill was a very successful man of letters. Although his great reputation is now in eclipse, his novels were once ranked with those of Wells and his plays with those of Shaw, at least among the Jewish community, and he has by no means per-manently vanished, for he is certainly one of the greatest Jewish writers of whom this country can boast. He was very much a Jew. In later life he neglected his writing in order to crusade with great singleness of purpose for Jewish causes. He was, as I re-member him, a dedicated and pensive man with a certain under-lying fierceness in his temperament. Meditative he certainly was to the point of a remarkable absentmindedness. I remember an occasion when he filed his breakfast toast away with the morning's letters, placed a sausage carefully on the mantelpiece with various

25

cards of invitation which had just arrived and then searched diligently for it under the breakfast-table. I also recall that he regularly placed his dress suit in the laundry basket, and on one occasion blew his nose on a razor, having forgotten which hand held the handkerchief. Despite and also because of these eccentricities he was awe-inspiring, with an oriental dignity of which I was aware long before I knew him to be anything more than an uncle.

My recollection of the painter is less clearly personal. It is coloured by a long and close acquaintance with his painting, with his writings and with things written about him by such observant authors as Osbert Sitwell. Apart from being an artist, Sickert was a quick-change artist, for he never gave up acting. If I met him half a dozen times he was at least half a dozen different people, changing mood and even appearance in the most confusing fashion. There was Barnacle Bill and the Actor Manager and the Whistlerian Wit – and then there was Lazarus, as he called himself in titling his late self-portraits, who looked like an Old Testament Prophet. But out of these recollections comes very little light on any relationship between Sickert and Zangwill which might have caused so formidable a portrait to be painted.

Sickert was not a professional portrait painter. He painted for love and lived by selling the products in a rather haphazard fashion. Zangwill did not buy any. Indeed, he was not much interested in the visual arts. He never, so far as I have discovered, showed any personal interest in the portrait of himself or tried to acquire it; although his study contained a Whistler etching, which I have inherited, and lithographs of Thomas Hardy and Henry James by William Rothenstein. There was also, I recall, an insipid pencil drawing by Simeon Solomon.

Nowhere have I ever come across any reference to Zangwill the man or to the portrait in Sickert's writings, nor any reference to Sickert in Zangwill's surviving letters. How, then, did the portrait come about, and why? The main link is with Sickert's first wife, Ellen Cobden, who numbered Zangwill among her radical friends, and the second is the fact that in 1897, Sickert had made a caricature of Zangwill for *Vanity Fair* whilst standing in for 'Spy', the regular cartoonist of that journal. Zangwill never seems to have referred to that occurrence either.

24

In 1904, when it is likely, for various inconclusive reasons, the portrait was painted, Sickert was living in Venice but Zangwill, it seems, was not in Venice at any time during 1904. No amount of probing about on my part has elicited any information as to whether he could have been. No sketch or drawing for the portrait seems to have survived, which might indicate that Sickert, who often painted from drawings, had done the preparatory work in London at some other time and painted the portrait from memory. The background of the painting is quite clearly the *Ghetto Nuovo* in Venice, a harsh enclave of tall buildings new only in the sense that anything later than 1600 is new in Venice.

But although the picture looks as if it were painted directly from the model this is not necessarily the case. The painter may have begun the picture elsewhere and finished it in Venice in order to place the author of *The Children of the Ghetto* and the *Ghetto Comedies,* which were among Zangwill's most famous books, against the background of an historical ghetto. Wherever it was, I think it probable that Sickert was the instigator. Zangwill would not have had himself painted by an *avant garde* artist. The most likely and the simplest explanation is that Sickert recalled the occasion of the caricature to the author, and perhaps their other meetings, and suggested that he would like to make a serious attempt upon the subject, *con amore* like everything else he did, because he admired Zangwill as a writer and found his appearance remarkable. That is one of the most powerful reasons for painting portraits.

The canvas is small, smaller than the image I have of it in my mind's eye, because the large simplicity of the forms implies a size which is in fact illusory. It is painted with apparent rapidity, and this, too, may be illusory, because the speed with which the brush strikes the canvas does not tell one the length of the pauses which took place between each thrust – and I use the words strike and thrust because one of the characteristics of Sickert's use of the brush is his vigour. He was the least slippery of painters and he held his brush at arm's length, painting from the shoulder. He never smoothed or slid over or stroked at the canvas, he scrubbed with a hard hog's-hair brush in a scouring fashion, or he loaded the brush and drew with it. The background of the

Zangwill portrait is scrubbed, the modelling of the head is drawn with short strokes. The simplified silhouette of Zangwill's black coat – a device perfected by Degas – is virtually unrelieved, which underlines the fact that if a tone is right in relation to its surroundings it will explain the form without the spectator feeling called upon to ask the painter for any qualification in detail.

Zangwill was a sallow man, and Sickert, drawing the head with a uniform dark tone, I think comprised of yellow ochre, *terra verde* and indian red, has worked up towards the light, which explains the bones of the face, in a dozen abrupt touches of the same mixture raised to a higher key: temple, cheekbone, nose, eye and upper lip. A suggestion of warmth has been got with rose madder under the nose and under lip and some more *terra verde* is in the fold of the tucked-in jaw. A final warming of the lips was achieved with a cadmium red, which then recurs in the red post behind the figure, and the drawing of the eye-socket and mouth was established with the cobalt blue and an umber also used for the window openings and the lights in the hair. A scumble of burnt siena seems to underlie everything in the picture, rubbed on to kill the initial white of the canvas. The precise adjustment of the background to the figure and the space implied between is purely a matter of tonal relationships unified by this underlying sombre base. The silhouette, dark in suit and hair, establishes the characteristics of Zangwill's physique with great economy. The eye does not linger there, nor is it held by the ambiguous and simplified hands folded on the book. These and the townscape are intended to be *apprehended* whilst the spectator's eye is fixed on the head. The white collar signals the eye towards the head and holds it there, fixed in chancery by the collar, no matter where the optical voyage begins.

By these expedients a living being has been realized on canvas, and it is a meditative and movingly beautiful, ugly man who sits there brooding. This man has to me the deep sadness of his ancient, scapegoat, exiled race, but also, and I speak as a nephew, he is quite clearly a man preoccupied enough to leave his sausage on the mantelpiece.

It is essentially a private picture, the reverse of the prestige portrait which can be seen at its grandest in the work of Velasquez or Rubens, and it was painted at a time when prestige portraits

were usually painted in England by John Singer Sargent, before whom the critics, the public and the fashionable world were prostrate, or, as Sickert described them, in literal translation from the French, 'flat-belly'. Before the Zangwill portrait no one prostrated himself 'flat-belly' when it was first exhibited at the New English Art Club in November 1904, and only a relatively small number of persons have been 'flat-belly' before Sickert since then. He came to be admired as a very good *English* painter, as if that was a heavy strike against him, or a talented but unremarkable follower of the French style. As a portraitist Sickert ranks, to my mind, pretty high, but as a private portraitist who selected individuals to paint rather as he selected music halls, or corners of Dieppe or Venice because they were parts of his world and not because they were commissioned. In his late portraits, sometimes painted from photographs, for like his master Degas, he valued the accidentals of the camera, Sickert produced some semi-public sorts of pictures such as the *Sir Thomas Beecham Conducting* in the New York Museum of Modern Art, but they are not of the quality, fine as they are, of the private portrait of Victor Lecour, painted in the early twenties, and they don't compare with the Zangwill.

There is a portrait of Hugh Walpole, the novelist, painted in *26* 1929, which it is interesting to compare with the Zangwill if only because he too was a writer, a younger contemporary of Zangwill and in striking contrast to him. The two pictures also provided a remarkable contrast between Sickert's early and late portrait styles, and, furthermore, they illustrate Sickert's simple maxim that 'the best portrait is . . . the canvas that would give the spectator the truest idea of the physique and through the physique the character of the sitter'. Zangwill was a small, stooped, sallow man, fierce perhaps, but in many ways withdrawn. Walpole was a large, pink, public man, very unhappy and exceedingly introverted, but giving an impression of expansive bonhomie. He was very generous, rather petulant, and far from being stooped he gave the impression of leaning over backwards. The Sickert portrait of him is larger than the Zangwill and it consists almost entirely of a large pink head, leaning backwards. This curious pink blur – scrubbed on in indian red – tells one a great deal about Walpole, his sensitivity, his great kindness, his pomposity, his

awful vulnerability, his frustrated desire to be taken seriously by the *literati*. He, unlike Zangwill, was most unalarming, and one of the most touching things about him was his delight in his popular success as a bestseller. The contrast with Zangwill, who just about the time Sickert painted the portrait in 1904 began to give himself wholly to the creation of the future state of Israel, looks, in the two portraits, like the contrast between a literary Judas Maccabeus and a literary rural dean. One has a face faceted like a diamond, the other a countenance like a cushion.

Both portraits are true portraits, both have a detachment, an objectivity which makes them that. They do not flatter, they do not caricature. They have a psychological penetration which is the hallmark of a painter who understands the portraits of Degas. The handwriting, the way in which each is painted is character-istic of the painter, but it is unobtrusive. Walpole is Walpole, Zangwill is Zangwill, neither is self-consciously scribbled over with the marks of the painter's 'personality', nor is either overlaid with the lumbering tautology of a sitter's demand for flattery. But the Walpole is an adumbration, the Zangwill is compellingly *a fact*. It is incomparably the more compelling image, and not the least reason for this is that whatever Zangwill may *in fact* have looked like, what he *now* looks like is what Sickert tells us to believe, and I find it to be believed implicitly. It is a comment on Zangwill so precise that it can only be called the *mot juste* and if Zangwill is utterly forgotten and in time the painting comes to be called *Portrait of an Unknown Man,* it will remain the *mot juste* about a meditative Jew, a man who, whatever his name, made some positive contribution to the world he lived in. We shall know this because Sickert leaves us in no doubt.

1961

W. R. SICKERT

A portrait of Israel Zangwill

page 101

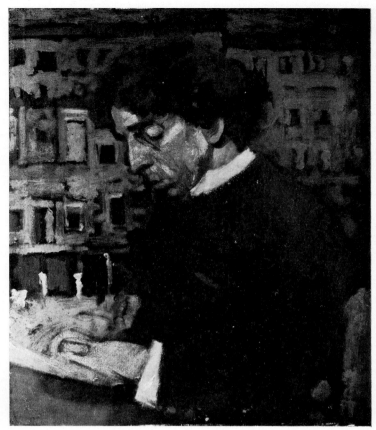

25 WALTER RICHARD SICKERT *Portrait of Israel Zangwill*, 1904

24 WALTER RICHARD
SICKERT (1860–1942)
A Child of the Ghetto:
caricature of
Israel Zangwill
from *Vanity Fair*,
25 February 1897

26 WALTER RICHARD SICKERT *Portrait of Sir Hugh Walpole*, 1929

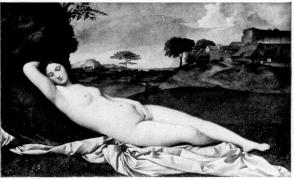

27 GIORGIONE (c. 1476/8-1510)
Sleeping Venus, c. 1505-10

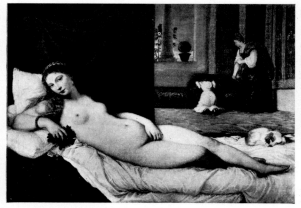

28 TIZIANO VECELLI (c. 1487/90-1576)
The Venus of Urbino, c. 1538

29 EDOUARD MANET (1832-83)
Olympia, 1865

30 VELASQUEZ (1599-1660)
Pope Innocent X, 1650

31 FRANCIS BACON (b. 1909) *Pope I,* 19:

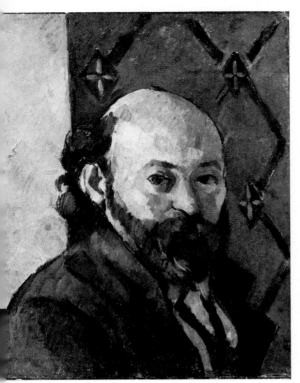

32 PAUL CEZANNE (1839–1906) *Self-Portrait*, *c.* 1879

34 JEAN-AUGUSTE-DOMINIQUE INGRES (1780–1867)
Self-Portrait, 1835

35 MICHAEL AYRTON (b. 1921)
Copy of Ingres' *Self-Portrait*, 1835, 1951

33 JUAN GRIS (1887–1927)
Copy of Cézanne's *Self-Portrait*, 1916

36 EDGAR DEGAS (1834-1917)
The Belleli Family, 1860

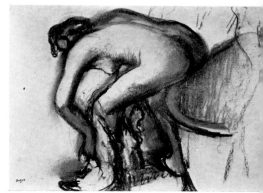

37 EDGAR DEGAS
After the Bath, c. 1900

38 EDGAR DEGAS
La Petite Danseuse de Quatorze Ans,
1880

39 EDGAR DEGAS *Les Repasseuses,* 1884

The
Grand
Academic
page 182

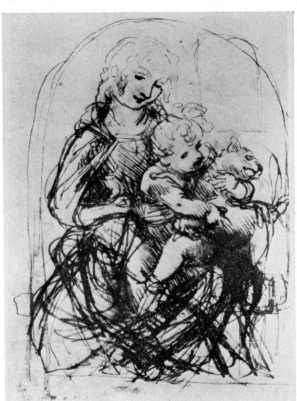

40 LEONARDO DA VINCI (1452-1519)
Study for *Madonna and Child with a Cat*,
c. 1478

41 PAUL CEZANNE (1839-1906)
Head of a Woman with a Milk Can

42 ALBRECHT DÜRER (1471-1528) *Studies for the Right Arm of Adam*, before 1504

Sight Unseen

page 195

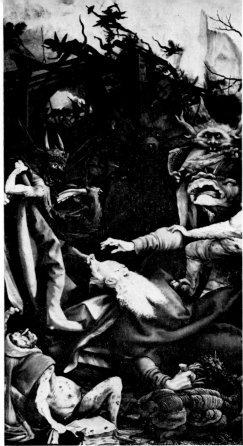

43 GRÜNEWALD (*c.* 1470/80-1528)
Temptation of Saint Anthony (detail)
from the Isenheim Altarpiece, 1513-15

44 FRANCESCO TRAINI
(first recorded 1321)
Triumph of Death (detail),
c. 1350

45 ANTOINE WATTEAU (1684-1721)
*L'Embarquement pour l'Ile de
Cythere*, 1717 (detail)

46 MICHAEL AYRTON (b. 1921)
*Portrait of Hector Berlioz in
1868* (detail)

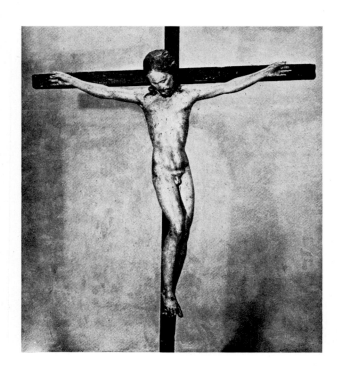

The
Crucifix of
Santo Spirito
page 133

47 MICHELANGELO BUONARROTI
(1475-1564)
Crucifix from Santo Spirito, Florence
after restoration, 1492-93

48 MICHELANGELO BUONARROTI *Crucifix* from Santo Spirito, Florence, in course of restoration, 149

49 MICHELANGELO BUONARROTI
Crucifix from Santo Spirito, Florence,
before restoration
(detail of head), 1492-93

50 MICHELANGELO BUONARROTI
*Crucifixion with the Virgin and
Saint John, c.* 1555

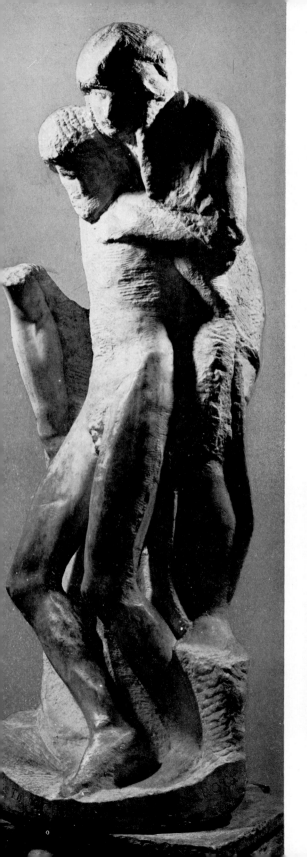

51 MICHELANGELO BUONARROTI
Rondanini Pietà, 1554-64

52 AUGUSTE RODIN (1840-1917)
Walking Man, 1877-78

53 ALBERTO GIACOMETTI (1901-66)
Bust of Annette IV, 1962

Prometheus Bound

MICHELANGELO'S CONTEMPORARIES thought him the greatest artist who had ever lived and they called him 'divine'. His reputation as sculptor, architect, painter and draughtsman has not subsequently been surpassed and who is to say that his contemporaries were wrong? Their opinion has not dated. He was, and is, the archetype of genius in the visual arts. He is also the archetypal *artist* and the central paradox around which his life revolved is the basis of the mystique which surrounds that term. That paradox, put simply, is one of success and failure, the failure of a superhuman achievement in the light of an even more superhuman ambition. In Michelangelo the man, it showed itself in a profound melancholy marching step by step with a vast public esteem until the man, raised to a status of demi-god, found himself forced further and further out of human intercourse and into an especial purgatory. Fortuitously but none the less certainly, it was Michelangelo even more than Raphael and Leonardo who raised the image-maker from craftsman to artist, that mysterious state of forlorn grace beyond normality. In doing so, he changed the attitude of the spectator from one of simple satisfaction to one of awed disquiet. The fate which was imposed upon Prometheus for the crime of stealing a coal of divine fire from Olympus and betraying its secret to mortal men, caused him to be chained to the summit of a mountain for thirty or some say thirty thousand years. Furthermore his liver was perpetually gnawed by an eagle, an insatiable bird which might perhaps be identified symbolically with a particular kind of self-knowledge. Chained to the summit of the Renaissance for thirty years, the Promethean Michelangelo imposed his chains upon his followers. He took the image-maker and transformed him.

Primitive man did, and in some places still does, make images to gain power over the unknown forces which menace him and over those elements, creatures and conditions of the natural world upon which he depends for survival. His rituals, among them his dance, his song and his painting, are directed towards the conquest of opponents who may be vulnerable, or the propitiation of gods who could make them so. In the course of time these rituals have become enormously diverse but throughout man's prehistory and his history, the impulse towards power has generally been more potent than any other and the practice of image-making is a profound exercise of power. Aesthetics are a by-product of this exercise and aesthetics vary greatly throughout history, not only in their general relevance to image-making but in their importance. Primitive man was perhaps at once priest and image-maker. Society, as it developed, divided the function and subordinated the image-maker to the priest. From Pre-Dynastic Egypt at least until the Reformation the priest dictated the form of the most significant kinds of image; the craftsman followed that dictation as literally as the conventions required. The difference between a painting made as a votive offering to a rain god or to Apollo or to God the Father is not an absolute difference. The sculptured totem of a tribe dedicated to antelopes or of a church dedicated to a saint, remains sculpture motivated by the same kind of impulse. The change that Michelangelo brought about does not alter the basic impulse but adds a further dimension to it. The Promethean situation restores to the craftsman his initial status as priest and he becomes again the shaman, the direct manipulator of power, but the implications are different. The chains of Prometheus hold him captive.

The title of *magister* in medieval and Renaissance times meant 'master' in the sense of a master of skills. It did not mean *artist*. The master required of himself an integrity to his craft in the honourable practice of his skills and although he may have sought to extend their range, the purpose to which those skills were put was specific – as specific as the work required of him. Its success or failure depended upon common consent, or, at least, upon the consent of rulers spiritual and temporal.

If, in their essence, the visual arts were intended to make the unknown visible and knowable and therefore governable, that

governance could only be exercised by common consent. From the flattery and propitiation of gods to the flattery and propitiation of princes is a small step and it was taken early. The prestige of princes lay, and has always lain, partially in the excellence of the craftsmen who served them, so that a mutual prestige which lent status to the craftsman and pride to the prince rested naturally upon what the prince and his court deemed excellent. Even this is a mere extension of the function of image-making, since prestige lent power to the prince. Nor has this altered superficially. The prestige of artists still depends upon the consent of customers, but with a subtle and vital difference for which Michelangelo was in some degree responsible. To suggest a parallel, the success of the painter or sculptor, before Michelangelo, was not unlike the success of an actor today. The status of an actor depends specifically upon immediate and common consent and in this his problem remains an external one. It can be tested and measured. His ambition need not lead him further than to perfect his craft in the esteem of his audience and his colleagues. He serves his profession, he serves his public and no Prometheus is necessary in him to hurl any prophecy at Zeus. He has no call to teach a God 'How far from sovereignty is servitude', as Aeschylus put it. This was true of the image-maker before Michelangelo and has often been true since, but it is not true of that creature called *the artist*. Only a master of Promethean stature could, as early as the sixteenth century, have played the Promethean role and earned the first chains. Only a Michelangelo could have earned the initial attention of the eagle and left *the artist,* his every successor, with a predatory chick from that dread bird's egg. For in that egg is a sense of failure which cannot be comforted by applause and a distrust of applause so profound that it is a kind of *hubris*. The lonely figure in the grip of the eagle's claws is the romantic *idea* of *the artist*.

Michelangelo was the first and greatest *artist* in this sense. He was the first man to count himself a failure in the very teeth of the greatest personal success ever won by an image-maker. His failure lay in his ambition and in the distant goal – far beyond the praises of a sequence of popes – he set himself to gain. In striving for it he achieved a level of creation which earned him the title of 'divine' and he explored and made visible an area of experience.

He did not, however, make it governable, conquering only a part of it, and even that part only he could govern: it eluded his followers. In that process he initiated a struggle which has since become the norm. The artist dying in squalor, the misunderstood genius, the artist driven mad, the artist ahead of his times, haunted by immeasurable longings, persecuted by philistines, reaching towards the unattainable, trying to 'express himself', all these notions and their catch-phrases are part of this heritage. All of them create a sense of the *artist* as disorientated and this, for various complicated reasons, has become increasingly acceptable to us. There is, however, a paradox present in the fact that the romantic conceit feeds on overt if temporary failure – on the passion and tragedy of a Van Gogh – and not upon its exact opposite, the torment of the acknowledged demi-god. It is not so easy to enjoy vicariously the secret sorrows of the 'divine'.

When I suggest that Michelangelo explored the unknown and made it visible in a new aspect, that, in its deepest sense, is no more than the ancient function of the image-maker and I do not wish to suggest that his art was not founded on that of his predecessors. Without the Renaissance of Masaccio and Donatello and the proto-Renaissance of Giotto and Giovanni Pisano, he could not have made the extraordinary thrust into the unknown which he accomplished.

The traditions to which Michelangelo belonged were two and they were at odds. At first glance he grows in the sunlight of the Florentine Renaissance with its noble homage to the ancient world, its open and ordered classicism and that splendid concept called *disegno* which brought drawing to its highest estate; drawing as the definition of structure, as the explanation of form and as the description of volumes. But Michelangelo's tradition was also rooted in the Gothic and it is his Gothic inheritance which enabled him to express, with such splendour, a restless and tormented energy held in ruthless check. His dark sense of martyrdom, of torment by unrealizable aspirations, of that melancholy which regarded life as a transitory thing, have their forerunner in Giovanni Pisano, the greatest of Italian Gothic sculptors, no less than in the puritanism of Savonarola's reaction against Renaissance humanism. Where Michelangelo differs from his every predecessor is in the depth and extent of his introversion. Rodin

described Michelangelo as 'the culmination of Gothic thought' who 'celebrated the epic of shadow while the ancients celebrated that of light' and Michelangelo himself speaks of 'walking from dark to dark'.

The central concern of Renaissance art was with the definition of objects, with their *particularity* and their exact appearance, with their shining, apparent reality. The tangible and actual, revealed in pristine clarity, ordered by geometry, celebrated in light, these are the qualities which the Renaissance shares with ancient Greece. Compare the world of Leonardo da Vinci with the cosmic limbo of Michelangelo. No aspect of the study of natural phenomena escaped Leonardo, from the stratification of rocks to the formation of a spray of bramble, from hydraulics to cartography. No curiosity has ever been more boundless, no researches into the particularity of things has been wider than Leonardo's, but the only point at which Michelangelo and Leonardo meet is in the field of anatomy. The only quality they share is stature.

Nothing is more remote from Michelangelo than this curiosity about specific things. No one rejected the particularities of the world about him more vehemently in his art. Nothing is specific in it except the titanic nude. There is no costume in his painting, only such impersonal drapery as will further explain the action of the limbs beneath it. There are no utensils, there is no still-life and no furniture. His people occupy architecture but they do not live in houses or walk the streets, or ride horses. They do not inhabit a landscape and they are unaffected by the seasons. Where they occupy ground, it is a treeless desert which surrounds them, a bleak platform for activity. No specific portrait from Michelangelo's hand survives, although he is thought to have made a handful of portrait drawings during his seventy-five years of working life. In short, he needed nothing to forward his grand design but the naked human body. As his vision evolves, even the extremities of that body, the fingers and toes of his sculptured figures, sometimes cease to be defined and lose their particularity. The protagonists in his drama take no account either of place or time. Even the definition of sex in Michelangelo's images is equivocal. The male and female distinctions shift disconcertingly and give place to the three elements central to his vision: weight, articulation and thrust. The envelope he evolved for the im-

measurable energy which impelled each protagonist is super normal and totally at odds with the natural realm in which his contemporaries had their being.

Sonnet XVIII proclaims a devotion to art which achieves the conquest of nature at a terrible physical cost. It proclaims a burning will to act without hope of success and a desperate and restless energy as remote from Olympus as it is from Arcadia.

Antique art, which to Michelangelo meant Hellenistic and Roman sculpture and to which in his youth he paid great attention, was also occasionally subject to this tendency, although never on such a scale. We are inclined to think of Greek sculpture in terms of the Elgin marbles and of earlier works, wherein an ordered proportion aimed at an ideal. We think of a harmony Pater described as the condition wherein 'the thought does not outstrip or lie beyond its sensible embodiment'. This ideal meant nothing to Michelangelo and his 'antiquity' lay in the torment of the *Laocoön*. He outstripped at every stage the sensible embodiment of the thought and no less the physical possibilities of the human frame in his response to his impulse to subject this fragile human vehicle to extremities of weight, thrust and energy beyond the limits of its articulation. In creating the painted titans of *The Last Judgement* and the unfinished marble *Slaves,* intended for the tomb of Julius II, he brought forth a race of superhumans which rapidly degenerated, in the hands of his followers, Vasari, Giulio Romano, Pellegrino Tibaldi and others, into a race of ludicrous muscle-bound monsters.

In the light of this, the failure of the major sculptural project of his life – the tomb of Julius II – is important because although this grandiose scheme failed to materialize through no fault of Michelangelo's, less indeed than was the case with the Medici funerary chapel which was also abandoned incomplete, his melancholy obsession with his own inadequacy is connected with the failure of his greatest schemes as a sculptor, and this is expressed most intimately in his verse.

Sculpture is a physical experience different in kind from painting and, as a sculptor first and last, Michelangelo is concerned with the human body as a plastic entity, that is to say, as a three-dimensional object to be experienced and manipulated as a solid in space. In painting he sought to represent form sculpturally

rather than pictorially, with the same ends in view. Yet in his verse he practically never refers to the human body, except to the decrepit condition of his own and when he does, he does not deal with it as a tactile thing. On the contrary, *the face* of the beloved and not his or her body is continually in evidence in the sonnets. This is curious in a man who paid so little attention to the particular appearance of people in painting and sculpture that he did not practise the art of portraiture despite its importance in the Renaissance canon. It is also strange that a man whose sacrament in painting and sculpture might be described as an outward and visible sign of an inward *and physical energy,* should dwell at such length in his verse upon the weary frailty of old age and the spiritual implications of platonic love. It is almost as if the poetry of Michelangelo is a complementary aspect of his genius, so exactly is it the reverse of the medal struck by his sculpture and painting.

His verse is confessional. Much of it is a plaint, much of it illuminates an almost craven humility and when it celebrates an occasional and short-lived victory over the looming darkness of life, such moments are attributed solely to grace. Where in poetry he enjoys for a moment a fraction of the gigantic exaltation which is at the core of his visual images, he attributes his relief solely to the virtue or beauty of the loved object. He himself is nothing. He walks from dark to dark, 'living on his death'. In the sonnets after the death of Vittoria Colonna and in the last sequences of penitential sonnets, he repeatedly stresses his weakness, his baseness and his total reliance for survival upon forces outside himself. Sonnets LXIV and LXX, for instance, show this abject humility yet they were written by the man whose ferocity and grandeur were famed in the word *terribilità,* the man whom Pope Leo X called 'terrifying' and to whom Sebastiano del Piombo wrote, 'You frighten everyone, even Popes.'

Michelangelo's war within himself, his struggle to survive the Promethean eagle, was, I believe, a struggle to withstand the pressure of his own personality. The twin forces at war, good and evil, God and the devil, the spirit and the flesh, as they may variously be called, may seem to be represented in the artist by a struggle between the impersonal and the personal. The *personality* tends to laud its limitations as positive virtues, whereas

the area beyond those limitations can only be gained by the deliberate rejection of the personal in order to overcome or penetrate the limitations. Of this, Michelangelo was plainly aware and the excessive humility and self-abasement of his verse seem to me to show it. The greatness of his painting and sculpture exists paradoxically not in a triumph of 'self-expression' but in the reverse, in a triumph over the self, the greater because as the archetypal *artist,* Michelangelo was in fact the image-maker confronted with *himself.* Self-knowledge, an overwhelming awareness of the self, in the special sense in which I use it here, is opposed to the creative act in the arts, principally because it inhibits the act of identification with the subject, which is essential to the making of potent images. A man who cannot *become* the thing he seeks to portray by an imaginative transference which requires the rejection of himself, cannot truly portray it. In the light of this, Sonnet XXI is no mere poetic conceit. It describes precisely the process necessary to come to terms with the loved object by an act which is at once both one of propitiation and one of conquest.

The majority of Michelangelo's sonnets were written in the last thirty years of his life, that is to say, after he finally settled in Rome in 1534. By this time, Leonardo and Raphael were dead and Michelangelo was without rivals. He was the surviving giant from a golden age, but he was also, in some sort, a refugee from his native city of Florence and from the tyranny of a Medici newly created 'Duke'. As a man without rivals, with Spain, France, Flanders and Venice following his lead and with artists as great as Tintoretto and El Greco in his debt, employed by the fifth in the series of popes to commission him and about to begin *The Last Judgement* in the Sistine Chapel, he must have seemed to his contemporaries to have arrived at the summit of human ambition. To read the sonnets is to see how little that meant to him, and to follow those last thirty years of his life is to watch a supreme master move towards the lonely and desperate condition of one who is answerable only to himself. And this is to watch a man embark upon a work *which cannot be finished.*

Michelangelo's life before he settled in Rome in 1534 had consisted of a series of triumphs offset by a series of grandiose schemes which remained unrealized for external reasons beyond

his control. Ultimately his very last works were to fail, if such a word could be applied to them except by their creator, for internal reasons equally beyond his control. The pattern of triumph and frustration had been constant throughout his life.

Born in 1475 at Caprese in Florentine territory, he had mastered the techniques of painting, in the studio of Domenico Ghirlandaio, by the time he was fourteen. His three years' apprenticeship as a painter was then cut short by Lorenzo de' Medici, who set him under the sculptor Bertoldo in the school founded by Lorenzo, in the Medici gardens. By 1496, Michelangelo was in Rome, after an interlude at Bologna, and there carved the *Bacchus* and the first *Pietà*, now in St Peter's, which made his name. In 1501 he returned to Florence and worked on a number of commissions, including the colossal *David* adapted with incredible ingenuity from a block of marble botched and abandoned by another sculptor. In 1503 he began a series of twelve marble Apostles for the Cathedral of Florence. They were never completed. In 1504 he made numerous studies and a complete cartoon for a fresco representing an incident in the Pisan war. This fresco was intended for the Council Chamber in the Palazzo Vecchio and was to complement Leonardo's equally ill-fated *Battle of Anghiari*. Michelangelo's cartoon for this painting, the so-called *Cascina Cartoon,* became one of the most influential works of the later Renaissance. It was destroyed during his lifetime. His failure to complete the fresco was caused by the importunate demands of Pope Julius II, and Michelangelo left for Rome to begin the sculptures for a tomb which the Pope was anxious to have completed during his own lifetime. There were to be forty marble sculptures ornamenting the Papal resting place and on this project Michelangelo worked for forty years. It was never completed, although it was the subject of five successive contracts with four successive popes. In 1506 he completed a colossal bronze of Julius II at Bologna. In 1511 it was destroyed. In 1508 he returned to Rome and began to paint the ceiling of the Sistine Chapel, and on this he worked in circumstances of great difficulty, virtually alone, until 1512. How he felt about this undertaking is described in Sonnet V, but at least it was finished. This work, at the age of thirty-seven, earned him the title 'divine'.

Julius II died and the new Pope, Leo X, was a Medici, the

younger son of Lorenzo. He remained Michelangelo's master until his death in 1521, when another Medici became pope, Clement VII, who continued to employ Michelangelo so that it was for the Medici family or for a Medici pope that he worked until 1534. During that time he wasted four years on the façade of S. Lorenzo – which to this day has no façade – and carved the sculptures for the Medici Chapel, which remains incomplete. He also designed the Laurencian Library.

In 1527 the Medici were expelled from Florence and Michelangelo, an ardent republican, took part in the defence of the city until its capitulation in 1530. The Medici were reinstated and Michelangelo was pardoned, but after working for four more years on the sculptures for the Medici Chapel, he left Florence for good. It was the pattern of his life that in painting, an activity of which he thought little, his greatest designs were completed, with the exception of the fresco for the Palazzo Vecchio, whereas in sculpture, which he considered his proper profession, all his greatest projects failed to materialize or remained in some compromise form to mock him. He was the longest lived of the three masters who stand at the summit of the High Renaissance and who together created *the artist* in his new status. The pattern these giants present is one of a strangely blighted perfection, as if the gods had shown their jealousy towards men in the ancient fashion. Michelangelo, as we have seen, saw himself defeated; Leonardo da Vinci watched his grandest achievements destroyed or perish; Raphael failed in nothing, but he died at only thirty-seven. The defeat of Leonardo, if it can be so described, might be called the result of a divine carelessness, of an impatience so profound and a restless curiosity so deep that specific achievement meant little to him. Michelangelo's nemesis was a divine discontent so high and terrible that specific achievement was for ever unattainable. In his latest carvings, when he was working solely for himself and for his God, nothing is finished, but in many much earlier works he deliberately left his marbles rough and 'unfinished' as compared to those of his contemporaries. The *Slaves* emerge ambiguously from the marble as if man remained for ever embedded in a primeval matrix. What remained unresolved in the sculptures for the tomb of Julius was certainly the fortuitous result of circumstance and the normal frustrations inherent in

130

contracts drawn up with princes and popes, but there is also an enigma beyond simple circumstance, an unanswerable question posed as to whether or not Michelangelo recognized implicitly that these sculptures would not and could not, of their nature, come to completion.

Carving is the slowest and the most laborious of the arts. 'By sculpture,' Michelangelo said, 'I understand an art which operates by taking away superfluous material; by painting one that attains its results by laying on.' Michelangelo therefore sought to release his vision from the core of stone but as his wisdom and pessimism increased, the definition of his vision became increasingly uncertain. Inevitably the doubts which develop from this huge uncertainty as to the nature of truth, create a condition in which it becomes impossible to know *what material is superfluous* and from this must follow the suspicion that all material may be superfluous. In this dilemma, I suspect, Michelangelo dwelt at the very end of his life and perhaps it explains the last and strangest of all his sculptures and the four final lines of his poetry (LXXVIII), where he describes a final identification with the material from which he had wrought his life. The sacrament of Michelangelo had grown from the outward and physical sign of a gigantic inward and physical energy into the outward and barely physical sign of an inward and spiritual grace.

Although the forms in his last drawings are palpable and dense, they seem to emerge from a mist of hazarded contours. It is as if he had begun to build back the matrix round the core of his vision. They are drawings which lie in an area of experience only dimly perceptible to the spectator but they still emanate restless power. In contrast, the *Rondanini Pietà* is a statue so stripped, so 51 bare, so passive and so patient that all the spent strength of the titan is drained away and only the spirit remains within a slim and fragile shell of stone.

Is it possible that the resignation embodied in this extraordinary carving derives from a reconciliation with the most relentless and immediate of Michelangelo's three judges? There are only three who can sit in judgement upon a man so exalted by genius above his fellow men and their institutions. One is Time – and we know Time's judgement of Michelangelo. One is God who does not pronounce judgement until time stops. The third is the

man himself and the sonnets describe the terrible harshness of that judgement in Michelangelo's case. On the 12th of February 1564 he worked, standing all day, at this last *Pietà,* drastically recutting the stone so that it remains now in a state of transition between two quite different conceptions of the same subject. A disembodied arm remains to testify to the first vision, as does the first version of the Virgin's face, upturned and left like a ghost upon the headdress of her bowed head. The dead Christ, slim and worn as a sea-washed bone, is as remote from the all-conquering athlete of *The Last Judgement* as sleep is from earthquake. The thrust is gone, the weight is gone, the articulation no longer describes energy.

In the *Rondanini Pietà* is the still centre. The trembling mountains, the turbid seas and the fallen angels of which he speaks in sonnet LXXVI may seem to surround the spectator; they do not touch the sculpture. It is unfinished and it is finished. Six days later, on February 18th, it was all finished. Michelangelo was dead. He was eighty-nine years old.

<div align="right">1960</div>

The Crucifix of Santo Spirito

WHEN Lorenzo the Magnificent died in 1492, the young Michel- *plates*
angelo remained in the service of the Medici but, as Condivi *47–50*
reports, 'whereas Lorenzo had given him such men as Poliziano
for his associates, Piero de' Medici coupled his name with that of
a Spanish lackey, boasting of these two as his most useful
domestics.' As such, Michelangelo was consulted by Piero con-
cerning the purchase of antiques and cameos, but given no more
serious a commission as a sculptor than the execution of a colossal
snow-man, in the palace courtyard, in January 1494. Seeing,
however, the sculptor honoured for his abilities, presumably for
expertise in antiquities and for carving in snow, Michelangelo's
father 'began to clothe him in a more stately manner', as Vasari
put it, and thus stately in his dress, Michelangelo must frequently
have crossed the Arno in order to study anatomy, in a room in the
hospital of the Priory of Santo Spirito. He did this at his peril,
stripping off his finery to work secretly, at night, with his mother's
kitchen implements and scissors upon the bodies of those who had
died in the hospital of the Priory. This zeal, which carried con-
demnation for sacrilege if he were discovered, gave him that un-
surpassed comprehension of the structure of the human body upon
which his whole art was founded.

How many long night hours Michelangelo spent, during his
unsatisfactory employment as Piero de' Medici's domestic,
secretly carving dead flesh in the charnel house of Santo Spirito,
can only be surmised, but before he left for Bologna in the first
half of October 1494, he had carved a crucifix in wood for the *47*
Prior which Vasari tells us was placed in the lunette over the high
altar of the church. We do not know where it was carved, but I
submit that it was not in a woodworker's shop. Perhaps the wood
was fashioned in the very room where Michelangelo had so

133

diligently used his mother's kitchen implements, but carved it was, and so far as we can tell, the crucifix remained over the high altar until the seventeenth century when, like so many Renaissance churches, Santo Spirito was 'improved' in the Baroque fashion: a new altar with an elaborate baldachino was installed and Michelangelo's crucifix did not suit these elaborations. It was removed and disappeared in circumstances in no way unusual, for fashion has decreed a greater loss of masterpieces than fire has destroyed and pillage has scattered. Even so notable a riot as caused the sacking of the Medici Palace, on the occasion of Piero's exile, cannot be said to compete in spoliation with such changes of taste.

The story of the disappearance of the crucifix is not strange compared to its origin, if one considers the risks the Prior of Santo Spirito ran when he secreted an eighteen-year-old sculptor, however well dressed, in a room next to the hospital and encouraged him to commit sacrilege at a time when Savonarola was preaching his hell-fire sermons across the river. As for the jeopardy in which Michelangelo placed himself, it would have been dangerously increased by his known employment in the service of the Medici, for it was a time when the city's discontent with what Michelangelo himself described as Piero's 'insolence and bad government' was reaching a climax. On November 4th, Piero, justly called 'The Unfortunate', was banished from Florence for his inept handling of the crisis brought about by the presence in Tuscany of the Emperor Charles VIII who, with his French army, was moving south towards the siege of Naples.

No examples survive from these crucial two years in Michelangelo's work. Of his earlier development we have the surviving evidence of his marble reliefs of the *Madonna of the Stairs* and *The Battle of the Centaurs,* together with a handful of masterly pen drawings which are copies after Giotto's and Masaccio's frescoes. For the rest, we must rely on written references to a colossal marble figure of Hercules and to the snow-man. There are no surviving anatomical drawings or studies of the nude before 1496 and we therefore do not know how he recorded his researches into anatomy at Santo Spirito. All that we are told is that his 'prolonged habits of dissection injured his stomach to such an extent that he lost the power of eating and drinking'. And well he might, in view of the circumstances in which he must have worked when

the only preservatives of organic substances were vinegar and *aqua fortis,* and the stench in a shuttered room in high summer must have been insupportable for more than brief periods once a body began to decay. If we may judge from the errors to be found in Leonardo's drawings of dissections, it seems reasonable to suppose that a necessity to leave the room and draw from memory elsewhere would preclude clinical accuracy in the most complex drawings of the internal organs, even to so formidable an observer of natural detail.

That Michelangelo came to possess a greater command of the human form than any other of his contemporaries can hardly be disputed, and that this knowledge of structure was aided by clinical dissection, as reported by Vasari, is convincing, but lacking the evidence of the drawings themselves there is nothing to confirm this, except his later work, unless the wooden crucifix has been rediscovered. If it has, and this is not accepted by all authorities, then his new learning should be evident, as it clearly is in the *Bacchus* which is his first monumental study of the nude in marble, carved in about 1496. During the years between 1492 and 1496, which is a long period for a growing youth of genius in the Renaissance, we have nothing but the three statuettes in Bologna, which are too heavily draped to make for a satisfactory comparison.

The *Bacchus* is a statue of a soft plumpish youth very different from the vigorous athletes of the *Battle of the Centaurs,* and whilst the *SS. Proculus and Petronius* at Bologna are altogether tougher, the kneeling *Angel with a Candlestick* is also distinctly soft, however masterly. Now if the Santo Spirito crucifix is compared with those earlier crucifixes which Michelangelo would have known well, that of Brunelleschi (the architect of Santo Spirito) in Santa Maria Novella and the early carving by Donatello in Santa Croce, the factor most clearly common to both is that they represent mature and muscular men who have suffered grievously. Both belong in fact to the tradition of the Gothic crucifix, although they are less agonizingly pain-wracked than earlier or more northern examples. This suffering and the maturity are equally present in the most consequential Florentine paintings of the subject which would have been familiar to Michelangelo, the fresco by Masaccio in Santa Maria Novella and those by Andrea Castagno in S. Maria

135

degli Angeli and S. Apollonia. It is also likely that he knew the *Entombment* by Roger Van der Weyden, which had caused a considerable stir in Florence when it was brought there in 1488, and this too is a Gothic image in its emaciation and the evidence of the pain endured by Christ before his death.

Masaccio's crucified figure in Florence and in addition the crucifixion which formed part of his Pisa polyptych which Donatello knew, show the legs of Christ frontally, in line with the torso, with the knees parted. So do the carvings of Brunelleschi and Donatello and Castagno's frescoes. The Santo Spirito crucifix departs radically from this format in portraying a *contraposto* which brings the knees together and gently swings the legs to the left from the hips, giving a degree of relaxation to the pose and a calm in death to the image which is classical. The body is soft and immature, that of an adolescent, of much the age that Michelangelo himself would have been, and finally the face wears an expression of complete repose which is augmented by the feature, rare at that time, that the mouth is closed. True, the softness is not of the Hellenistic obesity to be found in the *Bacchus*, but there is no hint of strained muscles and stylistically, it seems to me, the nearest comparison which can be made with the Santo Spirito crucifix is the figure of the dead Christ who lies in his Mother's lap in the marble *Pietà* in St Peter's, Rome, completed five years later in 1499. In the *Pietà*, there is the same tranquillity, the same suppleness of form, with no suggestion of *rigor mortis*, to be found in the crucifix albeit the marble shows a more mature physique and a more developed musculature.

Style critique is a hazardous activity and if the attribution of the crucifix were to be based on that alone, I might be hesitant to support the ascription of the crucifix to Michelangelo. There are, however, two other factors which give grounds for such an assumption. One is derived from the implication that the muscularity of the Renaissance nude under stress, as it frequently is in portrayals of the crucifixion, argues the living model (or the inherited schema), and if a young man has spent his time dissecting the newly dead he has been dealing with flaccid and relaxed flesh. Secondly, and far more consequential, however negative, are the technical details of the crucifix itself which became apparent when the figure was in restoration. To these I shall return.

The circumstances of the rediscovery of the crucifix are so commonplace as to point up the drama of the creation of the work. It was found, during restorations to the Priory, in 1947 when a certain Padre Bolognese caused a wall to be removed from an ante-chamber abutting the sacristy. There, among the agglomeration of demoted images typically to be found in the sacristies of ancient churches, was a crucifix which so attracted Padre Bolognese that he hung it over a door in a passage between the church and the cloister. In 1963, Dr Margaret Lisner of the Freiburg Art Historical Institute spotted it and, being a specialist in fifteenth-century Tuscan woodcarving engaged upon research into crucifixes of the period, she had naturally been on the look-out for this particular example, without much hope of finding it. She had the prestige to move the authorities to send the crucifix to the Institute of Restoration at the Uffizzi, where it was placed in the expert hands of Professor Bannella. It was there that I was able to examine it closely at various stages of its re-emergence from the blackened and crudely overpainted condition to which time had brought it. Perhaps the most startlingly simple aspect of the matter, assuming that this carving is by Michelangelo, is that it had remained for four hundred and fifty years within thirty yards of the site above the high altar of the church for which it had been carved.

The debate as to the possible survival of the carving is not new. Earlier and less scientific experts had optimistically proposed that a smaller, later and inferior crucifix which still stands, or stood, near the altar of Santo Spirito was the Michelangelo, and clearly it is not. Since an inferior work, readily to be dismissed from the canon, remained where Vasari suggested a Michelangelo should be, scholars had naturally long assumed, because Vasari was not always accurate in his ascriptions, that this was an example of one of his misattributions. And in addition, the readiness of earlier *cognoscenti* to put as grand a name as possible to any work of art served to increase later scepticism. It was hard to accept the presence of a crucifix by Michelangelo in the church for which it had been carved, if scholarship forbade the acceptance of quite a different work which had replaced it. The scholars were of course right. It seems however that the Michelangelo was in the next room all the time, covered with the glutinous layers of paint

and impregnated with the candle smoke to which religious wood-
carvings of such an age have usually been subjected.

To me the most convincing argument of all which can be
advanced for the authenticity of the carving is a negative one. As
I examined it closely where it lay, on its back, on the restorer's
48 workbench, looking for all the world like a pathetic subject for
anatomical dissection, it became clear that as a woodcarving it
was the most incompetent piece of carpentry I had ever seen
which could none the less qualify as a memorable work of art.
It is a masterpiece, and to make a masterpiece in wood is hard
enough: to make one very badly takes genius.

The manufacture of wooden crucifixes in Tuscany in the
fifteenth century followed traditional technical procedures of
even earlier date. The majority of such carvings were shaped
from three lengths of the white Tuscan poplar colloquially called
gattice, laminated together to form a baulk of timber from which
the head, trunk, hips and legs were carved. When carved and
nailed to the cross, the laminations ran vertically down the full
length of the figure, and the arms, which were carved separately,
were joined into the shoulders. Thus the cranium consisted of
two slabs and the face, or mask, made up the third, the sections
being joined vertically. In the case of the Santo Spirito crucifix,
some gross miscalculation has led to the head being made up from
two slabs joined *laterally.* As a result, the line of the join may be
49 seen, in the reproduction of a photograph made before restoration,
to run across the right cheekbone, below the nose, over the
upper lip and below the left cheek-bone. Furthermore, the
cranium is filled in at the back with tow which was disguised by
the gesso covering in which the hair is modelled. It is highly un-
likely that any trained journeyman would have made such an
error or overcome it with so improbable an improvisation. Nor
is this all; the miscalculations continue down the figure so that
the right knee and ankle are both built up by the addition of thin
slivers of wood glued on to correct the anatomy, although these
slivers are less than a quarter of an inch thick.

Assuming that the sculptor had initially visualized a *contra-
posto* which departed from the normal tradition, such a mis-
calculation is comprehensible if he had no great familiarity with
the craft of woodcarving and had failed, however minutely, to

138

recognize the necessity to allow greater bulk to the laminated block at the lower end. As for the improvisation of the back of the head by means of a lump of tow, it argues either a lack of wood or a remarkable impatience, and no apprentice would have suffered the first nor been allowed to gratify the second of these conditions in normal workshop circumstances. Such departures from the norm suggest an amateur of outstanding talent, impatience and ignorance of a particular craft and may even suggest a young man to have been at work alone, outside his technical element, without the benefit of professional expertise nor an adequate supply of the white poplar wood called *gattice*.

Having carved the wood impatiently and made miscalculations, the author of the crucifix yet contrived to treat the large forms and the surfaces of the figure with great subtlety, and having covered it with the traditional thin coat of gesso which carried the paint surface, to colour it with great delicacy. The repaint removed the gouts of disfiguring 'blood' which had been daubed on, whilst the removal of the gesso-impregnated linen loincloth revealed the pubic hair minutely delineated despite the fact that the genital organs of the crucified Christ could not and never were intended, at that date, to be exposed to the eyes of worshippers in the Church of Santo Spirito.

I am not myself profoundly informed in the matter of Renaissance woodcarving and have not been able to examine other crucifixes of that date in detail and at very close range. Those that I have looked at closely are still disguised by layers of repaint and it may be that scholars will dismiss my slender knowledge of the subject by proving that other carvings of the period are equally badly made and many a god-head is stuffed with tow. If, however, the Santo Spirito crucifix *is* by Michelangelo it is the only known example of his work in wood and I find it even more remarkable that it should be his sole carving of the crucified Christ. Despite the great marble Pietàs and Depositions, despite the fact that he painted the crucifixion of Haman on the Sistine ceiling and of St Peter in the Pauline Chapel and that late in life he repeatedly made drawings of the event, Michelangelo has left us no other 50 example of his vision of the crucifixion of Christ in sculpture.

1969

The Non Finito

plates
51–53 SOME HISTORIANS tend to feel that since they are confident in having their feet firmly planted on the ground of the known facts, they are wise to reject metaphysical speculation as to the individual character of the human being whose art they have chosen to study. If, they seem to suggest, we know what we are talking about, then you may assume that we know all that is worth talking about. In consequence, the late Martin Weinberger★ had established, presumably to his own satisfaction, that the much-debated question as to why Michelangelo left so much of his sculpture unfinished does not exist. 'There is', said Mr Weinberger, 'no *problema del non finito* in Michelangelo's art; it is the tragedy of his life that more or less well-intentioned patrons constantly interfered with his work.' If that is all, then Michelangelo's was a tragedy which must have overtaken all manner of artists, to say nothing of hairdressers, interior decorators and pastrycooks. Weinberger's verdict does not, however, seem to me to take all the factors into account when discussing, with whatever learned authority, an artist of the stature and complexity of Michelangelo. Nevertheless, the art critic of the *Burlington Magazine* declared that such a view as Weinberger held was warmly to be welcomed.

Mr John Pope-Hennessy† is less given to such warmly welcome blanket assertions, although he too is impatient of the notion that Michelangelo's inability to complete his sculptures arose primarily from a concern with matters spiritual or metaphysical, and main-

★ *Michelangelo: The Sculptor.* Routledge & Kegan Paul, London, 1969.
† *Italian High Renaissance Sculpture.* Phaidon, 1963.

tains that it is to be explained in more practical fashion; the root cause being Michelangelo's temperament and the fact that he worked 'at the limits of the possible'. He assumes that, committed to this frightening area, the sculptor lost interest in the work 'as soon as the problem was formulated to a point where the solution was no longer in doubt'. Thus Michelangelo's concern 'lay with the problem, not with the completed work of art'. This makes a good deal more sense than the dogmatic 'common sense' of Weinberger, but it still leaves the situation at a point where the problem is formulated but solutions remain in doubt. They could scarcely remain anywhere else, but despite Mr Pope-Hennessy's scholarly conclusion that there are almost as many specific reasons why works were left unfinished as there are unfinished sculptures, I find myself unconvinced that no more need be said. I do not think the word 'temperament' as applied to Michelangelo is more explicatory than the phrase 'self-expression', so often and so glibly used nowadays to describe the creative mystery of the visual arts in general. I do not think that 'working at the limits of the possible', highly perceptive though this view of Michelangelo may be, will suffice to explain the matter unless it may be assumed that he worked there not only as a result of his temperament but because his intellect was gradually shaped by the spiritual and philosophical problems with which he was concerned, no less than by those emotional responses suggested by the word 'temperament'.

I realize that to look beyond the known facts and the irrefutable historical documents is quickly to risk overstepping the limits of the possible in the area of speculation. Reverence too can easily topple into sentimentality. On the other hand, to take up a stance as austerely banal as Weinberger's is to risk letting the baby go down with the bath water.

Two major sculptors within the last century have been plagued with the problem of the *non finito* in their work to an extent which has made their appearance of palpable distress highly acceptable in the area of fashionable taste which enjoys the ambiguous and the imperfect. This taste allows a wide and entertaining exercise of personal emotional response to the spectator and that is an appetite so deeply contained in our twentieth-century collective psyche as to be inescapable. Temperament is what we have in-

dulged, and indulged in, before all else, for more than a century and a half.

Rodin is recognized as being the greatest sculptor of the nine-teenth century and he was certainly interfered with by well- and less well-meaning patrons. He also had an abundance of temperament which caused him to excel in the creation of highly evocative fragments which are nowadays largely found prefer-able to his completed works, allowing for notable exceptions such as the *Balzac* and the *Burghers of Calais*. These fragments are moving in that they suggest, as Mr Robert Melville has put it, that they are 'alluring emblems of desperation' peculiarly sym-pathetic in our desperate times. They are also effective because they carry with them not only the spontaneous urgency of an impatience with the work of art after the problem has been formulated but also, paradoxically, the emotive battered look which hallows by antiquity works worn and fragmented in their vicissitudes as they achieved survival from the remote past. They are quasi museum pieces in that they suggest the rediscoveries of archaeologists.

I myself am peculiarly prone to these enchantments and in no way free of emotional response to the allure of the fragment except that I would rather have antiquities as whole as the sculptor intended and am perhaps aware, in the midst of my relish, that I am contemplating in a Rodin fragment, cast in bronze, not the detritus of a long gone century which excites me by virtue of its having survived, but an imitation of survival, conscious or unconscious, which must have something dubious about it because in its facture each sculpture apes, like new green patination, the passage of Time.

Puritan that I am, I am prevented from modelling a headless and limbless torso for its own sake, just as I reject patinating my bronzes to look as if they have lain underground for a millennium or so. I cannot believe in either. Even then, I am perhaps incon-stant because I can readily justify to myself the production of a head without being driven to add the whole of the rest of the figure to it. Illogical though it may be, I could not leave any other part of the body cut, or torn, or broken from the human frame without regarding it as *non finito* in the relatively trivial sense that it was a sketch for work in progress made as an aid to the completion of

some larger sculpture. It is a great trial to me because there is no doubt that formally the human figure in sculpture is much easier to deal with when such natural but aesthetically excessive members as arms and legs are eschewed, but I am helplessly compelled to complete these members unless the image specifically represents, from some specific intention, a maimed body.

Rodin's *Walking Man* is, I concede, much more to my taste 52 than his *St John the Baptist Preaching,* but this is because when he drove himself, or was required by interfering patrons, he had to bring his work to completion in some accord with the taste of orthodox nineteenth-century patronage. Beyond this, I think, lay a frequent inability to take the work to a conclusion without dropping the emotional charge and this reflects flaws in Rodin's genius rather than virtues, because to Rodin incompleteness was a matter of taste rather than a matter of desperation. In this I may be wrong, but then 'taste' to me is a quality which I find relevant only in the spectator and not in the artist. The gratification of 'taste' alone is too trivial a motive to impute to Michelangelo, but not to Rodin who, on this count, among others, stands far below Michelangelo in stature.

The problem of leaving a stone carving unfinished differs in its nature from leaving a plaster unfinished and casting that plaster in bronze. The act of casting deliberately completes the object as an artifact, apart from minor modifications which can be achieved with a cold chisel, or with burins and rasps. The decision to cast the work in metal *is* the decision to complete the artifact, whereas an unfinished carving in wood or stone remains to be finished if the sculptor decides to continue, providing he sees how to continue and does not die or become permanently separated from the work in the meantime. Michelangelo's problem as a carver was therefore wholly different in practice from Rodin's as a modeller, and whereas Michelangelo's fragmentary sketches in clay and wax were not cast by him, Rodin knew himself to be at his best with sculptures at this level of completion on whatever scale they were, and often had them cast.

To me, the modern artist whose problem truly relates to that of Michelangelo is Giacometti and despite the enormous chasm which separates their achievement, Giacometti was, I am convinced, truly driven to desperation by his inability to complete.

This had nothing whatever to do with the interference of patrons who, from the early 1950's onward, have enjoyed the spectacle of Giacometti's struggle; his avowed and repeatedly lamented failures seeming to add a special zest to their acquisition. His work had much to do with temperament but its form had even more to do with his conviction that he could force his sculpture no nearer to 'reality' than its fragile, tentative and vibrant appearance allows, without falsifying his response to it. It is at this point that the *problema del non finito* re-emerges from the tidy filing cabinet of art historical studies and hobbles, lame as Hephaistos, into view, albeit on a wholly different scale of achievement from that which affected Michelangelo. Giacometti's quivering, passionate probing of space to find space in space for the awesome confrontation of one human being with another was metaphysical. His was a genuine alarm, a genuine sense of *hubris,* a twentieth-century equivalent of the 'sacred dread' which Plato saw to be at the proper core of man's response to the image. Thus in parallel with Michelangelo's sense of moral failure and despite the mystique which Giacometti developed around his attitude to his own sculpture, this attitude differed fundamentally from Rodin's in that Giacometti was truly involved not with the attraction of the unfinished but with the frustration suffered from what was unfinishable.

Paradoxically, as Mr Melville has also pointed out, it is precisely Giacometti's nervous searching 'all knobbly with the signs of anxiously fingered clay, that has brought Rodin's virtuoso modelling into favour again', but it is also the far from relevant but readily comparable surface of his sculpture to the painful fumbling of the wax by the near-blind Degas. In three wholly disparate ways the painful struggle to make sculpture is undisguisedly demonstrated by Rodin, Degas and Giacometti, and in this lie three different aspects of the problem of the unfinishable. The results are immediately attractive, for, like Giacometti, who spoke with special passion of what he called *l'artiste cassé,* Rodin's failure to realize his sensations by maiming the figure is different from Degas's inability, despite his tremendous mastery of the human form, to pursue his natural genius for sculpture until increasing blindness drove him to it and yet caused him to leave it at the point beyond which his fingers could not see. Rodin

could and did achieve the *Balzac*. Degas could and did achieve *La Petite Danseuse de Quatorze Ans*. They are finished and they are the greatest works of nineteenth-century sculpture. Much else that both masters made in sculpture is *cassé* in one way or another, either deliberately or fortuitously. Neither was consciously concerned with the unfinishable but only with the inability to finish. Giacometti was concerned with the unfinishable and the fact that he frequently avowed his frustration and spoke of his desire some day to model a *fat sculpture* make this frustration the more poignant, but it is the failure in all three cases which has become, in the twentieth century, the attraction. Cézanne's anxiety, as Picasso once said, is what makes him interesting and he too, in yet another way but one much closer to Giacometti than to Rodin or Degas, was driven to leave his work unfinished because he could not see how anything as unstable as natural appearance could in truth be 'finished' in the sense that would accord with the taste of the Salon he so earnestly strove to enter.

It is not hard to perceive why today the expression of anxiety stretched almost to breaking point at the level of genius should engage public attention, notwithstanding recent attempts to supplant the spectre with plastic simplicities, kinetic multiples and kapok-stuffed domestic appliances. What I seek to do here is to suggest that the aesthetic factors which have given Rodin's anxiety a renewed popularity, the physical factors which affected Degas and the metaphysical ones which affected Giacometti stem in different ways, and of course in different degrees, from the step first taken by Michelangelo which led to that Promethean condition I have attempted to suggest in the essay 'Prometheus Bound'. Enough has been written about and by Giacometti to indicate to future Weinbergers that the *problema del non finito* does exist, has existed and may be seen to exist when it comes to the practical problem of creating a certain kind of essential paraphrase of the human condition in the form of imagery. This practical problem is more practical than striving to be practical in describing or ignoring the artist's motives when writing art history.

In 'Prometheus Bound', I argued that Michelangelo was, in the highest sense, a failure and I meant a failure at the level of Prometheus, a condition central to the problem of being the archetypal *artist* whose achievement fell short of his ambition

and who possessed the genius and the prestige to leave despairingly unfinished what lesser men of the Renaissance would have been compelled *as professionals* to complete. This proposition sorts well with Mr Pope-Hennessy's statement that Michelangelo worked 'at the limit of the possible'.

I am not in a position to know where Mr Pope-Hennessy believes the limit of the possible lay for Michelangelo, but I must assume that it could hardly be in a technical area, since Michelangelo, as a technician, was capable of performance far beyond anyone else's possibility of achievement. It must therefore have lain elsewhere. Now the practical reasons why Michelangelo left so much of his sculpture incomplete are expressed with admirable clarity in Mr Pope-Hennessy's book.* These proposals are more complex than Weinberger's and they allow for Michelangelo's temperament in relation to his patrons, to his reaction to subjects he was given which displeased him, to his fiery temper which could make him wantonly damage the marble and to his psychological inability to maintain a steady course. Mr Pope-Hennessy also makes the important point that Michelangelo's unfinished sculptures introduced a new factor into art in that they revealed the possibilities of the indefinite, 'and postulated a relationship between the work of art and the spectator whereby the spectator was called on to invest with meaning forms whose exact meaning was not defined.' 'The full significance of this', he goes on, 'transpired in the nineteenth century when Michelangelo's lack of finish was acclaimed as an affirmation of individual liberty,' and he concludes by stating convincingly that in the nineteenth century Michelangelo's unfinished sculptures were regarded as triumphantly complete, which, incidentally, gave Rodin his mandate, whereas in fact by objective standards they are not. The new consequence of the *non finito* paradoxically caused it to be regarded as a positive achievement to be revered rather than the product of that melancholy sense of inadequacy so poignantly expressed in certain of Michelangelo's sonnets.

It is worth while to introduce here a further factor, the influence of the antique fragment which, during the sixteenth century, assumed great importance when enthusiastic excavation in Rome

* *Op. cit.*, p. 6.

gave rise to the widespread assumption that such newly-dis-
covered marbles as the *Belvedere Torso* provided the visible means
for High Renaissance sculptors to attain parity with the ancients.
The fragment at this point achieved and has retained its special
aesthetic virtue, and the whole illogical procedure of making new
pseudo-fragments as objects in their own right, had begun.

I myself reject, as does Mr Pope-Hennessy, the romantic notion
that Michelangelo's unfinished carvings may be regarded as
finished because a lack of finish became aesthetically desirable
during the nineteenth century. I also reject the notion that
Michelangelo *enjoyed* an inability to take his carvings to the stage
of completion he surely envisaged when he began them. Nor was
his prestige sufficient to prevent critics in his own time from
disapproving of the *brutezza* of these unfinished works. He had
however a prestige so great that he was able to get away with
not completing them and this would not have been allowed in
the fifteenth century. I have maintained elsewhere that Michel-
angelo earned 'the supreme liberty to fail', a paradox which
caused Mr Pope-Hennessy great irritation. It seems to me, how-
ever, that this is precisely what he did and why the myth of
Prometheus and his fate is the relevant one. This means that
Michelangelo came to believe that what he had begun in this
world could certainly be completed to a point to which no one
else could begin to aspire, but would yet fall desperately short of
what it could and, to Michelangelo, should be. What he saw, in
the depths of his introversion, could only be made whole in the
next world, and not in this one.

Michelangelo is extraordinarily unapproachable at the deep
levels of his work, a quality which contributes to the inexhaustible
nature of it. He totally lacked that extrovert curiosity about the
natural world which places Leonardo at an opposite pole from
him, concentrating all his genius within the image of the naked
human body as the vessel required to contain his thought.

To Leonardo, the human body was part of the main, a territory
to be charted and mapped as one superlatively important but by
no means exclusive aspect of the natural world. Committed as he
was to the geography of that marvellous envelope we inhabit, he
drew back with a certain distaste from certain disturbing areas of
it. Michelangelo saw the human body cosmically or micro-

cosmically as the one sign specifically created in God's image and
he explored it wholly differently from Leonardo, drawing back
not from distaste but from the fact that it was ultimately inade-
quate. Cosmic or not, beautiful beyond all other creations, the
body was an envelope he too inhabited, and his own body he
found and described, from time to time, to be both painful and
impermanent. It was not of course the physical aspect of his
nature or the physical inadequacy of his body alone that tormented
him, although to be the supreme sculptor of the human form is to
be perpetually aware of one's own physique, but rather the
dangerous equation, the temptation inherent in Christian human-
ism generally and in Platonist Christian humanism in particular;
the temptation to take the image of God in man (accepted from
Christian tradition) as constituting of and by itself a disposition
to union with God.*

The final development of this proposition is its complete
reversal; the idea that man makes God in his own image. This
concept would of course have been abhorrent to Michelangelo,
but his situation was unique. He was the one human being capable
of representing at least a convincing shadow of the dynamic force,
the energy and splendour which went into the creation of Man.
This led him deeply into the dread of *hubris,* a dread which Pro-
metheus disdained and for which he was horribly punished. It
also led Michelangelo to regard his total commitment to the
human form as a sculptor as no more than a mere track from
corporeal beauty to spiritual beauty which is invisible. He con-
tinually finds the sensual and with it inevitably the very act and
material of his art to be an obstacle, a distraction coming from the
outside which interferes with the intellect which, left to itself, he
believed would inevitably reach God. This is not only the dark
side of humanism, it is not only Christian Platonism, but it has
in it the seeds of an iconoclasm restrained only by the conviction
made evident in his own art that visible, human beauty at least
demonstrates the presence of God. The stress such an ambivalence
created in Michelangelo is borne out continually in the later sonnets.
He, whose gift to externalize and to make visible the splendour of
the naked body has never been surpassed, was drawn continually

* I am indebted to Father Kenelm Foster O.P. for his review of my previous essay
in *Blackfriars,* Sept. 1963, London, for this definition of the problem.

inward in hope of the sight of God, while knowing that no genius for creating images of the evidence of God's presence will enable him to reach it. At this level the sense of personal or more specifically moral failure is tragic indeed, for despite his achievement Michelangelo saw his own art as finally worthless to aid him in the greater cause and cried out in Sonnet LXV that neither painting nor sculpture could ever again satisfy the soul that has turned to divine love.

At such a pass, who indeed would finish a carving? Yet Michelangelo was still cutting into the *Rondanini Pietà* two days before he died. Who would even begin to carve? The answer perhaps lies at a tangent. It lies in the apprehension Michelangelo expressed in Sonnet XV that the figure is buried in the marble and wants to be released and that no figure exists that does not already lie there hidden.

As early as 1492 he had left his first known carving, *The Battle of the Centaurs,* still partially buried in the stone and although this instance may have been fortuitous, as he grew older he seems to have taken the finish of his sculptures no further unless it was specifically required of him in fulfilment of a commission which necessitated that 'finish' required of a Renaissance professional. Even the *Moses* had stood unfinished in his workshop for thirty years before its final destination was determined. At that point he brought it to the state in which we see it today, but who knows how much he may have regretted the necessity?

It is not the least astonishing thing that Michelangelo did not regard himself as a professional, in that he had no workshop assistants. This too was a radical departure from the normal relationship of the craft of sculpture to the act of patronage at that time. In being recognizably above the level of the craftsman, by virtue of his acknowledged genius, he came to be tacitly accepted by society as a creative force beyond the external claims of patrons, no matter how much his patrons tormented him, and thus he could leave the figure partially buried in the stone more often than any other sculptor of his age.

The belief or superstition that to take an image to the point of absolute completion is to challenge God as a creator is very ancient. It may also relate to the Greek legends of the lame or maimed craftsman who could not, in his own body, rival the

149

beauty of his subject. I have put the case that Michelangelo's sense of personal or moral failure resulted both from his uniquely earned 'liberty to fail' and the terrible humility of his scruples. There may be something else. There may be the challenge to God which he felt himself compelled to conceive but eventually could not bring himself to utter.

If this is still meaningful today, it must be perceived in Giacometti's alarmed response to the confrontation he endured whenever he began to make a sculpture from the life. It was not only the confrontation with another person, another human being occupying space before his eyes that worried him, but the implicit fact that he could not truly perceive the image because he could not reach that person: therefore he could not show the sitter complete. It is of no consequence that Giacometti is not comparable in stature to Michelangelo. What matters is that in this special sense Michelangelo believed he could not reach God, and Giacometti believed he could not reach a fellow human being. That sense of inadequacy, in each case, by being confessed with such terrible honesty, so touches the spectator in its humility that he reveres it. Michelangelo's humility may not be the first quality to which one responds in contemplating his art but whatever the scale of the enterprise, the true image as he alone could conceive it, seemed to lie beyond the limits of the possible.

1969–70

The Translated Image

WE LIVE in an age of dubious propositions about what is valid
and invalid in art. We are dominated by romantic notions which
have raised the virtue of originality so high that to imitate has
become one of the artist's capital crimes, an activity suited only
to young students who blush to be accused of it. To copy, to
follow, even to quote from the past, except in witty paraphrase,
is to stand condemned, and this is an attitude of mind which has
been growing for many years. Critics will scornfully describe
a painter who learns by imitations as 'derivative'. The public,
impressed with the specious concept that all virtue lies in 'per-
sonality' and in mannerism, will regard such an artist as trivial.
They will regard him uneasily, whatever his talents may other-
wise be. They will suspect him in some vague way of cheating or
they will seek to excuse him, if he is young, on the grounds that
he is seeking a style.

plates
27–35

Not the least of the dubious propositions we entertain today is
that through the medium of mechanical methods of reproduc-
tion, all art is available to all. Since we can now inspect a coloured
postcard of Michelangelo's *Last Judgement*, that vast fresco is
available to us, at the breakfast table. A reproduction, notwith-
standing the inevitable falsification of scale, surface, handling
and everything else which we patiently overlook, is more accept-
able to us than a copy. The phrase 'a mere copy' is commonplace
and we cherish the belief that we have superseded the need for the
copy by our invention of mechanical means of reproduction.
The status of the copy has fallen in proportion to the rise of the
reproduction. But the word 'reproduction' is in itself a misnomer.
A painting is not reproduced, it is imitated mechanically and
frequently with no more accuracy than the 'merest' copy. A

copy of an oil painting made in oil paint even by an inferior painter partakes of at least the same physical nature as the original. The material is similar and so are the tools with which the copy is made. A reproduction is not, and although drawings and water-colours can by now be multiplied in very close facsimile, it would be salutary if the 'reproductions' of oils by Renoir and Van Gogh which hang on people's walls were termed 'coloured imitations', a phrase which sounds much less respectable.

The crux of the matter is in the curious belief that the photo-graphic image is true *because* it is mechanical, *because* there is no apparent human interference between the image and the object. This is not really tenable, but it is accepted, and whilst it would be absurd to deny the utility of the photograph, or of the art book, its value lies in its use as reference material and as a stimulus to travel farther and see more, rather than as any true substitute for works of art in the original. Yet we are gradually coming to accept the specious concept proposed by Malraux as 'The Museum without Walls' in which the world's masterpieces are served to us in a range of format, scale and surface dictated by the publisher and the printer. This has been rightly termed the creation of a 'Buchenwald of the plastic arts'.

The general prejudice against the copy today lies not only in our faith in mechanical techniques but also in the irrational belief that copying verges on forgery. This is perhaps the fault of the amateur who in his enthusiasm buys some sad daub, in a country saleroom, whose malign function it has been to delude him. Thinking he has made a fortune, he finds he has purchased a 'copy'. In general, the copy has been made with the most honest intentions to fulfil a need, engendered in Hellenistic times if not earlier, which persons have had for more than one version of an image. But if this has been the main cause for making copies, it has not been the only one.

Forgery, it is true, has played a part in the history of the copy, and once at the highest possible level. Vasari tells us that the young Michelangelo, who at the age of fourteen made the copy after Giotto, turned such drawings into forgeries 'in such sort that the copies could not be distinguished from the originals, making them look old with smoke and other means'. A few years later this supreme master was reputed to be forging antique sculptures

and burying them in the earth to age them quickly. Sir Peter Paul Rubens, as far as we know, played no such practical jokes, yet he not only copied works by Michelangelo, Titian, Leonardo da Vinci, Mantegna, Raphael, Andrea del Sarto, Correggio and Caravaggio, but also those by artists greatly inferior, such as Vermeyen, Key, Muziano and Barocci. He made drawings after antique sculptures, including no less than twelve of the *Laocoön* and twelve after reliefs in Trajan's Column, and he employed others to copy for him. An activity, then, which has occupied artists as great as Michelangelo and Rubens as well as thousands of lesser painters whose copies may indeed be 'mere', is clearly of profound importance to art history. Its function has not exclusively been to reproduce and certainly not to forge, despite Michelangelo's supposed example, and if, when they copy, great artists *recreate*, that is their good fortune as often as not, rather than their overt intention.

What, then, have been the purposes which copies have served? The primary one from the point of view of the artist himself is surely that of acquisition, the enlargement of his vocabulary of forms and ideas. No work of art is utterly self-engendered and very few have really been engendered solely as a result of the artist's direct experience of nature. Even to make a life drawing from the nude or a study of a briar patch requires certain terms of reference, and since the adult eye is never entirely innocent, it refers to precedents in the memory.

The creation of any work of art, however great and however original, is dependent on these precedents. Even those works which seem most vigorously to break with tradition do not in fact do so. It may seem that they do because they show a rejection of the popular concepts of their immediate predecessors. A rejection of nineteenth-century academic precept, for instance, seemed to show the Impressionists, in their day, to be wild nihilists smashing the sacred edifice of art itself. In fact, and it became clear quite quickly, they relied on precedent as the point of departure for their most courageous excursions into the study of light on form. They looked back to Delacroix, to Constable and to the Dutch landscapists, and never denied it. Even Gauguin, that most exotic and original opponent of the prejudices of his time, leaped from the head of his antipodean Zeus, armed with the Japanese print

and a thorough comprehension of his elder contemporaries. Even Constable, whose communion with nature seems to have been so deep that he needed nothing but the natural landscape of Suffolk to inspire him, had Ruisdael and Hobbema behind his eyes when Dedham Vale lay before them. Seurat looked back to Piero della Francesca at a time when that sublime master engaged little interest among connoisseurs. A measure of Seurat's extraordinary skill in arranging spatial elements in his pictures derives from a sympathetic understanding of Piero's geometry. It is possible that much which is hailed as original results from the artist having found his sources where the public has not thought to look for them in him. This is especially true of the twentieth century. Certain exotic derivations such as the debt the cubists owed to Negro sculpture are common knowledge. Primitive art, that spicy condiment for jaded palates, whether provided by the anthropologist, the ethnographer, or the prehistorian, has had a powerful influence on modern art. But so wide are the sources of style available to the living artist that the spectator must be highly educated to analyse them in individual influences. The artist today looks to cultures very remote from him and often far more ancient than the antiquity with which the Renaissance was concerned.

If it were possible to devaluate the currency upon which celebrity is based in painting, much of which bears as little relation to the truth as a banknote does to the gold it purports to represent, then individuality of style would cease to be the virtue most highly valued in our time and would appear in its proper perspective as a vital but essentially accidental addition to a sum of parts comprised of observation, passion and precedent.

The impulse to create images is fundamental to us. It is an act of power resulting from an act of worship. This is obviously no place to explore the ramifications of such a statement with all that it implies in relation to religion, philosophy, history and economics. The form of creating such images, however basic the impulse, changes endlessly as a result of these factors and the circumstances in which the artist works. He is conditioned by his times, his status, the prejudices and desires of the society to which he belongs, or upon the outskirts of which he uneasily maintains himself, whether he complies or revolts. We today

harbour a prejudice which finds the creation of an apparently original image admirable, the making of a copy faintly discreditable, or at least peripheral to the proper function of the artist, which we see as the expression of an individual personality working in as individual a manner as possible. But during many past centuries no such invidious distinction was made. It seemed perfectly natural to the artist to produce desirable artifacts; only the madman was wayward. The copy of something of agreed excellence was a desirable artifact; making copies taught the artist how to produce such artifacts, and also supplied a demand.

Although we are a little unbalanced today in our admiration for the unique personality and for originality, yet these elements, although they are accidental, are present in every work of art in some degree and are essentially part of its vitality. They are the exciting phenomena which Sickert felicitously called the 'co-efficient of error', by which he meant that between the thing seen and the image made, no matter how dedicated to precision the artist might be, errors occurred. These errors Sickert felt to contain a vitality and a personality of their own, a touch, a handwriting, which even in the most prosaic painting gave it an individual character. Such 'errors' made by a great artist are accidentals which make the comparison of an original by, say, Delacroix, with a copy of it by Cézanne absolutely fascinating.

The act of worship in such an instance is the expression of admiration, the profound regard of one artist for another, and is no less an act of worship for that. The act of power lies in the attempt to do again, to recreate, an image so that it may be truly mastered.

To study the subtle differences which exist between original and copy is to gain insight. Both original and copy may reveal more of themselves, and of the artists who made them, from the comparison, because the copyist will invariably place greater emphasis on one aspect of the original than another. In turn, this emphasis may discover to the spectator aspects of the original to which he has not given his fullest attention, and this is not necessarily a matter of small details but of large rhythms, the relationship of forms, harmonies and dissonances of colour. At this level the copyist, acting intuitively, will bring out those aspects of the work he studies which touch him most nearly, but he will also

be thinking himself into the mind of the master whose secrets he hopes will be revealed to him, by copying. Technically, the making of a drawing or a painting is to think visually no less than to feel. The problems which form and colour set, require answers of a logical order no matter how illogical at first glance the results may seem to a third party. The copyist is in the act of questioning, examining, accepting and discovering the thought of his predecessor. To compare a great copy with a great original is to attend a conversation between great artists.

To draw a nude, even with the most painstaking attention to the appearance of the model, is to think by way of Ingres or Michelangelo, or whoever seems to the person drawing most congenial in his recollection, towards the formal solution of the problem set by reality. Cézanne reasonably pointed out that it would be grotesque to imagine that the artist grows blindly like a mushroom when he has all the generations of masters behind him from whose work he may profit. The most natural thing to do is to go to the sources, to the already established images. No biologist in his senses would try to write a textbook without reference to the publication of previous researches in the field – and no artist in his senses, faced with the nude, would, at least in the past, have failed to refer to Rembrandt or Renoir or Praxiteles or whoever seemed most relevantly informed in the matter.

One of the problems of our own day is that the artist has been made shy to do this. He does it, but by shifts and disguises he pretends not to have done it, for he must continue to show his individuality by demonstrating his independence. Picasso, the mighty paradox in this respect, is a subject to which I shall presently return. No such vanity troubled Titian or Rubens. They took what they wanted where they found it, copied when opportunity offered and the more readily when commissioned to do so, and they stored the information thus gained in their minds for future reference. By this process, a vital cross-fertilization took place which has helped the European tradition to flourish. From the direct copy to the quotation – the adaptation of individual parts of one artist's picture to another artist's purposes – is a short step.

It might be valuable to examine an instance of this cross-fertilization in detail. The germinal work in this case is Giovanni

Bellini's great *Feast of the Gods.* This masterpiece, completed in 1514, passed rather unexpectedly into the hands of Alfonso d'Este of Ferrara although it had been partially paid for by Alfonso's sister Isabella and was intended for Mantua. A scheme of four paintings for Alfonso d'Este's study developed from the *Feast of the Gods* and Bellini, having died, the subsequent pictures were by Titian. To bring Bellini's picture into harmony with his own treatment, Titian boldly repainted the background.

Titian's three pictures were *The Sacrifice to Venus,* the *Bacchus and Ariadne* and the so-called *Bacchanal* now in the Prado. It is with the latter picture that we are here chiefly concerned, but its debt to the *Feast of the Gods* is vital, for Bellini was the inventor of a new paganism in painting, despite the fact that he was in his seventies when he revealed this aspect of his astonishing powers. This paganism is essentially Venetian in spirit and differs considerably from the earlier Florentine manifestation. Together with Giorgione's *Concert Champêtre,* the *Feast of the Gods* must be regarded as establishing one of the most influential and fruitful sources of derivation in the history of painting. Poussin copied the *Feast of the Gods,* and the copy was clearly a profoundly important labour to him, for although it is Titian's *Bacchanal* which Poussin most frequently used for his own Bacchanals, it is the Bellini which he copied entire.

Titian's *Bacchanal,* which should properly be called *The Andrians,* illustrates an essay by Philostratus⋆ and the subject treats of the Island of Andros where the god Dionysus had so charged the earth with wine that a river of it flowed through the island. This conceit from the pen of a second-century Greek was printed by Aldus Manutius in Venice in 1503, in Greek, and translated for Isabella d'Este in about 1510. Philostratus was a widely popular author among the highly educated at that time. Titian's interpretation follows Philostratus very accurately and it is in no way a typical *Bacchanal,* nor does it illustrate the legend of Bacchus and Ariadne, although it is often confusingly mistitled.

⋆ The passage formed part of a corpus of descriptions and discussions of various pictures set in the walls of a house in which Philostratus was teaching. Several of these pictures deal with Dionysus and one especially with Andros. See F. Saxl, *A Humanist Dreamland,* reprinted in *A Heritage of Images* (Peregrine Books, London, 1970).

The nude figure on the right is not Ariadne, for the episode in the Dionysiac legend in which she took part occurred on the neighbouring island of Naxos. This wonderful nude is, however, deserving of special attention. Sir Kenneth Clark describes her as 'an ecstatic counterpart of Giorgione's Venus. The utter relaxation of her head and stretched back arm,' he continues, 'had been used already by Perugino in the allegorical *Victory of Chastity* painted for Isabella d'Este's study and was to occur again in Poussin's *Midas and Bacchus*.' That the d'Este brother and sister cultivated a most fruitful garden of imagery from which was to grow a wonderful profusion of perennials becomes clear. From the calm sleeping figure partially draped, in Bellini's picture, has come the superbly abandoned maenad of Titian, one of the most splendid nudes of the High Renaissance. Between 1605 and 1608 Rubens copied the picture, and although the resemblance of the copy to the original is superficially close, he again transforms the image. The whole composition moves differently and more intensely. Where Titian's Mediterranean calm is drugged and noon-hot, Rubens' sky has cooled, the figures move more violently and the implications of the picture have subtly changed. Everyone is drunken in Rubens' version and it is almost as though his figures were made riotous on schnapps and strong Flemish ale rather than lulled by the miraculous wine of Andros.

A close comparison between Titian's sleeping maenad and Rubens' copy of it shows the metamorphosis involved. Rubens' figure is plunged more deeply into sleep than Titian's, her mouth has fallen open and she is more utterly relaxed than mere sleep would suggest. She has acquired a branch of foliage and is the less modest for it than is Titian's lady, who lies in the splendid dignity of utter nakedness, but she has a ripe and earthly vitality which are her own. Still sleeping, she has renewed herself by contact with a second genius, a northern beauty has evolved from a southern one. Philostratus has gone and with him the courtly classical mood of Ferrara and Venice, but the alfresco celebration will continue through Poussin's renewed classicism and Watteau's romantic elegiacs to find itself eventually in the grandeur of Cézanne's bathers.

The decorations of one small room in Alfonso d'Este's castle at Ferrara have flowered across the Western World through the

modest practice of copying. The *Feast of the Gods* is today in Washington. Poussin's copy of it is in Edinburgh. Its neighbour at Ferrara, Titian's *Andrians,* is now in the Prado, Rubens' copy is in Stockholm. Van Dyck's copy of Rubens' copy adapted to be *Amyrillis and Myrtilus* is at Gothenburg and Poussin's version of the sleeping maenad taken from Titian's picture is to be found in his *Midas and Bacchus* at Munich. These are direct copies. As the diffusion continues, the germinal image spreads outwards by means of a series of quotations, adaptations and derivations.

The positive birth and evolution of imagery, here so wonder-fully demonstrated, can be seen again and again to emerge from the sequence of example and imitation. Few great inventions or observations of experience have long gone unimitated and few therefore have long gone undeveloped.

During the Renaissance and long after it, imagery was still largely shared. As in medieval times, drawings passed from hand to hand and cartoons were pricked out on walls and panels until many such cartoons fell to pieces from continual use. The sense, to which we attach so much importance, of the personality of the artist with its incumbent personal baggage of imagery and manner was in embryo and the vocabulary of images was relatively small. New ideas were seized upon as avidly then as they are now but as the communal property of the art and without that uneasy sense of copyright infringed which obtains today. The copy served the arts as a necessary method of publication.

We are today so accustomed to our museums, our art books and our easy access to the world's art that the very diffusion which the practice of copying once served now overwhelms us. An *embarras de richesse* swamps the artist with sources, stimuli, examples and references. A veritable banquet has been laid for him. But it is important to remember that until relatively recently even the wealthiest, most travelled and most studious of artists, a Dürer or a Rubens, could only see in his entire lifetime the quantity of material now displayed to the casual visitor who spends one day in the Louvre or the Metropolitan Museum.

Many crucial questions are debated in the learned journals as to the effect of particular masterpieces on the arts of different periods. A really exhaustive treatise on how the arts were diffused throughout Europe by means of copies, and the influence which

trends developing in one part of Europe may have had on artists many hundreds of miles away, is almost impossible to contemplate. What was the effect of the *Portinari* altarpiece of Hugo Van der Goes, on Piero della Francesca and hence, ultimately, on the arts of Ferrara, Padua and Venice? Could Rembrandt have seen an original Caravaggio and did his use of chiaroscuro stem directly from this source or via Elsheimer and Gentileschi? Such questions and a thousand others are debated by scholars. In illuminating these matters the record of the travels of originals about Europe is only a touch more important than the diffusion of copies. To the practising artist, such academic ruminations are, today, as remote as a world without the internal-combustion engine. Yet the European tradition was established as a unity by the slow and often haphazard interlocking of its disparate parts and the history of the copy is to a considerable extent the history of the means by which this unity was achieved.

If all other considerations are left aside and the tradition of copying is regarded exclusively as a pre-mechanical method of reproduction, a means by which students and collectors could assemble replicas for study and display, there yet remains the important factor of the diverse media employed. A copy in oils of an oil painting, on the same scale as the original, may, like the many versions of the same image by one artist, El Greco for instance, be simply a commercial undertaking intended to satisfy more than one client enamoured of a particular work. This is an obvious purpose for making a copy and it is this type of copy which first springs to mind at the mention of the word. There are also the engravings made 'after' paintings, by means of which pictures could be circulated in monochrome in the same fashion as photographs are today. These were avidly collected by amateurs and also by artists, Rembrandt and Rubens in particular being celebrated for the extent of their collections of this sort. Great artists, such as Dürer who made engravings after Mantegna, and Goya who in his youth engraved versions of paintings by Velasquez, took part in this relatively humble method of diffusion. But many copies have been made for quite different reasons. The relationship – one of enormous importance – established between painting and sculpture by means of the painted or drawn copy of the three-dimensional work is not simply a matter of reproduction. It is

possible that Mantegna's copy of a Donatello stucco-relief was made purely as a reproduction, but it seems more probable that, like a very large proportion of copies, it was made for purposes of study. The Renaissance painter, quite apart from his concern with the antique (which had survived principally in the form of sculpture rather than painting), was dominated by the need to realize the illusion of volumes in depth. It was natural to him to turn to sculpture in his search for the means of translating three dimensions into two.

The value of drawings of this order must primarily be to the artist himself. Reproduction is of secondary importance here, for clearly the primary concern is a special and concentrated study of the original. This penetration and comprehension of a master's work can only be achieved by copying it. The copy, the end product, is the least part of the matter. As a reproduction it may have a practical value to the artist, for he may thus carry away, on a single sheet of paper, an image which might otherwise occupy part of a wall or weigh several hundredweights, but since pre-Renaissance times artists have been trained and have trained themselves in their craft by copying. The Renaissance apprentices, including the young Michelangelo apprenticed to Ghirlandaio, learned three kinds of drawing. The first was copying, the second plastic drawing from sculpture and architecture, and the third, drawing from nature, in that order. Nor has this practice ceased, unless it has done so very recently. Mantegna, Michelangelo, Rubens, Tintoretto, to choose at random among the greatest names, have left numerous studies of this type behind them, and it is clear that they continued the practice far beyond their apprenticeships just as Cézanne continued to draw from sculpture until he was in his sixties.

Sculpture has been copied from sculpture and sculpture has even been copied from painting. Whilst the practice of adapting antique pagan marbles to Christian purposes, by altering the symbolism in the copy, is not uncommon in the Renaissance, it had occurred far earlier. Nicola Pisano copied from the *Hippolytus Sarcophagus* the figure of Phaedra, and turned her into a matronly Roman version of the Virgin in his Pisa Baptistry pulpit completed in 1260. This is a rare case of original and copy remaining within a few hundred yards of one another during seven hundred

years, for the *Hippolytus Sarcophagus* was brought to Pisa in the eleventh century and still remains there in the Campo Santo.

About seventy years later another Pisan sculptor, Nino Pisano, produced a more or less faithful copy in marble of the figures of the Madonna and Child on a panel painted by Ambrogio Lorenzetti some ten years earlier. Both images are called *La Madonna del Latte* and the marble which until recently was in Sta Maria della Spina is to be found in the San Matteo Museum at Pisa, whilst the painting is in San Francesco in Siena. These examples indicate the extent to which the system of copying from the antique as well as from contemporary work runs through the whole history of art. The Greeks practised it and even more so the Romans, and indeed the forms of many major Hellenic bronzes have come down to us in marble replicas dating from Roman times.

But aside from the function of the copy as a method of reproduction, a method of study and a source of solution to formal problems for which purposes artists have seized upon one another's works quite ruthlessly, there are other reasons for making copies. Perhaps the most profound is the desire to pay homage. In turning to their predecessors and their contemporaries, it has been and is natural to the artist, both in developing his style and from pure admiration, to copy as an act of love. This can be most impersonal, for Michelangelo copied Leonardo and Leonardo copied Michelangelo despite their cordial distaste for one another as individuals, or it can be as personal as the motives which prompted Van Gogh, in the shadow of the asylum, to copy engravings, transforming them into blazing colour, from their modest monochrome. A combination of personal and terrible foreboding and that passionate sympathy with the oppressed, which had earlier led him to undertake his tragic mission in the Borinage, must have caused him to copy *The Prison Courtyard* from the engraving by Gustave Doré. William Blake, despite the extraordinary individuality of his vision, founded his entire drawing style on engravings after Michelangelo and yet, at a further remove, Fuseli found Blake 'damned good to steal from'.

These are examples of homage coupled, perhaps, with the desire for deeper knowledge, but there is another aspect of the copy which is the reverse of humility. It can be satiric or the product of

162

amazed curiosity. Rembrandt's copies of Moghul miniatures may quite possibly fall into the latter category, and Hogarth's second engraving of *Paul before Felix* is an amusing example of the former. Hogarth had adapted the composition of Raphael's cartoon *Elymas Struck Blind* to his purposes in his first version of *Paul before Felix,* engraved in 1748, and thereafter he satirized his own work in a version 'designed and scratched in the True Dutch Style' in 1751, as a squib on the inability of the Dutch masters to rise to 'the grand manner'. A certain masochism is implied here, for Hogarth strove mightily and unsuccessfully to achieve the grand manner himself. This innocent joke, however, is a forerunner of a far larger and stranger ambivalence wherein great images have been at once reverenced and savagely mutilated by the mighty attack on them made by Picasso.

Oswald Spengler, with ponderous gloom, contended that Manet's source borrowing, his use of Marcantonio Raimondi's engraving after Raphael's *Judgement of Paris* for *Le Déjeuner sur L'Herbe* and so on, was indicative of the final decay of painting in the West. Here is an early example of the initial condemnation of a copy based upon a curious ignorance of the tradition of painting, for this proposition could as well relate to Rubens or Poussin, masters of quotation, as to Manet, and must, if it is to be entertained, apply to most of the artists already mentioned here. If the decay of the West may thus be demonstrated, it has certainly been a long one. Manet's *Olympia* in the Louvre belongs to a *29* whole sequence of copies. Ultimately* the image derives from Giorgione's *Sleeping Venus* in Dresden, one of the most magical *27* pictorial inventions in the whole history of painting. Titian borrowed her entire, altering only the position of the right arm (of which he made use in the sleeping Bacchante of the *Andrians*). He transposed her from her landscape into a domestic setting and she became *The Venus of Urbino*. Manet made an oil sketch from *28* this picture in 1856 and in 1886, by changing little more than the background and the position of the lady's head, he adapted *The*

* 'Ultimately' is here the wrong word. The sequence of derivations moves further into the past if Saxl is right in proposing that Giorgione took the pose of his *Venus* from a woodcut published in 1499 in the *Hypnerotomachia Polifili* representing Ariadne discovered by Bacchus. This woodcut in turn derived from an antique sarcophagus relief. See Saxl, *Titian and Pietro Aretino.*

Venus of Urbino to become his *Olympia*. This brought down upon his head a shower of critical abuse for 'vulgarizing' the subject. Some fifty years later, Jacques Villon made a careful copy in pencil of this once notorious picture.

The qualities or defects which Spengler castigated in Manet, are, however, precisely those upon which Picasso has raised himself to the peak of eminence he now enjoys. He is the most eclectic artist ever to achieve the reputation of greatness, and he has done so during a period when eclecticism and indeed any tendency towards imitation is condemned. This paradox is not simply explained and this is not the place to discuss in detail the multifarious sources of style upon which Picasso has been dependent during his long career. That in adopting one manner or another he has invariably given a new 'chic' to his source and sometimes more, is not in dispute. That he could possibly have done so before the laborious copy was superseded by the mechanical reproduction is improbable, for Picasso is essentially the inhabitant if not the curator, of Malraux's 'Museum without Walls'. We are, however, concerned here not with Picasso as an artist adopting a sequence of styles but with his activity as an actual copyist. The bulk of this activity is recent and perhaps for our purposes may be considered as beginning with his gouache copy after a reproduction of a Poussin *Bacchanal* which he made whilst the Allied Forces were entering Paris in 1944. Once again Bellini and Titian are the progenitors and ultimately Picasso's *Bacchanal* looks back to Alfonso d'Este's *camerino* at Ferrara.

Since 1944 Picasso has made a number of such interpretations, the principal ones being his series of fourteen variations on Delacroix's *Femmes d'Algers* painted in 1954 and 1955 and his forty-five variations on Velasquez' *Las Meninas* exhibited for the first time in 1959. Picasso has explained his intention in making this apparently profound obeisance to his great predecessors, and he has done so in epigrammatic terms. 'What fundamentally is a painter?' he asks rhetorically. 'He's a collector who wishes to obtain a collection by making himself the paintings he likes. It's like that and then it becomes something else.'

What it becomes in Picasso's hands is worthy of profound speculation. He has spent his long life in dismantling and reassembling the component elements of appearances. In order to facilitate

this procedure he has adopted various mannerisms from a wide variety of styles; those of Negro sculpture, of Cézanne, of Ingres, of Roman sculpture and Greek vase painting are instances. In the process of these reorganizations of visual components he has remarked, 'I find, I do not seek', and it is clear that he has not had far to look, no further, indeed, than a good library will nowadays provide. But Picasso's genius lies in his ability to transform, with protean energy, observation into paraphrase. His use of paraphrase during the thirties and forties has had about it a ferocity which might almost argue a hatred not only of the image itself but of the human material upon which such imagery has long been based. At least it would seem a matter of ambivalence and this ambivalence poses the question as to whether his variations on the masterworks of El Greco, of Courbet and especially of Delacroix and Velasquez are acts of homage or of revenge.

The implications of the final version of Picasso's *Las Meninas* are humorous. Among them is an exploration of Velasquez' mastery of space which is an act of homage, but there is a reorganization of the human element which argues satire. Where, in Velasquez' original, the self-portrait of the artist takes its place in the scheme of the painting as an important element in the composition, in Picasso's version Velasquez has been inflated at the expense of everything else in the picture, a huge puppet with head propped on the cross of the order of his knighthood, he dominates the image and as the eye progresses across the big canvas, the forms become slacker and more vague until they peter out in the sausage dog and the casual linear adumbration of the right-hand figure.

To Picasso, it would seem, the figure of 'the artist' is all, the image no more than his vehicle. In this he underlines the anomaly of the successful artist of the twentieth century, whether by intention or not, and at the same time deranges the work of art itself. No more instructive paraphrase of his own condition could possibly be conceived, and in the light of his long series of drawings of the relationship of the artist to his model, to his critics and to his public, which he made four years earlier, it is tempting to assume the cynicism to be entirely conscious. These drawings, published as a set in *Verve,* Vol. VIII, are an instructive revelation of Picasso's attitude to art in recent years.

In contrast to Picasso, who began his research into the interpretation of specific earlier masterpieces in his sixties, Cézanne ceased to do so at much the same age. No one in the history of painting has had more facility than Picasso and perhaps no one, among the great, had less facility than Cézanne. No one has leaned more heavily upon the history of art than Picasso, no one has derived more profit from it than Cézanne, and to pile paradox on paradox no one has derived more from Cézanne than Picasso. Nevertheless, the attitude of each of these two great men could not be more diametrically opposed in the matter of copying. Cézanne's humility when he came to copy is at precisely the opposite pole to Picasso's arrogance – and if it is possible to find the counterpart to Cézanne's humility in the twentieth century, 32, 33 it is in Juan Gris' copy of a Cézanne self-portrait. Here is no brilliant adaptation but a searching enquiry at pencil point into the proto-cubism inherent in Cézanne's method. This little drawing, a copy made for purely traditional reasons, in order to extend Gris' understanding of the art of a great predecessor has the same motivation as Michelangelo's copy after Giotto and the same motivation as Cézanne's own copies must have had. '*Je suis plus traditionnel que l'on ne croit,*' as Cézanne himself put it.

Joan Miró, that most ebullient of fantasists, has probably taken the paraphrase further than any other contemporary. The sense-nonsense relationship which he has established with the works of the past is utterly without Picasso's ruthlessness, or Bacon's morbidity or Buffet's wearisome impoverishment. Using curiously chosen pictures, as apparently irrelevant to himself as to each other, such as Raphael's *La Fornarina,* Jan Steen's *The Cat's Dancing Lesson* and Engleheart's *Portrait of Mrs Mills,* he has made cheerful game of the old Masters and in doing so he has translated the initial image into a language far more remote from the original than Picasso's. The element of ridicule in Miró is effortlessly benign. It is not satire or homage here but *jeux d'enfants.* Such a paraphrase *en travesti* is very instructive in terms of the copy, and the point it has now reached.

But the copy today, unless it is such a paraphrase, unless it is entirely coated with the manner of the copyist, and translated into his personal idiom, commands little public interest. Reproduction has deprived it of its commercial value no less than its value as an

extension of communication. The copy and its value are widely misunderstood and it is perhaps startling to look back at the history of copies and to observe that, despite the individual nature of genius which inevitably transforms the copy by a great master of a great master, how little conscious attention to this individuality most great masters have given. When Rubens transformed Titian's *Andrians* into his Flemish *Bacchanal* his translation is subtle and in no way drastic. Where he has imposed his own personality on Titian's he would seem to have done so unself-consciously. There is no doubt, however, as to Picasso's imposition of himself upon Velasquez. The whole image is destroyed and reassembled. This imposition, which makes Picasso's copy acceptable, in our own day, could only be significant when, publicly at least, the interest in a copy depends upon its departure from the original as opposed to its adherence to it. In Picasso's words, 'it becomes something else'.

A copy has, perhaps, something of the performance of a piece of music about it. A pianist who studies a Beethoven sonata 'copies' it in performance rather as a painter who studies a Rembrandt might 'perform it' in copying. A European composer who had never played a composition by Mozart or Bach, on any instrument, would be an unlikely member of his profession. If the musical analogy is permissible, then the direct copy might be compared to the executant interpretation of the composer's intentions. The copy in another sense, where the image is totally transplanted, is perhaps comparable to those variations on a theme exemplified by Brahms in his use of the *St Anthony Chorale,* thought then to be by Haydn. It is tempting to see in Picasso a virtuoso, a Liszt encompassing orchestral works on his pianoforte, but Stravinsky's 'copies' of Pergolesi in *Pulchinella* are possibly a closer parallel. It would be rash in any case to press the analogy.

Among the most formidable living protagonists of the para-phrase which transfigures its source is Francis Bacon, whose long series of paintings, taking as their point of departure Velasquez' *30, 31* portrait of Innocent X, introduce an element of dislocation from the primary image which has had considerable influence on contemporary art. Bacon has long maintained that he had not seen the original Velasquez when he began to produce his varia-

167

tions on the theme but that he had seen photographs of it. At what point he saw the original I do not know but it is a curious fact that where the picture is hung in the Palazzo Doria it is first to be seen through open doors set with mirrors and brass rails. If the picture is seen obliquely in one of the mirrors the image is curiously distorted and the brass rail runs across the image much as it does in several of Bacon's pictures. The combination of this illusion taken in conjunction with the black and white photographs (Bacon's colour is in no way related to that of the Velasquez) for which Bacon has a strong appetite, especially when they are hazily reproduced on newsprint, may account for this dramatic departure from the tradition of the translated image so far discussed. Suffice it to say that the relationship between painted and photographed images has become a principal source of that ambiguity which is felt to provide the *frisson* in much contemporary art. What is relevant here is that just as the individual is 'involved in mankind' so the artist is, and always has been, involved with existing images whether ephemeral or not. He moves through and over an intricate web of *images reçus* and ranges across time in the struggle to clarify and establish his own visual experience. The translation of images is part of that process.

1960

The Act of Drawing

plates
40–42

IN A NOTE on Ingres (*L'Exposition Universelle*, 1855), Baudelaire asks rhetorically whether Ingres' draughtsmanship is 'absolutely intelligent'. It is an unusual question and not one to which painting or sculpture would normally give rise. One does not immediately ask whether a Turner seascape or a Rodin bronze is intelligent, indeed to apply such a critical term to either, nowadays, might seem odd to the point of derogatory irrelevance. It would not be so, but it could seem to be. To ask such a question of drawing however is surely both logical and inoffensive. The process of drawing is before all else the process of putting the visual intelligence into action, the very mechanics of taking visual thought. Unlike painting and sculpture it is the process by which the artist makes clear to *himself,* and not to the spectator, what he is doing. It is a soliloquy before it becomes a communication.

I do not intend to discuss all aspects of drawing here. Drawings expressly prepared as artifacts I leave aside, not because I despise them but because they lie slightly at a tangent from the centre of the process. Michelangelo's presentation drawings and Ingres' portrait drawings, for instance, are drawing augmented, 'finished', beyond the point of self-communication which I believe to be the clue to the real nature of the function I am concerned here to examine.

I do not wish to suggest that drawing is a purely intellectual process. The relevance of Baudelaire's question is not as to whether Ingres' intellect was keener than say Corot's nor whether his drawing is more logically conceived than that of Daumier. The question is whether in discovering to himself, for his own purposes, a relationship of forms, Ingres' intelligence was fully engaged. Was he successful in this or that instance in revealing to

himself a further body of important information? Painting, if it is not improvised, has in the past been the codification of such information. That is why a large proportion of surviving master drawings are 'studies' for painting. Yet even an improvisation as apparently summary and direct as a painting by Monet or even Soutine is still in a large measure a distillation of an adaptation of pre-knowledge, a sum of experience brought to bear on a particular problem, and however intuitive may be the immediate relationship between the painter and his canvas, the controlling factor, the intelligence in action will be drawing. Ultimately the work will stand or fall by the extent of this control.

There is however such a thing as the imitation of drawing, and it is a trap into which it is easy to fall. There is a moment between the search and the discovery when the pure urge to solve, to 'realize' the intricacies of the particular problem may be vitiated by the temptation to please oneself at the expense of the elusive solution. The avoidance of the issue, the unresisted temptation to repeat what one already knows, is the hallmark of the imitation of drawing, and because drawing is of its nature opposed to rhetoric, in that one does not make speeches to oneself, drawing makes more precise and delicate demands on the intellect than does the physically more generous art of painting. It is for this reason, I assume, that Baudelaire elsewhere calls the draughtsman 'the philosopher of art'. He draws to give order to his thought whereas he may paint to give ease to his heart. I do not mean that painting is easier to achieve than drawing but rather that the field of operation in painting can be less closely concentrated intellectually and that painting may succeed in some measure if it possesses virtues of a purely physical and responsive order whereas drawing cannot.

The thought projected into drawing may or may not run smoothly: with Leonardo da Vinci it presumably did, but on the other hand with Cézanne it manifestly did not. He was often unsuccessful and sometimes totally confounded by his own intentions. But paradoxically his drawing gains from this, from his inexpert manipulation, because he never for one moment relaxed his grip upon the self-set problem and his anxious intelligence builds form into conclusive fact with every pencil stroke. The image which is sometimes very shaky is yet laboriously built, touch on touch, by the mind engaged fully in every move-

41

ment of the hand. By contrast the extraordinarily smooth movement of Leonardo's intellect is transmitted without hesitation. For instance, an early sheet of studies in the British Museum shows a Madonna and Child with a cat, which reveals Leonardo's indifference to effect, in his concern with the solution to the problem, to be comparable to Cézanne's. His pen delineates the legs of the Madonna but immediately afterwards re-poses and re-states them with different emphasis *through* the preceding ones, with a resulting tangle of lines and overlapping washes which superficially resembles the kind of hesitant sketching which marks the unskilled. The drawing is however the very reverse of this. Each image is partially realized and then abandoned, re-stated and jettisoned at high speed, the speed of Leonardo's thought; by the time he lifted his pen, he knew what he had to do. *40*

In Cézanne and Leonardo the extremes of education in draughtsmanship reveal intellects of entirely opposed kinds. Leonardo's line is in a sense the most highly educated in western art; Cézanne's is the most untutored among the great. But compare the drawings of either with those of Fragonard, an extraordinarily accomplished and suave draughtsman, and a gulf appears between the easily conceived drawing of the latter and the intense concentration of both the former. Fragonard thinks clearly and reached his conclusion with skill and delicacy but the conclusion is in itself less significant.

I do not mean, when I describe drawing as a process of thought, to imply a chilly cerebration, divorced from feeling. I do not see thought itself in that light, for the mind has hot and cold winds blown upon it, no less than the body. Nor do I mean that great drawing is produced by calculatedly predetermined systems. Ingres, for instance, whose method of drawing minutely with a hard pencil seems to argue a cool, detached and systematic method, clearly reveals himself in his drawings as a man of powerful sensuality. When he draws a female nude he seems to me to suggest that he does so with the tip of his tongue. The long smooth caress with which he establishes the contour of a thigh is a sexual gesture but the controlling mind directs the hot impulse with the elegance and skill of an experienced lover. He is not making an overtly expressive movement, great drawing is only incidentally expressive, and his eroticism is directed not at the spectator but at *34*

171

the image. He is no pornographer catering for the *voyeur*. Nevertheless, the amorous impulse whether self-conscious or not removes the chill from what might otherwise seem a bloodlessly dispassionate kind of drawing.

Thought is not, I imagine, ultimately divorced from appetite even among philosophers. Cézanne's urgent groping for form could not achieve its powerful grip upon the solid without a certain greed for the solid as a tangible satisfaction. An apple has no final reality even for the painter unless he bites it. So he bites, but the decision to bite into the apple and where to bite into it and how exactly it will feel as lips and teeth meet it and the fingers hold it for the biting are, in the process of transferring these intentions and sensations to paper, subject to an intellectual transmutation.

Rembrandt, who, far from seeming to draw with his tongue, has upon me the effect of a man planting with gentle, stubby fingers, the green fingers of the spirit, an endless diversity of plants and seedlings with the blunt and spatulate movements of an immortal gardener, has neither elegance in his sensuality, nor anxiety. But again there is no dislocation between thought and act and no suggestion of the desire to communicate or to express his intentions except to himself. In his etchings, as in his paintings, Rembrandt is public as Ingres, Cézanne and Leonardo are public when they choose to be so, but in his drawings he is private and speaks only to himself.

It is important to recognize the privacy of drawing, and it is not easy to do so since Michelangelo (perhaps inadvertently) and his followers made public an essentially private activity. Drawings have long been sought and treasured by the discerning and not least because they reveal an intimacy which the more ceremonial aspects of the visual arts do not. But in the process of becoming desirable acquisitions they have in many ways altered in their character, like the unprofessional participants in those post-war Italian films who lost their innocence by being real people in 'realist' entertainments.

Until the sixteenth century, drawings were used, circulated, passed on, discarded and lost as being of no more importance than the first draft of a poem or the rehearsal of a performance, and this tradition has never quite died out. For this reason we have

no surviving drawings by Masaccio or Piero della Francesca, a mere handful by Uccello, Giovanni Bellini and El Greco and scarcely any by Velasquez. Even Cézanne regarded his drawings as too personal to exhibit and they were never shown during his lifetime. But on the other hand Leonardo's drawings are his principal memorial and despite Michelangelo's ruthless destruction of a huge bulk of his studies, those surviving have been made more public than most, and are perhaps more famous than any.

I myself am more interested in the private aspect of drawing, but I am not innocent of having made 'public' drawings. The public aspect is impossible unless preceded by the private, but by now the public aspect cannot be ignored. Illustration of books I propose to leave aside as another topic, and drawings made expressly for engraving in one form or another, purely professional drawing in short. But drawings made public *post-hoc* like those of Goya or Daumier, although they frequently bear a direct relevance to print-making, are semi-private, or at least relatively cryptic utterances addressed as much to the creator as to the spectator. The drawings contained in Goya's *San Lucar* sketchbooks are not polished into statements as are the plates of the *Caprichos* despite their completeness as images, whilst both in his drawings and indeed in those of his small paintings which approach so nearly the act of drawing, Daumier's penetrating whisper is different in its nature from the rumbling badinage of his professional lithographs.

Drawing is a linear expression which approximates very closely to writing, more closely perhaps than we in the West remember, for we make a distinction between calligraphy and draughtsmanship which is less clearly marked in China and Japan. The ideogram which is both word and image in Eastern art has precious little counterpart in the West unless one accepts Klee's delicate patrolling of the fringes of the subconscious in that light. On the whole the drawing of *an idea* in Western art tends either towards homily or allegory and generally approaches illustration, as it does with Blake, or an esoteric language of symbols as it does with Bosch, so that the metaphysical impulse of the European draughtsman, in his self-communication, is less direct than that of his Eastern counterpart. There is a dangerous limbo between word and deed which is inhabited only by visions as enormously

173

powerful as those of Goya, but upon the periphery of this no-man's land exist the needled fantasies of Callot, the masturbatory trances of Fuseli and the opaque broodings of Redon.

Modern cliché describes such work as 'literary' because it is capable of some additional interpretation in words, but although this may be true it is unimportant, for the condition which gives rise to such drawings may be 'literary' but their creators chose to write them in images and not in words. On the other hand the process of thought through which these images arrived on paper is clearly more diffused and less fundamental than the kind of drawing I have been discussing hitherto. There is an extra-visual impulse which is absent from the drawings of Rembrandt or Cézanne, but this impulse is not so much that of the communication or representation of ideas as of the exorcism of them. The artist seeks not to discover but to escape. He writes, as it were, the document which is his passport to tranquillity and so it is still a matter of contemplation made actual and not of public statement. Where the danger lies, except in the case of such a supreme master as Goya, is in the possibility that the perception of forms in addition to the exorcism of ideas is a burden too heavy to bear and the act of drawing is vitiated by the act of regulating the mind's behaviour. Even Daumier hangs perilously over this brink at times, for however stimulating the tradition of caricature may be – and its motives are also exorcism of a kind – it intervenes between mind and hand, in the sense with which I am here concerned, to the detriment of drawing itself.

False drawing is something of which all but the greatest have been guilty, and it can be and has been disguised by all manner of excellent surfaces, masques, dominoes, hoods, hats and fustians. A drawing by Dali is generally a lesson in false drawing, but a study by Guercino or by one of the Carraci may be a more rewarding example for it is usually a more curious mixture of false and true. The studied 'study' is the object lesson. This saleable product originates I think with the Bolognese, but late seventeenth-century and eighteenth-century Italian drawing sees it rife and despite the charm and skill of much of it, it remains an article for the tourist trade albeit in an aristocratic form. It is also common in eighteenth-century French art; in comparison to the undeniable truth of a Watteau drawing, the elegant dissemblance

of a Hubert Robert or a Moreau-le-Jeune is usually quite plainly discernible. But false drawing is by no means always intended to deceive. It exhibits self-deception rather than dishonesty, looseness of grip rather than sleight of hand. In drawing the human head, for instance, the problem of drawing an eye or the curve of a cheekbone, even with some command of the form, is relatively simple if regularly practised. Perfectly to relate that eye to its neighbour across the bridge of the nose or that cheekbone to the other is to be capable of great draughtsmanship, so long as the sequence of relationships is maintained down, across, round and along forehead, nose, lip, chin and jaw, etc., with a logic which determines the invisible forms below the superficial ones and argues the exact shape of the back of the head. But a semblance of drawing can be manufactured by contriving the parts in a convincing manner and leaving their relationship to be adjusted, by association, in the eye of the beholder, or by masking with shadow, or distracting attention from the problem with engaging textures or brilliant suggestions of tone.

Dali, whose manner, from time to time, requires an Ingres-like precision of hatching and elegance of contour, contrives again and again in his drawings either to stop short of the problem, by leaving it out, as if he had abandoned the drawing casually incomplete, or to place some amusingly improbable object across the awkward area. A lobster in place of an eye solves all if you do not know where to place the eye. But 'finish' is not drawing, nor is 'vitality'. Frenzied knitting of contours may suggest vigour, and rapidity of execution may suggest confidence but the distinction is that which differentiates music-hall patter from poetry. The precedent for the multiple contour was established by Michelangelo for profound reasons stemming from his doubts as to the exact placing of forms in space and his sense of the palpitation of living organisms. Since then a thousand prosaic drawings have been enlivened by stated and re-stated contours until this mannerism has become standard art-school practice.

Berenson once remarked that Cellini had reduced the art of sculpture to the level of jewellery (at least I think it was Berenson); the art of drawing has since the seventeenth century been continually in danger of being reduced from the level of meditation to the level of table talk. And because the media and size of

drawings are not generally adapted to bombast, such rhetoric, expressed in a politely modulated voice, has been, and continually is, mistaken for profundity of speech. You cannot 'make' a drawing any more profoundly than you can 'make' conversation, you can only arrive at a drawing as you arrive at a philosophical conclusion. This is the justification for Baudelaire's remark.

In a recent book called *Modern Drawings* by Monroe Wheeler and John Rewald, the authors remark with admiration that there is no simplicity of thought among 'the younger men'; 'so that the imagination of Dali is furnished with an astonishing familiarity with psychiatry, orthodox and otherwise; that of Masson with mythology; that of Seligmann with medieval prophecy and black magic; that of Tchelitchew with veritable mysticism and strange sciences.' It is all highly sympathetic to me, for I am much given to cluttering my mind with esoteric paraphernalia, but I have made enough false drawings myself to know that this kind of thing is ideal as an aid to the falsification of real drawing and I hope I have become wary of it. The bizarre and the exotic is probably the most useful equipment for this process of falsification and if an element of pastiche of an 'old master' can be added so much the better. Tchelitchew is an interesting case in point. An enormously talented draughtsman who at his best, in his early work, was capable of realizing volumes and relating forms with a skill which would have borne the burden of profound thought, his 'veritable mysticism and strange sciences' took him into an alchemy which submerged his intelligence. The falsification of his later drawings is the result of the confusion of his thinking. His skill remains extraordinary.

There is a world of difference between the false drawing and the bad drawing. Degas could draw badly but never falsely. Matisse could make one miraculous drawing and ten trivial arabesques but he seldom falsified; Tiepolo drew with such careless brilliance that he frequently made the true look false and Bonnard, whose drawing was invariably hesitant and often feeble, yet overcomes the weakness of his sense of form to the extent that his bad drawings are true because of their extreme relevance to his luminous and sensitive pictorial thought. False drawings on the other hand can be very good and very expertly made, but they are cream buns filled with custard. The form of the pastry may be exquisitely

achieved, the custard is delicious and made with real eggs and the pastrycook himself had no intent to deceive with his confection. To him cream buns *are* filled with custard.

For my own part, such tentative conclusions as I have arrived at about the nature of drawing result from my own practice of painting and sculpture. In one sense all the visual arts are interlocked and in another, painting and sculpture extend like wings from the body of drawing. Unlike either painting or sculpture, drawing is ultimately linear; the line contains the forms by implication and without a sculptural sense the draughtsman cannot convey the implication of volumes which his linear paraphrase must imply. Equally, the forms which he is concerned to draw are seldom stone or bronze, but rather earth, or fruit, or flesh enveloped in air; so he must possess some part of that sensual appreciation of these materials which is within the painter's province. It is relevant that the painter's drawing, especially in 41 the case of Cézanne, can sometimes suggest sculpture, whereas certain sculptors' drawings, such as those of both Maillol and Despiau, suggest painting. Rodin's water-colours are usually fluidly linear, with little or no hatching intended to convey form in depth, whereas Degas continually, in his drawings which are studies for painting, models tonally to suggest sculptural forms 37 in space. That part of the artist which is Pygmalion apparently directs this tendency. In drawing he seeks perhaps to compensate for flesh if he is a sculptor and to remark bones if he is a painter. Maillol's soft nudes in red chalk, spongy and ill articulated, are at the furthest tactile remove from his noble matrons in bronze and stone. They are far more glutinous than any but the most unsuccessful Renoir. But in order to think flesh back from rock and metal, in order as it were to impregnate by proxy, he drew in sanguine the soft counterpart of hard sculpture. By these dual means, drawing and sculpture, he brought the woman herself to life.

When Baudelaire asks his question, he is really asking whether Ingres knew exactly what he was doing, whether he was equating the act with the intention in the most pertinent way possible. But of course Baudelaire was the spectator. In fact Ingres himself was arriving at the answer to the same question while he was drawing. Drawing is essentially an act of the intelligence because

177

in the act of drawing the artist attempts to discover what he is doing and the extent to which he finds out is the extent to which the drawing succeeds in its private purpose. The intelligence he brings to the researches of his pencil will accord with the extent to which he is deeply conscious of what is happening in his eyes. By these signs shall he know him.

The artist in Western society has often been encouraged to distrust his intellect. There is a deep-seated urge on the part of society to see in him something of the 'natural', the semi-sacred idiot revered in primitive communities. What precisely it is in man's memory which fosters this delusion, I do not know, but perhaps the menace of the image-maker's magic can thus be partially dispersed or hidden and the disquieting relationship he has with society becomes easier to condone. At all events there is a belief, almost a hope, that the development of sensitivity and the refinement of intuitive emotional responses is incompatible with a keen intelligence. And the artist himself responds to this proposition gladly if he is stupid and silently if he is not. But like many long-sustained conspiracies, the plot eventually deludes the participants. The artist betrays his mind and the public betrays its distaste by requiring less and less from the artist. That is to say, the public shows less and less inclination to accept from him anything which requires time, thought or any intellectual relationship, anything more indeed than sensory stimulation. When this occurs drawing becomes flaccid and diffuse and is overlaid with the mucous of simple sensation. This fluid secretion is ever present and the individuals struggling against it are always in a minority. At times there is a concerted drive towards intellectual clarity. The Renaissance in Italy, the period immediately following the French Revolution, and again the last decades of the nineteenth century, in France, these historic moments throw up great draughtsmen as a natural corollary. Leonardo and Michelangelo co-existed, so did Ingres and Goya, Cézanne and Seurat. The climate was right for them. We do not on the whole enjoy such a climate today perhaps because we tend to be advancing technologically rather than philosophically.

I am aware that I am defining the art of drawing in a very special sense. I believe myself to be searching in my own mind towards an examination of Baudelaire's generalization that the draughtsman

is the philosopher of art. Whatever the primary motive, the ultimate virtue of a work of art lies in its ability to enlarge human experience and presumably one of the virtues of philosophy is its ability to order experience so that the perception of experience may be enlarged. In the visual arts, drawing is the process by which experience is simultaneously ordered and enlarged.

1956

Postscript

Long after I first drafted this essay, I encountered Francis Bacon in a bar. There he accused me, with the greatest good nature, of having asserted that he could not draw. I had done so, rashly, and I admitted it, furthermore I rashly maintained it. 'Is drawing what you do?' he asked. A characteristic pause followed. 'I wouldn't want to do that.' In the circumstances, it seemed to me, I had nothing to do but acknowledge the palpable hit and buy the next round. The point he made was just and it has nothing to do with the fact that Bacon does not draw, as distinct from painting, but rather that the act of drawing to him is part of the act of painting and in no way separate. The attack which he makes on form, when he paints, is fierce and, as he himself has said, chancy and preparation for painting by means of drawing is no part of his practice. Were he as certain as Velasquez of the conformation of the human hand, my assertion would have been empty, for Velasquez too must have drawn directly in paint, without much preliminary skirmishing with the form on paper, to judge from the rarity of his surviving drawings. Bacon is extraordinarily intelligent but he is a gambler whose appetite for chance plays upon the insecurity of his sense of form. That a human hand is a structure totally incomparable to 'the lamprey, which hath no bone in it', concerns him very little compared to the sensation of a human presence. He seems to encounter flesh agglutinated haphazard on gristle rather than on bone. Unfortunately for me, I need the bones so that the flesh he thrusts and twists to such powerful effect is held in tension by some internal scaffolding and this requires a deep comprehension of structure which he disdains to establish below the neck. He understands and

can gamble on the human head as no artist since Picasso has understood it. Indeed it is a measure of his mastery that he alone, since Picasso, can totally disorientate the formal elements which comprise a portrait head, without losing the likeness. By comparison he represents the human hand as if it were ectoplasm as incapable of holding a brush or a papal bull as his heads are capable of holding the character of the sitter and the attention of the spectator.

This digression is prompted not only by my recollection of the anecdote but by the fact that when I began to set it down I came to divide my attention between what I was seeking to set down and how.

I am watching my own hand write. As it moved across the paper or rather (to correct the tense, since I am in the act of writing) as it moves, I am aware of it as a complex of interlocking forms in tension. The most visible of these tensions rests in the web of sinew which runs across the hand from the upper joint of thumb to the knuckle of the first finger. The thumb, bent in, presses the pen against my second finger-tip whilst the remaining two fingers, bent towards the palm, brace the hand against the block of paper. None of these forms lies slack, pressure thrusts the knuckle bones outward. The slack forms, the loose flesh corresponding to the tense sinews, lie in the palm of the hand and are hidden. A whole sequence of actions is formally related and subtly visible to me. If I take my hand from the paper and stretch the fingers, the whole complex structure is reset and all the forms and boundaries of form which determine the shape and articulation of my hand must at once be wholly reconsidered *as drawing*. To dramatize the action will require one approach, to tranquillize it will require another but in the repertory of movements my hand can make, as I sit with my elbow on the table, lie a dozen or ten dozen drawings to be made. If they can be convincingly made, there is nothing I cannot do with the image of the human hand, but I must be convinced that I know what I am seeing and how it changes as I move it. There is a Dürer drawing in the British Museum, a sheet of six studies of Adam's hand and arm, made as a preparation for an engraving. Five of these studies are concerned solely with what happens to the hand in the act of holding, or being about to take hold of, an apple. They examine the nature

of a casual grip and they contain the doubt that Adam had in accepting the apple from Eve whilst at the same time they propose to Dürer where the thumb and fingers are so opposed as to contain an apple naturally and yet demonstratively. It is a measure of Dürer's *intelligence,* and no draughtsman has ever been more intelligent, that he examined these alternatives so minutely, knowing himself to be showing a hand taking into its grip the knowledge of good and evil. How that should be shown, with all its implications, was something Dürer needed, very precisely, to know.

1970

The Grand Academic

plates
36–39 IT HAS BECOME customary to classify Degas in company with
Renoir, Monet, Pissarro and Sisley as one of the great Impres-
sionists, but in fact the art of Degas is entirely removed from the
chosen field of his great contemporaries on three counts of such
importance that, as he himself realized, it is impossible to con-
sider him in this company. Firstly, Edgar Degas was in the deepest
nature of his talent a sculptor, secondly it is in the quality of his
drawing that he first demonstrates his claim to be considered a
great artist, and thirdly he was the only great artist in his period,
whose approach to his subject was predominantly that of the
psychological portraitist.

In the art of reading the mind's construction in the face, and this
is the quality which distinguishes the great portrait painter from
the less, Degas possessed no rivals in his time. Furthermore he
read the mind's construction in the body. Manet, his senior, was,
as a painter, more gifted but as an observer of the human being
far less penetrating; Toulouse-Lautrec, his short-lived junior,
was perhaps of the same cast as Degas himself but is the lesser
artist in the same degree that psychopathology is only a part of
the larger study of psychology. The other great masters who
formed the Impressionist group and evolved the Impressionist
aesthetic, all manifest less interest in the human being than in the
quality of light falling upon the human being, all were less
interested in human relations than in the model's relation to the
background, less interested in human motive than in visual
material.

It is a remarkable paradox that the Impressionists were all
known to one another as men of good will and this reputation
has descended to posterity, yet they were none of them funda-

mentally concerned with the human condition, whereas Degas, a morbid hypochondriac and in later years an embittered recluse, who deliberately formed about himself a reputation for cynicism, bigotry and anti-semitism, was in fact more deeply involved in mankind than any of his peers. He alone pursued the observation of human behaviour at the expense of pictorial felicity, he alone concerned himself deeply with human beings as human beings, rather than as objects of purely sensual or optical interest. In this he is susceptible to the criticism of being a literary artist, if this outworn epithet still counts for anything, for he chose as his study the human being caged within the circumstances of his or her professional environment and in particular he chose the professional occupations of the sex whose professional opportunities were, in his day, the most rigorously restricted, the most exhausting and the least respectably rewarding. There was in Degas something of Zola's realism but Degas, unprejudiced as he was by liberal morality, was also unfired by moral indignation. He regarded his subjects with the detachment of a surgeon and was deliberately disinterested in the social conditions which gave rise to their plight and thus to their physical condition. He sang no Song of the Shirt about his milliners and laundresses, indeed it was his pose to manifest the most reactionary and anti-humanitarian views whenever occasion arose, but paradoxically he was, as his work shows, far more deeply engaged with the human species than this pose suffices to disguise. He read the faces, and even more the attitudes, of his inconspicuous models with the most delicate comprehension. His eye registers the most subtle of occupational gestures and the way in which the human body becomes adapted to the continual repetition of these gestures, reshaping itself accordingly. He recorded the hollow-chested stance, the heavy shoulders, of the ironers of shirts, the red hands of the milliners, the stiff calves and out-thrust feet of the dancers whose gait, disrespectfully called 'the ballerina waddle' results from the endless assumption of the 'five positions'. He notes the bony elbows, the sharp profile of the *grisette* and the sedentary, thickened hips of the patient *femme de plaisir,* not less than the sensitive features of the pensively bored aristocrat. Notation of such penetration only achieves dispassion in the distillation of passion.

I illustrate a particular example here precisely because it is an
39 exceptionally austere one. Unlike the ballet or racecourse pictures,
it is utterly without glamour and in 1884 would not, I judge,
have been a popular example of domestic genre painting as, for
instance, a Chardin might have been. Degas painted three versions
of *Les Repasseuses,* all superficially very similar to one another.
The one that continues recurrently to occupy my mind's eye is
not a picture which gives me great pleasure but it exemplifies
an aspect of Degas more than usually remote from rhetoric even
for him. It shows two very bored women in a laundry and their
boredom is emphasized by the mechanical action of the one who
irons. The other merely yawns and stretches. She holds a large,
black bottle not, as was once thought, because the working classes
drink, but because linen must be kept damp whilst being ironed
and the traditional manner of achieving the requisite degree of
dampness was to take a mouthful of water and spray it on to the
stuff from between the teeth.

No evidence is present that Degas felt any sense of outrage that
women should slave for many hours a day at derisory wages in
order to achieve the rigidly starched structures which dominate
the foreground of the picture and resemble nothing so much as a
splendidly designed machine made from linen. There is no charm
in the picture nor, on the other hand, is there any of the social
criticism which would have motivated Daumier, or Millet, or
van Gogh, to paint such a subject. Indeed it would even be fanciful
to suggest that Degas derived amusement from the spectacle of
the preparation of the evening armour of men about town being
so professionally spat upon.

What there is in this picture which excites me is a quality which
I have come to call 'the stress factor', because it is central to my
own work, and that is the product of Degas' concentration upon
the mechanics of strenuous action. What I share with Degas,
deeply admire in him and wish I could emulate, is his extraordinary
capacity minutely to observe and magisterially to depict the
physical results of specific and endlessly repeated actions. Human
beings are shaped by their occupations. A jockey is shaped in that
his size, weight and muscularity are geared to his occupation, but
this is less remarkable since it is very obvious. Certain activities,
such as running or digging, or fighting, or riding, have through-

184

out art-history produced powerfully muscled men doing power-ful things and pictorially these actions passed into *schemata*. Any artist during the last four hundred years who contemplated a *Rape of the Sabines* or *The Raising of the Cross* had at his command a battery of received images and anatomies derived from his pre-decessors, to support his own academic study of the nude. In the course of time, such schemata had inevitably declined into rhetoric. Degas was unique in the nineteenth century in his analysis of gesture and of the articulation of the body conditioned by repeated action, in his concern with the tension deriving from the taut sinews strung along the tired limbs of ugly girls. This alone would have sufficed to stimulate in him a preoccupation with sculpture, perhaps only partially recognized by the artist who, despite his impatience with his own talents as a colourist, continued to paint despite the gradual onset of blindness even when sculpture and the drawings associated with sculpture came to play so important a part in his later work. His early portraits, precise in drawing, sensitive in their implication of volumes, are sculptural only to the extent that the drawing beautifully explains the forms; explains it with the same kind of exactitude as a draw-ing by Ingres. Yet the handling of the paint is vibrant and more atmospheric than Ingres would have tolerated, and although they are relatively impersonal in manner, these portraits are informed with a tender regard for the sitter's personality very different from the conventional austerity of Ingres. They are the paintings of a man whose worship for Ingres was combined with a profound admiration for Delacroix and at their best they reconcile the classical and romantic elements which, throughout nineteenth- and twentieth-century art, have been so continually at war. It is reconciliation only possible when the painter's expression of his own personality is deliberately subordinated to an impersonal concern with the character of the subject.

'*Faîtes un dessin, calquez-le, le recommencez et calquez de nouveau . . .*' is a classical, perfectionist attitude. It is a method of work more compatible with the attitude of the architect, or even with that of the scientist, than with the impressionist painter and it is enormously remote from the generous sensuality of Renoir or the pulsing emotionalism of Monet. Nor is it a spontaneous response to colour, the prime intuitive response of the Romantic,

which we find even in the most marvellous of Degas' pastels, for his colour harmony and dissonance are created as an act of will and skilfully calculated to act emotively with the maximum impact on the beholder. It is an extraordinarily sophisticated, deliberated and almost cynical approach to colour, nor is it invariably a successful one. Compared to Degas, Seurat, for all his intellectual study of optics and his calculated effects was, in his small pictures, a colourist far less artificial and more intuitive.

It is possible that this view of Degas as an indisputably great artist whose work is nevertheless so unintuitive, so much the product of a keenly analytical brain, so little that of the illiterate, emotional genius of whom the public, ever sentimental, is so fond, may seem unacceptable to that public. It is not impossible that the public whose view of the creative arts as an activity was as oozily romantic then as now, caused Degas to assume the armour of bitter raillery he wore so consistently. Certainly he is no better understood today than he was fifty years ago, he is merely differently misunderstood, and there is no doubt that the current popularity of his ballet pictures (because they are pictures of the ballet) would have called forth some scathing comment from the master.

Degas in later life has been reported at first hand by many distinguished persons, among them Edmond de Goncourt and Paul Valéry. The majority of these observers viewed him with veneration, but also with a substantial admixture of alarm. He is known to us from the writings of these visitors as an individual at once fierce, pitiable, impressive and unenviable. From Halévy's memoir, from his own letters and those of his intimate friends he emerges as affectionate but reserved, deeply concerned to protect himself and deeply conscious of a lack of the quality of invigorating inspiration which, it must have seemed to him, came relatively easily to the Impressionists.

A patch of sunlight on the river, a bowl of fruit upon a garden table, these provided sufficient visual impetus for a fine essay in Impressionism. This gay and sunlit world was Renoir's province and Monet's; a cooler but equally tranquil landscape sufficed Pissarro and Sisley. But Degas was seldom gay, nor was he tranquil, he was disciplined. His vision of landscape was profound, and astonishing in its austerity, but his uninhabited landscapes

are rare while his interest in still life was that of the theatrical 'property master' and was limited to the provision of those objects necessary to give verisimilitude to the environment of his human material. The bouquet and the compotier left him as unmoved as did cherry trees and motherhood. He disliked working out of doors and the completion of a picture was to Degas not the 'catching of an effect of light' but a painful 'series of operations', which phrase suggests the saving of the patient's life by surgery rather than the flowers and grapes of convalescence.

The relationship of Degas with the Impressionists themselves was fairly cordial if a little uneasy; the relationship of his art to Impressionism was at once consequential and to him unsatisfying. He was fully aware of the implications of Impressionism, recognizing that in their concern with the colour and play of light on form the Impressionists were exploring a new range of pictorial possibilities, but Degas also recognized that light is an element which at once reveals and destroys form, and in particular that it is the element most detrimental to line, for except where light creates the sharp silhouette, it tends to submerge the contour of objects and to elide forms in a way which can only be explained by juxtaposed tones. The problem of creating solid forms strong enough to permit the voracious element of light to gnaw and corrode them without weakening their structure was part of Cézanne's problem and explains his hesitation in establishing the contour except after hours of trial and error, but Degas was in addition an artist primarily concerned with the psychology of types and with the human figure in motion, and he was temperamentally remote from Cézanne's preference for static forms. It is not surprising that faced with this pictorial problem Degas found the act of drawing with its established linear and plastic conventions a more rewarding realization of his vision than painting, and that sculpture, which creates its own relationship to light, occupied much of his time even if for many years he used it as an adjunctive medium to painting. Nor is it remarkable that in painting he made frequent play with form silhouetted against a strong light, for this was the only way to impose a purely linear concept upon the Impressionist method.

Degas adopted Impressionism wholeheartedly to the extent that he found it useful and his later work could not have been

achieved without it. He stopped short of it in practice only where it interfered with the analysis of human behaviour, which was his controlling obsession. Where he differs from the Impressionists and where he is most removed from Cézanne is in his study of those human motives which condition the personality and thus inevitably the physical action of his human material. In the Renaissance tradition, Degas placed his emphasis on forms, and especially human forms, seen under light, whereas the Impressionists placed their emphasis on light conditioned or interpreted or interrupted by forms, any forms. Cézanne's triumphant reconciliation of these opposed elements could not, by its very nature, also embrace the elaborate psychological implications of human behaviour. Both Cézanne and Degas employed the Impressionist method of colouring light itself, but Degas rarely to the extent of allowing the colour of light to be a determining factor in the picture. Where Cézanne, one of the greatest of technical innovators, built form and caused it to vibrate by an altogether unprecedented method, Degas until late in life caused form to vibrate under the vibration of light only by adding a masterly Impressionist touch and a personal handwriting to a long established mode of formal expression and only in pastel was he entirely successful in this. In short, faced with a problem which Cézanne solved at the expense of the humanity of the subject, Degas compromised and his later development mainly consists of discovering the nature of the compromise it was necessary to make.

His early pictures are generally subdued in colour and austere in form. The *Jeunes Spartiates* for instance is linear in concept, influenced as it was by Ingres and the Florentine *quattrocento* with which Degas was much concerned at the time. The portraits, such as the magnificent group of the Belleli family, are frequently of a precise and subtle tonality within a cool and muted colour range. The processes by which Degas moved from this sensitive, noble but deliberately unadventurous beginning to the extraordinary daring with which he summarized form, colour and personality of subject in his late works is closely related to his acceptance of Impressionism but scarcely less to the development of his sculptural sense. He was primarily gifted as a draughtsman of remarkable power and subtlety, and his early draughtsmanship

36

is in the linear convention which comes usually to the born draughtsman as opposed to the born painter, but he transformed this concentration upon line so staunchly advocated by Ingres (*'Faites des lignes, rien que les lignes . . .'*) into a plastic use of chalk in which line exists mainly by implication or is stated with such vigour that the subtlety is expressed entirely in the volumes contained within the contours as opposed to the flexible delineation of the contours themselves. The wonderful drawings of the last period are entirely sculptural in their approach to form, and it is the absolute sureness with which Degas creates sculptural form by drawing which permits his pictorial organization so to extend all previous compositional precept.

37

Degas' organization of forms within the boundaries established by the picture frame and those devices of posture which allow his figures to move, by implication, beyond those boundaries is far more important than his personal handling of oil paint. He was interested in snapshot photography and took many photographs himself and found in the arbitrary pictorial boundaries imposed by the lens a convention which added greatly to the sense of *the event* with which his pictures are concerned. By his use of this synthetic, visual technique, he created a mode of composition almost without precedent. Only Vermeer, as Lawrence Gowing has pointed out, evolved a comparable pictorial method in his 'intricate orchestration of optical accident'. To ourselves, conditioned to a daily diet of press photography, this cunningly contrived simulation of optical accident strikes us less by its strangeness than by the sense of intimacy and immediacy which it evokes, as if the spectator were permitted to view for a moment a group of human beings about to depart in different directions. One moment the dancers are with him in the wings but in an instant they will rush on to the stage or out to lunch, or the horse race will start, or the waiter distract the concentrated attention by urgently presenting the bill. The spectator today is hardly aware of the innovation for which Degas is responsible, yet until he gave them authority, images on canvas had no such freedom of movement within the composition.

This apparently casual and temporary relationship of one dancer to another, this brief café meeting, this nodding acquaintance acknowledged on race-course or in foyer is the product of

the most painstaking stratagems, the endless repetition of each composition, the remarking of every variation of pose. By means of tracings Degas would plot slight changes of movement in a model, until the number of superimposed images became comparable to what today we should call 'animation' in the cartoon film. This was his 'series of operations', this laborious delineation of posture, the multiple changes of muscular formation involved in the simplest daily procedures of urban life, no less than in the anguished disciplines which require the contortions of the dancer. The absolute conviction which even the most negligent gesture carries in any picture by Degas is the result of this 'series of operations'. They led him to establish that an ungainly, unself-conscious attitude of body and the most unstudied facial expression, was possessed of a greater striking power, as it were, in the degree to which it was at once familiar and yet pictorially improbable. One has only to compare the studied regularity of feature and amiability of expression, the conventionally graceful attitudes in nineteenth-century *salon* art with the deliberately graceless posture of a Degas *toilette* to recognize the force of his apothegm, '*Cette pointe de laideur sans laquelle point de salut*': a maxim to which he remained always faithful. This is a ruthlessly analytical approach to the image, and despite the subject often seeming to be caught off guard it has nothing to do with the charmingly casual *coup d'oeil*, rather it is a calculated rejection of elegance. '*M. Degas, pourquoi faîtes vous toujours les femmes si laides?*' asked an outraged lady. '*Madame, parcequ' en général la femme est laide,*' replied the master, urbane but uncompromising. As he looked through the bars of the cage he had built to protect himself he was not inclined to offer buns to the fauna he observed.

However remarkable his innovations, and despite the originality of his vision, Degas, more than any of his great contemporaries, maintained the established grammar of the pictorial language. He enlarged the vocabulary to include an argot which has something in common with Goya's flexible and powerful visual speech, but the very nature of his departures from academic conventions shows his underlying reliance upon them. His pictures are usually calculated variations from and extensions of established practice, and his original thought was brought continually to bear upon the possibility of augmenting and expanding

190

the tradition to which he knew himself to belong, rather than to breaking through the confines of that tradition as the Impressionists must seem to have done in order to realize their optical sensations.

By academic conventions, I do not mean the moribund conventions of *salon* painting to which the word 'academic' has come generally to be applied in a pejorative sense, but rather the grand academic tradition which has been transmitted by precept and practice and is the very backbone of European art. It is not an inflexible and certainly not an arid tradition which finds its canon of proportion in the architecture of the Parthenon and its intellectual justification in Raphael's *School at Athens;* with ramifications extending from Bellini through Poussin in terms of design and from Masaccio to Rembrandt and Velasquez in the evolution of plasticity, or, as Berenson called them, tactile values. To call this tradition 'academic' is to use the word precisely in terms of what it should mean and very frequently has meant in the past, as the study of a visual language which must be learned. During the last fifty years or so, 'academic' has become a dirty word. It has become synonymous variously with 'dull and lifeless' but more devastatingly with 'out-moded'. This word is the heaviest bludgeon in snobbery's art armoury, but the narrow sense in which it has come to be so is the result of confusion among persons who do not recognize its true meanings and associations. The word 'academic' is only sterile because the word 'academy' has come to imply bad, devitalized teaching. It did not sound out of place in connection with Plato. Much undoubtedly has taken place of great consequence to painting either outside or in direct opposition to the academic precept, not least both the Tenebrist and the Impressionist revolutions, but it is only in the twentieth century that the term 'academic' has come to be a general epithet to be used to discredit the unfashionable.

The paradox of this semantic misuse is made both more poignant and more comical by the fact that a vast preponderance of what is now *avant garde* is related to the hypothesis that being 'in advance' of what is generally being enjoyed by the unspecialized spectator is *ipso facto* anti- or unacademic. It seldom is, any more than *haute couture* is at any stage engaged in trail blazing as opposed to hysterically maintaining ephemeral attention. Innumerable

modestly fashionable artists are academic, without realizing that the schools in which they are variously enrolled are not contained in classrooms but in glossy magazines and because the word itself has become associated with certain institutions which have themselves lost their claim to academic status.

Degas' conception of drawing was academic in that it accorded with the Florentine conception of *disegno*. For him it was a vehicle for communicating movement within a structure of self-explanatory, completely realized forms, and, as Kenneth Clark has pointed out, in running the gamut of the possibilities of *disegno,* from Pollaiuolo to Michelangelo, Degas discovered in women a muscularity which the Renaissance had thought confined to men. It is an extraordinary innovation to have made, but not an illogical one.

Degas, as a pupil of Ingres, was the inheritor of a vigorously rational conception of his art well founded in academic precept, the boundaries of which he enlarged by the application of his great talent and penetrating intelligence but from which he did not break away, either in action or intention. The intuitive and the irrational were entirely foreign to his temperament and unacceptable to his formal cast of mind.

Today this proposition is only difficult to concede because it runs counter to much in the prevailing *Zeitgeist* and because it is found difficult to respond to works of genius without reassessing them in terms which correspond with contemporary predilections. For this reason Degas is misunderstood almost deliberately in order not to detract from the enjoyment of his undeniable greatness.

Cézanne has frequently been quoted on his avowed adherence to the classical tradition of Poussin and without doubt Cézanne's devotion to Poussin enabled him to re-establish certain plastic conventions after their virtual negation at the hands of the Impressionists. But Cézanne's great contribution lay in his comprehension of the weight and volume implied by the unit of each touch of colour and his extraordinary ability to construct solid forms by means of overlapping these exactly shaped touches of colour as opposed to the general Impressionist practice of juxtaposing relatively shapeless if vibrant strokes and dabs of paint. His pictures are a sum of these units held in tension by means

of the fabric of his touches rather than by large relationships of tone or the cunning use of linear perspective, and he fused tone and colour into a single operation. In this he differs profoundly from Degas, whose reliance upon both tonal juxtaposition and perspective remained constant, at least as points of departure, who remained dependent upon a traditional regard for tonality and whose 'camera angles' required the subtlest understanding of traditional spatial organization.

Where Degas differs both from the Impressionists and the Post-Impressionists is in his refusal to be a 'revolutionary' artist. He did not break out of a prison of pictorial limitations into the light, as the Impressionists did, by concentrating their full attention on one technical innovation of vast importance, he simply enlarged the premises from within. He did not in fact revolt, he consolidated. His innovations, exciting though they were, are ancillary to his main achievement.

As a lonely and neurotic man, his long cherished ill-health and weakness of sight became in later life, as imaginary ills usually do, both organic and severe. He suffered with vigorous impatience the fame which came to him in these later years, and despite the demand for his work he hoarded the greater part of it in his studio. Towards the end of his working life his range of subject narrowed, and his last period, apart from sculptures in wax, consisted almost entirely of large drawings, touched with pastel, representing women at their toilet. Before blindness descended upon him he reached, in these drawings, his loftiest stature. They are drawings of absolute simplicity, and they contain the unknown ingredient to which skill, observation, and all the ingenuity and sensitivity of a master draughtsman are subordinate. They are the vital distillation of painfully acquired experience, refined to the point where the resulting images possess a quality of the 'abstract' in no way connected with the term as it has come to be used to denote the non-figurative.

The word now in use which precisely describes Degas' chosen relationship to his *motifs,* but which was not part of our slang when I first drafted this essay, is *cool.* And *cool* is an ambiguous usage which suggests an aristocratic *froideur,* an insulation designed to guard the possessor from the heat of his own emotions. Degas maintained his *cool* in an urban society, an attribute which

cannot be claimed either for Forain or for Lautrec, who were not only fiery but hot under the collar, and he developed it to a pitch which exaggerated his reputation as a misanthrope. Yet Halévy's memoir and Degas' portraits of his family and friends go far to give this reputation the lie. His detachment may not have made for easy bonhomie and certainly he distanced himself from any implied participation in the *toilette* of the weary but powerful women who scrub themselves ungainly in their shallow hip baths. The late drawings and pastels deny any intrusion upon the intimate activities suggested by the keyhole view, but cool or not the results are incandescent. With Ingres the nudes look aware of the presence of the artist. With Degas they do not. This distancing, this assumption upon the part of the artist that he is concerned with what exists and not with how he feels about it is, with Degas, a sublime confidence trick. It is the classical stance which, like ice at a certain temperature, burns. It is the product of a physical identification with the subject which removes her from the sexual arena because the artist feels the stress in the model's action and becomes an extension of it rather than a future participant in it.

Degas disdained possessive participation as he disdained honours and as he disdained the fame which eventually came to him. 'There are certain kinds of success', as he told Forain, 'which are indistinguishable from panic.' That is the remark of a man who keeps his cool.

1953–56

Sight Unseen

THE INTEREST which musicians have taken in painting is peculiar *plates*
and I have been speculating about it on and off for years. I do not *43–46*
suggest that my speculations have been anything but idle and the
conclusion one is tempted to make, that musicians are seventy
parts as blind as bats, may be an unjust one. They are, however,
taken as a section of society, very odd in their tastes and the greater
the composer the more eccentric his appetite if any for the visual
arts appears to have been.

I was led originally into this idiotic field of research for the
negative reason that Hector Berlioz, for whose music I have a
passion amounting to mania, expressly stated that painting meant
nothing to him. When I first encountered this remark in his
Memoirs, it came as rather a blow to me personally, for Berlioz
is surely of all great composers the painter's composer and in
any case takes his place in my private pantheon in company with
a number of painters and sculptors whose conversation he would
clearly have no desire to share. I felt obscurely that Berlioz had
put me at an unfair disadvantage.

In his *Memoirs* he reports a tribute paid to him by Spontini
when the latter remarks: 'You were wrong to blame the *Institut*
for sending its prizemen to Rome: you never could have com-
posed that *Requiem* unless you had seen Michelangelo's *Last
Judgement.*' One sees clearly what Spontini was driving at and
one sees that the remark was intended as a high compliment.
Indeed it was the only direct compliment which Spontini ever
did pay to Berlioz and the only occasion apparently when
Spontini actually spoke to Berlioz about his music. In view of the
fact that Spontini was a fine composer upon whom, ostensibly,
the mantle of Gluck had descended, and that Gluck was Berlioz's
first and last great love, one might have expected a gracious

acknowledgment of the comparison between the *Requiem* and the *Last Judgement*. Not so, however, for Berlioz comments succinctly that Spontini was 'strangely mistaken' and that as far as he, Berlioz, was concerned the only effect produced by the celebrated fresco had been one of utter disappointment. He goes on to say, 'I know nothing of painting and am not susceptible to conventional beauty'.

I can't say I altogether blame Berlioz for this tart rejoinder. Spontini's comparison is maddeningly apt and the more irritating for that. It has stuck in my mind ever since I read it and I have been unable to look at the *Last Judgement* without seeing in the gesture of the central figure a move to conduct a performance of the *Requiem*. The *Tuba Mirum* seems to fit the picture with the exactness of the sound track of an art film and the extraordinary effect which Berlioz obtained in the *Hostias* by using flutes over a sustained trombone pedal note comes whistling and groaning out at me from the tense groups of figures surrounding the heavenly throne. Furthermore, if you are going to compare the *Requiem* to anything at all, the *Last Judgement* is closer than most things and certainly closer than anything in music.

The flat denial of any interest in painting which Berlioz made on this occasion is in itself intriguing. Here is a composer, whose admirers and detractors alike combine to call him the most 'visual' of all musicians, dismissing the visual arts in one fell swoop. And yet his magical gift for pictorial evocation in sound is continually manifest. The breaking wave which strikes through the song of Hylas in the *Trojans at Carthage,* the wispy glimmer of the spirits over the waters of the Elbe in the *Damnation of Faust* are, to me at least, visionary. They are visionary to me because apart from their beauty as sound, Berlioz contrives by the manipulation of rhythmic emphasis and subtle scoring, a transmutation of sound which extends to the other senses and especially to the inner eye. He has the same ability to call up sights as Shakespeare has. To hear the *Fantasia on the Tempest* is to see the island itself lie milky green and falling into indigo under the travelling clouds while the shafting moonray silvers the foliage as delicately in the music of Berlioz as it does in Shakespeare's words.

I am prepared to accept that this may be my personal reaction but I do not propose to stop at that, for painting or no painting,

Berlioz's power to conjure visions cannot be denied even by pedants who suggest that this extra-musical element detracts from the purity of his music. This is one of several threadbare censures often levelled at Berlioz and I will have a tilt at the four principal ones, at the risk of digressing from my theme.

There are those who despise 'programme music' and suppose that an opus number is a loftier designation than a title for a composition. Such people believe that a frowsty fugue on nothing in particular is worthier than a *Royal Hunt and Storm*. Berlioz himself retorted firmly to this proposition in the parody *Amen Fugue* in Brander's beer cellar. Then there is the notion that Berlioz makes a great deal of noise for its own sake despite the fact that although he required four brass bands and eighteen kettle drums for the *Requiem,* which may be extravagant, he used this entire battery only three times in the whole long work and reaches the ultimate heights in the *Sanctus* which is a tenor solo with a muted accompaniment for strings and chorus. Another proposition frequently made is that Berlioz is not really great because his work is of uneven quality; as if that stricture were not applicable to Beethoven and Mozart despite the critical amnesty granted to the latter which allows even the most trivial occasional piece, written to garnish the Archbishop of Salzburg's dinner-table, to be elevated to the level of great art. The penultimate untenable postulate is that Berlioz was an inadequate melodist. This criticism is made mainly by the deaf and by those whose powers of concentration are limited to the stunted melodies of Wagner who, however remarkable his gifts, could scarcely write in more than four-bar phrases and frequently restricted himself to two- and even one-bar tunes. Berlioz, on the contrary, had a melodic line rivalled, in his time, only by Bellini for its sinuous length. He could encompass eighteen- and twenty-bar phrases and the reason why the inattentive listener finds the great arc of a Berlioz melody impossible to appreciate is that he is incapable of the concentration required to embrace so extended a melodic line.★

Finally there is the business of romanticism. One has often heard Berlioz scoffed at, or alternatively extolled, for his extreme romanticism and in a sense this is a tenable if superficial judgement.

★ *The Repose of the Holy Family* from *The Childhood of Christ* is forty-five bars of unbroken melody.

Berlioz was indeed a romantic human being and went to great lengths to create a legend round his behaviour and the passionate violence of his continually expressed personal sentiments. It was however in his behaviour and in his words that this romanticism finds full expression. It is Berlioz as the protagonist of the *Fantastic Symphony* and *Lelio*, the tormented Berlioz casting himself at the feet of irresponsible females and not the Berlioz of *The Trojans* or of *The Childhood of Christ* who is the romantic. Rather it is the *idea* of Berlioz which is romantic and it is I believe a curious paradox that whilst Berlioz is often dismissed from academic discussion because of this self-imposed romantic fustian, his music is less popular than it might be precisely because much of it is so austere, so carefully if surprisingly shaped and so unromantic. His orchestration is lean and muscular and when he uses, as he occasionally does, enormous orchestral forces, he uses them very sparingly, whereas Tchaikovsky who is much nearer to the true romantic uses, as does Brahms, a far softer and thicker orchestral texture and is as a result far and away the most popular of all romantic composers. A work like the *1812 Overture* has the whole orchestra engaged almost every moment of the time.

The paradox of Berlioz lies in the fact that, a romantic in life, he was, insofar as he owed a direct debt to his predecessors, a composer whose musical thought was formed in a classical mould. He owed his ultimate allegiance to Gluck but the fact was partially disguised, not only from his contemporaries but from posterity, by his extraordinary melodic originality and equally extraordinary powers of harmonic invention together with his passionate receptivity to poetic expression in literature.

Primarily for these reasons he is uneasily coupled in the public mind with his contemporary, Liszt, whose intentions are misinterpreted for a variety of apparently similar but in fact quite different reasons. The extent to which both these great composers are suspect here, mainly results from the predominant influence of German romantic music and from the musical heritage of Brahms via Stanford and Parry, to which the British concert-goer is, all unawares, accustomed. To him both Liszt and Berlioz are suspiciously un-British, whereas Mendelssohn, Schumann, Brahms, Tchaikovsky, César Franck and even Sibelius are not.

All this is, I admit, a digression, but it has served to bring

198

Berlioz together with Liszt, and it is this association which caused me to consider in some detail the relationship between music and the visual arts. I belong, as doubtless all this has revealed, to the cult of Berlioz fanatics. I acknowledge it. Berlioz is the composer whom, above all others, I hold dear, possibly because I am a visual person and Berlioz provides more splendid visions for me than other composers. I do not say that he is as great as Bach or Mozart, I merely say that I have him in my blood and must have shots of him at intervals, although by way of the gramophone needle rather than the hypodermic. Liszt, on the other hand, I admire and consider both underrated in general and ill-considered in particular, but not to me an absolute essential.

The late Cecil Gray, whose conversation in its wisdom and whose enormous knowledge played a considerable part in forming my musical tastes, made in his *History of Music* the curious observation that Berlioz was greatly influenced by literary and pictorial conceptions. Now much that I have to say about Berlioz derives from Gray and probably has been better put by him, but in this he was in Berlioz's own words, 'strangely mistaken'. Berlioz was not influenced by pictorial conceptions as far as I can discover. He was influenced by literature and created, apart from music of great beauty as music, pictorial images in music by an alchemy which does not seem to have stemmed from any great concern with visual images. Liszt, on the other hand, is quite a different matter. Gray has pointed out that Berlioz's intention when he wrote 'programme music' was not, like Wagner's, to use music as a means to a literary or dramatic end but rather to compel literary ideas to subserve a musical end. *Romeo and Juliet* is a superb example of how completely he achieved this. And Gray goes on to say that 'far from allowing foreign elements belonging to the other arts to intrude, he rather extended the boundaries of music in such a way and to such an extent, that it was able to express many conceptions which had hitherto been considered exclusively literary or pictorial. In a word, the art of Berlioz represents an extension of the frontiers of music, a victorious invasion of the territory of the other arts by music: not, as is generally supposed, an invasion of musical territory by literature and painting.'

This is equally true of Liszt's intention, but whereas Berlioz,

disdaining the pictorial and knowing 'nothing of painting', so successfully invaded the painters' territory, Liszt, more than any other composer, went directly to painting and massed his invading musical armies there rather than upon the frontiers of literature – if this lumpy metaphor is admissible.

Faust, one of the subjects most widely interpreted of all by composers, was transformed by Berlioz into a dramatic cantata, the words by Goethe in a translation by Gérard de Nerval. It is an early work much of which was conceived even before the composition of the *Fantastic Symphony* and in its final form it has a looseness of structure which, despite glorious music, makes it an uneasy work to perform, particularly when staged as an opera; nor is it an easy shape to encompass when heard in concert performance. It has many lucidly visual moments, but it very clearly derives its impetus from Goethe and de Nerval. Liszt's *Faust Symphony* on the other hand is one of the very greatest of his works, a complete expression of his sombre genius. It is infused with that deep, intense melancholy which is at the true heart of Liszt's music and which is so remote from the show pieces which are continually and regrettably thrust forward to increase his popularity but undermine his proper fame. Yet what does one discover to be the supposed source of this great work? Not simply Goethe but three pictures by Ary Scheffer.

The source of this information is a programme note written for a performance of the symphonic poem *Die Hunnenschlacht* and published on the occasion when Richter conducted that work at the St James's Hall in 1880. This analysis is signed C.A.B., which means presumably C. A. Barry, whose word is not lightly to be dismissed. Ary Scheffer, one of those salon painters whose work, together with that of Bougereau, was singled out by the Impressionists and Post-Impressionists as the epitome of all that was spurious and trivial in the world of 'official' painting, did in fact paint Liszt's portrait, and one is asked to suppose that he also painted three pictures capable of moving the composer to create the three great movements of the *Faust Symphony*. Where the pictures themselves are I cannot say. It may be that they hang in the sort of whore-house that Gauguin and Van Gogh visited at Arles where they found the Bougereau oil which made them laugh so much. And when one begins to examine the pictures from which

Liszt drew inspiration for his symphonic poems, one is left equally baffled. *Die Hunnenschlacht* itself is a battle piece of resounding grandiloquence. It is not profound music comparable to *Héroïque Funèbre* or the great piano sonata, but it has force, fire and a certain majesty. The impulse to write it, according to the composer himself, came from the vast and dull picture of the same subject by Ernst von Kaulbach and as if this were not enough, it appears that in 1861 Liszt considered a whole cycle of symphonic poems based on Kaulbach's dreary paintings and to be called *The History of the World in Sound and Picture*.

Liszt began to make use of pictorial material during his stay in Rome in 1838–39, seven years later than Berlioz's visit. He had developed an acquaintance with the painter Ingres, whose interest in music was so considerable that any divergence from specialization into other arts on the part of minor practitioners, came to be known as a *violon d'Ingres* in tribute to the master's proficiency as an amateur performer upon that instrument. Liszt's friendship with Ingres undoubtedly encouraged him to look at works of art and he was moved to draw unlikely parallels between the arts, even going so far as to compare Rossini with Titian.

Michelangelo, who had left Berlioz so cold, inspired Liszt to compose *Il Penseroso* after the funerary statue of the younger Lorenzo de' Medici in San Lorenzo at Florence; a Raphael seen at Milan (and now in the Brera) inspired the equally celebrated *Sposalizio* and both these piano fantasias were duly published among *Les Années de Pélerinage*. Thereafter there are many additions to the corpus of pictorially inspired compositions. *Die Seligkeit,* a choral work subsequently incorporated in the *Christus* Oratorio, honours a picture by Cornelius, the *St Elizabeth* oratorio derived from six frescoed scenes of the life of that saint by Moriz von Schwind, the symphonic poem *Orpheus* from an Etruscan vase painting. *St Francis of Paolo* was suggested by a drawing by E. J. von Steinle, and that deeply moving and wonderfully unornamental late orchestral work, *Von der Wiege bis zum Grabe* appears to have been touched off by a deplorable water-colour from the hand of one, Count Michael Zichy.

It is a considerable problem to track down the water-colours of artists as obscure as Count Zichy and in no other way rewarding to contemplate the frescoes of Moriz von Schwind, but an excep-

201

tion is the remaining work to be mentioned in this peculiar catalogue, the fantasia for piano and orchestra called the *Totentanz*. The painting which inspired this strange work is as famous as any in the world and is indeed inspiring in itself, for it was the huge fresco in the Campo Santo at Pisa, called *Il Trionfo della Morte*. This great fresco, thought, in Liszt's time, to be by Andrea Orcagna, is now generally considered to be the work of Francesco Traini. A wider consideration of the period and the circumstances that gave rise to this macabre masterpiece will be found in the essay entitled *The Terrible Survivor* included in this volume, but suffice it here to say that it is one of the major paintings of the *trecento* and clearly connected with the ravages of the Black Death of 1348. Liszt's treatment of the theme combines the qualities of his greatness with those glittering, virtuoso pianistic extravagances which have caused his music subsequently to become so suspect to those who have heard only the popular aspects of it. It is abominably difficult to play, full of ferocious *glissandi* and complicated fingering and again there is a parallel with Berlioz, for the *Totentanz* consists of a series of variations upon the *Dies Irae* which inevitably recalls the last movement of the *Fantastic Symphony*. There is, however, a large disparity of intention and effect to be found in comparing the two works. Berlioz's *Ronde de Sabat* is played against the *Dies Irae,* and his witches lurch and vomit across the solemn chant in an unholy contrapuntal rollick. Liszt varies the *Dies Irae* itself, making it thunder out its solemn warning at the opening and then surge, leap, jingle, rush, trickle and subside, grimly pointing the passage of Death itself, in its many guises. Both works are despairing, both in a sense melodramatic but where Berlioz has used the *Dies Irae* to paint a composer's post-mortem, Liszt has used Traini's painting to comment musically upon the very figure of Death. If one can throw off the prejudice which finds virtuoso piano writing to motivate against profundity, the *Totentanz* becomes profound.

The extent to which Berlioz and Liszt enlarged the scope of musical expression is great, but no one as yet has quite forgiven either of them for doing so. A fairly large body of opinion still exists which looks upon any radical departure from the sonata form as not quite decent, as some kind of confession of failure or alternatively some kind of cheating. And it may well be that in

dwelling upon Liszt's curious and uneven taste in painting I seem to play into the hands of those to whom music can only be 'great' if it suggests no extra-musical association. The parallel prejudice applied to painting is obvious, but it has worked in a historically reverse direction for twentieth-century painting has tended to rid itself increasingly of content – certain painters frequently stress their desire to approach the purity of 'musical' abstraction – whereas music since Liszt and Berlioz has increasingly come to incorporate aspects of subject matter thought by many to be the inviolable preserve of the other major arts. The Romantic Period saw the decay of 'history painting' and both Impressionism and Post-Impressionism tended to minimize the significance of the subject. On the other hand, the epoch when the cry for 'significant form' in painting was at its loudest was also the epoch when the symphonic poems of Strauss and Sibelius were the music lovers' newest pleasure and Debussy, Ravel and Stravinsky were concerning themselves with subjects as positive and diverse as musical seascapes, Spanish landscapes, the spectacular behaviour of Greek Gods and the religious celebrations of primeval Russians.

During the second half of the nineteenth century and the first half of the twentieth, painting appears to have stimulated an extraordinary collection of composers; from Ambroise Thomas who maintained that the song *Connais tul e Pays* from the opera *Mignon* was the direct result of brooding upon a picture by . . . who else but Ary Scheffer . . . to William Walton whose overtures *Portsmouth Point* and *Scapino* derive respectively from a water-colour by Rowlandson and an engraving by Jacques Callot. Rachmaninoff and Reger both responded to the romantic lure of Arnold Böcklin's gloomy *Isle of the Dead;* Böcklin in fact proves to be the composers' favourite after Ary Scheffer, at least he can be blamed indirectly for a record number of musical compositions including eight variations upon different pictures by a certain Hans Huber, the most bizarre of whose tributes is entitled *The Hermit Fiddling Before the Statue of the Madonna.*

Great painting also has its adherents. Goya inspired Granados and Botticelli inspired Respighi, although to no great effect. Breughel's *Carnival and Lent* was chosen by the Czech composer Zdenek Fibich and Dürer was the cause of Richard Mohaupt's *Stadtpfeifermusik.*

45 None of this is of any great musical consequence but undoubtedly three works by major composers have resulted from the contemplation of paintings, since Liszt's day. Of these the slightest but not the least beautiful is Debussy's *L'Isle Joyeuse*. This exquisitely elegiac work for piano was intended as a musical comment upon Watteau's *L'Embarquement pour L'Ile de Cythère* and it is a comment of the most delicate relevance. To hear the one played in the presence of the other is to have both augmented and this is rare indeed as an experience. The case of Moussorgsky is rather different. The intensity with which he responded to the exhibition of Victor Hartmann's pictures cannot be questioned but the extent to which he was affected by his friendship with Hartmann and by the latter's sudden and tragic death may have had a good deal to do with it. Certainly it is difficult to see how the rather depressing water-colours which made up the *Pictures at an Exhibition* could have caused such superbly exciting music but then one should always remember Ary Scheffer's three pictures of the protagonists in *Faust*. Victor Hartmann was an architect of some distinction, a friend of the painter Repin, a member of the Balakirev circle, and one of Moussorgsky's intimates. The sudden death of Hartmann at the age of thirty-nine came as a profound shock to the composer and, as his letter to his friend Stassov shows, moved him to a wildly Russian passion of grief. It was the memorial exhibition of Hartmann's water-colours and drawings in 1874 which Moussorgsky visited, composing in honour of his friend the set of ten piano pieces, linked by four intermezzi, which is called *Pictures at an Exhibition*. It is, as far as I know, the only occasion when an entire exhibition of pictures has been paraphrased in music. Moussorgsky describes his intermezzi as *Promenades* during which the spectator moves along the gallery from picture to picture, in sound as resplendent as the progress of a Czar, and the musical impact of each picture upon this majestic spectator, whether it be a costume design for *A Ballet of Unhatched Chickens* (designed for a ballet improbably called *Trilby*), a self-portrait of Hartmann exploring the catacombs of Paris with a lantern, or an architectural drawing of the Great Gate at Kiev, is enormously greater than the visual effect is likely to be upon anyone catching sight of any of the pictures themselves. Moussorgsky was in truth inspired by Hartmann

rather than by his works so that in a sense, magnificent though the music is, it is only indirectly connected with painting.

In this I believe Moussorgsky differs from Liszt, for despite the fact that Liszt wrote music in connection with pictures more trivial even than Hartmann's, he was, unlike Moussorgsky, far more deeply concerned with the image than the artist. Moussorgsky loved Hartmann but very clearly Liszt had no cause to love Ary Scheffer personally for, according to Legouvé, Scheffer was disgustingly rude to him and whatever Liszt's personal feelings for Steinle and Zichy may have been, he obviously cannot have had any particular concern with Raphael or Traini as persons.

Now this prodding at one aspect of the extra- or submusical tastes of composers, and in particular of Liszt, will not appear consequential to people who like to keep the arts in separate compartments. But then such people are not likely to be deeply concerned with either Liszt or Berlioz, or for the matter of that with Moussorgsky either. They may admire *Boris* but they will prefer it in the Rimsky-Korsakov version.

Berlioz and Moussorgsky are alike in their singularity and in that both are virtually inimitable. Liszt on the contrary has had the widest and most powerful influence upon music, wider and more general perhaps than any other composer of the nineteenth century. Without Liszt, Wagner would have composed very differently. He stole ideas from Berlioz (I do not wish to imply anything discreditable in this) but he made no bones about his debt to Liszt. The symphonic poems of Richard Strauss derive an immeasurable amount from Liszt; Smetana, Dvořák, Saint Saëns and even Grieg were all essentially from the Lisztian stable: the great Russians Balakirev and Borodin owed him much and the lesser lights from Glazounov to Scriabin could hardly have existed without him. Busoni was his direct musical descendant and the twelve-tone system foreshadowed in Liszt's *ordre omnitonique* makes even Schönberg's spiky enclave a cadet branch of the family.

In the light of Liszt's influence, the fact that he, more than any other composer, was concerned with visual images becomes of considerable interest. It would probably be justifiable to suggest that all the compositions inspired by painting are ultimately brain children of Liszt from his own *Sposalizio* to Hindemith's

Mathis der Maler symphony, the major twentieth-century example of the genre. The opera★ *Mathis der Maler* has as its hero the mysterious figure of Mathias Gothart-Nitart called Grünewald, one of the greatest, if not the greatest, of all German painters, and Hindemith's libretto deals with the religious problems of this tormented Protestant contemporary of Luther. The libretto, by the composer himself, is of unusual excellence and the opera, if not a masterpiece, is of considerable importance. But the orchestral music which describes Grünewald's *chef d'oeuvre,* the *Isenheim* polyptych now at Colmar, is directly inspired by the painting and not by the painter; it is also complete in itself. The three movements are named after three panels from the ten which comprise the great altarpiece. The first, the *Concert of Angels,* interprets the left-hand inner panel in which an array of gorgeously spectromatic beings play stringed instruments before the Madonna, the second movement concerns the predella panel of the *Entombment* and the third describes the wild frenzy of the *Temptation of St Anthony.* In no sense can this music, impressive though it is, be described as a musical counterpart to the mighty creation of Grünewald himself. It is Hindemith's response to a masterpiece and not a masterpiece in its own right, but it is music of high quality.

43

I know of no painting of the first rank to have come directly from music in the sense that the compositions mentioned in this essay derive directly from painting. Music played a large part in the lives of artists as different from one another as El Greco, Gainsborough and Ingres, but to my knowledge only Fantin-Latour was rash enough to attempt in painting the reverse process, by interpreting music visually. This he did with conspicuous lack of success. The musical analogies which Whistler suggested by calling certain of his pictures 'Harmonies' and 'Nocturnes' is perhaps a little nearer the mark, but the connection is scarcely more than titular. Clearly the relationship between the arts of painting and music has acted mainly in one direction and in a slightly dubious direction at that. Such composers as Chabrier, who really possessed a passion for painting and a rare discrimina-

★ There are in fact quite a number of obscure operas dealing with great painters, but these do not come within the scope of this essay as the music results from the romantic life stories of these artists, rather than from their art.

tion among Impressionist pictures, which he collected, never admitted to being directly inspired to musical composition by such possessions.

Nevertheless, it is not quite so simple as that. A visual inspiration, however nearly literary it may be, is not precisely the same as an outright literary inspiration because a visual image, however inadequate as a painting, does not have precisely the same effect as a passage of prose or verse. The paraphrase of natural sounds in mundane circumstances which, for instance, Couperin and Scarlatti exploited so elegantly upon the harpsichord is essentially a different *kind* of response from Debussy's paraphrase of Watteau, although Couperin might fancifully seem to be Watteau's musical counterpart.

To recall a story musically whether it be that of Tyl Eulenspiegel or Francesca da Rimini may or may not necessitate, in the creative process, some array of protagonists upon the stage of the composer's mind, but that again is different from the composer's direct response to a visual image. Somewhere in between, one must assume, comes the sort of musical landscape painting of Smetana's *Ma Vlast* or Mendelssohn's *Hebrides* overture.

It would be perfectly possible for a blind musician to write a symphonic poem on the Temptation of St Anthony or The Triumph of Death but the impulse to do so would not be Hindemith's nor would it be Liszt's. Unfortunately, when one examines the visual images which have had a positive effect on composers, one is disconcerted to find that with about four exceptions the better the musical tribute the more trivial has been the object to which the tribute has been paid. Composers who salute Botticelli or Goya are minor figures and presumably those who admired Rembrandt and Giotto have been so unimportant that no one has come across their music.

All that one can really look forward to with enthusiasm in this odd field would appear to be some hitherto unpublished work of Bartok inspired by Marie Laurencin. The reader may choose his own hypothetical combinations of sights and sounds. In the end I am left rather nonplussed. Perhaps it is a pity Spontini made that remark to Berlioz.

1956

The Ear of Man Hath
Not Seen

NONPLUSSED I was in 1956 and in 1970 I am no less nonplussed to read the assurance, in Mr Rollo Myers's book on Chabrier, that today the view is widely accepted that there is a new twentieth-century tendency to stress 'not so much the differences that separate the arts as the features they have in common'. I seem to have missed this when, in 1956, I compiled, haphazardly, the rough catalogue of music inspired by painting upon which the previous essay was based. Certainly I was largely concerned then with music directly inspired by specific pictures. I did not wish to convey the impression that composers in general were wholly insensitive to painting and sculpture, nor indeed that painters are deaf to having their savage breasts soothed. On the contrary, we know that El Greco used to employ a small orchestra to play to him while he painted and Baudelaire refers to Liszt as reporting that Delacroix 'was wont to fall into deep reverie at the strain of that tenuous and impassioned music (of Chopin) which is like a brilliant bird fluttering above the horrors of an abyss'. Doubtless as many painters have responded to music as musicians have to painting, but that was not the point I was making: rather I was concerned with the direct bridge from painting into music which Liszt himself built on more numerous occasions than anyone else. Common enough *correspondances,* as Baudelaire might have put it, exist between literature and all the other arts, despite the disapproval of academic purists, critics and simpletons in various camps.

Mr Myers notwithstanding, I haven't found much to add to my *catalogue provisoire* in the last fifteen years, except for John Taverner's songs inspired by surrealist paintings, Gunther Schulz's *Seven Studies on Themes by Paul Klee,* Humphrey Searle's

Jerusalem based on Blake's prophetic book together with the illustrations, and the *Vesalii Icones* of Peter Maxwell Davies which was inspired by the anatomical engravings which illustrate the *De Humani Corporis Fabrica* and did much to make Vesalius famous, as well they might, for these vigorous *écorché* figures, posed as if alive in the landscape of the Veneto, are by an artist of outstanding talent who may even have been a pupil of Titian. Vesalius however did not acknowledge his collaborator and his identity remains disputed.*

What seems to have happened otherwise in recent years is not so much a fusion of the arts as a confusion among them. Rejecting much of orthodox notation, *avant garde* composers have taken to conveying their intentions by making elegant abstract drawings to signify combinations of sounds, which presumably advances the proposition in a practical fashion that all art tends to the condition of music and vice versa. True, sculpture has taken on the colours of brand image packaging, while kinetics tinkle, painting has bulged into simple relief and much in the way of 'happenings' and performed events of an aesthetic nature have had music to aid in holding the attention of those whose pleasure lies in public experiences of this kind. I do not think any of it contributes to my narrow field of speculation here, but I may be wrong.

What I was wondering about in 1956 has become to me marginally clearer as a result of my increasing addiction to Berlioz and an interest in his *correspondances,* however sternly disavowed, with the visual arts.

When I first read Berlioz's rather dismissive remark to Spontini about Michelangelo's *Last Judgement* and its relevance to *The*

* With this essay in proof a small hoard of further examples came to my attention. Of these, there is one I should have known about. This is a sombre composition by Janacek composed in 1901, called *Otčenaš* (The Lord's Prayer), a tragic cantata in five sections for organ, harp, woodwind, and chorus, inspired by seven pictures by the Polish painter Joseph Krzesz-Mecina. The others are Gerard Schulman's six orchestral studies after paintings by Francis Bacon and (as a reward perhaps for my researches in the field) a further composition in preparation by Humphrey Searle to be called *Labyrinths,* derived from my own sculpture. Finally, there is the important but peripheral case of Hans Werner Henze's *The Raft of Medusa* which is related to Géricault's masterpiece, but which was not directly inspired by it. The idea, according to the composer, came from his librettist Ernst Schnabel, but Géricault's image of the negro, Jean Charles, who plays so important a role in the work, as he did in the historical event, was important to Henze.

Requiem, I accepted it uncritically as a statement which was patient of no modification. I now doubt this. I think Berlioz's response to the visual to have been intense, and whilst this is a subjective speculation on my part and Berlioz never did modify the statement, there is no doubt that sculpture, as in the case of Cellini's *Perseus,* meant quite a lot to him and I do not believe Cellini's autobiography to have been his sole inspiration or he would not have gone out of his way to look at the great bronze in the Loggia dei Lanzi once more before he left Florence with the intention of murdering Mme Moke, Mlle Moke and M. Pleyel. Furthermore, Berlioz had been inspired by, or at least had related himself in some measure to, Delacroix's *Death of Sardanapalus* and the very fact that the resultant cantata came to disgust him, may well have been enough to make him snap at Spontini. For one who expressed himself as 'knowing nothing about painting' and being 'not susceptible to conventional beauty', by which I interpret him to mean pictorial imagery, Berlioz's eyes, I would maintain, remained as receptive as his ears. Be that as it may, he obstinately declined to admit of visual inspiration, frankly triumphant though he was in celebrating his debt to poetry.

To me, Berlioz had the most optical ear ever granted to a composer. I do not mean by this that he 'painted' a more varied farmyard than Beethoven did in the Pastoral Symphony, nor do I think he was concerned with the kind of tone poem which floats the listener along Bohemian rivers or is intended to evoke a misty vision of a Finnish swan at swim. I mean that for me he experienced the sort of nervous response to visual phenomena, by means of sound, which such a visual as myself needs to work by sight, and this experience as he transmuted it was of an intensity which I must seek to celebrate although I may fail to prove my contention in scholarly terms.

At its most subjective, my conviction that the *Scène aux Champs* from the *Symphonie Fantastique* could not exist without Giorgione's *Concert Champêtre* is not likely to gain much learned support, since Berlioz may never have seen it, but more especially in view of the fact that even the most ardent critical advocates of Berlioz want only to prove that he was as 'pure' a musician as Beethoven and his work is no more affected by such a trivial gift as the ability to stimulate visual responses than that of any equally

great musician. It does not seem to me to denigrate Berlioz to suggest that the correspondence between sight and sound which he could establish in the electrifying moment when the wave breaks on the shore, in Hylas's song in *The Trojans at Carthage,* contributes to the effect. I do not doubt that it was the sea itself and no painting by M. Vernet that enabled him to do so, but I think it was sight no less than sound which made it so exact. I think too that Piranesi's *Carceri,* his etchings of imaginary prisons, which Théophile Gautier set such store by and may well have introduced to Berlioz, relate with such extraordinary precision to *The Funeral March for the Last Scene of Hamlet,* that it cannot simply be an imaginary correspondence discovered and relished by me. It may be that it is, but my instincts deny it.

What cannot be denied is that Berlioz composed no music to which he attached the name of any picture by any painter and only Cellini's *Perseus* among sculptures is known to have inspired him. This ostensibly it did in the last act of *Benvenuto Cellini* when the licence he took with the techniques of bronze founding as a spectacle must rank with Auber's contrivance in *Masaniello* where, to the best of my recollection, the dumb heroine from Portici leaps the distance from the Ducal palace of Naples into the crater of Vesuvius; a record as yet unrivalled for the long jump, even in opera.

All this would be idle speculation and probably is, were it not for a development to which Mr Myers refers, which must, I suggest, stem from Berlioz. That development was the nineteenth-century concern in France to relate music to painting without specifically citing an individual work of visual art as the cause of a musical composition. I do not doubt that Liszt was also important in this context, but then Liszt did specify his pictures.

Considering how wide and deep Liszt's influence on piano composition had proved to be, it seems odd that a composer as concerned with that instrument as Chabrier and clearly so interested in painting should not have followed Liszt's example and composed at least one piano work directly inspired by a picture. I do not suggest that Chabrier would have slavishly followed Liszt in this but rather that the later nineteenth century was such a period for collections of short 'autobiographical' piano pieces of the kind assembled into *Les Années de Pélerinage*. Chabrier owned

more pictures by his contemporaries than any composer on record and lived with Manet's *Un Bar aux Folies-Bergère* hung above his piano, but did not, so far as I know, make musical use of it. What he did do was to employ techniques in music which corresponded with the pictorial intentions of the Impressionists. In effect he translated, according to Mr Myers, 'the impressionist theory in terms of light into terms of sound', decomposing harmonic roots into sonorous components and thereby creating harmonies of a kind which Debussy adopted and made his own, just as Monet broke local colour into harmonic components which he reassembled to create the effect of light on form.

That this tendency was in the air in the 1880's is further borne out in an exchange, quoted by Mr Myers, between Eric Satie and Debussy. 'What we have to do,' said Satie, 'is to create a musical scenery, a musical atmosphere in which the characters move and talk – a certain atmosphere that suggests Puvis de Chavannes.' It is odd to think that thirty years later Satie should have created the musical atmosphere through which Picasso's cubist 'managers' pranced in *Parade,* but then the art of Puvis was in its time consequential enough to influence Picasso's 'Blue Period' and the act drop for *Parade* shows marked traces of the memory of that influence.

When Chabrier was born in 1841, Berlioz was thirty-eight. When Berlioz died, Chabrier was twenty-eight and none of the dominant figures in music was French. Berlioz himself had been set aside in France and despite the respect in which he continued to be held by enlightened individuals including Chabrier, the French then neglected his music much as they still do. Wagner was the centre of attention with Liszt, Brahms, Mendelssohn and Schumann in command of the piano and much of the orchestral repertoire, and it was precisely to find their way from under Wagner's suffocating weight that Chabrier and his younger contemporaries took the path they did, despite their admiration for much that Wagner had composed. As Satie put it to Debussy: 'We ought to have our own music – if possible without *choucroute.*' The *choucroute* describes the Franco-Wagnerian trend with an accuracy typical of Satie. It is cabbage. Translucent, of a fascinating texture, savoury and tart it may be, but cabbage it is and of a flavour so pervasive that only sausage or pig's knuckles can with-

stand it in combination. What it has is weight and this, it seems to me, is an attribute which might well lead the composer of *España* or *Joyeuse Marche* to feel some indigestion. A man who singles out *The Damnation of Faust, Romeo* and *L'Enfance du Christ* for special admiration is not likely to swallow unlimited musical cabbage, however succulent the dish may be thought to be. There are, he said, in Wagner *'les moments sublimes, mais des mauvais quarts d'heure'*. Moreover, a most conspicuous quality lacking in Wagner is just that ability to create a visual correspondence with sound of which Berlioz is the supreme exemplar in music.

Could it be therefore that Berlioz, who austerely denied any knowledge of painting or any interest in conventional beauty, was in fact the progenitor of that 'certain atmosphere' which his admirers of the next generation, Chabrier and d'Indy and those even younger, Satie, Debussy and Ravel, sought to create and which might at least be compared with painting at the level of evocation? True, the atmospheric blurring of the contours of shapes by which the Impressionists showed light to eat into form is much more clearly to be compared with the unresolved and unrelated chords in the opening bars of Chabrier's *Le Roi malgré lui* than it is to the crystalline evocation of dappled light which shines through the *Queen Mab Scherzo*. The latter is too crisply scored to feel like Impressionism and indeed it was written long before Impressionist notions were fully evolved. A Sisley or a Renoir would not have handled the sensation of light so sharply or so classically. Seurat perhaps might have done so.

Satie in a lecture on Debussy asked: 'Why shouldn't we make use of methods employed by Claude Monet, Cézanne, Toulouse Lautrec, etc., etc. . . . ? Nothing simpler. Aren't they just expressions?' and if this proposal, outrageous though many will doubtless find it, is allowed, then the textures of sound which are in some ways worlds apart from the textures assimilated through the eye, may be experienced with comparable responses. In this case the 'drawing' delineated by Berlioz in his astonishing use of rhythmic shifts and changes is as often as abrupt as a Goya when the long melodic line is not as sinuous as an Ingres. These too are expressions.

Chabrier numbered Manet among his closest friends, knew

Monet, Renoir and Sisley and collected their works. He never composed his responses to Manet's *Le Skating* nor Monet's *Les Bords de la Seine* nor joined Renoir in *La Sortie du Conservatoire*. He simply lived with the pictures and with seven other Manets, seven other Monets and five other Renoirs, together with pictures by Sisley, Cézanne and Forain. Would one have any inkling of this enthusiasm and these possessions from his music? In Mr Myers' view one would, and in my view Debussy's passion for Turner is no less evident in his compositions inspired by the movement of water than his feeling for Watteau which he avowed as the inspiration for *L'Isle Joyeuse*. Despite his rejection of the term 'impressionist' as applied to his music, that music is related to a way of seeing.

It might reasonably be argued that the arts do not cross-fertilize so generously as I have suggested and the circumstances of this pollenization have perhaps been uncommon. They have however existed, especially in France between 1830 and 1840 during the most formative period of Berlioz's career. It might also be argued and certainly will be, that in making a tentative case for Berlioz as a 'visual' I am indulging in special pleading for my own response to his music rather than advancing a convincing case. If I do so, it is to seek to add to, rather than detract from, his stature. I am, as David Cairns has described me, 'a Berlioz maniac' doomed, as he optimistically wrote, to become 'superfluous as a species, superseded by evolution'. He should know, I suppose, as the translator of Berlioz's *Mémoires* and the most prescient and vocal champion of the master; but I wish I were as sure as he is that the cause is won. Despite my extinction, I feel more Bottom than Brontosaurus where Berlioz is concerned, for I find in his music that 'the eye of man hath not heard, the ear of man hath not seen . . . what my dream was'. Furthermore, I have been but an ass to go about to expound this dream, because it has no bottom and yet I have done so in one medium and another for twenty years and more, making portraits of that sardonic, hawklike head from youth to old age and finding, in the landscapes I painted, strains from his music running in my mind as I worked. And, peradventure to make it more gracious, I exhibited my dream in London in 1969, all sixty-three bronzes, paintings and drawings, and I called it *A Debt to Hector Berlioz*. It was in the latter end of a

46

play, not before the Duke but before the English and in this play, for a whole year, we heard the celebration of the music of Hector Berlioz and paid homage to the man on the centenary of his death. As for those who may feel inclined to dismiss these speculations and for the matter of that my mazed involvement with music in which I am in no way learned, or even to disparage Berlioz, the Oberon of my midsummer night, I say to them, in the words of Baudelaire: 'You have forgotten the colour of the sky, the movement and the smell of animality, you whose wizened fingers, paralysed by the pen, can no longer run with agility up and down the immense keyboard of the universal *correspondances.*'

<div align="right">1970</div>

*Three
Essays on
Picasso*

The Master of Pastiche

A Juvenile Essay, 1944

'There ought to be a dictator of painting.' PICASSO

To WRITE anything but praise, or to attempt anything but a favourable analysis of the present value and future significance of the art of Picasso, is to be attacked at once. One is accused, if one is a painter who has been influenced by Picasso, of ingratitude and of changing one's spots in midstream, to coin a mixed metaphor in the manner of the master's painting. It is rapidly and ably demonstrated to one, that almost all good painters, and bad ones too, have been affected by his work, and it is pointed out with awe that he has changed the course of European art, that he is a great genius and that to do anything but genuflect to his art, is to be either a bigot, an envious retrograde or worse, a fool who cannot understand the great man's purposes.

I do not for an instant deny the first two arguments. Picasso's influence has probably been greater in his own time than that of any artist in history, and unquestionably he has changed the course, not only of art, but of decoration, and the applied arts. There is no question of his genius. I suggest, however, that changing the course of European art does not *ipso facto* improve that course and that, whilst to have done so compels admiration, it does not necessarily command veneration. Such men as Hitler have changed the course of human history to the disadvantage of mankind, and I believe that Picasso, taking all into account, has been of very negative service to art in his changing of its course. But the one accusation I find hard to take, is that of not understanding Picasso. Heavens alive, his work is not difficult to understand. If it was really obscure, if it really required long and concentrated study, Picasso would not be the richest and the most famous artist alive. Once the fairly simple mechanism of his approach is grasped, and once one is familiar with a large body

of his work, his diverse mannerisms and his recapitulation of basic themes follow an inevitable, perfectly comprehensible course.

Picasso has required numerous art forms upon which to base his experiments. He is not concerned with nature, nor with a single tradition, and in this he differs from the artists of the past, as Woolworth's differs from the craftsman's shop. What he does is to engulf an existing formula, choosing, it seems, at random from the history of his art. It may be Negro sculpture, Greek vase painting, or the drawings of Ingres. This formula, once digested, he regurgitates, like the albatross feeding her young, accentuating certain characteristics and obliterating others. Having exhausted one formula he turns to another, possibly maintaining part of the first. As soon as the student recognizes the process, he will, with a fair knowledge of art history, be able to recognize the derivation and judge the value of the variations.

Nothing could be simpler than this process, and it is indicative of Picasso's genius that the objects he chooses as vehicles for his method have always been equally simple – a table, a female nude, a piece of newsprint or an old guitar. From the point of view of the observer, the commonplace object combined with the spectator's vague familiarity with the underlying mode – the classic Greco-Roman head, for instance – establishes a comfortable association of ideas which prepares him for whatever apparently outrageous exaggeration Picasso may see fit to use to enliven his picture. Since Picasso has a magnificent gift for linear expression and complete technical mastery at his command, the result is a very tasty or, intentionally, very disgusting dish. But whatever the taste, it remains a dish; it is cooking, not art. The opposition will say 'nonsense'; they will say that all painting is only this, and that Picasso is perfectly entitled to employ these means since he triumphantly justifies them. I would say that whilst this utilization of an adopted manner begins the development of all young artists, whilst the influence and traditions of their predecessors are the basis of all great artists' work, the perpetuation of this procedure throughout a long life is not to develop a vision but to perfect a pastiche. Changing the derivation does not complete the artist. The difference between, say, Breughel and Picasso, is that whilst Breughel produced pastiches of Bosch in his youth

he looked at nature as well and eventually arrived at a mature and personal vision of nature itself, whereas Picasso has never been able to shed the element of pastiche underlying his work because he has always looked to art and not to nature to supply his visual material. Paradoxically the *dilettanti* of today who are so foolishly quick to despise a legitimate influence present in a young artist's work are prepared to swallow with delight the painting of Picasso whose derivations have been so blatant for forty years. Originality is in itself an exceedingly unimportant aspect of art from the point of view of the practitioner, and it has only achieved a spurious importance during the twentieth century, the very times which have been dominated by Picasso himself. This significant paradox is in my view one of the major disservices which the art of Picasso has paid to contemporary painting, for it is Picasso's transitions from one derivation to another which have created the false supposition that self-conscious variation of style is originality and therefore commendable. Genuine originality in painting is not a conscious virtue but merely the artist's minute personal addition made to a tradition by the study of nature. In a broadcast recently, an admirer of Picasso praised him for the fact that he had 'opened his mind with astounding versatility to a wide number of stylistic influences' and went on to enumerate them at length, as if there were some unusual virtue contained therein. But is there? And is Picasso's constant delving into the secrets of gradually evolved methods applicable to the problems and ways of thought of divers times past, compatible with his mystic dictum, 'I find, I do not seek'? Theft may be the perquisite of genius in an art; well and good, but kleptomania is another thing.

Perhaps the reply to my argument would be to repeat that any means are legitimate to attain the ends and are not Picasso's ends marvellous? In my view the whole of Picasso's art has been an intellectual exercise of which ninety per cent has been pure artistic vampirism without the natural visual stimulus necessary to produce great art. Picasso is a genius after all and can only be judged by those standards, for his ends are, if nothing else, marvellous as sheer virtuosity. Marvellous, but utterly false, and the means carry with them, in Picasso's supernormal talents, a tremendous power to communicate the spurious and to menace the living stream which the visual arts have been since pre-history. Picasso's

achievement has been to juggle with the archaic so fast that it appears alive as it glitters in mid-air. Had he not been an acrobat, as Jean Cocteau remarked, he would not have saved himself. Picasso's intellectual power is coated with the fierce colour of his nationality. The trappings of Spanish passion, bulls, women, guitars, blood and cruelty, recur at intervals and convey, again I think by association of ideas and brilliance in performance, deep, vital emotions which, in my own view, are often simply not there.

I do not believe that it is possible to create living art out of anything but the direct visual experience of nature, combined with the heritage of a tradition, unless it be by the practice of magic ritual. Since Picasso does not attempt the former, he must be considered in terms of the latter, and considered in these terms his processes of stylistic inversion and formal disintegration are black magic, no more, no less. That inversion and disintegration of form are present in most of his work may be easily observed at once in Cubism, which was based on the latter principle and in the convention which he has employed at intervals, of re-stating the human head in unrelated sections.* The parallel with black magic can be carried further, for distortion and alteration of ritual is at the basis of the cult and of the art of Picasso. To his most devoted admirers he is celebrated for his gift for paraphrase. Black magic is also the cult of personal power, and fame goes with it. Of these two latter attributes Picasso shows no lack. He is the most powerful influence and the most famous artist alive, but is it possible that any contribution to the mainstream of European art can be made by this particular form of diabolic egocentricity? In view of the fact that black magic is a death cult and in view of the fact that the whole impetus of Picasso's art stems from manners and modes created for now extinct ends – the Romanesque, Catalan primitives, the Greek vase and medieval stained glass are examples – he is a very master of necrophily. Magnificent embalming – but death all the same.

Regarded without hysteria, it is surely plain enough that Picasso's constant, mercurial changes of style, which are today extolled as the fruits of an unique and all-embracing genius, are not a genuine development but superlative conjuring. Remark-

* 'In my case a picture is a sum of destructions.' Picasso, 1935. *Conversation with Picasso,* Christian Zervos (Cahiers d'Art, 1935).

able though it is to have pulled so many rabbits from a three-cornered hat, it is not necessarily a superior procedure to the more prosaic course of visual development experienced by all previous great masters of painting.

It is obvious that present-day transport and world-wide communications have made it possible for the twentieth-century artist to acquire a greater general knowledge of the world's art without leaving his capital city than could his sixteenth-century predecessor. But Picasso's eclecticism is not excusable simply on the grounds that earlier masters would have utilized the same gamut of stylistic derivation as Picasso had they had the opportunity. I do not believe that they would, because once each, following in his natural tradition, had accepted from his predecessors the influences of best service to his vision, he turned to nature for his material. Pieter Breughel, for instance, learned much from Hieronymus Bosch and Joachim Patenir in his youth, and indeed he scrupulously imitated Bosch for several years; Watteau acknowledged and paid his debt to Rubens, El Greco to Tintoretto and Goya to Velasquez, but these men must have been equally well aware of other aspects of painting. Breughel must have seen Italian and Spanish pictures, Rembrandt, in his days of affluence, collected every form of *objet d'art* from Indian miniatures to Mantegna's engravings, and Watteau knew the collections of pictures from all the European schools which were assembled in Paris. But these artists having assimilated what was useful to their own art, from that of other men and other times, looked at the object, and adapted it to their purposes. Herein they differ radically from Picasso, for they discarded the borrowed props of style quite early in life, in favour of natural observation. The art of a Breughel, a Rembrandt, or a Goya is a complete and logical development from beginning to end, so is that of Rouault or Renoir and even that of Blake; for though the latter borrowed technical crutches from the Italians, and though nature was a secondary consideration in his art, his expression was consistent and its strength lies in that consistency. Blake was not remarkable as a technician and his own technical shortcomings excuse to some extent his borrowed mannerisms. No such excuse is needed by Picasso, the greatest technician of his age.

I suggest that the sheer instability of Picasso's genius is not a

priceless miracle, but simply the result of exhausting the possibilities of manner to such an extent that his most original-looking works are actually those in which he combines his own early periods with his current clichés, thus confusing the obvious sources. And yet he himself has strenuously denigrated self-imitation.★ The effect that their idolatry of these essential weaknesses has had on his numerous followers has been to deify an originality which in actual fact is only ingenuity.

It is, however, obvious that no individual could maintain such sway over the arts for so long, nor carry such conviction to so many intelligent and sensitive artists and laymen, unless he was possessed of tremendous powers. What these powers are, has been dilated upon at enormous length in numerous publications, but what I surmise they amount to is this: Picasso is a master technician and his many 'periods', whilst they may not accord with the development of a real vision, are at least in accord with the prevailing hysteria of the times. Furthermore, the immense excitement which Picasso is able to evoke is in part due to his superb use of line, for he is primarily a draughtsman, and also to the emotion provoked by the novelty of his gift for paraphrase and his ability to carry a discovery, or the product of a movement, to a logical, or sometimes illogical, conclusion. It is part of his power that he is able to embrace the efforts of lesser men and re-state their aims, in his own terms and in relation to the formula current in his own work. This in itself is the hallmark of a particular form of genius. But more than all this, his power lies in his position relative to his times, his temporal domination. Nor is this incompatible with the archaism of the different stylistic starting points of each new *'époque'*. It seems that Picasso is contemporary in the hysteria of his art in exactly the same way that Hitler is contemporary in the hysteria of his politics, much of which – anti-semitism is an example – is archaic in principle. In the course of profoundly disagreeing with my assessment of Picasso, a contemporary English artist once made the point that Picasso's major positive contribution to painting was his invention of the 'paraphrase of reality'. I do not believe that this is what he has done; rather, I believe he has evolved a brilliant paraphrase of *art,* so brilliant and so all-embracing that one is unable to see the wood

★ 'I have a horror of repeating myself.' Picasso, 1935. *Ibid.*

for the trees and in the immense prodigality of his gifts he has thus foxed a whole generation into believing in a set of 'emperor's new clothes'.★ Idolatry has been carried so far that Picasso's every work, from doodle to mural, is now greeted with indiscriminate approval. Even a piece of torn-up paper is solemnly reproduced in a recent book. His own clichés, which he has taken to imitating in his most recent work, are marked as wondrous and immaculate conceptions, new, devastatingly new phenomena of immense value, both in terms of money and posterity. But if one examines his life work, his many periods, one finds that in each one he has but grasped at the straw of another man's discoveries and twisted it to his own ends. This activity may be wonderful in the skill of the achievement, but it is not a deep and personal vision of nature or life and its products are as transitory as the winds. In time they will date as badly as the later music of Igor Stravinsky, a very similar if lesser figure.

Picasso is first seen as a child prodigy, painting with precocious skill, and in Paris at the age of nineteen he embarked upon his first recognized 'period', which is now named after Toulouse-Lautrec, who was the principal influence upon Picasso at this time; a perfectly legitimate derivation for a young artist, and undoubtedly of use to him. In 1901 he painted in a decorative, poster-like manner under the influence of Van Gogh, Maurice Denis and Vuillard, and in 1902 he turned to Puvis de Chavannes, a painter of sad, blue lyrical pictures which Picasso skilfully combined with El Greco and seventeenth-century Baroque mannerisms to produce the famous 'Blue Period'. To this ragout he added various of Degas' subjects and much of the latter's theatricality. The 'Pink Period' which follows is still a fairly straightforward development from the Blue, incorporating the harlequin of Watteau and a soft Greek flavour compatible with the wistful sentimentality which replaced the morbid gloom of the previous five years. The first of the abrupt transitions took place in 1906 when Matisse presented the young Picasso with a piece of Negro sculpture and Picasso abandoned his previous formula in favour of a stark series of pictures based on Negro art. Three years later he recognized that Negro sculpture was compatible with Cézanne's

★ 'The artist must know the manner whereby to convince others of the truthfulness of his lies.' *Ibid.*

compression and separation of natural forms, to underline their organic structure. Picasso seized on this logical practice and carried it to its illogical extreme in cubism where his tendency to disintegrate form was given a specious theoretical backing by various poets and apologists. By 1911 the forms were so entirely disintegrated that, far from stressing the natural structure, the sections were only related in terms of design. Originality in one sense, but the basis was Cézanne's ready-made hypothesis, and thus was still based on art and not the observation of nature. Cubism, which passed through various forms, from close imitation of Cézanne, through the 'facet cubism' of complete disintegration, arrived in 1914 at a decorative formula for producing harlequins and loaded tables which included the use of 'pointillism' which Picasso borrowed from Seurat. In 1917 Picasso went to Rome to design the ballet 'Parade' for Diaghilev and in Rome he embarked upon the first of his dual roles. He painted decorative cubist harlequins and at the same time heavy, romantic, realistic female nudes derived from Roman sculpture. His ballet designs combined both, and in 'Pulcinella' an echo of the 'Pink Period' with an added overtone of *commedia dell'arte*. Picasso's appetite for influence now became increasingly vicarious, for he had added Ingres to his scalp belt in 1915, with a large number of pencil drawings in the manner of the great classicist. The 'Neo-Classic Period' which resulted, lasted until 1924, but the decorative cubism continued through a series of monumental still-lifes which became steadily more calligraphic as Picasso's great linear gift developed. These still-lifes still owed a good deal to Cézanne, but they were interwoven with various decorative conventions invented by Georges Braque and colour relationships derived from Matisse. The late twenties produced a wide variety of concurrent manners from numerous sources, and it is between 1927 and 1936 that Picasso evolved something like an individual contribution to art, a synthetic but very convincing paraphrase. This was naturally a linear convention, arising out of cubism, and the paraphrase remained a paraphrase of art, but the complexity of interwoven influences was such that this very paraphrase seems to be a personal statement, culminating in the famous *Guernica* of 1936. But during these years, and particularly between 1930 and 1934, Picasso was making hay with the Romanesque, with

certain Greek conventions, with a formal still-life manner based on medieval stained glass and with variations on the theme of Mathias Grünewald's *Crucifixion* at Colmar.

The effect of Grünewald upon Picasso has been enormous, probably the most important individual influence on his work, after Ingres, and probably also the most beneficial, since Grünewald was too big to be swallowed in one gulp and had to be digested slowly. Grünewald himself was probably the greatest Gothic expressionist, if this rather clumsy term may be permitted, who has ever lived. Torment was his métier, he twisted the limbs of his crucified Christ and lamenting Madonna into the most agonizing expressions of human suffering ever portrayed. This was grist to the cruel Spanish mill of Picasso's search for a means of expressing his own apprehension, for Picasso, naturally enough, was sensitive to the increasing misery of his times. Grünewald was the most potent source for such a statement, and from 1930 Picasso began to paint crucifixions and tormented figure pictures. concurrently with neo-Greek line drawings, such as the celebrated illustrations of Ovid, curvilinear still-lifes in a stained-glass manner and jolly beach pictures in which he combined his earlier Greco-Roman nudes with flat pattern cubism. The so-called 'Bone Period' is, however, the most interesting of these multifarious activities, and here Grünewald was responsible for the passion and cruelty of the expression. Between 1928 and 1933 Picasso produced a great deal of sculpture, an art in the practice of which he was singularly, even uniquely, inefficient. He had no sense of the material and inevitably produced the clumsiest possible forms. To justify these heavy lumps he immediately utilized them as sources of expression in paint which he knew he could master, and grafted his Grünewald formula on to it to produce his 'Bone' pictures. In 1934 trouble in Spain turned Picasso to a reconsideration of the bullfight theme, which he made the somewhat banal symbol of his country's pain. At last he was truly moved by an emotion unrelated to art, and, in my own view, the real potential of Picasso may be seen during the brief period between 1934 and 1937. All the technical mastery and gift of expression was in those years turned to a genuine purpose. The hieratic gestures of the figures in the best of his pictures leading up to and following the *Guernica* of 1936, are derived from Grünewald,

the colour and manner from Van Gogh, but here, in such key works as the *Minotauromachy* etching and the paintings of weeping women, something like a genuine synthesis was achieved.

Tenth-century Catalan wall painting was the next art to feed Picasso's avid appetite for formulae and the multi-eyed profiles of the years preceding the 1939 war are derived from that source. During the war, to judge from the pictures recently exhibited at the Victoria and Albert Museum, he has neither advanced nor added any new conventions to those existing in 1938, except in etching, where his aquatint illustrations to Buffon's *Histoire Naturelle* are variations on Chinese and perhaps Persian mannerisms.

This brief chronology does not pretend to be complete, because since 1917 Picasso has produced pictures in several different modes concurrently, with a dazzling inconsistency which gives the lie to most of them. Some contain sections with different and incompatible styles in different parts of the same picture. What then is the sum total? What is the actual value of the pictorial three-ring circus? I believe that no part of it is great art by absolute standards, but everyone knows that it is great accomplishment by any standards, and that all of it possesses the power to excite. To pin the history of one's own times, like a butterfly to a setting board, takes genius, and that Picasso has done; to influence the visual approach of half the world requires supernormal powers, and this Picasso has; but in my view neither of these impressive achievements adds up to great art. In the hierarchy of the great masters, the greatest have a quality beyond the temporal which Picasso lacks, and shock tactics are not a final way to alter human vision. The crux and centre of Picasso's art is, in my view, hysteria and in this he so echoes the prevailing evil of the age that he seems to be its prophet. Added to this is the element of speed, which Picasso has brought to such a jet-propelled perfection that he can hit the target of taste with repeated but varied hammer blows. For several years now he has painted enormous canvases at the rate of one or more per day, apart from his enormous productions of drawings, etchings, lithographs and sculpture. One of his many styles is therefore almost bound to strike a chord in the personal taste of each individual spectator. One final thing has helped to make Picasso the monument of his

time and that is the useful fact that his painting almost invariably looks better in reproduction than in the original. This is in part due to the fact that Picasso is first and last a draughtsman and quality of paint is never a very important consideration in his work, so that his pictures tell on a small scale as, say, a Renoir does not. A glance at the recent works at the Victoria and Albert Museum demonstrates this at once. There is no feeling for the medium of oil paint in any of these pictures. A very high proportion of his reputation rests on reproduction, for he is the most widely publicized painter in history, and the hurried and faulty craftsmanship of much of his recent larger work is not discernible in a book of plates on a fairly small scale, whilst the immense output always provides material for new publications.

The whole body of Picasso's work amounts, in my opinion, to a vast series of brilliant paraphrases based on the history of art. This is in itself a wonderful phenomenon entirely compatible with the times, but I believe that it is only of value viewed in this light. In terms of the art of painting, in terms of the living, breathing symbol of man's tribute to the work of God, it is no more than a vast erection of bones in the graveyard of experience.

1944

A Reply to Myself

1956

THE ESSAY called 'The Master of Pastiche' originated as a broad-cast which I made in 1944. In the same year I expanded it to its present length and since then I have gone on painting and drawing, and latterly making sculptures, for twelve years. Until now I have not re-read 'The Master of Pastiche' which I wrote to protest against the fact that I was aged twenty-three. However it is republished here, unaltered, because whilst I do not altogether repudiate what I had to say about Picasso at that time, I find myself replying to myself on re-reading myself.

When the original broadcast was made, I became very un-popular particularly with a number of people whose good graces I sought and very popular with an even larger number of people whose opinions I regarded without enthusiasm. By the former my outburst was held to be impertinent and to be an unprovoked attack upon Picasso himself rather than upon the opinions of those who admired the master uncritically, which is what I think I was really driving at. I see what they meant, but I think they were impatient with me for whilst the emotionalism of my diatribe was perhaps rather tiresome, there was some cause for it. My unwelcome supporters, pleased that anyone should attack so heavily fortified an enemy position, looked no further than this fact and I was disconcerted to find myself with allies whose enthusiasm for my cause was entirely divorced from the intentions I had had in making my initial skirmish. Mr Graham Sutherland smote me hip and thigh, Lord Brabazon of Tara, if I remember rightly, applauded me to the echo. In between, a group of people seemed to think my proposition, whilst overstated, had some foundation and I remember that Mr Raymond Mortimer, rather to my surprise, temperately called the essay 'a good speech for the

prosecution'. On re-reading the thing I am inclined to modify this and call it an impassioned speech for the prosecution which might be calculated to sway the jury but would not altogether hold up, in the opinion of experienced counsel, under prolonged cross-examination. The exaggerations, oversimplifications and the special pleading weaken the case but they do not, I think, entirely invalidate it. What makes it more difficult is that the case is not primarily against Picasso, but against his times, and cogent argument cannot easily be aimed at an age, especially the one to which one belongs oneself. Such arguments become evangelical and turn back upon the protagonist.

The moment when a major artist ceases to be a controversial figure and becomes an 'old master' is not readily apparent, especially when a World War intervenes at around about that time to obscure the issue, but as far as Picasso is concerned, what was already happening when I wrote the piece is clear and the subsequent years have only made matters clearer. Even in England Picasso has ceased to be the rallying point of factions and the only people who still become heated upon the subject are those who are not profoundly interested in it. The great man enjoys a fortunate, productive, and relatively cheerful old age in which, for the moment, he is able to relish his own posterity. He has rounded off an enormous career by becoming the first painter to enjoy film-star status, and where once he excited his fellow-artists to engage in heated defence of him, thus making me a renegade, he is no longer controversial. There is a parallel in politics. Many a run–of–the-mill Communist who from his early youth has been dedicated to the active support of the beleaguered Soviet Union, imperilled by the machinations of international capitalism, has only recently noticed that the Soviet Union is one of the two most powerful nations in the world. It has become so whilst he was engaged in protecting it against slander and attack, but his reflexes have become so conditioned to this function that he cannot easily stop regarding this now gigantic world power as a lonely bastion short of the necessities and perpetually under threat. That is why he is such a bore. And so it is with Picasso's enthusiastic biographers together with those who continue to make expensive anthologies of his work in book form. They still write of him as if they must defend him. The point now reached is an interim one. There is

no longer any cause for me to tilt at this vast double-profiled windmill and there is even less cause for anyone to champion him. The really influential artists today may not be of the stature of Picasso, in fact none of them is, but Giacometti, de Staël, Bacon and de Koonig, to name four, have much more effect on twenty-three-year-old painters at the moment than Picasso does. This is no reflection on Picasso's quality as an artist, it is merely the passage of time.

What emerges, for me, from re-reading 'The Master of Pastiche' is something quite other than the obviously violent and even hysterical protest against the weight of Picasso's genius upon a young painter struggling to throw off a fashionable and unacceptable influence. I am left with the desire first to attempt to analyse the reality of Picasso's protean achievement and not less the unreality of a situation which still makes a dispassionate appraisal of it unacceptable to many who apparently still like to regard this world power as a downtrodden genius. A fundamental dichotomy occurs in the realm of meaning. A substantial body of critical opinion leans upon the proposition that meaning in the symbols used by the twentieth-century painter must not be overt and that the accident and the ambiguity are not less important than the intention in painting. M. Michel Tapié★ carries this so far that he writes criticism with the same disregard for precision of intention as the painters he praises, taking to himself what are, to him, the virtues of the impulse unalloyed by control or reflection. Even Mr Alfred Barr, who is a scholarly man, is capable of remarking apropos Picasso's *Minotauromachy* etching that Picasso 'probably cannot put into words the meaning of this dramatic charade of the soul'. Maybe he cannot and very wisely he has not, but what we are left with is the impression that Picasso is performing in a trance and that his allegory is so subjective that it could not be paraphrased by the artist himself were he forced to explain his intentions. Well and good, but so far as Mr Barr is concerned much, much better than well and good. What is wrong with this celebration of these secret pleasures is that the *Minotauromachy* is not an 'action painting' by Jackson Pollock, reliant purely on the optical and intuitive response of the spectator for its effect, but an organization of images which are quite clearly of a

★ *Un Art Autre* (Gabriel Giraud et Fils, Paris, 1952).

profound symbolic importance to Picasso himself. It seems probable that Picasso discovered pretty clearly what he meant and wished to make it explicit whereas Pollock in trickling paint out of tins upon a canvas placed flat on the floor, clearly intended no overt 'meaning' and was content that the spectator should derive, by association, such separate and personal stimulus as that spectator was capable of experiencing. There was no need for Pollock to know what he meant whereas Picasso was clearly making a communication, however apparently cryptic, in which *meaning* was important. To imply that he did not know what he meant, except intuitively, is to deprive this work of art of part of its real value in order to exalt its subjective implications. This is, I suspect, ultimately to do Picasso a disservice despite Mr Barr's desire to praise him.

Our appreciation of the involved and curious images of Hieronymus Bosch may or may not be augmented by our ignorance of the significance his vocabulary of symbols held for him and for his contemporaries. Myself, I doubt if we are better off for our ignorance. We do not know the exact significance of the recurring strawberry in Bosch's imagery, for instance, but it would be absurd to suppose that it did not possess one, or that the paintings of Bosch would not have been explicitly comprehensible to his contemporaries. If they had not been, the work would simply not have been paid for and in those days that meant the work would simply not have been done. We may accept or reject the various interpretations placed upon Bosch's use of symbols, we can even re-interpret them in the light of psycho-analysis and thereby further confuse the issue, but there can be no doubt that this *meaning* was to those of his contemporaries most nearly concerned, exact and explicit. Bosch did not, as far as we are aware, leave a written key but that does not mean he could not have paraphrased his intended meaning in words, or would have thought twice of doing so, in addressing the members of the relevant heretical sect, if such a sect did commission the more esoteric of his pictures, providing he was quite certain he would not be overheard by the militant orthodoxy.

And therein lies the point. A cryptic or hermetic utterance is justified by the positive need for secrecy, and that such a need for secrecy should be imputed to Picasso is manifestly absurd. It

therefore seems to follow, either that this secret is necessary, as an added pleasure, for Mr Barr or that Picasso did not know what he was at. An explicit meaning would in fact detract from the mystery as far as some people are concerned, and by that reasoning we are better off for not understanding Bosch or certain passages in Donne's poetry or the Etruscan language. It is cosier that way.

The truth of the matter, as I see it, is that Picasso has been essentially an explicit artist whose vocabulary of symbols can quickly be learned and quite frequently can actually be translated without much trouble into a paraphrase of words, so there is precious little reason why he should do it for us. I do not mean that the words would be substitute for the image. Fear that this might be the case has frequently caused painters to obscure their meanings in order not to be found out but Picasso, unlike Bosch, has no reason to make himself obscure for he has never had cause to fear that he may be discovered. Nor is Picasso the kind of artist whose lack of talent could at any time have given him cause to worry about being caught with a meaning which could simply be explained. If he has not gone in for words much himself, it is because, I suspect, in part, he enjoyed the spectacle of people mistaking his intention and praising him for it. He has always enjoyed such jokes, and no one laughed more heartily than he when Gertrude Stein decided that his painting of *The Three Musicians* was a still-life.

What is untranslatable in Picasso's pictures is not the meaning but the gesture by which the meaning is made explicit, whereas what is untranslatable about Pollock or Riopelle is the gesture in which no-meaning is implicit. Both may be enjoyable but it is a confusion to impute one set of values to both.

The importance of the gesture, the movement of the fingers, wrist and elbow, and I use the word gesture to define the unique quality which distinguishes say Picasso from Braque, or Braque from Picasso, even in the period of analytical cubism when they approached one another so nearly, is the quality in Picasso and in all great virtuosi which is untranslatable into words. It is equally to be found in Rubens and it can be true of artists like Van Gogh who are by no means virtuosi. It is Picasso's gesture, combined with his great inventiveness in paraphrasing appearances, which is the basis of his extraordinary achievement. This is not simply a

matter of 'line' although Picasso's gesture with a pen is the most marvellously expressive in our time, but a vitality inherent in the touch and movement of his every contact with his medium.

This quality is difficult to define metaphorically. It seems to me the most Spanish element in Picasso's peculiarly Spanish temperament for it combines the peculiar tireless, snapping strength in the fingers which the supreme *flamenco* dancer achieves, with the deep swinging power in the wrist which the long slow pass with the fighting cape requires of the *torero*. It is directly physical and it not only conveys tension in the forms the gesture describes, but inescapably implies controlled muscular tension in the movement of the arm which creates each stroke.

This is not, however, everything, for Braque's gesture is not in itself powerful and Bonnard's is positively feeble, although both are major artists. Furthermore, some of the world's greatest art has been created with gestures as anonymous and in themselves inexpressive as say those of Zurbaran. The gesture is not necessarily a prime concomitant of a painting but it can be an intoxicating one. Such is the potency of Picasso's gesture that the world has been drunk with it for several decades, and potency in a directly sexual sense is the intoxicant.

The other quality, the inventive gift, is measurable in terms of the freedom which Picasso has earned, to paraphrase appearances, for Picasso has achieved an almost total freedom of operation without discarding appearances. Initially this resulted from a courageous and splendidly wilful temperament and latterly it has been facilitated by the total critical amnesty which has been proclaimed on his behalf and the accruing deification which has been his for more than thirty years. This has great splendour but its dangers are mortal. When Cocteau remarked that Picasso saved himself by being an acrobat he was right, and so quickly can Picasso pick himself up that many spectators are unaware of the occasions when he has fallen flat on his face. More important, he does not seem to have noticed them himself. For the time being this clearly does not matter and anyway it is not surprising. Picasso has genius and superabundant vitality and he has been placed in the most extraordinary position, as a human being, wherein a large proportion of the normal issues, with which people must contend, can mean nothing to him. It is not simply

that he is a wealthy and famous man whose creations are enormously valuable, it is that not only has he arrived beyond criticism but also that currency is worth less in Picasso's hands than a sheet of blank paper and this condition promotes the problems with which the legendary Midas had to contend. Such ambitions as Picasso may still entertain can only be relevant to the continuation of his vast reputation in the future, for he is probably the supreme *individual* in the world, aside from those who occasionally achieve dictatorial political power. These last he has naturally and very properly outlived. But Picasso is a man of intuitive perception and shrewd though he is, his drive has always been physical and sexual rather than intellectual. He probably could not have achieved his extraordinary eminence had he been meditative in the sense that Rembrandt was meditative or as intellectual as Leonardo. The result has been the largest body of work, in the widest range of media, that any single individual has ever created: a vast production valued more highly, during his own lifetime, than the life's work of any comparable predecessor, however great, and inevitably containing a great mass of trivia. If it is impossible to sort this trivia from his truly significant work, during the next few years, Picasso is likely to suffer an eclipse commensurate with his present effulgence, and this would be for his work to suffer a misunderstanding and a neglect as great and as thoughtless as the adulation his admirers award to his present eminence.

If, as Mr Mortimer remarked, I could make a speech for the prosecution twelve years ago, I could equally make a speech for the defence today, but how little value a defence would have among so many paeans of praise. To have defended Stalin in Moscow a generation ago would be a comparable analogy. Nor clearly am I in a position to assume the ermine and sum up or pass judgement. In any case I am not dispassionate for there is too much to envy and my admiration, no matter what I say, is too great for me to follow the impertinence of an attack at twenty-three with a judgement at thirty-five. But there are points to be made which I hope will not be taken to be *hubris,* for although I am now not so sure as I once was, I must obstinately remain, at the moment, among those who cannot see Picasso in the ultimate pantheon.

His claim to be there is unquestionable for if an artist can rise to such points of culmination, over and over again, during his development, as the Stein portrait of 1906, the cubist master-pieces of 1912, *The Three Musicians* in 1921, the *Pan Pipes* in 1923, the *Red Table Cloth* in 1925, the *Girl Writing* in 1934, and eventu-ally achieve the *Guernica* in 1937, he should be safely home. And Picasso has produced many more wonders than those. If he is not a god it is because whilst the whole achievement is miraculous I am conscious of a factor missing which is present in supremely great painting, and this factor is the depth which accompanies ineloquence. The still centre.

What I think ultimately defeats him is his speed. The vitality and immediacy of Picasso's physical gesture has this in common with *tachisme*★ as, say, Riopelle or Mathieu practise it. It is only effective if the action itself is made at high speed, for it is an orgasm, or rather a mock orgasm. To make a gesture with a brush or pen at speed and with great boldness will in any event have some hint of this orgasm and some power to stimulate. The mark itself has urgency and no mark has more compelling urgency than Picasso's, but even the most intuitive and casual gesture of this sort must explain itself or else the spectator, by placing his own interpretation upon the mark, must put up his own explana-tion. Otherwise the image itself would be without power, the gesture as empty as masturbation. If the spectator must do the whole job himself in contemplating a picture which expressly disavows any specific significance, he may paint his own picture upon the canvas merely by taking up the arbitrary references made by spilt paint, rather as Leonardo proposed the student should do when catching sight of a damp and discoloured wall. Alternatively he will respond to an image which is explained by the marks made by the artist, in which case some direct communi-cation is effected. In the latter case the spectator may enlarge his experience through the vision of the artist, whereas in the former he can only enlarge it by working upon himself, which is a masturbatory activity. Where Picasso has exhibited his mastery is in the extent to which he can create a deliberate image with the same or almost the same unfettered violence as the man who throws a pot of paint in the face of the public. But the point is that

★ 'Tachisme', like 'action painting', is a form of 'abstract expressionism'.

Picasso at his best explains the image completely no matter what violence he has done it in the process.

Nevertheless, in order to give his gesture the maximum impact it seems he must make it at maximum speed and he must correct the trajectory by destroying the previous direct hits on the target. This process gives immediacy to his pictures but it deprives them, with some exceptions, of profundity and ultimately of staying power. You do not have to come to a Picasso gradually, building it into your mind as you do a Titian or a Cézanne; you are either raped or you lift an eyebrow. What his pictures contain, he shoots at you. He may miss. A few pictures, notably some early cubist masterpieces, some portraits and some etchings and drawings, stand out in contrast to this generalization, but in the last twenty years, a period of maturity when in the lives of other great and long-lived artists the pace would have slowed and all the powers have been concentrated into such prodigious efforts as Bellini's *Feast of the Gods* or Rembrandt's *Jewish Bride,* Picasso has become increasingly diffused and apparently casual in his creation.

Four or five large oils are finished in a day, half a dozen lithographs or a dozen ceramics are manufactured and breathtaking though some of them may be, they do not add up to more than the *jeux d'esprit* of genius. Certainly no major work since 1937 has the concentrated power of the *Guernica* and such large works as *War* and *Peace* are relatively insignificant when compared to the achievements of analytical cubism.

It seems to me that Picasso has been caught in the rat-race of his own powers of immediate improvisation, as if Cocteau's acrobat had been imprisoned in one of those wire contrivances in which white mice incontinently run endlessly whilst remaining in the same place. Out of this comes, again and again, some amazing drawing or superb lithograph but no major work, and these minor masterpieces you must pick out of a vast rag-bag of doodles. So absolutely natural is Picasso's flow of invention that he has apparently little time for reflection. His embrace is vastly wide, his appetite for visual sensation enormous but his gratification of it is greedily impatient. He gnaws upon the history of the visual arts like the Minotaur upon a virgin's shin bone.

I complained in 'The Master of Pastiche' of Picasso's eclecticism, of his extraordinary cannibalism upon the body of the art itself,

but it is clear to me now that not even he could have achieved his dynamic paraphrase purely from a response to natural appearances. Van Gogh came nearer to achieving this, perhaps, than anyone, but Van Gogh's violent *coup d'œil* destroyed him as much in its release into action as any paranoiac tendencies which may clinically have been put forward to explain his tragic collapse. For Picasso this combination of gesture and intention was made possible by a ruthless use of the existing work of art which had inevitably partially solved the visual problem and was therefore in its (to Picasso) predigested condition capable of carrying the force of his blow without losing all contact with reality. The work of art upon which he chose to perform had in fact initially achieved a distillation of reality before Picasso passed it as steam through his tubes and retorts and redistilled it.

It has remained for painters of generations younger than Picasso to discard the explicable image entirely, in favour of a reality which is actual only as far as the surface of the canvas itself is actual, without implications except those which the spectator must create for himself from the haphazard maelstrom of paint. The *tachiste* cannot function and take thought, he can only contemplate what he has done when he has finished and either like or dislike it. In some ways this is true of Picasso who quite clearly has seldom bothered to like or dislike what he has done, perhaps secure in the knowledge that a large public will admire it anyway.

I do not wish, as I may once have done, to diminish Picasso, even if I could, but at the time I wrote 'The Master of Pastiche' I could not precisely see what anyone, including myself, did next. I have now had the opportunity to see, not perhaps more than an indication of what happened next but at least, since the decline of Picasso's immediate influence, something of the outcome. What has happened, as might have been expected, has been a flight not only from Picasso's method but from his iconography. There has been some surge towards a contemplative realism, with its rejection of Picasso's drastic shorthand in favour of a desperate recognition of objectivity. Picasso himself has continually done the same thing. On the other hand, there has been a surge towards *tachisme* with a rejection of the image in favour of his dynamic shorthand with this difference that no translation of this automatic writing in paint could have any specific meaning, whereas Picasso has

237

never departed far from the significance of the object. A further reconsideration of the human form appears between these two trends in the anxious ferocity of Bacon and the uneasy space-mystique of Giacometti. Others, too, have emerged from beneath Picasso's enormous shadow, but not without their work having been foreshadowed in some part of his colossal *œuvre,* and in a sense I was not altogether wrong when I proposed that Picasso's huge maw had engulfed us all, so that like so many Jonahs we were in search of a way out. For the time being the anal exit is the more popular of the two, but practically nobody is still sitting in the stomach.

Where his imagery remains most vigorous is in the graphic arts. The very weaknesses, the qualities of carnal improvisation which appear to slacken the tension of his recent larger paintings, so that they sustain themselves only as long as the invention itself sustains them, give an immediacy and a fierce grace to his prints and drawings. Picasso makes sculptures as a baker rolls up loaves and ceramics appear under his hand like batches of *brioches.* Marvellous though such wilful culinary legerdemain clearly is, the sculptures frequently look half baked and the ceramics delicious, until they stale. But the best of his prints, his unbelievable felicity of line in his engravings, the richness of his lithographs are comparable to supreme piano writing. They intoxicate as one must surely have been intoxicated with the virtuosity of Liszt's playing. In fact, to suggest a parallel between Liszt and Picasso is not inappropriate. There is the same enormous inventive gift, the same virtuosity, the same versatility and there is the same occasional and perhaps unexpected profundity. It seems to me not improbable that Picasso will suffer the same fate as Liszt and no less unjustly, for Liszt enjoyed a prestige in his lifetime not altogether dissimilar to Picasso's and has subsequently been cast down far below the level he deserves. Such reactions of public taste are usual. Liszt was a much greater composer than most people think. In a hundred years it may well be said that Picasso was a much greater artist than people think.

It is one of the most genial paradoxes here that the realist retreat from Picasso should have been identified with the left wing in politics for none of the realists of consequence in this country is, as far as I know, a member of the Communist Party, whereas of

238

course Picasso is. Yet in every logical sense Picasso must be identified with the Right, for the only people who reject him without question today comprise the proletariat and the peasantry, whereas those who both by word and deed support the edifice of his enormous fame generally belong to the classes whose downfall is supposedly imminent. As the Individual Triumphant he represents the ideal pattern of success in a world where income is considered more important than status, yet he represents that rare class whose income is only the product of his status. Communist painters in Italy and France reverence him whilst uncomfortably trying to disguise his past influence upon them whereas reactionaries elsewhere plunge further into deliberate obscurity in the hope that they will seem more advanced by those means.

The 'abstract artist' and especially the *tachiste* is once and for all the ultimate materialist in art. Since his contribution denies specific meaning each example of his art can only be valued as an object, a *thing* which pleases or displeases and has certain physical dimensions and material qualities but no others. It is not surprising therefore that it should be valued so highly in capitalist societies. What is, however, almost comically paradoxical is the irritation which the uninitiated manifest in failing to 'understand' this form of expression. No one ever seems to remark that this is not the function required of them. All that they must do is *respond* and be content with that, or forget the whole thing.

It would perhaps be unjust to attribute this flurry of retreating figures solely to Picasso. The spectres of the School of Paris, Matisse, Bonnard, Braque and Rouault also have had everyone rushing about for some time. *Ars longa vita brevis* is widely thought to be a description of somebody's girl friend, and Picasso stripped to the waist and looking much younger than most of us, is starring in a film called, for no apparent reason, *Le Mystère Picasso*. There's no mystery . . . except that damned great talent.

1956

239

The Midas Minotaur
1969

plates
54–58
I FIND I have written a piece on Picasso once in every decade since
1938; indeed the first piece I ever published on any subject was a
short and badly written panegyric on the *Guernica* when it was
shown in London during that year. This, then, is the one on
Picasso for the sixties. The sixties however have also produced a
more extended study of this protean man than I have ever written
and this book has sharply and notably punctuated the ceaseless flow
of adulation, which has been poured like balm on the master's
head for more than half his lifetime and during the entire course
of mine. John Berger's book *The Success and Failure of Picasso*
(Penguin Books, 1965) remains, to my knowledge, the one
extended examination of what happened to the Minotaur to
have appeared so far. I regard it with considerable admiration and
great irritation, largely because not only should I have written it,
but I was asked to write it and declined, proposing John Berger
as an alternative in the light of our prolonged discussions on the
subject and because we agreed on many aspects of the matter. I
suggested the book to him and when it appeared he sent me a copy
inscribed to that effect and wrote to me personally that he believed
me 'the prophetic exception', which I take to mean that I was
among the few to have written about Picasso who had shown
themselves ambivalent about him.

Berger's book on Picasso is certainly no less vulnerable to
criticism than the subject of it, however differently, for John is of a
puritan persuasion which must follow, as I see it, from an allegi-
ance in almost equal measure to Karl Marx and D. H. Lawrence.
Such a mating must produce a hybrid which, however remarkable,
is likely to be weak on irony and unable clearly to see, or to approve
of jokes. This placed him at a disadvantage in confronting the

240

ironic aspects of Picasso's work and his comic gifts. Nevertheless, the book is wonderfully perceptive in many ways and I much admire the shrewdness and cogency with which he has enlarged upon several of the ideas and metaphors which we discussed.

The point is made in *The Success and Failure of Picasso* that his identification with the Minotaur is an important clue to Picasso's imagery and to his temperament. 'The Minotaur', Berger wrote, 'represents the animal in captivity of an almost human form: it also represents (like Beauty and the Beast) the suffering which is caused by aspiration and sensibility being rejected because they exist in an unattractive, that is to say untamed, uncivilised body. Either way, the Minotaur suggests a criticism of civilisation, which inhibits him in the first case and dismisses him in the second. Yet unlike the Beast, the Minotaur is not a pathetic creature. He is a king. He has his own power – which is the result of his physical strength and the fact that he is familiar with his instincts and has no fear of them. His triumph is in sexual love to which even the civilised "Beauty" eagerly responds.' The point is well made even if it tends to suggest Mellors rather than Minotaur, but there are holes in the argument, not only in the parallel with Beauty and the Beast which is not apt because the Beast required only a kiss to restore him to his kingdom, or at least his principality, whereas, more significantly, the Minotaur's aspiration is without hope of success and he must forever remain crippled by the weight of his bull's head and the tumescence of his bull's pizzle, however frequently he is gratified. Sensitivity he may have, hope he has not. Victim he is: king he is not. Furthermore, Picasso sees, or saw, more deeply into the nature of the Minotaur than Berger suggests, for the bull-headed man *is* pathetic, hidden as he is in the labyrinth, although the attempt to dismiss him from sight by this imprisonment contributed largely to his celebrity.

Excusably I hope, since after Picasso I have been more concerned with the Minotaur than most people nowadays, I seek here to penetrate the metaphor a little further. Not being Picasso and not being a Spaniard who, as Mithraic inheritor, congratulates himself by the ritual death in the bullring on every Sunday of the season, I am at a considerable disadvantage. I may identify with the Minotaur myself, but I am not Picasso and I cannot claim an ethnic right to *tauromachia*, nor can I claim to be a star, for it

70

was to that condition that the Greeks elevated the Minotaur, calling him Asterion, just as it is to that elevation that the twentieth century has elevated its most vital if unruly pictorial talent, calling him Picasso. It is, however, possible that, as a shorthorn Minotaur, I may see further behind the bull mask, recognizing as I do that Picasso's acceptance of the Minotaur as a tutelary demi-deity from 1932 to 1935 served him marvellously well. Given that bulls argue potency and potency has been Picasso's most vaunted attribute, not only was the Spanish bull an emblem to be worn, but so too was the Cretan bull. All horned creatures from Arcadia may then join the rout and celebrate the epiphany of Dionysus in bull form, for Euripides pronounced his status even more ruthlessly in the *Bacchae* than Picasso has shown it in imagery, and Dionysus is thus proclaimed Lord of Mis-rule by divine right.

The *Vollard Suite* contains etchings of the Minotaur who rapes or lounges about with girls on couches in a sculptor's studio and takes refreshing glasses of wine, rather than blood, to cool off. He does this right through the summer of 1933, pausing only when his urgent activity has tired him to death, to stagger into the bullring and expire under the sympathetic eyes of the girls 55 lining the *barrera*. On May 29th he is stabbed by an hermaphroditic youth and this is the only occasion, to my knowledge, when Theseus, in some sort, could be said to have played any part in the business. By June 18th, in one of Picasso's greatest etchings, he 57 is all set to have another go with 'Beauty', but thereafter his 58 vigour abates and by September 22nd the Minotaur is blind.

There are four plates of the blind Minotaur, of which the most carefully worked is the aquatint, made in October 1934, which shows him stumbling forward, head jutting upward and piteously lowing, against a night sky. He is contemplated by three sailors, two of whom are hoisting sail and none of whom displays more concern with his presence or his condition than do the peasants who ignore the fall of Icarus in Breughel's painting, but then this is true of all four etchings. In each plate, the Minotaur carries a staff and either gropes with his other hand or gently touches a little girl who carries a dove in her arms and seems to lead him. If this is a king, it is a bovine and banished Oedipus. It cannot be supposed that he is sexually concerned with the girl and he is as pathetic as any blue-period harlequin. Theseus would have had less trouble in

242

killing him than the girls have had in wearing him out – if that might be the interpretation to be placed upon the image.

It may seem remarkable that Theseus gets so little chance to find, or do battle with, Picasso's Minotaur, but this seems to me in no way odd. Theseus has never got a look in with mine either. The defeat of the Minotaur lies elsewhere, partly in exhaustion and partly in the sensed disadvantage of an inadequately developed intellect. Picasso's greatest etching, the *Minotauromachia* of 1935, not only gives the clue to where this defeat lies but may also be an autobiographical comment on a period of personal distress. 54

The *Minotauromachia* is directly related as an image to the aquatint and etchings of the blind Minotaur. The seaport setting is the same, the Minotaur gropes, the little girl is there, although she holds flowers and a lighted candle and is turned to confront the Minotaur as if to light his way. The tame dove has flown up to join another, in an embrasure from which two girls are leaning. True, the sailors have set sail and departed but the bearded man who climbs a ladder on the left of the picture makes little effort to hurry. He does not seem alarmed by the monster, but rather contemplates the tangle of horse and female matador who occupy the centre of the stage. As for the Minotaur, his ferocious aspect is belied by an air of stupid confusion. His eyes are open, but stare emptily. He gropes with one great hand, but with the other he touches his breast and the hilt of the sword grasped by the bare-breasted and swooning female bull-fighter. The odd relationship of the sword to the Minotaur might at a casual glance suggest that he holds it, as he so vigorously does in the first drawing and four etchings of him, which appeared in the journal *Minotaur* (No. 1, 1933), a publication whose title is believed to have inspired Picasso to embark upon the series. This curious disarmed relationship of Minotaur to gutted horse, to female matador in the *Minotauromachia,* in turn relates to a number of etchings of 1934, where the Minotaur is replaced by a bull who is absent from the heap of wounded horse and tranced lady bullfighter in the *Minotauromachia*. If some creature gutted the horse, the image does not suggest that the Minotaur had much to do with it. He does not seem to see it.

Mr Alfred Barr Jr has written that the 'moral melodramatic

charade of the soul', as he describes this print, is 'probably of so highly intuitive a character that Picasso himself could not or would not describe it in words'. This is not of course to suggest that it is without precise meaning, especially when the other images of the Minotaur are taken into account. 'It is clear', wrote Mr Barr, 'that the ancient and dreadful myth of the Minotaur has been woven into Picasso's own experience of the modern Spanish *toromachia*.' It is indeed, but how and in what relation to the ancient sources of the myth?

There are, I suggest, three related factors. One is the bull as a symbol both of Spain and of Picasso's physical prowess, another is the destruction of the bull by a female mounted on a dying horse, and the third is Picasso's awareness of the myth in its ancient form. The implications of the first two are not difficult to recognize. The third involves the idea, unfashionable until recently, that it is possible to be literate despite the fact that one is 'an artist'. This is confused by the tendency of the masters of the twentieth-century French illustrated book seemingly to have paid scant regard to the texts they decorated, which has given rise to the improbable notion that they did not, or could not, read them. Picasso's etchings for the *Metamorphosis* of Ovid of 1930 reveal no such ignorance of the text of the poem and in his etchings for the *Lysistrata* of Aristophanes, also made in 1933–34, I have the word of the translator, Gilbert Seldes, for whose edition they were made, that Picasso had read the comedy with care and his illustrations diverge from Seldes' translation only because, being unfamiliar with English, he had read the work in French.

Whether or not the Minotaur, as a symbolic image, originated for Picasso with the name of the magazine, there is every reason to suppose that Greek and Roman mythology had begun to affect him in the years following 1917 when he visited Rome and Pompeii, and I should suggest that this was not solely a visual and stylistic matter, nor what John Berger proposes to be the 'caricature' of earlier European styles in which Picasso has frequently, and often ironically, indulged. His sense of both the *persona* and the activity of the Minotaur seems to me to go deeper than that and if he were wholly unaware of the myth, in a conscious sense, he must have been more 'artistic' and more naïve than anyone has reason to suppose.

The Minotaur is the only hybrid in Greek myth to wear the head of an animal. Other zoomorphs, among them the Satyr and the Centaur of which Picasso has made frequent use, the Ker, the Sphinx and the Siren, possessed bizarre animal attributes, but it may be that such was the regard in which the Greeks held the human head that they were disposed to keep the goat, or lion, or bird, or horse below it. The Egyptians, on the contrary, were much given to topping off their deities with the heads of jackals, hippopotami and the like.

Picasso has made frequent use of metamorphosis, not simply in Ovid's sense, but in eliding creatures and human beings fancifully into one another and redistributing the parts, superficially perhaps, from caprice. In an etching of May 1933, he even turned the Minotaur into a Sphinx, to its apparent consternation, and in later years he caused a whole pageant of Arcadia to prance about Antibes in a frolic which indicated a large admixture of honey and water in the wine. Long before this, satyr and quasi-Minotaur in human-visaged but horned form crop up to take advantage of situations arising from his concern with, and gift for, the female nude. The Minotaur himself does not last very long in Picasso's iconography, before turning into a member of Silenus' rout on the one hand, or pure bull on the other. In this latter capacity he towers over the weeping women of Guernica as the one undaunted and undamaged member of that maimed throng and as such must represent the brute triumphant, which is one side of Spain's conceit of herself. The flux that is essential to Picasso's personi-fication of the Minotaur shows him agreeably gratified by his prowess on the one hand and defeated by those who receive the flood of it, on the other. That is simple and John Berger makes much of the groin to groin relationship and writes most per-ceptively of it, but Picasso has an intellect, sardonically orientated, which underpins or overrides his physical and emotional forces. He seems well aware that the Minotaur is herbivorous (due doubtless to his bovine dentition) and did not *devour* the youths and maidens sent in tribute to him on Crete at regular intervals. The tribute was to vanity and not as provender. Perhaps too he recognized that tribute in the ancient world had more point to it than pelf and yet, in the simplest sense, was precisely that. He may not have known that the earliest recognizable Minotaurs occur

57

245

on coins of the fifth century BC at a time when cattle had rather less significance in trade and tribute than they had had at the birth of the legend. On the other hand, he may.

I do not suggest that Picasso is learned in the writings of Plutarch, or Bachylides, or Diodorus Siculus or has steeped himself in Virgil, or Catullus, or Apollodorus, or Hygnius, or Pausanias. He has however had a look at Ovid and who knows what else? Maybe Euripides is familiar to him. At all events, the Minotaur, to Picasso, has more consequence as a concept than as an epitome of the randy, or a king, or a Beast desired by Beauty (who invariably gives him his quietus) or a simple criticism of civilization which inhibits and/or dismisses him. In Picasso's case civilization has done neither. But the Minotaur entered Picasso's world at a specific time and departed from it some six years later in a painting which Picasso owns and which has been called *The Minotaur Moving his House,* where the much domesticated creature is seen trundling a small cart behind him, piled with a pregnant horse in labour, a ladder (the ladder of escape up which the man on the lift of the *Minotauromachia* climbed?), various pot plants and a picture in a frame.* In simple terms, the Minotaur, having moved in on Picasso and enjoyed various girls, parties and deaths, only one of which had to do with Theseus, moved out.

What had happened was that the Minotaur, who is certainly powerful, had departed on a note of amiable mockery which is exactly the ever-present element in Picasso which John Berger fails to see clearly and if a sour, ironic factor may seem to intrude upon the long series of wash drawings in 1953 and one of a more frenetic nature in the outpouring of etchings and aquatints, of all sizes, produced between March 16th and October 5th 1968, I see nothing to suggest that Picasso is overwhelmed or wholly undermined by the probable decline of his sexual powers late in life. He, like any other man however talented, must have expected that and he has compensations, and doubtless delusions, to buttress them, at the age of eighty-eight.

Some play is made in the first pages of Berger's book with the legend of Midas, as it relates to Picasso – and indeed I mentioned the parallel myself in 1956 (see p. 234) but neither he in 1965 nor I, nine years earlier, went very far with the simile. It is instructive,

* It is reproduced as pl. 86 in D. D. Duncan's *Picasso's Picassos* (Macmillan, 1961).

since myth is such a phoenix, to look at the fable in more detail. Midas, a Macedonian king, was the son of a satyr and in his youth a procession of ants was observed carrying grains of wheat into his cradle and placing them between his lips as he slept. This, as Charles Graves says, was 'a prodigy which soothsayers read as an omen of the great wealth which would accrue to him', and in Picasso's lifetime one could name each ant. Silenus, a drunken straggler from the company of Dionysus, chanced to pass out cold in Midas's rose garden. Midas entertained him cordially when he came round, and in gratitude Dionysus offered him a gift. This gift with its golden benefits and hazards is well known and it is one Picasso inherited. What is sometimes forgotten is that when Midas despaired of his discomforting metallic benison, Dionysus sent him to bathe at the source of the river Pactolus, which cured him, whereas Picasso has had no such luck. Midas however remained fortunate in being adopted, significantly, by Gordius of Phrygia who remains famous for the complex knot he tied around the pole of the cart in which he had trundled his belongings. The parallel here scarcely requires comment. Furthermore, Midas remained vain in that he challenged Apollo at music, a contest which he lost and which gained him a pair of asses' ears which he wore thenceforth covered with a Phrygian cap. He was not disgraced until his barber discovered the ears and whispered the news to a hole in the river bank. The unhappy result of this was that a reed grew there and whispered the truth to passers-by. Midas then drank bull's blood and died and whilst it would be rash to press the comparison, it is surprising how much truth ancient myths manage to distil and how relevant they can be today. Picasso's barber in Valauris, his Figaro in the Spanish tradition, is both talkative and totally bald. If the asses' ears are not being worn by Midas currently, they are certainly garnishing the heads of those who have eulogized the protean gush of 347 etchings which Picasso produced in those busy months in 1968. This merry, remarkable, but rather trivial explosion has been compared by the critic of a publication called 'Skyline' to *Hamlet,* Beethoven's 9th Symphony and Michelangelo's *Last Judgement.*

John Berger, with just that solemnity which so undermines his percipience, took great pains to point out the tragic allegory of Picasso's sense of his failing physical powers in the series of 180

wash drawings he made between 1953 and 1954. These are, he says, 'autobiographical; they are Picasso's own fate' in that in most of them there is a girl who represents 'nature and sex', and therefore 'life', placidly confronting a series of little, old, wizened men in masks and in clown's garb by which, he avers, Picasso shows himself impotent or becoming impotent from age. Maybe so. The drawings also demonstrate, as do many recent paintings, that he is grimly amused and even disgusted by the solitary eminence he has gained and this he demonstrates by caricaturing, with savage wit, the relationship between artist and 'model' (Picasso has not used professional models in seventy years) and the general absurdity of his court, of which he makes a circus, monkeys, donkeys and all. What is missing from Berger's assessment is the irony and that has always been there. It was the girls who undermined the Minotaur, in the etchings of twenty years earlier, and you don't have to be an octogenarian to know that when it comes to playing a bull among the heifers, it is the Minotaur who first needs the reviving drink, bull's blood or not, and not the cows. Furthermore, the 347 etchings of 1968 consist largely of three elements: jokes about girls, jokes about great artists and jokes about classical mythology, and good, sharp jokes too, if remote from *Hamlet* and on a somewhat smaller scale of achievement than *The Last Judgement*.

John Berger argues, and probably rightly, that Picasso's failure is a proof 'that success and honour as offered by bourgeois society should not tempt anyone' and I argue that the legends of the Minotaur and of Midas prove things about society which were consequential before they became bourgeois. I would also suggest that Midas competed in the wrong area and with the wrong gods, but then again I think that in the long run irony is the quality which saves Minotaurs from wearing asses' ears, and irony Picasso has.

1970

54 PABLO PICASSO (b. 1881) *Minotauromachy*, 1935

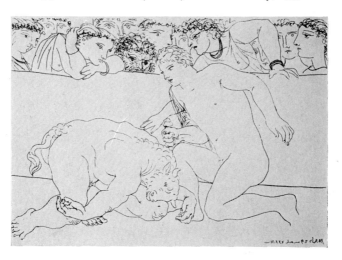

55 PABLO PICASSO *Dying Minotaur*, 29 May 1933

56 PABLO PICASSO
Bull-Headed Sphinx,
May 1933

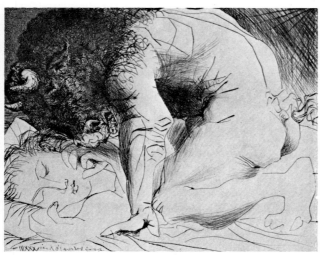

57 PABLO PICASSO
Minotaur and Girl,
Boisgeloupe, 18 June 1933

58 PABLO PICASSO
Blind Minotaur,
May 1934

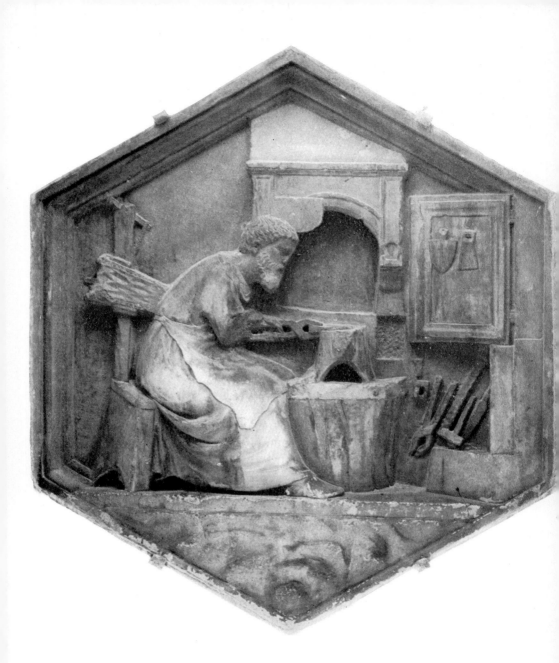

59 ANDREA PISANO (*c.* 1290–1348) *Tubal Cain:*
Relief panel from the Campanile of the Cathedral Florence, *c.* 1348–50

The
'Unwearying Bronze'

page 273

The 'Unwearying Bronze'

page 273

60 *Kouros* (Ptoon group)
found in the Piraeus in 1959,
late sixth century BC

61 ANDREA DEL VERROCCHIO (*c.* 1435-88)
Colleoni, c. 1479-88

62 BENVENUTO CELLINI
(1500–71)
Perseus, 1545–54

63 FRANÇOIS GIRARDON
(1628–1715)
Maquette for
the *Equestrian Statue
of Louis XIV*,
c. 1688

64 PIETRO TACCA
(1577–1640)
*Equestrian Statue
of Philip IV*,
after 1634

The Glutton Eye page 268

65 MICHAEL AYRTON
(b. 1921)
Still Life at Christmas
1954

The Making of a Man

page

66 MICHAEL AYRTON *The Acropolis of Cumae, 1956*

69 MICHAEL AYRTON
Maquette for the *Daedalus-Icarus Matrix*,
designed for the Arkville Maze

67 MICHAEL AYRTON
The Golden Honeycomb,
1968

68 MICHAEL AYRTON
Maquette for the *Arkville Maze*
on Armand G. Erpf's estate
in the Catskill Mountains,
New York State,
1968-69

70 MICHAEL AYRTON
The Minotaur in the
Arkville Maze, 1968-9

71 WYNDHAM LEWIS (1884–1957) *Self-Portrait, c. 1912*

73 MICHAEL AYRTON
Unpublished monotype for
The Human Age by Wyndham Lew
1955

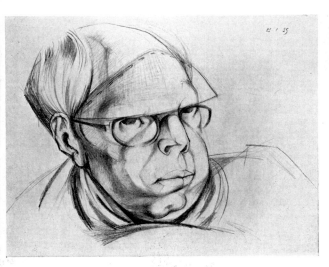

72 MICHAEL AYRTON (b. 1921)
Study for a *Portrait of Wyndham Lewis*, 1955

The Enemy as Friend

ONE WAY AND ANOTHER I have written a fair number of bits and
pieces about Wyndham Lewis since 1945 and a good deal of it has
been fighting talk since I came to believe during the late forties
that I should enlist in the company who carried spare drums of
ammunition with which to reload the Lewis gun while he was
alive, and hold the pass after his death. I doubt if that beleaguered
position will need holding much longer but it has until recently,
despite the admiration in which his coevals Joyce, Pound and Eliot
held him and notwithstanding the near idolatry in which they
themselves are held. Myself, I shared their view of Lewis, both as
writer and painter, before my first encounter with him. Our
first meeting was the result of a little book I had written called
British Drawings and in this, with chauvinistic heartiness, I
trundled through one thousand years of history in fourteen
thousand words. Breathlessly I emerged in the twentieth century
and found that once I had said a good word for Sickert and a
half-hearted one for Augustus John, I was faced unavoidably
with the basilisk glare of Mr Lewis. I did not approve of this, for
I was most anxious, as who is not, to see right on one side only and
this was not the side I was on. However, it was perfectly apparent
that Mr Lewis was a draughtsman and a British one and not less
than the finest portrait draughtsman of his time in England, not
to speak of the founder of the one coherent *movement* in twentieth-
century British art. Such was the vortex in which I found myself
and I went uneasily to the Leicester Galleries and inquired for
drawings by Wyndham Lewis so that I might reproduce one in

my book. I was welcomed with extraordinary, if guarded enthusiasm and great portfolios were set before me in the basement. A big stock of Lewis was hanging fire. I chose a drawing and in due course it was reproduced and the book came out and the critics said the drawings were not as good as French ones would have been, for it was not done in England, at that time, to speak well of English art. At this point I was telephoned by Mr Lewis and asked to tea. Arrived, I was made welcome and encouraged to express my point of view at tedious length. The room, sparsely daylit, was booklined, crowded, gas-fire-warm, almost cosy. I had such a preconception about Mr Lewis that I felt I had come to the wrong house. I had hazily expected a vast empty studio, harshly angular, with sparse furniture ready to bite the shins. I had expected to see Mr Lewis in a black sombrero, casually grinding some modish volume, such as Herbert Read's philosophical speculation on the importance of child art, into the bare floorboards with an iron-shod heel.

Gingerly seating myself in an arm-chair, I was much reassured by the presence of two ash-trays; one of glass like the base of a Cyclopean jam jar, I recognized as that which stands on the table in Lewis's portrait of Ezra Pound, now in the Tate Gallery. This pretty weapon, I had always felt, could be flung in a parabola by Mr Pound, and glancing off some distinguished Georgian personage, return to base. The other ash-tray, no less formidable, stood by Lewis's chair. Black, metal, some two feet in height with, sunk into its summit, a shiny chromium cup, pierced at the base with a round hole, it was a most implacable ash-vortex. Mr Lewis, clothed in black, sat hunched in a blue-black chair squared off, partner to his ash-tray and on the summit of Mr Lewis's black and formal figure was Mr Lewis's head, wedge-shaped, blade-nosed, with a forehead like a sledge-hammer beneath which the girders of his spectacle-frames seemed to provide a dangerous cakewalk for ideas to cross.

I specify that this was the first time I had laid eyes on Mr Lewis, who was, at that time, an ogre to me, inexcusably a man of genius on the wrong side of the fence and therefore as embarrassing as the Stone Guest at the Supper Table. Mr Lewis, well aware, I imagine, of this relationship, was mildly curious at my having included him in my little book. He did not, I surmise, expect

such a degree of objectivity in anyone who could write a book called *British Drawings* and I must admit it surprises me to this day. The interview went smoothly and Lewis charitably forbore to heat the oven round the half-baked.

At much about this time, or perhaps it was a year or so later, Lewis began to write art criticism regularly in *The Listener*. To the vague alarm of many, Lewis praised without stint among the younger painters and, on my return from a fairly lengthy visit to Italy, I was among those whom he encouraged and continued to encourage. In May 1949 the Redfern Gallery staged a large retrospective Lewis exhibition. I had seen relatively little of Lewis during these two or three years and can remember nothing remarkable about our occasional encounters with the exception of two. One was a chance meeting in the Redfern Gallery, during his 1949 show, when I wandered in to find two silent figures contemplating the exhibits. One of these was Mr T. S. Eliot dressed with quiet elegance in a blue business suit, stooped like a benevolent osprey and gazing intently at Lewis's early self-portrait. This imposing picture shows the artist gazing stonily out from the canvas and wearing a large, fierce hat. The sole other occupant of the room was Mr Lewis himself, wearing a large, fierce hat and gazing stonily at his own portrait of Mr Eliot, a picture in which the poet is dressed with quiet elegance in a blue business suit.

The other, an earlier occasion, which stands out in my mind is an evening which happened to be the late Constant Lambert's birthday. During the course of this event, Lambert remarked that he had, on a previous birthday, met Lewis in the rather dispiriting public bar of the Notting Hill Gate Underground Railway Station, a spot rarely patronized by rank and fashion. Lambert told me that on this previous occasion, he had enjoyed the rare privilege of hearing Wyndham Lewis sing a song, or part of a song, called 'Pretty Polly Perkins' and nothing would content Lambert but to make a pilgrimage to the scene of this past triumph. When, fairly late at night, we approached the entrance to the bar, he explained to me that the opening stanza of the song began 'I'm a broken-hearted milkman . . .' and I was much struck by the singularity of Lewis so designating himself. As we pushed open the door of the bar, only two people were standing at the

long counter. At one end was an orchestral conductor known to us both as having deserted from the army some years previously and who was still technically on the run. At the other end of the bar Mr Wyndham Lewis was standing, with a large black hat pulled down over his eyes. No one spoke and the only sound was that of trains groaning and roaring beneath our feet. Without seeing us and without singing a note, Lewis turned and strode out into the night.

When Lewis published in *The Listener* a short and moving article of astonishing power called *The Sea Mists of Winter* in which he informed his readers that, being blind, he was disinclined to continue as a regular art critic, I was entirely unprepared for this information and very uncertain what to do. I was fearful of making any overture to him, since our acquaintance had been a casual one founded upon matters visual, and these, I felt, Lewis would not wish to discuss. The occasion for re-establishing relations came early in 1953 when I was asked by the editor of a symposium (which eventually never came to publication) to try and obtain a contribution from Lewis. This editor, although filled with nervous good will, could not summon the courage to approach Lewis direct and I accepted the task. I visited Lewis in the spirit of a visitor to Gaza but found no Samson Agonistes. Instead, I found the same man, in the same chair, abutting the same loaded ash-tray.

During tea he informed me that he was completing a new novel and was half-way through revising a book on the current dilemma of the visual artist. He had, he said, several short stories to hand and would be pleased for me to take one for my purpose. We talked of Pound, I remember, and of painting. Lewis insisted that he was no longer interested in anything visual, including his own pictures. He then spent three-quarters of an hour disproving all but the latter part of this assertion. Physically he was little changed except that his eyes, no longer concentrated in their regard, were shaded by a green plastic peak. This added a curious dimension to his face. The forehead which hitherto had been, it seemed to me, designed for striking ringing blows, was now bisected but armed with a green obsidian cutting edge from beneath which the nose reared like a secret weapon; an armed head indeed. His hands, with delicately exploratory movements,

sidled over the limited terrain of knees, and teacup, with fingers held together.

From then on I saw him fairly frequently and towards the end of 1953 he told me that he had instructed his publishers that they were to commission me to do a dust jacket for his forth-coming novel *Self-Condemned*. This would have come as a surprise from any other author for in my experience, authors accept gratefully or at least unprotestingly, whatever their publishers choose to wrap round a book. Not so Lewis, who was seldom readily given to accepting anything wrapped round a publisher, let alone a book. And Lewis avowed a confidence in my ability to design suitably for him, which I did not wholeheartedly share. It was not that I was unenthusiastic, it was that I was terrified. To illustrate, or even to draw with relevance from an image in another man's mind is an uncertain procedure especially if that mind is an intensely visual one: to make a drawing as a sort of substitute for the eyes of a draughtsman of Lewis' stature, insecure in the knowledge that he cannot see the result, is the most dis-concerting of challenges. I recalled with vividness an occasion in a public house when Dylan Thomas had almost tearfully requested me NOT to make a drawing to accompany a poem of his in a magazine. I did eight versions of the jacket for *Self-Condemned* and submitted the best to Lewis, who pronounced himself satisfied.

I do not know how Lewis extracted from a description the quality he required from a drawing. Mrs Lewis, I assume, described the design in detail and Lewis, using his previous knowledge, constructed the image from this description. Upon a later occasion when I was making the nine drawings for *The Human Age* he was explicit in his requests for alterations and new versions. (I some-times wonder, since blindness was the only barrier, why he did not continue his regular art criticism, for this was a drawback which in no way set him apart from other critics then or now in practice, and they after all do not even know their affliction.)

I followed the jacket for *Self-Condemned* with another for a new, limited edition of the *Apes of God*. Worse and worse, here was a revival of a production for which Lewis himself had set the visual scene. His famous jacket for the original *Apes* was con-sidered by the obscure publishers at the time in question, to be

73

'out of date', which caused Lewis to laugh grimly. However, I produced the drawing and all was well, or at least all was well as far as Lewis was concerned. The publishers were not pleased until Mr Lewis instructed them to be so.

Late in 1954 I began to draw for two volumes of *The Human Age*: three drawings for *Monstre Gai* and three for *Malign Fiesta*. This was as difficult an assignment as I had ever undertaken, mainly because this book is to me one of the greatest works of fiction of this century, which is difficult enough to contemplate decorating, but also because every chapter inspired a drawing and my only desire was to do sixty rather than six. Lewis, however, would have none of this and forbade me even to double the number and make six for each book, despite Messrs Methuen's willingness that I should do so. He was no doubt right to limit the number so rigorously, but the problem of how to produce anything faintly capable of measuring up to the writing remained. Finally, I compromised with my urge to illustrate the book episodically and concentrated on portraying the principal characters. I also made three drawings for *The Childermass,* which is Part I of *The Human Age* and was subsequently reissued in a uniform edition with Parts II and III. I made in all forty-eight variations on the nine drawings which were published and I should be better pleased if I had been allowed to publish a further couple of dozen.

Having come to be, in some sort, trusted to act as Lewis's eyes in terms of his book jackets and the illustrations for his books which he himself would have undertaken had he been able, it seemed necessary and appropriate that I should make drawings of him in addition to those I had made for him. Commissioned by his publishers which, for Lewis, satisfactorily established that I be paid for my labours (and it was important to him, far more in this instance than to me, that I should be), I set about it. I spent many weeks on the task which, eerily, had about it some quality of making a 'self-portrait' of someone else, so closely was I concerned to satisfy a man who could not see what I was doing, as to his appearance. If the portraits are any good it is a great deal to do with the sitter that they came to be. Not only was I concerned to justify his generous faith in my own work, but I was pushed full out by the fact that I was painting Wyndham Lewis and I am prepared to accept that I was indulging in the blatant snobbery of

72

262

being conscious that I was making a historic document. I take no shame in this, for I suspect that the reason why so many popes and princes at other times got themselves so uncommonly well painted, is connected with this simple vanity on the part of painters; and it also explains why so few tycoons and duchesses these days get more than they deserve. A proper intellectual snobbery is the only tenable one left. Anyway the terms of reference were that no one had painted Lewis, except himself, since Augustus John had done so before World War I; that Lewis was himself a master draughtsman and in particular a superb portraitist; and that Lewis was blind. If one could not make a portrait out of this, one had better give up and become a disc jockey. There was never going to be anything more difficult or more rewarding. So in the course of March and April 1955, I painted the thing. It is Lewis in the dark arm-chair in which I first saw him, slumped across the canvas from left to right, with the armour-plated ash-tray at his elbow and the green-bladed eye-shade on his brow. I took the composition basically from Lewis's own portrait of Pound and reversed it. The size of the two pictures is the same. 'I'm not easy to paint,' said Lewis at the time, 'because I have a wedge-shaped head, but then I do not greatly care what I look like.'

Mr and Mrs Lewis lived in a flat at the top of a building at Notting Hill Gate. The stone staircase which led up to it was as forbidding as any part of the landscape described in *The Human Age* and very tall. I visited them pretty regularly, making appointments by telephone. This required time, since Wyndham would not have his telephone answered. He would rise from his chair and slowly negotiate all obstacles as he crossed the room. It took on an average twenty-eight 'ringing tones' to get him there. He would then state his name with a power which, despite the fact that I live in Essex, made the telephone redundant. 'COME AND SEE ME ON MY BIRTHDAY,' he roared on one occasion, and responding to this summons, my wife and I decided to take the occasion to give him one of the three pleasures he had assured us remained to him. These were champagne, caviar and walnut cake. A fourth, gin, he was no longer allowed. We bought for him a jar of genuine caviar and for ourselves a pot of the eggs of the lump-fish which, dyed black, make a fair substitute

for the real thing. We presented the genuine caviar. 'Is it,' inquired Wyndham, 'that kind with the little grey eggs? I prefer the cheap kind with the large dark eggs.' So down the long stone stairs to the car we went and made the exchange. So expensive had the genuine caviar proved to be that we could not bring ourselves to eat it for eight months. 'Eliot,' said Lewis, 'often sends me champagne.' He paused and after a long silence added ruminatively, 'not very good champagne.' Mrs Lewis provided the walnut cake, which was excellent.

In 1956, Lewis was given a retrospective exhibition at the Tate Gallery. He was desperately ill by then and, as Mrs Lewis was recently forced to point out in response to the last venomous personal attack on Lewis to have appeared to date, he was only able to attend the private view under heavy sedation and he was unable to climb the steps to the main entrance to the gallery. He was not only blind, but at intervals deaf, and as I sat with him briefly, surrounded by his paintings, I doubt if he was aware of the curiously urgent solidarity of those who were present at his last and greatest exhibition. Yet that solidarity was almost palpable. Eliot sat on his other side and we, among many, tried to get through to him and make him feel – what? I am at a loss to say, but it was urgent. He sat in a calm and, I suppose I felt, impermeable solitude, a sea mist indeed as dense and cold as winter itself, politely trying to acknowledge acquaintances.

Returning home I wrote a review of the exhibition which I called *The Stone Guest* for reasons not simply literary, nor polemical, but that the man seemed, on that afternoon at the Tate, to be as founded as a storm-worn rock and to display, in dreadful irony, the adamantine carapace he had so long championed; the external armour which he maintained was the proper study for him as a painter.

'Mr Lewis no longer cuts up rough,' I wrote, 'he cuts up as smooth as plate armour and his pictures, all indian reds and acids, clank down the walls of the gallery like conquistadores, cutting their way through the lush jungle of contemporary art.

'What is to be done with these warrior pictures: where do they fit; where to put them? Must one recognize that Mr Lewis is a great artist or something? Mr Lewis is unavoidably something. If he did not exist, would it have been possible to avoid inventing him?

264

'The general practice has been to do the worst one can about Mr Lewis, so perhaps this tradition should be maintained. He is not and never has been a Cubist, any resemblance to Cubists living or dead is purely coincidental. He is not and never has been 'painterly', his brushwork gives no sensory pleasure. What he has done has nothing to do with painting, in the sense we have been taught to believe is desirable. Where others made paintings, Mr Lewis made ikons. He was an image-maker in a period when the image itself was, as it still is, required to be subordinate to the means of expression. He was a draughtsman capable of drawing a sharp line through the *Zeitgeist*.

'With a bit of luck it would have been possible to avoid the issue Mr Lewis raised. It might have been practical to shift him off the stage by making him *historically important,* or a grand old man; or, the other way, he might have been dubbed a follower of the Futurists or an offshoot of Cubism or an interesting early abstract painter. This has been tried, but of course the portraits got in the way and the drawings shift him out of the company of Balla or Severini or Delaunay or Gleizes, where it would have been so cosy to have stashed him away. If there are ten great portraits since Picasso's *Gertrude Stein,* who are they by? They are by Matisse, Modigliani perhaps, Bonnard, Picasso again, Balthus maybe, Kokoschka, Sickert, or take your choice, but quite unavoidably the tenth will be by Wyndham Lewis. The portrait of Ezra Pound, for instance, is not something you can argue with.

'The problem for the spectator faced with the work of Mr Lewis, is that he is not on the same side. He is in perpetual opposition and grinning at you, in as much as he was ever looking in your direction at all. It is not heartlessness. No one who was a mere Tyro and without a heart, could paint such dignity and warmth into the portraits of the artist's wife, nor infuse the first Eliot portrait with such a sense of meditative reticence, without possessing deep human sympathy. Indeed, the best of the portraits are, as they should be, of persons whom Lewis admires and more than admires. He is not, however, endowed with the kind of gregarious *bonhomie* which makes a Vuillard or an Augustus John portrait so jolly. It is not a sociable gift he has. And it does not look, from this exhibition, as if Vorticism was a movement engendered in terms of the robust collective romps of the Futurists.

Rather unfairly, since several of them are men of talent, the other Vorticists collected at the Tate look rather like a lot of sprats a whale has caught. But then, as Mr Lewis points out in his catalogue introduction, Vorticism was what he, personally, did and said at a certain period. What Mr Lewis did both then and later, may be seen at the Tate. What he said has been no less considerable, so some of his books, pamphlets and manifestos may also be seen there excellently displayed in glass cases, although in a sense a glass case is a very improbable place to put a book by Wyndham Lewis. However, in one of his pictures, *The Tank in the Clinic,* he himself has put several eggheads, 'visually logical beings', as he calls them, into a glass case of their own. The visitors to the gallery, eggheads included, do not at first glance appear to be in glass cases, but that is about the only advantage they have.'

The representation of the other Vorticists at the Tate, with special reference to my unhappy phrase about 'sprats a whale has caught', was among the grievances which caused Mr William Roberts to publish a series of petulant pamphlets attacking Lewis, Sir John Rothenstein and myself for deliberately misrepresenting the Vorticists by exaggerating Lewis's role in the movement. A furious wrangle developed in the press of the kind in which, throughout his life, Lewis had taken so vigorous a part, but it was too late for him to participate in it. Not until some months after his death did the matter flare into a fully fledged furore when, on 22nd November 1957, *The Times Literary Supplement* published a laudatory review of the Roberts pamphlets which accused Lewis of being unscrupulous, a 'virulent hater' and 'not a great painter or anything like one'. As W. K. Rose described it in his edition of Lewis's Letters,* 'The correspondence columns of the *T.L.S.* boiled for several weeks. One feels the Enemy's spirit was still abroad.'

During the preliminary skirmishing, Lewis wrote to me† about Roberts and concluded with the words, 'Hope you will be up (from the country) sometime soon. Not about above matter but just don't see you often enough.' It was a poignant use of the word *see* and it was the last letter from him I received.

One final episode remains for me to record and that took place

* Methuen, 1963, p. 566.
† *Ibid.,* p. 566.

on the day following Wyndham's death. My wife and I went to offer help and condolences to Mrs Lewis and found the flat in total disarray because – and perhaps it was an appropriately malign fiesta – workmen had arrived to tear down the building. They were indeed tramping through the living-room and up to the studio, which had been closed since Wyndham went blind. On the stairs was a Lewis drawing with the mark of a large boot on it. With Mrs Lewis's agreement we dashed up to the studio, which I had never seen, and gathered together everything we could lay hold of. It seems, as I recall it as if in nightmare, that the walls were actually falling around us as we piled the drawings together. In the circumstances it was not the occasion, nor did there seem to be time, to collect the dusty books and other treasure trove I feel there must have been in that long-locked studio. We just took the drawings, an oil portrait and some unfinished canvases into safekeeping – in a laundry basket. Among those we rescued was a large pencil drawing of Ezra Pound, with half the head torn away. This half head, in due time, I replaced. It was my last act as a sort of substitute for the eyes of Wyndham Lewis.

1955–1969

The Glutton Eye

plate
65 THE TERM *still-life* is common enough. At first glance it is a bald, flat designation; a description of a genre in painting whose status, it may be thought, lies below that of landscape and that of portraiture. Often enough it is looked upon as a technical exercise for industrious artists, and no more. Yet those two words 'still life' have about them other implications. To me they imply an undercurrent of meaning at once poignant and vital, suggesting objects at once motionless yet alive, objects curiously related to one another, silent, composed together in tranquil or even ominous association. Alive, and even lying in wait for the spectator. Still and yet alive.

Strange that the French term for those related objects should be *nature morte,* the ultimate opposite. What could be less dead than Cézanne's pulsing, heavy apples or more vital than the bread of Chardin? Those apples lie breathing on the table's floor, buttressed by jugs and bottles which themselves are both the participants in an event and the austere architect of its setting. And Chardin's bread crumbles into the spectator's mouth and his wine flickers in its glass, the one dense and procreant, the other waiting like blood in a dark heart. Rough and smooth on the tongue, just as those lemons out of seventeenth-century Holland, their serpentine skins uncoiled, their citron centres sharp as the knife blade that laid them open, bite and contract the mouth. Are those dead nature or still life? Is it an odd reaction to painting to taste it? One hardly thinks of painting as edible – or perhaps one does. Metaphorically and more than metaphorically, certain pictures enter through the mouth or the eye's mouth and penetrate the senses, between the teeth. Renoir has left us peaches which are at once fruits and kisses and forms in space.

268

Possibly I should not have become so acutely aware of this vegetable embrace had I not left the city, where until a year or so ago I had spent my working life. You do not become acquainted with cabbages in cities and rarely with kings. But I, uprooting from the asphalt, buried myself and undertook the cabbage. I grew up during the winter months with a red cabbage, emerging with it, I followed it through deep green into deep violet and ran along its crimson veins into its black centre. I also spiked with onions and watched their pale, cold, bladed leaves stab out of the earth like dragon's teeth and I waited nine months for the jagged bud of the artichoke.

For me still-life grew out of the ground where I myself had planted it and the discovery of still-life for me took one full year, through the turning seasons. And as the growth of these and other plants is imperceptible, so that they seem motionless though alive, so it was that I discovered still-life and began to brood on the two words as well as on these things which I had planted. In the course of this year the sequence of my painting was the sequence of flowering and fruiting and when I had finished a painting I ate the subject of it. This was a complete cycle.

On occasion such a stately procession down the months, through the eye, and into the mouth, was rather anti-social. At Christmas my great red cabbage fully unfurled and swung its black-blue banners and I set it on a table, on a yellow cloth. I put with it a ham and apples, and the intercourse between these glowing objects was as solemn as a colloquy between kings, on a field of cloth of gold.

My wife, however, wished to cook these things for Christmas. She felt the matter to be pressing and would stand uneasily in the studio doorway with pans and pots whilst I swore it would only be a matter of hours. The children and the children's friends began to lay wagers on when the day would come upon which the ham and the cabbage would achieve their proper destiny.

It was after all a ham of unusual nobility. Bred within a mile of the red cabbage, cured within an hour's journey, this ham's rind blazed in earth colours and in reds as deep as embers. Halved, the cut flesh parted heavily, first silvered and waxen shot with a pale rainbow and then an island, rose-pink and dissonant, rose towards the bone. It was as if a Titian had opened to reveal a Watteau. Or

65

so it seemed to me. The children, however, saw it as a ham.

Eventually, under great pressure from without, the picture was completed and we ate all these things, the ham, the cabbage, the onions and apples, at New Year, with here and there a *doppelgänger* for some vegetable which had laid down its life for an art.

And so it went on along the year. There was a moment when spring sank into summer and the tossing beanrow like a vertical sea hung, shot with scarlet flowers, above the creeping strawberry clutching and feeling its way slowly across its bed. And another time when the broad beans, clicking and dappled in their cotton-centred pods, drooped over the tangled undergrowth from which the orange shout of the marrow flower, lying on its neighbour's heavy child, sang from the green shallows.

In the midst of this, in May there was the asparagus, a sudden muscular gesture which mocked the sluggard evolution of all other plants. The asparagus struck upwards all speed and surprise and within a few days from the white pride of the stem and the suffused excitement of the sceptre's head a gout of seedling fern, a fountain of green spray would explode into grace.

In the lumbering summer of slower growing things, the marshalling of this regiment of lances, close grouped and springing from their raised bed, remains in my mind as a matter of minutes. It was in fact, a matter of weeks, for this rigid and arrogant army grouped and regrouped heroically as their ranks were thinned by our appetites. Nevertheless time, which had been slowed by summer into a snail's slippery stretch across the garden, under the dome of the sun's dominance, seemed to be defied by the asparagus: every morning a new, small palisade of stalks stood in the earth. And every morning or nearly every morning I hewed it down and gathered it into a thick, short stook and carried it in the fully extended circle of my hands, into the house. And the asparagus was eaten and some of it was painted. In a sense, all of it was painted, because the spectacle of all its effortful growing was in my eye whenever I painted a single stem of it.

It was exactly the opposite situation with the quince tree. I waited for the quinces to ripen and I waited so long into autumn that I had them ripe in my mind's eye and ochre and cadmium jostling on my palette, a month before these quinces peculiarly

quickened. I tried to stare them into countenance. Somehow I felt a sufficient number of hot impatient looks would colour the sallow lime of their rinds. And eventually these looks and the season's passage bronzed and gilded them and the quinces passed into paint and then into cheese. And so it went on down the year into winter.

Aside from these vegetables, leaving aside for a moment these organic denizens of still-life, there remain other mysterious inanimate personalities who figure in such compositions. The bottles, plates, dishes, cloths, glasses, knives, forks, coffee-grinders, egg whisks and the toasting forks strut and fret, or jugs stand like monuments. These also take on a private and personal life, taking up and discarding the light, springing a sudden light high and as suddenly retreating round a contour into darkness.

Removed, and uncatalogued by style, a bottle waits, removed and real on my table. It waits to perform, to act, without comment. If I move this bottle an inch, it will change the structure of its small world and transform the other objects, also lying there, which confront or abet it. It will change the intervals between objects, reorganize the space between conversing forms and the relationship between bottle and glass and that between glass and bottle will become more intimate or more constrained. It will be different. It may be a teacup storm, but it will alter the shape of the air. And presently, these objects, each establishing its own personality, will move into me and out again on to the canvas. Through my eyes and mouth, throat, stomach, arms and hands – or something like that – these things will determine their measure and become a painting.

And presently I returned to the art galleries and found a new dimension in the still-lifes of the great masters. I found in Braque's languid oysters and Courbet's shimmering, threshing fish a dimension of appetite wherein the sea stung singing on my lips. And I found in the flashing fruits of Matisse and in Bonnard's golden breakfasts an aesthetic that was a taste in taste itself, an ambrosia in the eye's mouth. So Derain's black bottle, pat and black and starred with a slash of white, among the oranges, so the groups of bottles, stoical and austere, on Morandi's little shelf and the splintered bottle flattened on the newsprint for Juan Gris or dervish dancing for Soutine, all these by alchemy were made flesh and are the ultimate bottle which like a djinn I inhabit.

Returning to the vegetable and the fish and the fruit, I find an egg on the table. This egg is the most absolute of forms. It stands alone in the still pantheon, holding life, or hangs, suspended by Piero della Francesca over a Madonna. It is geometry and Easter, birth and breakfast. You cannot alter an egg without destroying it, you cannot eat it without destroying it, but even broken, the image will remain whole in the eye. All that is left is to enter it and thus you yourself are eaten. And so it is with all the other things. I am not sure now if I have eaten my red cabbage my asparagus, my onions and my artichokes or if they ate me. But I think they were planted and grew and were painted and survived and were eaten and unended . . . even the ham.

1954

The 'Unwearying Bronze'

A Slight Sketch for a Large Book

plates 59–64

BRONZE is an alloy of copper and tin. In the course of five thousand years small quantities of other metals have been mixed into it either deliberately or by accident, but copper and tin combined are bronze, and nine parts copper to one of tin is the common proportion. Where, and by what chance that one part of tin was first added to copper will never be known. Utensils and sculpture were made of smelted copper in Sumeria and in Egypt before bronze was invented; and even before smelting was practised, men had used soft native copper, beaten into shape, for ornaments and tools. True bronze came into use early in the third millennium B C; and when Homer, two thousand years later, described how Hephaestus, the smith-god, smelted the metals for the armour of Achilles, he called the bronze 'unwearying'. It was not weary then, nor is it now. To Homer the vault of heaven itself was solid bronze, and Hesiod, in his *Theogony,* tells us that Day and Night meet and greet each other upon a bronze threshold.

There is in this metal a deep magic which is not explained by its practicality, by the fact that it pours molten more easily than copper and is harder when it cools, or that its colour moves mysteriously from red-gold to deep green or azure as time handles it; it is not that bronze served all practical purposes before iron slowly replaced it for common implements and thus elevated it to the metallic aristocracy; it is not even that much of the world's greatest sculpture has been made in bronze. Not being a precious metal, it does not prompt greed before admiration. It prompts love and it has inspired myth.

I have watched Henry Moore pick up a bronze of mine in the foundry and brush it hard and obliquely with the palm of his hand to wake the metal. Under his rough-skinned touch it came

273

alive; it seemed to stretch itself like a cat, and its surface sleeked like fur. He told me then that he remembered one foundryman whose hands had so particular and subtle an abrasive surface that he could burnish a bronze just by handling it. So if I have accepted and given currency to the myth of the magic hands of a bronze-smith, that myth can join the earlier one of the Dactyls who lived on Mount Ida in Crete, whose name means 'finger men', and who, some say, invented bronze itself.

The Book of Daniel speaks of five ages – clay, gold, silver, brass, and iron – and Tubal Cain in the King James Version of the Bible is called an 'instructor of every artificer in brass' (which is a mistranslation of the word 'bronze'). His counterpart in Greek mythology is Daedalus, whose name means 'cunning maker', and who was a bronze craftsman of marvellous skill. So was his nephew Talos, whom Daedalus is supposed to have murdered from jealousy (Talos had cast the skeleton of a fish in bronze and thus invented the saw). Daedalus fled to Crete, where he entered the service of King Minos, and, to his surprise, whom should he find there but Talos translated into a creature of bronze and the guardian of the island. Talos had a single vein through which his life ran, like the channel through which metal is poured into the mould, and he died when Medea unplugged it. Daedalus fell foul of Minos and had to flee once again, this time on wings of wax and feathers that he made for himself and his son Icarus in order to fly westward to Sicily. Icarus flew too near the sun, the waxen wings melted, and he fell into the sea and was drowned. But Daedalus flew on and took his skills into the West; there was bronze sculpture thereafter in Sicily and Sardinia.

Wax, from which the wings were made, is a substance relevant to bronze casting: the melting of Icarus's wings from the heat of the sun is a description in mythological terms of the lost-wax process, which is still the method generally used for casting sculpture in bronze. The lost-wax process served to cast the head of a ruler who is thought to be Sargon I of Akkad in the third millennium BC at Nineveh, just as it served Myron and Poly-cleitus in fifth-century Greece, Ghiberti and Donatello in Renais-sance Italy, and Rodin in nineteenth-century France. As a technique it was mastered in the third millennium BC, somewhere between the Black Sea and the Persian Gulf – possibly in the area

of Lake Van, where copper and tin ores are found together. During succeeding centuries the techniques passed through the Fertile Crescent to Egypt, Crete, and the mainland of Greece in the west, and northward to the basin of the Danube. Later still it travelled east to China by routes unknown.

If I describe the way in which a Minoan craftsman cast the image of a worshipper now in the British Museum, I am to all intents and purposes describing how my own small bronzes are cast today. More complex processes have been discovered for casting large sculptures, but for the casting of small bronzes from wax little has changed in thirty-five centuries save the method of heating the crucible. Charcoal, made at its best from pistachio or ash wood for this purpose, was the ancient fuel. Hard coke is our substitute.

Suppose yourself to be in need of a votive image, say in 1500 BC, and watch what happens. You will see, because you are not an initiate, several mysteries. The image is first made in wax, carved and modelled, and then sticks of wax are attached to it for reasons that will presently be clear. This image the craftsman coats with a mixture of wet clay and powdered terra cotta, mantling it entirely but leaving the ends of the wax sticks uncovered. Of these, one will be larger than the others and cup-shaped, for it will be the 'sprue' through which the metal will be poured. The figure, buried in its clay sarcophagus, he now places in a fire, so that the wax melts away.

There is now no figure; he has destroyed it. That is the first mystery. All that remains is the clay husk with its vents and openings where the wax sticks have been. Now the craftsman smelts his ores, some lumps of a heavy brown-grey rock or of a bright-green powdery earth, and a very little black-grey material. The lumps are native copper (the green carbonate called malachite is the most conspicuous ore), which will melt at 1,100 degrees centigrade. The grey substance is cassiterite, the ore from which tin will be extracted. It will melt at 232 degrees centigrade.★

★ Only in a handful of places, of which Cornwall is one, are tin- and copper-bearing ores found together. It was therefore necessary, from very early in the Bronze Age, to trade, over great distances, in the components necessary for the manufacture of the alloy. Cyprus, which was and remains the greatest source of copper in the Mediterranean world, has no deposits of tin.

The man now blows up the charcoal-fire with bellows of goat or oxhide. You will not see it, but the copper and tin freed from the ores are combining and fusing into bronze – not so pure as in later times, for there are traces of lead, nickel, silver, and arsenic in the mixture. These traces will affect the ultimate colour of the bronze, but not for some time.

Meanwhile a pit has been dug. In it the dry clay husk that once held the wax figure is buried, packed in damp clay, so that only the openings and vents are visible. Within that husk a perfect negative exists where the wax figure has been burned out. With long tongs the smith takes from the kiln the crucible, filled with liquid fire; the substances once brown or green or black or grey are now a blazing golden red. He pours this golden fluid into the cup-shaped opening (the sprue) until it rises through another vent and gases hiss from a third.

It must now wait many hours to cool, but when it does and when, like a nutshell, the clay crust is broken off, from that carapace a small, heavy, rough but recognizable figure will emerge, glinting and dusty from its earthen womb. That is the second mystery.

You have seen a wax figure destroyed and reborn in heavy metal from liquid fire. You have watched a brown sponge or sea-green powder become a dust-coloured image which the smith, with tools and abrasives, proceeds to hammer, scrape, and polish into a red-gold, for that is the colour of new bronze. The umbilical cords of metal which once were the wax sticks, and then the empty vents, are now cut off. Lovingly chased and burnished, the image is ready to act out your gift in the shrine. That is the third mystery. In time the weather and the fates will turn the red-gold to a warm brown or green or azure once again. That is the total mystery.

If you watch the same process today, there will be differences. The heat will come from a coke-fired draught furnace and not a charcoal one, and perhaps the image will be cast hollow instead of solid. The contents of modern bronze will vary but will be about 87 per cent copper, 8 per cent tin, 4 per cent lead, and 1 per cent zinc. There will be less 'cold work' – the chasing, hammering, and polishing of the newly emerged bronze – for we prefer our bronzes a little raw, but that is a matter of taste. Otherwise,

your journey back through time will have altered nothing except perhaps your state of mind.

For many centuries and in many places, craftsmen, like the one you have watched, made the harness and armour, the weapons and the images, that gave power to kings and warriors, and the tools and utensils that gave men sufficient leisure to build civilizations.

The simplest of these tools and weapons were made not by the lost-wax process but by piece-moulding.* This requires a negative impression of the object in two or more sections which can be keyed and fastened together, filled with molten metal, and then separated when cool. In these cases the mould survives and can be used again and again. Stone moulds of spear and axe heads survive from the second millennium B C. A much later alternative method, still in use, is sand-casting, where the object to be duplicated is pressed into tightly-packed wet sand and molten metal is then poured directly into the impression.

Given these several techniques, the problem of hollow casting, which was the next vital stage in the evolution of bronze sculpture, required the solution of one significant problem: *how to introduce a core of heat-resistant material around which the metal would flow,* so that, when cool, this core could be removed.

How and when this problem was solved is unknown. Traditionally (but erroneously) the credit for the invention of hollow casting is given to Rhoikos and Theodoros, two sculptors from the great metal-working community on the island of Samos, in the mid-seventh century B C. Whoever was responsible for it, the importance of the invention is obviously enormous. Quite apart from the weight and cost of the metal required to cast a life-size figure in solid bronze, the difficulties are very great.† In any case the larger the object being cast, the slower and longer

* There is some doubt as to whether stone piece-moulds were used in this direct fashion since the danger of cracking under heat must have been considerable. It seems to me likely that they were used to take wax impressions which were then mantled in fireproof material as described above.

† One of the earliest hollow casts known, the almost life-size figures of Queen Napirasu of Elam (fourteenth century B C) was filled with bronze *after the cast had been made.* This re-coring with metal may have some ritual significance, as in the case of certain medieval Indian solid bronze casts, but this is not known.

must be the process of pouring the molten metal. As it cools, bronze contracts violently, so that if the flow is interrupted by cooling, parts of the mould will not fill. When the crust is broken off, a leg may be found to have no foot or a hand no fingers. It was the fear of precisely this kind of disaster to which Benvenuto Cellini referred when he described the hazardous casting of his
62 bronze *Perseus* for Cosimo de' Medici.

There are, in fact, two methods of introducing the core into bronze; it is the later method that was used by Cellini. He first modelled his figure in clay, on an iron framework now called an armature, making it slightly smaller than the finished bronze would be. He baked the clay and then spread wax to a thickness of perhaps a quarter of an inch over the whole figure. In this wax he then modelled the surface of the figure in its final form. Duke Cosimo saw the work at this stage and insisted that it could not be cast satisfactorily, for which comment he got a sharp answer. The model complete, Cellini mantled the whole in clay and 'drew off the wax with a slow fire'.

(What he does not precisely describe in his *Autobiography* is the most difficult part of the whole trick: how to keep the core at exactly the right distance from the mantle so that the thin space between shell and kernel remains open to receive the bronze. In fact, the problem of suspending the core troubled the Greeks no less. Polycleitus is recorded as saying 'the work is most difficult when the clay is on the [finger] nail', and although this remark has been variously interpreted, it may mean that the core, held suspended by iron rods which were thrust into it through mantle and wax, balanced as precariously as something suspended from a fingernail. If it is not absolutely secure, it will shift and the work will be ruined.)

Cellini constructed a funnel-shaped furnace around the bulky clay parcel which contained that delicately adjusted envelope, the negative of his *Perseus*. With the wax drawn off during two days and two nights in the furnace and the mould well baked, he sank the whole thing gently into a pit and banked it in with tight-packed earth, leaving vents strategically placed to allow air and gas to escape during the pour.

The casting now began. In torrential rain, and with the artist sick from fever, the terrible story of this combined smelting and

casting reads like a sojourn in hell. The furnace in which the bronze was smelting exploded, blowing off its cap, and the flaming metal escaped and had to be controlled. Then the metal did not flow properly, due to an inadequate tin content, and the wretched sculptor threw all his pewter plates and household utensils into the crucible to lower the melting point of the alloy. Eventually, the plugs of the great crucible were withdrawn and the metal flowed down through the prepared channels into the mould. After a fervent prayer and, oddly enough, a plate of salad, the weary master went to bed. Two days later he began gradually to uncover the statue. Incredibly, the masterpiece emerged complete save for the toes of one foot. He himself attributed his success to the unusual heat of the metal and the hasty inclusion of all his pewter cups and plates. Duke Cosimo was confounded. Cellini had cast a larger-than-life-size figure in a single pour. An element of pure sixteenth-century vainglory had much to do with his attempting it and once the techniques for casting monumental bronzes had been rediscovered during the Renaissance, nothing would content the craftsmen but to do it the hardest possible way. In 1699, when the largest single casting in the world up to that time was poured, Diderot was so struck by the event that he gave much space to it in the celebrated *Encyclopédie*. The statue in question was Girardon's huge equestrian portrait of Louis XIV, 63 which stood in the Place Louis-le-Grand (now Vendôme) in Paris until it was melted down during the Revolution.

The Greeks in the sixth century B C cast their large bronzes in sections, socketing and riveting the sections together as shown in the figures on the famous Foundry Vase. They did this not from expediency but because the Greek tradition of monumental sculpture was one of carving, not of modelling. The figures of youths called *kouroi,* which are the first great Greek contribution to sculpture in the round, make it clear that their form depended for its initial shape upon the marble blocks from which they were hewn (this is also true of the Egyptian and Mesopotamian predecessors of the *kouros*). The early stone *kouroi* are rigid in pose and severely frontal. In every case one leg is advanced and the arms are held close to the sides. Small bronzes of this type survive from the seventh century B C, but quite early on they are slightly varied in pose and their arms are allowed some movements. Two monu-

mental examples also survive from the so-called *Ptoon* group,
the *Kouros* from Piraeus, made in the late sixth century B C, and
the *Apollo of Piombino,* made in about 485 B C. Both are hollow-
cast, but both follow the shape of a *kouros* carved from stone, with
one very important distinction. The arms below the elbows have
moved: instead of being bound to the figures' sides, they are flexed
and hold out their hands. This presages that larger freedom of
action which came when the Greeks realized that their free-
standing monumental sculptures were no longer restricted to the
limits of quadrangular blocks of stone any more than were their
smallest bronzes.

Strangely enough, this took a considerable time. Even after
they had invented hollow casting, the Greeks clung to the earlier
form of large bronze statue which had been made by the process
called *sphyrelaton,* a pre-Greek technique already two thousand
years old, by which thin metal sheets were hammered to shape
on a carved wooden figure and then riveted together. The *idée
fixe* may perhaps be explained by the fact that in Greece such
figures, called *xoana,* were held in great reverence. Few now sur-
vive, but the *Apollo* from Dreros in Crete is a small example which
does. Although details such as hands and feet were cast solid and
attached, the carved wooden body determined the form. The
hands of the *Kouros* from Piraeus are also cast solid and attached. It
seems likely, therefore, that the Greeks did not make their large
sculptures in clay, as Cellini describes, but carved the prototypes
in wood, cut them up, cast the parts in piece moulds – legs, feet,
arms, hands, and head all separately – coated the interior of the
moulds with wax, cored them, and then cast the sections. In any
event, hollow casting eventually liberated the monumental figure
from its stone matrix and altered the whole history of sculpture.

In the first years of the fifth century B C a profound change takes
place. If the *Apollo of Piombino* is compared with the *Charioteer
of Delphi,* the pose of the former is rigidly frontal whereas the
latter's shoulders are turned in subtle opposition to the direction
of his hips. This *contraposto,* first to be seen in the marble version
of the *Ephebe* of Kritios which must have derived from a lost
bronze, shows the human figure beginning to turn and release
itself from the plinth. The *Charioteer,* though still, like the
kouros, a vertical column in shape, is no longer rigid. And Myron's

Discobolus, which follows hard upon it in time but which now exists only in copies, has swung right out of the block. He moves in space – because the tensile strength of metal allows it.

When the bronze *kouros* first raised his arms from the chancery of the block, he set the whole figure in motion in a comparatively few years. Yet hollow casting as such was not new when Rhoikos and Theodoros 'invented' it. It had been known at Nineveh more than a thousand years earlier, as the head of Sargon proves. Eyes of precious materials were inserted from inside the head of Sargon, and held in place with bitumen, in the third millennium, just as they were fastened from inside the head of the *Charioteer* with plates of lead in the fifth century; this could not have been done had the heads been cast solid. Sargon's ravaged face as we see it today is the result of mutilation by robbers who gouged out his eyes for their value and threw the head itself upon a rubbish heap – an ironic fate for the likeness of the 'King of Battles', who no doubt in his own time had looted and melted down, as ruthlessly as anyone, many masterpieces in bronze.

The long history of bronze has many dark ages spaced through it, and the lost sculptures overwhelmingly outnumber the survivals. Ancient texts mention such casualties as the long-vanished metal figures of the remote Hittite city of Alaja Hüyük and the classical historians, Pausanias, Pliny, and Diodorus Siculus, record innumerable works of art in bronze that have since disappeared. The bronze Colossus of Rhodes – a wonder of the world – stood a hundred and twenty feet high for fifty-six years in the third century BC, fell in an earthquake and lay in pieces where it had fallen for nine hundred years more. Not one fragment of the original survives, nor do we clearly know from the one surviving fragment of the one possible replica what it really looked like.

Before Rome conquered the world, another great event had shaped the history of bronze sculpture, the rise and fall of the empire of Alexander the Great. Alexander's death did not bring on a Dark Age but rather an age of aesthetics not altogether different from our own. It created a new demand for bronze sculpture, but the function of that sculpture had changed. No longer were images made for sacerdotal purposes, to celebrate or propitiate gods or kings, but to please connoisseurs.

This is important, because the products of the two eras in which

aesthetics have dominated the arts are profoundly different from those of the ages that preceded them. The aesthetic phase that began with Alexander lasted six hundred years and embraced both Hellenistic and Roman art. During those centuries it was secular rather than religious art that predominated. It is not that religion played no part in men's lives but that connoisseurship removed the arts from their central connection with worship to an area where *taste* prevailed. The rise of Christianity put an end to this phase, which, after a gap of a thousand years, gave place once again to a new consideration of aesthetics during the Renaissance. Hellenistic art, whether in Greece or Egypt or the Middle East, maintained something of its native flavour but changed direction. From India, where Buddha wore an imported head of Apollo, to Alexandria, where small bronzes reached their highest technical perfection, sculpture became eclectic to please collectors, who as patrons usurped the position of those who served the gods.

Rome acquired its bronze sculpture by looting and by purchase. Countless bronzes left their places of origin in the baggage of Sulla and at the demand of Nero, while the dealers who supplied wealthy collectors ranged over the Western world as avidly as their descendants now installed in Bond Street or Madison Avenue. Antiques were in demand and forgery was widespread; the Greeks themselves forged or imitated their predecessors precisely as Ming craftsmen in China forged the bronzes of the Shang and Chou dynasties, hundreds of years after these dynasties were dust.

Rome fell. And with Rome's fall the West entered its most recent Dark Age, to the sound of execrations from the early Church which cursed Rome for her luxury and destroyed her brazen images with the greatest vigour. The destruction of Rome's metal monopoly was accompanied by a loss of techniques, as the craftsmen died, or were killed, or gave up. But only the most ambitious techniques were lost: it was the monumental hollow-cast bronze which ceased to be made. Bronze facture continued, especially in the Eastern Empire*which passed it back

* The Imperial tradition of the colossal bronze passed to the Eastern Empire. A surviving example is the clumsy fourteen-foot-high figure of an Emperor (possibly Heraclius) which now stands before the church of San Sepolcro in the Apulian seaport

to Western Europe in the form of minor artifacts. The major achievement was the sequence of great bronze doors, many of which still survive. In the West the earliest are those of Charlemagne at Aachen, cast in the ninth century, and the sequence culminates in the second pair of doors made by Lorenzo Ghiberti for the Florentine Baptistry in the years following 1425 – perhaps the most influential single creation of the early Renaissance. Sculptors like Bonnano, Oderisius, and Barisanus, like the Master of Hildesheim and Reiner of Huys, together with many others whose names are lost, contributed to the great corpus of medieval bronze sculpture which is collectively known as *Dinanderie,* because from Charlemagne's time the city of Dinant on the Meuse was supreme in the field.

During some thirteen hundred years of Christendom, a monumental bronze equestrian statue had remained standing in Rome as the result of an error of attribution. The fervid Christians, while bent on destroying pagan idols, believed this statue – which is actually of Marcus Aurelius – to represent the Christian emperor Constantine. Hence it survived. The other seminal masterpieces to be viewed with wonder were the four gilded bronze horses, made in Greece more than three centuries before Christ, which decorated the façade of St Mark's in Venice from the thirteenth century on (except for a temporary exile in Paris whither they were taken as part of Napoleon's plunder). These ancient marvels could not be matched by medieval man, but they were seen by Donatello, the sculptor who, like Ghiberti, bestrides the opening decades of the Renaissance. It was he who created for the first time since antiquity a monumental bronze equestrian statue, modelled on the antique and representing in Roman splendour, a professional soldier from Bergamo called Erasmo da Narni and nicknamed 'Gattamelata'. Erected in 1453, it stands to this day before the Church of San Antonio at Padua. The *Gattamelata* provided the impetus for a sequence of such monuments which, although individually they have steadily declined in quality, is only now coming to an end. The second of these monumental

of Barletta. If this bronze, which is of interest only for its size, does represent Heraclius, it dates from the seventh century. It is believed to have been found in the sea and has no provenance.

283

61 bronzes represented another mercenary, Bartolommeo Colleoni,
whose fortune was such that, after years of enforcing a lucrative
protection racket, he left a substantial sum to the Venetian
Republic to ensure himself an adequate memorial. He got one
that is the equal of Donatello's *Gattamelata*.

The story of its creation is somewhat confused. Andrea del
Verrocchio of Florence, Leonardo's master, was one of three
sculptors invited to compete for the commission, according to the
Dominican Felix Fabri, who recorded the story in his memoirs.
Instructed by the Signoria of Venice to show their skill at making
a horse, one sculptor submitted a large model in wood covered
with black leather, one a model in red terra cotta, and Verrocchio
the winning version in wax. 'But for what will be done about
casting it,' wrote the friar in 1483, 'I have not heard; perhaps they
will give the matter up.' Fortunately they did not. During a feud
with the Senate over whether he should be permitted to make the
figure of Colleoni, Verrocchio lost his temper, broke the model,
and went back to Florence. Induced by a repentant Senate to
return to Venice, he completed a full-size model in clay, took a chill
(traditionally in the foundry while casting, though there is con-
siderable doubt that Verrocchio was alive when the casting
began), and died in 1488, leaving instructions enjoining his pupil
Lorenzo di Credi to finish the sculpture. Lorenzo agreed and
placed the casting in the hands of Giovanni d'Andrea di Domenico,
but both he and Lorenzo di Credi were sacked. The work was
now undertaken by Alessandro Leopardi, who completed it. It
was erected in March 1496, although not in Piazza San Marco as
Colleoni had required but in Campo SS. Giovanni e Paolo.

In spite of this ludicrously involved procedure, not untypical of
Renaissance committee decisions, the result is a masterpiece.
There follow several others, the greatest of which do not survive.
Purely from the point of view of size and technical difficulty,
Girardon's grandiloquent Louis XIV was perhaps the apotheosis of
the single monumental cast in bronze of an equestrian statue.
Even this, however, is not the end of the story of great bronze
horses.

The masters of the early Renaissance, looking back on the
remains of antique sculpture in its decadence, transformed it.
In its rebirth it ranks with the great works of its progenitors in

284

Greece, which, paradoxically, the Florentines could not have seen. Donatello raised Ghiberti's relief style to an amazing eloquence and developed, in such works as his *Judith,* free-standing bronze sculpture of matchless quality. Verrocchio carried the tradition forward, while Leonardo da Vinci was able to make his famous boast that he could 'carry out in sculpture in marble, bronze, or clay . . . whatever may be done as well as any other, be he who he may.' This, in a letter to Lodovico Sforza, is followed by a paragraph which reads: 'Again the bronze horse may be taken in hand, which is to the immortal and eternal honour of the prince, your father of happy memory and of the illustrious house of Sforza.' This horse was never cast; indeed, the period of the High Renaissance has, apart from pleasing minor works, left us with only one masterpiece in bronze that can be traced with confidence to the art of Leonardo da Vinci. This is a statuette of a rearing horse, which exists in several versions. We have no major work in bronze either by Leonardo or Michelangelo. It could be called the period of the great losses. Leonardo spent many years of his life on two projects for colossal equestrian monuments, the *Sforza* already mentioned, and the *Trivulzio.* They survive only in numerous drawings. The *Sforza* monument was used as a target by French bowmen while still in clay and was thus destroyed; the *Trivulzio* was never actually begun. Leonardo went into very great detail concerning the construction of armatures for both these bronzes, as his drawings at Windsor and Madrid show, and in particular he was concerned with the technical problem of casting a rearing horse. This problem involved the mechanics of sustaining the whole weight of horse and rider on only the two hind legs of the horse. Despite the great tensile strength of bronze, no one had been able to achieve it. Beginning in 1483, with studies after Antonio Pollaiuolo's now lost model, Leonardo employed the device of supporting the horse's forelegs on a prostrate foe, laid low by the heroic Duke. Although as the work progressed he altered this figure so that the horse's forelegs were freed, he was clearly uncertain that the structure could be sustained, unaided, on such a colossal scale. It is not altogether surprising that even Leonardo quailed at the thought of raising so vast a weight of metal on two such slender supports as the hind legs. Donatello had not even risked leaving the single raised

foreleg of the *Gattamelata's* mount unsupported, and inserted the rather improbable device of a bronze orb beneath it; Leonardo's drawings for the *Trivulzio* monument indicate various objects such as a wine jug beneath the horse's hoof, which is a little odd considering that Verrocchio's *Colleoni* still stands triumphantly in Venice with a foreleg cocked and free.

It was not until the seventeenth century that the problem of the rearing horse in bronze was finally solved, apparently by the Florentine Pietro Tacca with a statue of Philip IV in Madrid's Plaza de Oriente. The king wanted a monumental equestrian bronze of himself and had Velasquez make a drawing for it. Velasquez represented the horse rearing in the classic manœuvre known in *haute école* as the *levade*. This was the pose in which Velasquez usually painted the horse in his equestrian portraits, but it confronted the unhappy Tacca with a task hitherto known to have been impossible on such a scale. Presumably having consulted all available precedent, Tacca decided to approach the greatest living scientist for advice. He wrote to Galileo and a correspondence took place which still survives. The expedient eventually employed was supremely simple: Tacca extended the florid baroque tail of the horse to the ground and braced it with a heavy iron internal support. The three iron braces in legs and tail have proved adequate to hold Philip IV in equilibrium on his prancing charger to this day.

Michelangelo was not by nature a bronze sculptor. It was against his will that he made and had cast a colossal bronze of Pope Julius II. Having little interest in bronze casting, he employed an artisan whose trade was cannon founding, and who in fact made a considerable mess of the business of casting sculpture. The statue, which represented the Pope seated, was fourteen feet high. At the first attempt the cast failed above the Pope's girdle and the metal remained caked in the crucible. A second attempt succeeded and the work was erected over the door of San Petronio in Bologna in 1508. After its destruction by the Pope's enemies, the Bentivoglio party, the fragments were sent to Ferrara; and there, with the exception of the head – which the Duke Alfonso d'Este kept intact, but which has since been lost – Michelangelo's major work in bronze was melted down and recast as a cannon called *La Giulia*.

How many masterpieces of sculpture have been turned into artillery is difficult to conceive. In some small degree the process has worked in reverse. Certain victories have been commemorated by recasting captured cannon into works of art of a kind. In London the reliefs on Nelson's Column in Trafalgar Square, which represent his victories, were made from French cannon taken at the Battle of Trafalgar; and the Victoria Cross, Britain's highest award for valour, is cast from cannon captured from the Russians during the Crimean War. Sentiment apart, however, it has been a bad bargain. No Michelangelo has been available for such official monuments, and wars have been more potent in the destruction of sculpture than in the reshaping of cannon.

It was not merely accident and artillery which brought about the decline of bronze sculpture as the Renaissance rose to and passed its zenith. It was aesthetics. The Renaissance passion for the dream of the antique world was accompanied, not surprisingly, by a passion for collecting antiques, and forgeries went hand in hand with originals. At all except the highest levels, Renaissance art makes so low a bow to the antique that it falls on its face. In this nothing is more instructive than the vogue for the bronze statuette, an object derived from the votive, but made as an *objet d'art*. In the hands of Donatello and of his pupil Bertoldo, of the Pollaiuoli brothers, of Verrocchio, and of Giovanni Rustici, the small bronze preserves enough vitality and majesty in miniature to keep it well above the level of the *bibelot*. Even as the cult spread, there were individual masters like Riccio of Padua who stood out; but as it proliferated in Italy, Germany, and Flanders and became an industry, as in the fashionable workshop of Giovanni da Bologna, it trapped itself in mannerism and fell into triviality.

No Renaissance dignitary could afford to be without his little bronzes; and they remain costly and sought after today as beautiful prestige objects, for the aesthetic phase which began with the Renaissance is still with us. But the bitter comment of Bernard Berenson that Cellini reduced the art of sculpture to the level of jewellery, if not altogether justified, is relevant. Sculpture in bronze passed into a long decline.

So far this potted history of bronze sculpture has been concentrated upon its spread from Mesopotamia into Europe over a period of some four thousand years. It also moved eastward in

287

circumstances of considerable mystery. The great age of Chinese bronzework begins with the Shang dynasty, and upon a level of such absolute mastery as to be extraordinary. Until recently, at least, it was assumed that there had been no primitive Chinese bronze, no period of trial and error; from the Shang through the Chou to the end of the Han dynasty – a period of seventeen hundred years – Chinese bronze facture remained at the highest level. Technically, every device and refinement was practised, but as far as we yet know, the objects that resulted were never very large in comparison to Western sculpture, whether they were the ritual vessels of the Shang period or the complex figurative bronzes of men and animals of the Han period, recently excavated in Yunnan. The Chinese apparently did not tend toward a grandiose art in bronze during these early dynasties, and the monumentality of their forms is contained in little. It is possible that Shang and Chou bronzes were not only made for ritual purposes, but that their making *was* a ritual and the metal in the alloy proportioned in accordance with magic precept. When, later, the Chinese too reached an aesthetic phase, they began to imitate their own earlier triumphs for the pleasure of connoisseurs.

In China this decline begins early in our era, and in bronze sculpture, although not in the other arts, parallels our own Dark Ages. As the Chinese, and coincidentally the Europeans, declined in this field, India began to ascend. The origins of Indian bronzework are more obscure and considerably earlier than those of China; a tiny figure of a dancing girl found at Mohenjo-daro may date as far back as 2500 B C. However, the greatest surviving Indian bronzes appear after the Gupta period, between the seventh and the thirteenth centuries A D, during the Pallava period and the subsequent Chola dynasty. They are invariably religious images cast by craftsmen who worked in accordance with the most rigid ordinances. The canons of the sacred texts were strict: even the bends and curves in images of human figures were dictated. *Samabhanga* is a figure without bends, *abhanga* means one with a slight bend, *tribhanga* means thrice bent, and *atibhanga* means greatly bent. Every gesture of the hands and fingers had its meaning, called a *mudra,* every posture was named and established, every proportion measured. In this latter particular there is a strong parallel with the Greeks, but in direct contrast to them – at

288

least in parts of India – images were cast solid rather than hollow, for ritual reasons. The image maker was bound by faith and tradition never to cast a hollow image for worship, under penalties of a curse lasting seven generations.

The complexity of the Hindu pantheon is far too great to set down here, but the forms fall into two main categories – small images for private worship, and large ones called *ustavi murtis* for carrying in procession – and these in turn fall into three groups, those of Brahma, Vishnu, and Shiva. Buddha co-exists with these, and in all cases there are numerous manifestations of the gods in different forms.

Just prior to and following our own Renaissance, two other bronze cultures came into being. A brief and trivial one in Peru, which perhaps began in the thirteenth century, is mysterious in that the Incas had reached a high level of achievement in goldwork long before this, and were skilled in metallurgy. Why this brief bronze age occurred, since the results are insignificant, and from whence it derived, is uncertain.

The isolated African bronze age has scarcely less mysterious origins but a far higher achievement. It was concentrated along the Gulf of Guinea and centred upon Yorubaland, where, at the city of Ife, a series of life-size and marvellously executed bronze sculptures have been excavated. The craft of Ife began some time before Europeans reached Benin in AD 1485. The casting technique was a lost-wax process virtually identical with the technique that had been practised for four thousand years in Europe and Asia, and the results are quite unlike anything else in African art. In no way primitive, the majestic striated heads of Ife are comparable to those of archaic Greece. From this culture the celebrated bronzes of Benin derive; local tradition has it that the first bronze founder of Benin came there from Ife. The finest Benin bronzes were made between the fifteenth and seventeenth centuries. Date, however, is not a significant factor in African art. All but the earliest and greatest derivatives of Ife could just as well have been made at one time as at another during those centuries, so rigid was the tradition of ritual which inspired the form. The only exceptions are those images which represent the rare and marvellous advent of Europeans, who carry guns and are some-times represented as wearing curious travesties of European dress.

In Europe itself the art of bronze sculpture had remained dormant from the death of Lorenzo Bernini in 1680 until its reawakening in France in the nineteenth century – or, if that is unjust, at least nothing occurred of such consequence as to find its way into this short survey. The rebirth when it occurred was the product not of professional sculptors but of painters. It had least of all to do with professional metal-workers and foundrymen who, apart from reproducing utilities and ornaments, were taken up with vast official pieces such as the final, the largest and the worst monumental bronze equestrian statue to figure in this account. In the year of Rodin's birth, 1840, one Matthew Cotes Wyatt began work on a huge bronze of the Duke of Wellington. It measured thirty feet in height and twenty-six from the nose to the tail of the Duke's mount, and each of the horse's ears was two feet four inches long. It was cast in eight pieces, having required a hundred tons of plaster for the moulds, and stood in London at Hyde Park Corner until it was banished by popular insistence to a distant suburb.

Sculpture as a profession had become a journeyman's job, but as a creative act its appeal was as powerful as ever. And so it was that Géricault, whose drawing has a muscularity that presupposes sculpture, took to making small models. Daumier, a supreme draughtsman who was unable to succeed as a painter, produced caricature sculpture which is among his greatest work. And Degas, who was the greatest amateur sculptor of all time, joined them in helping to set the stage for the revival of sculpture in bronze.

They were not themselves bronze sculptors – their work was made for the most part casually, and cast posthumously; they were men whose fingers were like those of the Dactyls, and who projected their drawings into solid form. They were modellers who built up their figures from clay or wax, and not carvers who cut their images out of stone. Thus they were at the opposite extreme from the Greeks and from Michelangelo, who had said: 'By sculpture I understand an art which operates by taking away superfluous material.' Despite the Greeks, this is the difference between the stone sculptor and the bronzeworker throughout history. It separates Michelangelo from Leonardo, who despised stone carvers and said so. During the nineteenth century it was the

38

modeller who triumphed, in the genius of Rodin. His models
were the work of his own hands, but many of his marbles were
carved by Italian artisans under his supervision. This was in
contrast to his last great forerunner, Bernini, who worked in
marble and was copied in bronze. There is an important difference
in handling which is characteristic of Rodin and which gives his
work a surface unlike that of the bronze sculpture of the past.
Traditionally the casting, no less than the cold work on the
finished bronze, was part of the sculptor's task. No less important,
the wax received the greatest attention from the sculptor before
the cast was made, and this determined the surface. But Rodin's
clay model was cast in plaster, a wax impression of it was taken
from a negative mould by professionals, and the result was then
cast – so that it is the clay model which is reproduced and not the
sculptor's own wax. The bronzes that owe so much to Rodin's
influence – those of Renoir, Matisse, and, in his early years,
Picasso – are also reproductions of clay models. Now clay is a
sticky substance close to paint and sympathetic to painters, but
it is a substance far removed from the metal. Metal long ago be-
came the province of the foundryman, who has no pretensions
to sculpture, and though the sculptor today – if he is worthy of the
name – knows his processes, he rarely casts his own work. Rodin
as a sculptor, in his comprehension of form and power of expres-
sion, was to the nineteenth century what Donatello was to the
fifteenth, but as a metalworker he was nowhere; and since much
of his work has been frequently and poorly repeated by subse-
quent generations of foundrymen, it is rare to see in a Rodin
bronze the potential splendour of the material itself. The twen-
tieth century, which has produced a vital and impressive revival
of the art of sculpture in bronze, has also produced an uneasy
dichotomy between pictorial, or modelled, and sculptural, or
carved, tendencies. For example, it would be fair to say that
Giacometti is a painter-sculptor as opposed to Brancusi, whose
bronzes reflect his stone carving. Marini's bronzes are those of a
wood carver and Maillol's stone carvings are the work of a
modeller. Henry Moore, beginning as a stone carver, has perhaps
more than any other sculptor mastered the differences in the
media. This results from his invariable practice of working the
wax itself, with enormous care, before it is cast. His wax when it

is 'lost' leaves behind it the true impression of his hand; no journeyman or plaster moulder comes between the sculptor and the object. What remains unchanged is the process, the wax which made and lost the mythical wings of Icarus. Every culture that has produced bronze sculpture, from China to Africa, from Nineveh to New York, has employed the lost-wax process, no matter how widely separate in place or time. Every age since the Copper Age has in some degree depended upon it.

Bronze is a base metal so common that you handle it every time you touch the small change in your pocket, yet to touch it is to touch the stuff of history, for it has shaped much of history. The eyes of two hundred generations have looked tirelessly upon bronze and it has patiently responded to tireless labour. It has been burnished, gilded, inlaid, enamelled, varnished, and patinated, yet nothing can make it live like the touch of the human hand. But perhaps time is its greatest artificer, for though it has destroyed much bronze, it has also weathered it to a beauty of surface which only time can achieve. Taking the unwearying metal, time turns it to the silver-green of malachite and the dazzling blue of azurite and the warm earth colour of native copper, which is where it began when first the earth uncovered it to man.

1956

The Making of
a Maze

I HAVE BEEN a traveller across time, first by chance and then by choice, and for some time with no choice. Once you are in, you are in: if you make a myth your matrix and if that myth is centred upon as ancient and potent a concept as the Labyrinth, you build it around yourself without becoming aware that you are lost in the thing. Finding your way out only takes you deeper in, and only the way in is the way out.

plates
66–70

Since 11 May 1956, when I stood on the point at Procida, west of Naples, and looked down the long isthmus towards the great rock of Cumae, which towers over the sea and the Pallid Lake, I have lived among the 'wandering ways', as Virgil called them, deep in the second millennium B C and no less deep in the twentieth century A D, because, in a maze, time crosses and recrosses and one time lives in another. If I can escape I shall, but whenever in fourteen years I have felt that I have said what I had to say about Daedalus, the Athenian who built the Cretan Labyrinth, and Icarus, his son, who flew with him and fell from flight, something has occurred that has given me more to know and more to do in sculpture and painting and more to say in words. Myth lengthens and thickens, coiling like a labyrinth around itself.

I began my wandering in the myth of Daedalus by making a wash drawing of the acropolis of Cumae, a sacred place colonized by the Greeks from Euboea about 800 B C, and before that a trading post that was known to the Mycenaeans, and before that the place where Daedalus landed at the end of his long flight. None of this I knew when I made the drawing. I walked along the isthmus in the heat of the day and went into the labyrinth of passages that honeycomb the great rock. From the centre of this

66

293

place the Cumaean Sibyl spoke her oracles. The voice of Apollo spoke through her, and what she said came to be set down in books that the Romans kept to consult in times of crisis, in the Temple of Capitoline Jove. Aeneas spoke to her, pausing on his voyage from burned and vanquished Troy, and went down through her maze of caves to Lake Avernus and into the underworld to seek advice from his father. Her voice was heard across the sea and across the landscape in 'a hundred rushing streams of sound' through 'a hundred mouth openings' in the rock.

Hearing them in the silence of my mind and commanded by the long-inhabited and numinous place, I obeyed. For fourteen years it has been the centre of my focus, and what began as one wash-drawing grew this year into a maze of brick and stone with 1,680 feet of wandering pathways and walls six and eight feet high. This year, too, it shrank to a honeycomb in gold, four inches across, inhabited by seven golden bees.

Virgil recounts the outline of the myth of Daedalus in Book VI of the *Aeneid,* describing the reliefs that Daedalus cast for the great doors of the temple to Apollo that he founded on the summit of the Cumaean rock:

'Daedalus when he was in flight from the tyranny of Minos adventured his life in the sky on swooping wings and glided toward the chill north by tracks unknown. At last he hovered lightly above the Euboean stronghold. In these lands he first found refuge and straightway consecrated the oarage of his wings to Phoebus Apollo for whom he founded a gigantic temple. 'On the temple gate he pictured . . . the island on which Knossos stands, rising high above the sea . . . the Bull's brutal passion, and Pasiphaë's secret union with him and the record of wicked love, hybrid procreation, two shapes in one, the Minotaur in the midst of the winding ways of the house that was there, which might not be unravelled except that the Builder himself pitied the queen . . . and guiding sightless footsteps with his thread unlocked the coils. And Icarus, he too would have found prominence on this great sculpture but for the power of grief: for Daedalus twice seeking to mould his fall in gold had twice failed.'

To Virgil's audience further parts of the legend would have been familiar. They would have known how Daedalus left the little kingdom of Athens and took service with Minos, who ruled

Crete from the city of Knossos, the centre of the first great European civilization. They would have known how he built for Minos and what marvels he made with the tools that he invented, among them the saw, the auger, the plumb line, tongs, and the ball-and-socket joint, for Daedalus was the archetype of architects, inventors, and technicians. They would have known how the craftsman Daedalus contrived the life-like simulacrum of a cow in which Pasiphaë crouched to receive the white bull who mated with her, and how Minos blamed the craftsman for this contrivance and locked him with Icarus in the Labyrinth Daedalus himself had made to imprison the bull-headed man, the Minotaur, and hide the hybrid evidence of the queen's lust. It was there, in the Labyrinth, that Daedalus made wings for himself and for Icarus, who were thus the first men to fly, and on that flight Icarus flew too near the sun so that his waxen wings melted and he fell to his death in the sea. They would have known, too, how Daedalus landed at Cumae and built the temple to Apollo, who had killed his son, and how he thereafter journeyed to Sicily, where Minos pursued him, and how he killed Minos and went from Sicily to Sardinia, taking his genius as a metal-worker to that island where perhaps he died. They would have known the myth as an amalgam of many variations on a theme, some in harmony, some in conflict, for that is what myth is. It is not simple, it grows and reshapes itself continually.

Virgil wrote of this legend, as did Ovid, Plutarch, and Diodorus Siculus and before them the Greek poets Epimenides, Bacchylides, Cleidemus, and Philochorus, in relation to the parallel myth of Theseus, which joins and crosses the myth of Daedalus, who was Theseus's kinsman. Fourteen hundred years after Virgil but before Breughel painted his *Fall of Icarus,* Chaucer wrote briefly of Daedalus and his son and Shakespeare speaks of them in *Henry VI,* as does Goethe in *Faust.* In modern times James Joyce's hero is Stephen Dedalus; Picasso and Matisse have painted Icarus; and Gide's *Theseus,* his last major work, is centred on the Cretan Labyrinth. Daedalus is alive, as he was alive before Homer wrote of him in the *Iliad.* I know. I have lived with him, and like those who have told and retold the narrative and portrayed the events, I have added what was given me to add and reshaped the legend where I had need to do so.

What began for me with the landscape of Cumae continued in the landscape of Greece and the islands. It was on Crete in 1958 that Daedalus became specific to me, a man in whose life I was inextricably involved. I began to know him and sense his uneasy relationship with his son. I made bronzes of them. Daedalus in turn, seemingly, was engaged upon making the wings somewhere in the Maze at Knossos. In 1959 I began to concentrate on the flight itself and the sea over which they flew, and these things emerged in paint and collage, in drawings and sculpture.

In 1960 I wrote a short narrative called *The Testament of Daedalus,* which told of the flight. On the day I corrected the proofs, a man won a prize for making the first man-powered flight since Daedalus and Icarus. It seemed odd, but then, for about twenty-five centuries after the origins of the legend, flight itself had been treated as a fantasy or a folly. It is not now, nor has it been since 1905; and it is a measure of the god's irony that the first air-borne invasion ever to take place should have led to the capture of Crete in 1941. As the stress of that first flight became clearer to me, so the parallel between the myth and the facts of our own time became more explicit. The head and then the whole figure of Icarus reshaped itself, and he evolved into something as remote as an astronaut and yet was piercingly immediate in his relevance to me as a human being under stress.

At this point the other *dramatis personae* of the myth began to pull at me down the passages of the Maze: Minos the king and his queen Pasiphaë; Tauros, their military commander; Talos, the bronze man, a technician turned into a metallic warrior to become guardian of Crete. I made images of him before I knew he had been Daedalus's nephew, but that can happen if you visit with so remote a family. The Minotaur came sharply into my foreground in 1962 and began the agonized evolution toward the human condition that to me is his nature and his ambition. Him I drew and cast in bronze, but I never painted him. I do not know why. It has been said that Theseus slew the Minotaur, but Theseus was a braggart, and the Minotaur is killed every Sunday in Spain or Mexico, and, as Picasso knows, he does not die. Icarus does nothing else.

I went back to Cumae, having been to Delphi, and the Sibyl demanded to be made in bronze in fifteen different forms. She

70

296

too was a relative both of her Delphic counterpart, the Pythian oracle, and of Queen Pasiphaë: the female factor in myth is no less powerful than it is in life. But finally Daedalus himself came to dominate the Maze, and by then I had identified myself with him so compulsively that the myth began to reshape itself, expanding in my mind, and without any warning I found myself writing a further narrative, a transposed autobiography.

I did this to complete a jigsaw, or rather, to find a way out of the myth itself. I believed that, if I could add to the sum of all the images I had made a narrative that would place, order and assemble the mass of fragments that all my work in painting and sculpture seemed to be, I might see the Labyrinth of Daedalus clearly and escape from it. I took two years to write *The Maze Maker*,* and the publishers called it a novel. During all that time I made drawings, paintings, and sculptures on the theme of the Maze Maker. It was no use: I was not out, I was deeper in. I had written the whole 'autobiography' of Daedalus to rid myself of him, and I had produced in fact the exact reverse of an illustrated book, for all the images preceded it or continued to emerge while I was writing, and the text did no more for me than explain what I was doing in there. Furthermore, I became entangled in the long, complicated, and curious history, pre-history, and meaning of mazes, which begins at least five thousand years ago.

In the ancient world great labyrinths were built of stone. Herodotus described the labyrinth of Egypt built by the Pharaoh Amenenhat III as consisting of three thousand intercommunicating rooms on two levels, while Pliny wrote of a maze on the island of Lemnos built on the Egyptian pattern and renowned for the beauty of its one hundred and fifty columns. There was another maze on Samos, said to have been built by Theodorus, and one at Chiusi, of which Marcus Terentius Varro gives a detailed if improbable account. This Etruscan maze lay underground, below the tomb of Lars Porsena of Clusium, and it was inextricable 'to anyone who entered it without a clue of thread'. That clue of thread derives from the red one Ariadne gave to Theseus so that he might find his way in the Cretan Labyrinth built by Daedalus.

None of these vast buildings has survived. What we have are heraldic versions of the Cretan Maze on coins of Knossos from

* Holt, Rinehart & Winston, 1967; Longmans Green & Co., London, 1967.

the fifth to the first century B C; ideograms of even earlier date, going back to Minoan times, which derived from the maze and were painted on the walls of houses, found their way into textiles and were incised upon funerary urns. Their purpose was to protect, and the familiar 'meander', or 'key' pattern is one of them.

In Roman times mazes took the form of mosaic floor motifs and even passed into children's games, where they have remained to this day. Pliny referred to them as *'in pavimentis puerorumque ludis campestribus'*. They have come down to us modified into hopscotch, which calls to mind the floor maze mentioned in Book XVIII of Homer's *Iliad*. Upon the shield made by the bronzesmith god Hephaestus for the warrior Achilles, there was depicted, among other things, 'a dancing floor like the one Daedalus designed in the spacious town of Knossos for Ariadne of the lovely locks'. Homer does not specifically refer to a maze, but there is other evidence that the pattern laid out for Ariadne was a plan of the intricate manœuvres required of the dancers imitating the mating ceremony of the crane or the partridge In this dance, called the *geranos*, the complicated circling, advance, and withdrawal from the female at the centre, practised by the male, may originally have been totemic or possibly mimetic, to insure success in the hunt. It is Ariadne's dance that Theseus is said to have learned from Daedalus and danced at the entrance to the Labyrinth, and in the twelfth century A D the learned monk Eustathius of Thessalonica related this part of the legend, recalling an old man on Delos who remembered the steps.

In the ancient world everything meant both itself and something else. A ritual devised for one purpose could come to represent another, and the *geranos* relates to the maze, since the maze itself is concerned with a complicated circling passage to the centre. It is a coil. In ritual the *geranos* threaded its way through that coil to act out the climax of the dance.

The function of the maze is twofold: to arrest the intruder by confusing him, and to protect the centre from intrusion. As a fortification it embodied the principle of the enfilade, without which the trench warfare of World War I could not have been conducted with guns nor the Iron Age Maiden Castle have been defended with spears and arrows. Those who sought to enter sought to kill.

The Maze at Knossos, as Virgil describes it, is wholly different from Homer's dancing floor. Virgil's labyrinth was a palace with high walls and 'wandering ways' through which Theseus was guided by Ariadne's thread. The Maze at Knossos had been built by Daedalus to imprison the Minotaur, and from it he and his son had escaped (like cranes or partridges) by flying out. It is in fact in Virgil's *Aeneid* that the version of the myth still familiar to us is to be found. However, Virgil also describes a dance or game – *Trojae Ludus* – that was performed by young Trojans at the funeral games for Anchises and at the foundation of Alba Longa. The exact origins of this tradition are lost, but an Etruscan wine-jug of the seventh century B C carries a graffito that shows a maze from which emerges a line of warriors both mounted and on foot, and the maze is clearly labelled *truia*. This is one among many indications that a myth or rite that associated Troy with a maze and with a dance existed at least eight hundred years before Virgil wrote. There is other early evidence to suggest that the defence of walled cities involved maze rituals. Joshua's circling of the walls of Jericho, which caused them to fall, coincides with the ancient convention that a maze has seven turns or seven 'decision points' at which the intruder must decide between alternative routes. If Joshua marched his army seven times around Jericho counter to the original foundation ritual of that city, the maze defences would be unwound, and the city could fall, as it is described as doing, to the conqueror.

There is a further symbolism of great importance and of even greater antiquity than the Homeric or Virgilian legends. This is to be found in the Sumerian epic of Gilgamesh, which exists in various Mesopotamian tongues and is at least a thousand years older than the occurrences on Crete relayed to us by Homer and Virgil. In the Gilgamesh Epic the Sumerian hero seeks to find his way through a cedar forest (a place of terror to the inhabitant of an alluvial plain devoid of trees of any sort). This labyrinth–like forest is ruled by the entrail demon Humbaba, and Gilgamesh succeeds in finding his way through the forest and killing the demon. Thereafter Gilgamesh rejects the goddess Ishtar, much as Theseus rejected and abandoned Ariadne on Naxos. Rahab the harlot, on the other hand, was not rejected after she had betrayed Jericho to the Jews and assisted their entry with a red cord. The

299

red cord hung from the window was the sign that she should be spared. In the epic of Gilgamesh, the entrail demon of the forest maze, whose image survives in a Babylonian terra cotta of the seventh century B C, is represented as himself a maze: his head is a complex pattern of intertwined entrails. Now the Akkadian word *ekkalu* means either 'palace' or 'temple' (as does the Hebrew word *heichal*), and Akkadian is among the earliest decipherable Mesopotamian languages. The word was used in the practice of augury, or divination from the entrails of sacrificial animals, to mean 'the palace of the intestines' and seems also to have been synonymous with the Mesopotamian word for the underworld. What is more, other Akkadian divinatory terms seem to have been elaborate metaphors in which parts of the entrails were represented as 'mountains', 'rivers', 'passages', etc., or, in effect, a description of landscape. The liver, by which the form of divination called haruspicy was practised, seems, together with the entrails, to have symbolized the Mesopotamian universe. Augury and haruspicy both continued into Roman times. Thus, by implication, man contained the image of the universe within himself from the third millennium B C until the practice of animal sacrifice ceased in the Christian world and the metaphor lost some of its physical significance.

It did not, however, die out. It was modified to mean the symbolic passage through life and death into redemption. As such it is believed to have been embroidered on the robes of Byzantine emperors, and by the twelfth century A D it had become a floor pattern once more, a dancing floor of pain where those who had failed in their vows to go on pilgrimage traversed it on their knees in penitence. Such a maze, forty feet in diameter, survives in the nave of the Chartres cathedral, but unlike the maze of Daedalus, the 'Jerusalem', or medieval maze, contains no traps or false leads. Those who patiently traverse every coil will reach the centre, and that centre was called *Le Ciel*. On the other hand, at Amiens there was a floor maze that contained the names of all the master builders of the cathedral, woven into the coil. Thus was Daedalus remembered as the archetypal architect, and thus his name appears in an inscription beside the twelfth-century maze in the wall of the cathedral at Lucca.

From the church the maze moved out into the garden, and topiary mazes, of which the most famous is the one planted at Hampton Court Palace in 1690, became a common feature in formal gardens. In my local town of Saffron Walden there were three mazes: one in the church, a medieval 'turf maze' cut in a field, and a topiary maze in a garden, but I knew nothing to speak of about any kind of maze until I went into the rock at Cumae. I knew none of their history until I began, in 1964, to write *The Maze Maker;* but perhaps because, like every human being, I contained a maze, I found that I wrote of the labyrinth below the rock of Cumae as the entrails of the Earth and believed, as Daedalus would have done, that the Earth was female. Her name in Greek is Gaia. The whole of the central part of the book takes place below the rock of Cumae, and in writing it, the idea came to me that the maze, which is a natural place of terror, a convolution of dark caves and buried passages, must have originated inside the belly of man and his animal prey. As a symbol, in its most profound and ancient form, the inexplicable yards of intertwining intestine that man first revealed when he inserted his flint knife into his victim were the source of his awe and the potency of the image. The complex of guts would have been inexplicable, and that his children were formed somewhere in the passages and chambers within the female body would have been part of the mystery. When a child was born from his woman, it was joined to her by a red thread, by Ariadne's thread. This I divined; the evidence of Sumerian divination and other recondite matters, I learned later.

When Daedalus went into the earth at Cumae under oath to build a temple to Apollo, he was faced with technical problems, and since it was he who wrote *The Maze Maker,* he had need to explain them, for where most myths are the work of poets who deal in the miraculous, Daedalus is a technician who deals with the practical. Thus he reports that under the rock at Cumae lived a race of metalworkers, craftsmen who, like the Cretan Dactyli whose name means 'finger men', lived secretly and apart. Such peoples in the ancient world were either dwarfs, like the Cabeiri, or giants, like the Cyclopes who toiled under Mount Etna. Those under Cumae were small men who never revealed their names, and only one could speak Greek. To enlist the aid of this man (whom he calls 'the Greek Speaker') and his fellow craftsmen,

301

Daedalus had to convince them of his mastery. He chose to make a perfect honeycomb in gold as an offering to the Earth Mother, and this he did, according to Diodorus Siculus, although Diodorus places the event at Eryx in Sicily. As an achievement this honeycomb remained a mystery and a marvel for two thousand years, since Diodorus, writing in the first century B C, did not suggest how it was done, and what is more impossibly fragile to make in metal than a honeycomb?

Since Daedalus dictated *The Maze Maker,* he could hardly leave matters so vague, and since metalwork is part of my trade, too, he revealed the secret to me when I came to write down his words. I quote him:

67 'To cast a honeycomb in gold is not easy, but it is less difficult than it might appear. I shall explain why and reveal a small mystery, one of those upon which my fame rests, for it was this task successfully accomplished which bound the small people to me and made the construction of Apollo's temple possible.

'I asked for a perfect piece of comb from a well-kept hive and after much delay, it was brought to me. I asked for privacy, saying that I must invoke the gods' aid with secret charms, and my demand was treated respectfully, for all metalworkers hedge their craft about with mystification. I was taken to a small but adequate cave and there supplied with wax, fire, tools, a bench, a kiln, bellows, and all the necessary impedimenta of the goldsmith.

'Fist to forehead, I invoked the Mother and the small men reverently withdrew. It was important that they should, for I gambled on their failure to make a simple connection between the craft of lost-wax casting and the nature of the honeycomb itself. Honey is sacred to the earth goddess and wax comes from the honeycomb. With wax men make the models cast in bronze, as I have described. The small people had given me a honeycomb but they had also given me wax to make my model. Thus I knew that they had not made the connection. They had not realized that the honeycomb itself, being of wax, is the only creation in nature which is itself a wax model and one more delicately constructed than any a man could achieve.

'I ignored the wax I had been given and took the comb. It was necessary to uncap the individual cells and to do this I cut laterally

through the comb and drained out the honey. Each cell of comb I now filled with fine ground clay and rock dust in a paste as thin as cream new risen on a pan of milk, so that each cell was filled with core. To the side of the whole piece of comb I attached a tiny pouring cup and thin "runners" of wax. It was solely for the pouring cup and vents that I used the separate wax I had been given. Then, I mantled the whole and when all was hardened in the kiln, I burnt out the waxen comb.

'Gold pours thin and quickly. I poured each section while the core was still hot and the gold could run smoothly, and so the honeycomb was cast. Breaking the crust and tapping out the core was long and delicate labour, but in time I had the golden comb clean and had covered all its faults with gold granulations to resemble drops of honey. Finally, I capped some of the cells to emphasize the structure. . . .

'I covered my work and called the Greek Speaker. "Send for seven bees", I said with heavy solemnity, "for without them the golden comb will never fill with honey".

'He went away and by whatever means, at that time not known to me, he made communication with the world outside and in due time brought me seven bees, workers from the same hive as the comb I had been given as a model. Of this he solemnly assured me. Left alone, I made sacrifice to Artemis of these seven bees.

'There is another trick of casting which I was certain would not be known to the small people and it is this. Anything small enough and dry enough to be burnt totally, leaving no ash or unconsumed material, will leave its negative impression as perfect in the mantle as will wax. I have cast the legs of grasshoppers into saws for ivory workers and cast real butterflies, wing perfect, by these means.

'And so I took the bees from the little box in which they had been brought. I killed each one with a needle . . . and I did so with as much reverential care as a priest would sacrifice seven bulls to Zeus. I mantled each fragile carapace and burnt it out of the mantle and, making each laborious insect laboriously immortal, I poured gold into these tiny moulds. When, many hours later, I broke them open there were seven bees of solid gold. Each wing and every leg perfect, they lay on the palm of my hand.

'"Here in your honour, Artemis," I said, "the most fragile sacrifice ever made you. Each victim ritually killed, each pyre

ritually kindled and behold, each is a votive to last forever." And I fastened the bees upon the comb so that they seemed to be coming and going about their sacred business without which no man could cast the bronze doors of a temple to Apollo nor make any bronze sculpture.'

In May, 1967, *The Maze Maker* was published in England. In January, 1968, George Wooller from New Zealand, who had read the book, asked me to make a golden honeycomb for him. 'If,' he said, 'that is how it was done – do it!' It has been done, and we did it – not, I admit, in one attempt, for neither my friend John Donald, fine goldsmith though he is, nor I could rival Daedalus himself. We have, however, done it much as Daedalus described it, except that it was cast in a centrifuge and failed sixteen times before we achieved it because we lacked the weight of gold necessary to thrust its molten way through the walls of the comb, which were little more than the thickness of hairs. The bees, too, were cast by the method Daedalus describes, and when all was complete, the owner took it to New Zealand, where a friend, an apiarist, placed it among his hives to photograph it, and there real bees clustered upon it among their golden companions and began to come and go about their sacred business.

The 'secret' of course, is simple. Metal has been cast by the lost-wax method for five thousand years,* and a centrifuge can be contrived by whirling a vessel in circles on a string.

In the autumn of 1967 the book was published in America. A New York financier, Armand G. Erpf, read it and expressed interest in the maze itself. In effect, he too said, 'If that is how it was done – do it,' and it too is done. It lies in a cup in the Catskill Mountains of New York, and it is built of stone and brick – 210,000 bricks. It is two hundred feet across, with seven 'decision points' spaced through it. Its walls are eight feet high and at the centre of its 1,680 feet of coil there are two chambers: one is inhabited by the Minotaur in bronze, the other by Daedalus himself, who is at work on the making of a maze, and his winged son, who leaps upward to fly out from the centre into the sky. They too are of bronze and their chamber is lined with bronze mirrors.

* For a more detailed description of this process, see The 'Unwearying Bronze', p. 276 *et seq.*

As for me, I cloak myself for the time being in the last paragraphs of *The Maze Maker,* for if I am not Daedalus, perhaps I may quote him to illustrate on an epic scale what I suppose in smaller measure my own condition to be.

'I have called myself Maze Maker with a certain irony because although I believe myself pre-eminent in many crafts, I have been, as Minos described me, first and last a maker of labyrinths.

'All this long burrowing and building, to protect or to imprison, this flight through the sky and tunnelling in the earth, seems to me now to add up to no more than the parts of a single great maze which is my life. This maze for the Maze Maker I made from experience and from circumstance. Its shape identifies me. It has been my goal and my sanctuary, my journey and its destination. In it I have lived continually, ceaselessly enlarging it and turning it to and fro from ambition, hope, and fear. Toy, trial, and torment, the topology of my labyrinth remains ambiguous. Its materials are at once dense, impenetrable, translucent, and illusory. Such a total maze each man makes round himself and each is different from every other, for each contains the length, breadth, height, and depth of his own life.

'I, Daedalus, maze maker, shall take this that I have written with me to Sardinia and dedicate it at the entrance to the maze which leads to death. Then you, before you follow me down into Gaia, who is the Mother, will know what is to be known of my journey and the fate of my son, Icarus. Before you follow me, look into the sky-maze and acknowledge Apollo who is the god.'

1969

305

Acknowledgements

Alinari 28; Annan 25; Arts Council of Great Britain 65; British Museum 40, 42; Bulloz 34; A. C. Cooper 65, 71; Copenhagen Museum of Decorative Art 63; G. F. Faiers 46, 69; Deutsche Fotothek Dresden 39; Florence, Soprintendenza alle Gallerie 47; Gabinetto Fotografico Nazionale, Rome 30; Giraudon 19, 29, 43, 45, 50; Glasgow Museums and Art Gallery 22, 26; T. Lewinski 66; London, National Gallery 5, 8, 9, 16, 21, 32; Manor Studio, Southall 35; Mansell-Alinari 1, 12, 15, 44, 59, 61, 62; Mansell-Anderson 2, 3, 4, 20, 27; Mas 64; Milan, Castello Sforzesco 51; Ottawa, National Gallery of Canada 72; Service du Documentation Photographique, Versailles 36; Walter Steinkopf 7; Stuttgart, Staatsgalerie 37; Tate Gallery, London 10, 38, 53; N. A. Tombazi 60; Tosi 13, 14; Wallace Collection, London 17; John Webb 67; Windsor Royal Library 23; Yale University Art Gallery 11.

List of Illustrations

307

List of Illustrations

Index

Index

Index

Index

Watteau, Jean Antoine (cont.)
 quality, 42, 92, 98–9; Ruben's influence on, 92, 93–4, 221; and work method of, 95–7; *The Ball in the Colonnade*, 98; *Champs Elysées*, 92; *L'Embarquement pour L'Ile de Cythère*, 93, 204; *L'Enseigne de Gersaint*, 92, 98; *Harlequin and Columbine*, 92; *The Music Party* (or *Les Charmes de la Vie*), 92–100
Weinberger, Martin, 140, 141, 145
Wellington, Duke of, 290
Wells, H. G., 103
Weyden, Roger van der, *Entombment*, 136
Wheeler, Monroe and Rewald, John, *Modern Drawings*, 176
Whistler, James Abbot McNeill, 101, 103,

104, 206; 'Harmonics', 206; 'Nocturnes', 206; *Portrait of My Mother*, 101
Wind, Professor Edgar, 47, 86
Windsor Castle, 285
The Woman Taken in Adultery see under Giorgione
Wooller, George, 304
Wyatt, Matthew Cotes, 300

Yale University, 13

Zangwill, Israel, 102, 103–8; *The Children of the Ghetto*, 105; *Ghetto Comedies*, 105
Zichy, Count Michael, 201, 205
Zola, Emile, 183
Zurbarán, Francisco de, 233